7

Homework

Design Education
Practice & Process
Alliance Graphique Internationale

안그라픽스

9

Homework

Design Education
Practice & Process
Alliance Graphique Internationale

14	Adrian Shaughnessy
18	Ahn Sang-soo
24	Alice Twemlow
32	Anna Lena von Helldorff
38	Ariane Spanier
42	Cho Hyun
48	Chris Ro
52	Christof Gassner
56	David Smith
64	Elisabeth Kopf
72	Erik Adigard
80	Erik Brandt
90	Finn Nygaard
94	Hua Jiang
100	Jaemin Lee
102	Jan Wilker
104	Javier Mariscal
106	Jean-Benoît Lévy
114	Jessica Helfand
122	Jin Jung
124	Johnny Kelly
126	Jon Sueda
138	Kiko Farkas
142	Kyungsun Kymn
148	Lucille Tenazas
156	Marc Català
158	Markus Weisbeck
168	Martin Venezky
176	Mucho
182	Nancy Skolos
188	Oded Ezer
192	Patrick Thomas
200	Pooroni Rhee
202	René Knip
208	Robert Probst
214	Rolf Müller
216	Ruedi Baur
220	Sabina Oberholzer
226	Stefan Sagmeister
228	Tai-Keung Kan
232	Thomas Widdershoven
236	Willi Kunz
238	Woohyuk Park

The Alliance Graphique Internationale(AGI) is a professional association for graphic designers whose membership often approach design in a manner that goes beyond the archetypal client/designer paradigm. There is a large proportion of membership who are active in what might best be described as that magical 'other'. The great et cetera. Ellipsis. Yadda yadda yadda. The peripheral regions of design that excite us. This 'other' that is at the root of shaking, stirring and sometimes moving design culture. These are the activities that are immediately connected to design but perhaps cannot necessarily be described under the traditional definitions of design. Through such activities, some designers become artists. Some make. Some curate. Some write. Some teach. And somewhere in these peripheral regions of design exists that really good stuff. The stuff that moves us, moves design forward and also sometimes scratches the ankles of the design industry itself. AGI continues to be that special place that encourages the existence of this magical 'other'. AGI is a place that embraces movement. A place that embraces change. A place that embraces that which ultimately may be hard to embrace.

An integral component of this magical 'other' exists in design education. That meaningful space and time where we share, exchange and develop. Many of us are teachers. We teach the nuts and bolts. The how. The why. But we also teach to contribute to the discussion. To challenge our understanding of the industry. To try the things that cannot be tried. To ask the questions that cannot be asked on a normal basis. A large part of our practice and our concept of design is deeply rooted in design education and its related activities. We are designers who continuously set aside time every week, outside of professional practice, to enter a place of learning to both contribute and converse.

But many of these efforts are extremely hard to capture. Design education is a labor that is hard to frame, hard to track down and hard to share. Sometimes the results are never seen and even more so, difficult to quantify. What happens after one workshop? After

Foreword

국제그래픽디자인연맹 (이하 AGI)은 전형적인 클라이언트/디자이너의 패러다임을 뛰어넘는 방식으로 디자인에 접근하는 그래픽디자이너들의 전문 단체입니다. 매력적인 '다른' 분야로 설명되는 영역에서 활동하는 회원들이 큰 비중을 차지합니다. 이들은 기타 등등 다양한 분야에서 대단한 활동을 하고 있습니다. 우리를 자극하는 디자인의 주변 영역들. 디자인 문화를 근본적으로 뒤흔들고 뒤섞고 때로는 바꾸는 '다른' 분야. 디자인과 관련이 있지만 반드시 전통적인 디자인의 정의로 설명할 수는 없는 활동들입니다. 그런 활동을 통해 어떤 디자이너들은 예술가가 됩니다. 어떤 이들은 제작을 하고, 큐레이팅을 하기도 합니다. 집필자도 있으며 교육자도 있습니다. 이런 디자인의 주변부에는 뭔가 정말 좋은 것이 있습니다. 우리를 앞으로 나아가게 하며 디자인을 발전시키는, 그리고 디자인 산업의 가려운 곳을 긁어주는 그런 힘 말입니다. AGI는 지속적으로 이처럼 매력적인 '다른' 활동의 존재를 장려하는 특별한 곳입니다. 변화를 포용하고 궁극적으로 포용하기 어려운 것도 감싸 안는 장소입니다.

이 매력적인 '다른' 활동의 핵심 요소는 디자인 교육에 존재합니다. 우리가 공유하고 교류하고 발전하는 의미 있는 시간과 공간. 우리 중 다수는 가르치는 사람들입니다. 우리는 기본을 가르칩니다. 방법과 이유를 가르치지요. 그러나 토론에 기여하는 일도 가르칩니다. 산업에 대한 기존의 이해에 도전하고 시도할 수 없는 것을 시도하고, 보통은 할 수 없는 질문을 하는 법도 가르칩니다. 우리의 실무와 디자인 컨셉의 큰 부분이 디자인 교육과 관련된 활동에 깊이 뿌리내리고 있습니다. 우리는 전문적인 실무 외에도 배움의 장소에 들어가 기여하고 대화하기 위해 지속적으로 매주 시간을 할애하는 디자이너들입니다.

하지만 이런 노력의 대부분은 포착하기가 지극히 어렵습니다. 디자인 교육은 구조화하기 어렵고 추적하고 공유하기도 어려운 노동입니다. 때로는 결과가 보이지 않고, 더 나아가 정량화하기 어렵습니다. 워크숍 이후에는 어떤 일이 생길까요? 한 학기를 보낸 다음에는? 4개월, 4년, 40년 후의 결과는? 디자인 교육은 질문에 답하면 그 다음에 이상하게도 더 많은 질문을 하게 되는 놀라운 순환 과정을 일으킵니다. 복잡하고 난해하고 어수선하게 진화하고 있어, 추적하여 발자취를 따르기가 힘듭니다. 이 책은 이러한 활동 중 일부를 포착하려는 개괄적인 시도로 볼 수 있습니다. 이 매력적인 '다른' 순간들을 기록하고 엿보고 공유하려는 노력이자 기회이지요. AGI의 폭넓은 교육 활동을 관찰하며 배후에는 무엇이 있는지 살펴보는 순간이기도 합니다.

one semester? four months? Four years? Four decades? Design education creates a wonderful loop of questions that lead to answers that then, strangely enough, create more questions. It is a complicated, sticky, messy and evolving thing that is hard to track and hard to follow. This book can then be seen as a broad attempt to capture some of these activities. An effort and chance to document, glimpse and share moments from this magical 'other'. An opportunity to observe some of the wide ranging educational activities of AGI. A moment to see what might be behind the curtains.

This publication you have in your hands here is themed and titled 'Homework'. At the core of any education is the process. The things that we do along the way that get us to where we want to be. Homework. As the name suggests, it is something that may ultimately not be so glamorous. It is the extra time, the extra work that shapes us at an early age. It is the process that will hopefully lead to a future. It is both investment and hope. The objective of this book is to shine a light on some of this process. It can be considered an archive or overview of 'homework'. Some of the efforts, both large and small that encompass design education within AGI. It is a collection of course projects, curricula, workshop briefs, workshop results, films, interviews, institution descriptions, readers and results. It is an archive of items, ideas and concepts within design education that normally never see the light of day. Concepts that seem to always exist as an interior discussion. Here we seek to share some of this discussion with other educators, students and even those practicing designers who also exist for this magical 'other'. We often talk about the importance of process in design education. This is a chance to see front and center, that process.

For these reasons this bound compilation is both concrete and amorphous. It is both a collection of practices and processes, or beginnings and results because design education is something always growing and evolving. Like this, so are the works and minds of the AGI members who have graciously shared their experiences. This book is a first attempt to share the side of

여러분이 손에 들고 있는 이 출판물의 주제와 제목은 '숙제'입니다. 어떤 교육이든 핵심에는 과정이 있습니다. 우리가 원하는 곳에 다다르는 길에서 하는 일들. 바로 숙제입니다. 이름이 시사하듯이 숙제는 궁극적으로 그다지 매력이 없을지도 모릅니다. 어린 나이에 우리를 형성하는 것은 잉여의 시간과 작업입니다. 바라건대 미래로 이끌어주는 과정입니다. 투자이자 희망이지요. 이 책의 목적은 이 과정의 일부를 조명하는 것입니다. '숙제'의 아카이브 혹은 개요로 볼 수 있습니다. AGI 내의 디자인 교육을 포괄하는 크고 작은 노력의 일부입니다. 교육 과정의 프로젝트, 커리큘럼, 워크숍 개요와 결과, 영상, 인터뷰, 기관에 대한 설명, 독자들과 결과물의 모음집입니다. 보통은 외부에 공개되지 않는 아이템과 아이디어와 컨셉트를 모은 아카이브입니다. 언제나 내부적인 논의로만 존재하는 것 같은 개념들입니다. 여기서 우리는 이러한 논의의 일부를 다른 교육자들과 학생들, 그리고 이러한 매력적인 '기타' 활동을 위해서도 존재하는 디자이너들과 공유하고자 합니다. 우리는 종종 디자인 교육에서 과정이 가지는 중요성을 이야기합니다. 이 책은 그 과정을 가장 중요한 위치에서 살펴볼 기회입니다.

이러한 이유로 이 모음집은 구체적이면서도 무정형입니다. 디자인 교육은 항상 성장하고 진화하는 것이기에 이 책은 실무와 과정 혹은 시작과 결과물의 모음집입니다. 이와 같이 감사하게도 경험을 공유해준 AGI 회원들의 작품과 정신도 그러합니다. 이 책은 그래픽 디자인 분야를 발전시키고 육성하는 데 전념하는 AGI의 모습을 공유하기 위한 첫 시도입니다. 또한 AGI의 국제적인 목표들과 병행하는 디자인 교육의 전인적인 비전을 포착하려는 시도이기도 합니다. 우리는 이 책이 전 세계의 디자이너와 교육자, 디자인 애호가 들이 적극적으로 활용하는 교육적인 자료가 되기를 바랍니다.

AGI는 2019년 현재 전 세계 40개국 509명의 회원이 소속된 그래픽 디자이너와 아티스트 들의 단체입니다. 수많은 이야기들과 그만큼 다양한 전달 방식을 가진 지극히 다채로운 조직입니다. 이 책은 이 가운데 한 가지를 전하는 방법이 될 수 있을 것입니다. 우리는 여러분과 이 이야기를 나눌 수 있어 매우 기쁘게 생각합니다.

Alliance Graphique Internationale
Education, Chris Ro

국제그래픽디자인연맹 교육분과, 크리스 로

AGI that is dedicated to advancing and nurturing the field of graphic design. It is also an attempt to capture a holistic vision of design education that runs parallel to the international goals of AGI. We hope that it will be an active and enlightening resource for designers, educators, and design enthusiasts the world over.

As of 2019, the Alliance Graphique Internationale is an association of graphic designers and graphic artists represented by 509 members and 40 countries from around the world. It is an extremely diverse organization with a billion stories and only so many ways to tell them. This may be just one way to tell one of these stories and we are elated to share this with you.

12

Foreword

13

I came to teaching late. That I came at all strikes me as odd. I have no formal design training (I'm a self-taught graphic designer), and I have no teaching qualifications. Even the word 'teaching' feels odd, because although I've worked extensively with students over the past decade, I don't actually teach them in the sense of giving instruction. Learning takes place, but it arises through a process of self-discovery, critique and most important of all, through co-discovery with peers.

I call this independent learning. In other words, it is non-hierarchical, and the 'professor' is not regarded as all-knowing. Of course, education authorities and funding bodies struggle with this: if it's independent learning, they ask, why do we need teachers? They have a point.

When I was first invited to take up a teaching role I hesitated. My lack of experience meant that I doubted my fitness for the task. But it occurred to me that I'd actually been 'teaching' most of my professional life. For 15 years, I was creative director and co-founder of a successful design company. At one point in the early 2000s, we employed 40 people and had more work than we could cope with. A large amount of my time was spent working with our younger designers, but I never thought of this as teaching. I encouraged our tyro designers to make work but always avoided telling them what I thought about the results. Instead I'd ask them questions. Why did it look the way it did? How successfully did it deliver the brief? What were their intentions? Mostly, I just asked the question, why? This forced them to reflect on every aspect of the work, and eventually they acquired the habit of critical self-reflection—an essential, perhaps the preeminent requirement for all designers.

So, when it came to entering the classroom (another word I try to avoid) and working with students, I realised that all I had to do was transfer the spirit of critical reflection from the design studio to the academy. This was made possible by the fact that I mostly worked with postgraduate students. At the levels below MA, there is a pedagogical need to give instruction and

나는 강의를 늦게 시작한 편이다. 사실 내가 강의를 한다는 것이 이상하게 느껴진다. 나는 정식으로 디자인을 배운 적이 없고(나는 디자인을 독학했다), 교육에 대한 어떤 자격증도 없다. '강의'라는 단어는 그 자체로 이상하게 느껴지기도 한다. 과거 십여 년 동안 학생들과 굉장히 많은 작업을 진행했지만 그들에게 어떠한 지시를 하며 가르친 적이 없기 때문이다. 배움은 자기 발견의 과정과 비평을 통하여, 그리고 무엇보다도 동료들과 함께 발견하며 이루어진다.

나는 이것을 '자율적 배움'이라 부른다. 다시 말하자면 이 과정은 비위계적이며 교수는 뭐든 다 아는 존재가 아닌 것이다. 당연히 교육 당국과 교육에 투자하는 주체는 고민을 할 것이다. 만약 자율적으로 배운다면 왜 교사가 필요한가? 일리가 있다.

처음 강의를 제안받았을 때 망설였다. 경험이 없던 탓에 내가 이 일에 적합할지 의구심이 들었다. 하지만 사실은 내가 일하면서 평생 '가르치고' 있었다는 것을 깨닫게 되었다. 나는 디자인 회사를 공동 창업하고 15년 동안 디렉터로서 성공적으로 일해왔다. 2000년대 초반에는 감당하기 어려울 정도로 일이 많아져서 마흔 명이 넘는 직원을 데리고 있었던 적도 있다. 나는 대부분의 시간을 젊은 디자이너들과 함께 일하며 보냈다. 하지만 이를 '가르침'이라고 생각한 적은 없었다. 초보 디자이너의 작업을 항상 격려하되, 작업 결과를 평가하는 일은 삼갔다. 대신에 나는 그들에게 질문했다. 왜 이런 형태인가? 작업 개요를 얼마나 반영하고 있는가? 어떤 의도로 작업했는가? 거의 대부분 '왜'라는 질문을 했던 것 같다. 그래서 그들은 작업의 면면을 모두 살펴보고 작업에 대해서 비판적인 자기반성적 습관을 가지게 되었다. 이는 모든 디자이너에게 필수적인, 아마도 탁월한 요소일 것이다.

그래서 강의실(사실 내가 피하는 또 하나의 단어)에 들어가 학생들과 함께하면서 내가 할 일은 비판적 자기 반성의 정신을 디자인 스튜디오에서 학교로 가져가는 것뿐임을 깨달았다. 이는 내가 거의 대학원생들과 함께였기에 가능했다. 석사 과정 이전의 학생은 기술과 디자인의 전통, 소프트웨어 활용과 기타 테크닉 부분에서 지시를 내리고 가르쳐야 할 교육적 필요가 있다. 이런 교육적 수요가 석사 과정에서 아예 사라지는 것은 아니지만 내가 만난 대부분의 대학원생은 기술적이고 방법적인 디자인 측면에서 뛰어났다. 대학원에서는 뭔가 다른 것을 원하는 것이다. 대학과 디자인 학교에는 강의 시간에 대한 커리큘럼과 규칙이 있다. 시험이 있으며 상을 주기도 한다. 정부와 금전적 지원을

14

Adrian Shaughnessy

Co-founder of Unit Editions
Former Visiting Professor, Royal College of Art

Teaching and learning— not always the same thing

tutelage in the craft and conventions of design, in the use of software, and in other technical matters. This does not entirely go away at MA level, but it is less important, and many of the postgraduate students I work with are highly qualified in the technical and craft aspects of design. They want something different from postgraduate study.

Universities and design schools have curriculums and regulations about teaching time. They have exams and academic awards to give out. They are under scrutiny from governments and funding bodies. All of which means that my ideas around independent learning and practice-based design education are often out of sync with the institutions I work in.

Happily, there are enough gaps in the curriculums of most design schools to allow me to smuggle in my ideas. But as the academisation of design teaching advances, I worry that there will be fewer and fewer opportunities to practice in this way.

For many design professionals, and increasing numbers of academics, design education is thought to be in crises. Studio owners and employers regard modern design courses as self-indulgent, over-theoretical, and providing inadequate preparation for professional life. This has been a familiar design industry gripe for many years, but it's one that I have little sympathy with. Contemporary design is too complex and too diversified for educators to produce oven-ready designers fit for every situation. Increasingly, designers are required to make things that are invisible —UX and certain types of experiential design, for example. This requires new thinking about what a designer does, and speculation about being a designer in ways yet unknown. Therefore, all a design education can hope to do is produce self-aware individuals with the ability to keep learning beyond graduation. It's up to design studios and employers to teach the practical and professional skills that they require in their employees.

Academics are equally troubled by the way design education is developing. Student fees are on the rise, staff pay is woeful, zero hours contracts are the new norm, resources are dwindling, and university man-

15

하는 주체들의 조사도 받는다. 이 말은 자율적 학습과 실습 위주의 디자인 교육에 대한 내 생각이 소속 기관들과 잘 안 맞는 경우가 많다는 뜻이다.

다행히도 대부분 디자인 학교의 커리큘럼에는 내 아이디어들을 몰래 실행할 수 있는 틈이 있다. 하지만 디자인 교육이 점점 더 학구적인 방향으로 나아가면서 이런 식으로 수업을 진행할 기회가 점점 더 줄어들지는 않을까 걱정이 되는 게 사실이다.

디자인 교육이 위기에 봉착했다고 생각하는 디자인 전문가가 많고, 그런 시각을 가진 학자도 더 많아지는 추세이다. 스튜디오 운영자나 직원 들은 현대의 디자인 수업이 제멋대로이고, 너무 이론에 치우쳐 있거나 실무에 대해 충분히 가르치지 못한다고 본다. 디자인계에선 여러 해 동안 이런 불평이 있었다. 그러나 나는 그 말에 그다지 공감하지 않는다. 동시대 디자인은 너무 복잡하고 너무 다양화되어 교육자가 모든 상황에 맞는 디자이너를 빵처럼 구워낼 수가 없다. 가령 디자이너들은 UX나 특정 종류의 경험 디자인과 같이 비가시적인 것을 점점 더 많이 만들어야 한다. 이 때문에 디자이너가 하는 일에 대해 새롭게 생각하고, 아직 알려지지 않은 길을 따라 디자이너가 되는 경우를 생각해야 할 필요가 있다. 디자인 교육에 바랄 수 있는 것은 자기 인식이 가능하며 졸업 이후에도 지속적으로 학습할 수 있는 능력을 갖춘 개인을 길러내는 것뿐이다. 직원에게 필요한 실용적이고 전문적인 기술은 디자인 스튜디오와 고용주가 가르쳐야 한다.

학계에서는 디자인 교육이 전개되는 방식도 고민하고 있다. 학생들의 등록금은 오르고 직원들의 임금은 낮으며, 근로 시간을 특정하지 않고 고용주가 원하는 시간에만 일하는 0시간 근로 계약이 새로운 표준이 되었다. 자원은 줄어들고 대학의 경영진은 커리큘럼을 짧고 진행하기 쉽게 축소시킨다. 아직도 대학 진학률은 높다. 수많은 젊은이가 창의적인 업계에서 일하기 위해 디자인 교육을 받고 싶어 한다. 하지만 기존의 전통적 교육방식에서 벗어나 대안을 찾는 이들이 많아지고 있다. 교육 기관으로 인가 받지 않은 곳에서 디자인 기술을 단시간에 가르쳐준다. 스튜디오들은 점점 더 적은 인원으로 작업을 하고 인공지능이 전문적인 디자인에도 손을 뻗치고 있다. 만약 앞으로 디자이너가 더 적게 필요하다면 디자인 교육의 역할은 무엇일까?

그럼에도 나는 디자인의 미래와 디자인 교육의 지속적인 가치에 대해 긍정적인 입장이다. 나는 디자인 학위가 다른 인문학 학위와 유사하다고 생각한다. 디자인은

Adrian Shaughnessy (AGI 2011) has evolved his design career from being a founding member of the design studio INTRO into many related activities such as writing, publishing and teaching. He reflects upon his experience teaching in the following essay.

에이드리언 쇼네시(AGI 2011)는 디자인 스튜디오 인트로의 창립 멤버로 참여한 것에서 시작하여 글쓰기, 출판, 교육 등 관련된 여러 분야로 활동 영역을 넓혀왔다. 이어지는 에세이에서 그는 학생들을 가르친 경험에 대해 이야기한다. 쇼네시는 현재 왕립예술대학교의 객원 교수이다.

agers are narrowing curriculums to make courses shorter and easier for institutions to deliver. Enrolment is still high — many thousands of young people want to study design with a view to working in the creative industries. But more and more are looking for alternatives to a formal academic education. Non-academic-accredited businesses are offering fast track learning in the skills of design. Studios make do with fewer and fewer people. AI is beginning to encroach into professional design. If fewer designers are needed in the coming years, what is the role of design education?

In the face of all this, I remain an optimist, both about the future of design and the continuing value of a design education. I see a design degree as akin to any liberal arts degree. It gives the individual an insight into many aspects of modern life and none more important than the art of communication. There are very few spheres of life that do not require communication skills. If that is all that design schools can offer (allied with technical, craft, and thinking skills) then they will continue to have a purpose.

개인에게 현대의 다양한 삶의측면을 바라볼 수 있는 통찰력을 제공해준다. 그리고 소통의 기술만큼 중요한 것도 없다. 삶에서 소통이 적용되지 않는 부분이란 거의 없다. (기술적, 공예적, 그리고 사고하는 능력과 더불어) 이것을 제공할 수 있다면, 디자인 학교의 역할은 앞으로도 유효할 것이다.

16

Adrian Shaughnessy

17

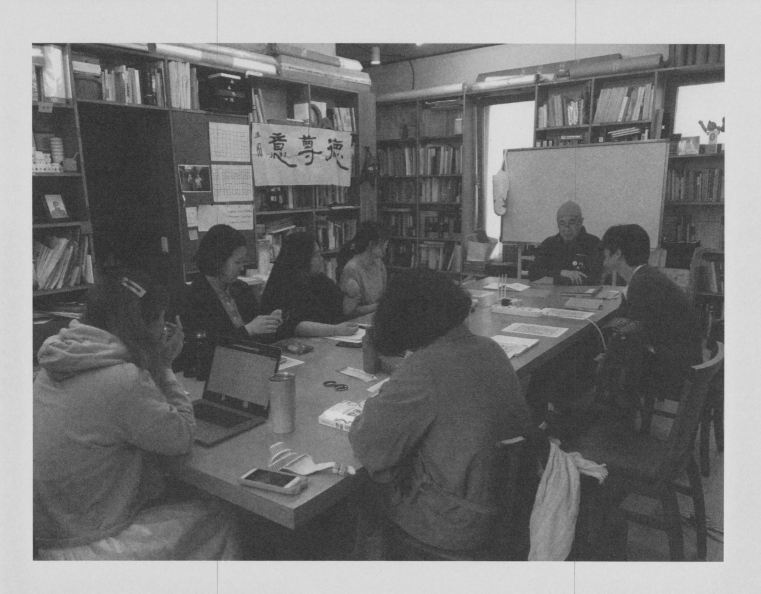

훈민정음 디자인론: 디자인의 시각으로 훈민정음 읽기

온누리 으뜸 멋지음이라 할 수 있는 한글에 대한 진정한 이해를 그 원본
<훈민정음 해례본>을 디자인의 관점으로 읽어내어 감응한다.

스승:
　　안상수

준비물:
　　훈민정음에 관련된 자료, 붓펜, 공책

참고문헌:
　　<훈민정음> 영인본
　　<훈민정음언해> 영인본
　　<28자로 이룬 문자혁명 훈민정음>, 김슬옹 지음, 아이세움

목표:
　　세계 최고의 디자인 이론서이자 철학서, 디자인 매뉴얼인 <훈민정음>을
　　디자인의 시각으로 읽어 나가며 한글에 대한 디자인적 이해를 높여
　　한국 디자이너로서의 자부심을 갖는다.

강의형식:
　　미리 예습을 한 배우미가 발표하고 토론하고 질문하며,
　　날개는 해설하고 답한다.

결과물:
　　보고서

Ahn Sang-Soo

Founder, Paju Typography Institute
Former Professor, Hongik University

Paju Typography Institute teaches students
about the principles of creating Hangeul and
its beauty. In a required course to have a true
understanding of Hangeul, they read the original
Hunminjeongeum Haeryebon ("Explanations
and Examples of the Correct/Proper Sounds for
the Instruction of the People") from a design
perspective and respond to it.

파주타이포그라피학교는 배우미들에게 한글의 창제
원리와 그 아름다움에 대해 가르친다. 필수 코스인
한글에 대한 진정한 이해를 그 원본 『훈민정음해례본』을
디자인 관점으로 읽어내어 감응한다.

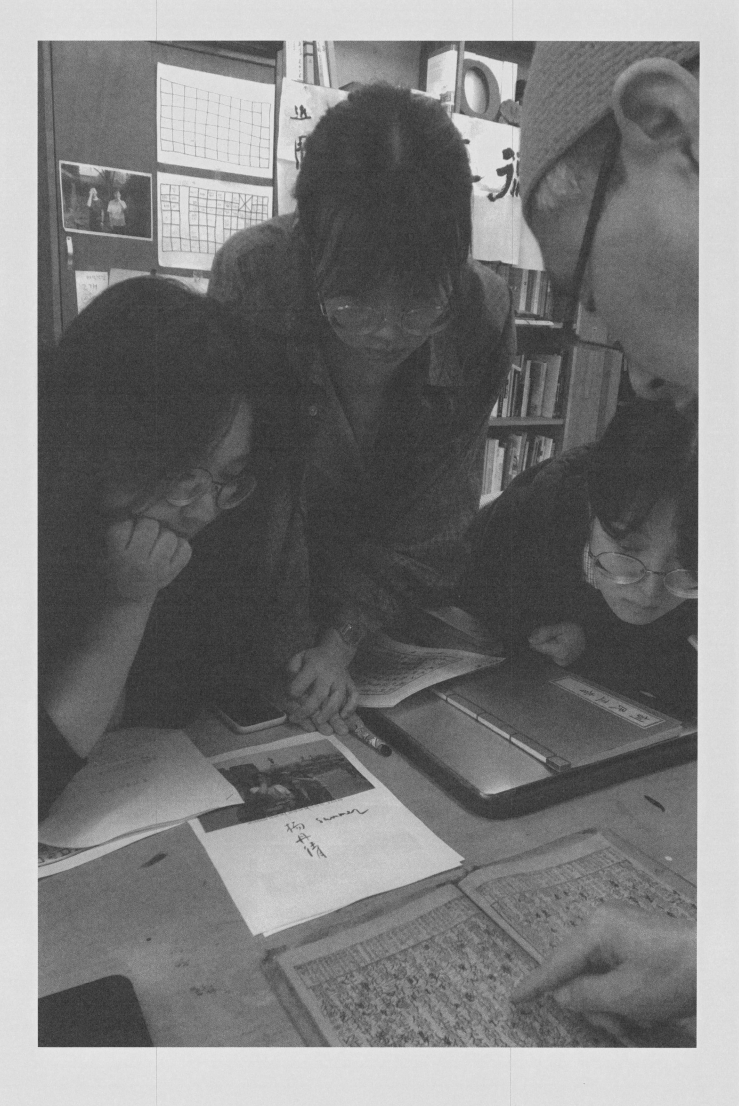

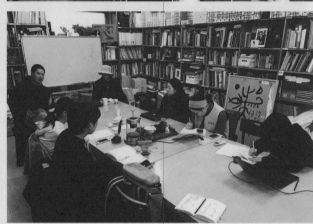

한글꼴 멋지음: 옛한글꼴, 탈네모 한글꼴

옛한글꼴 집자와 형태 다듬기를 통해 한글의 조형 원리를 익히고
한글꼴 멋지음의 새로운 가능성을 탐구한다.

스승:
　안상수, 안마노

준비물:
　컴퓨터, 붓펜

참고문헌:
　옛한글 판본 영인본 (50여종)

수업진행 :
　1일 (2018.10.1)
　오전: 열화당 책박물관 현장 수업(정혜경 열화당책박물관 학예사)
　오후: 옛 한글꼴 집자하기, 확대 후 고치고 다듬기

　2일 (2018.10.2) 한글꼴 문장 만들고 고치고 다듬기 (A1 size)

　3일 (2018.10.8) 한글꼴 문장 만들고 고치고 다듬기 마무리

　4일 (2018.10.10)
　오전: 탈네모꼴 한글 멋지음 (개인 및 조별 진행)
　오후: 결과물 발표 및 총평

Ahn Sang-Soo

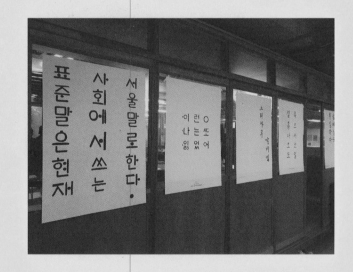

Korean type design classes that took place in October 2018 at PaTI. The course lasted for 4 days with 2 assignments. 1 is traditional Korean type design and 2 is non-tetragon module Korean type design.

2018년 10월 PaTI에서 진행한 한글꼴 멋지음 수업이다. 총 4일에 걸쳐 진행한 수업이며 두 가지 과제로 진행했다. '1.옛 한글꼴 멋지음 2.탈네모한글꼴 멋지음'이다.

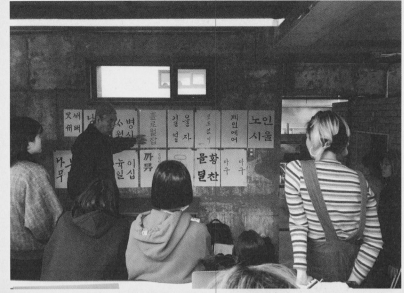

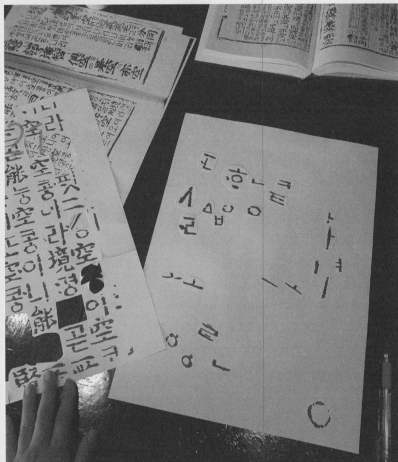

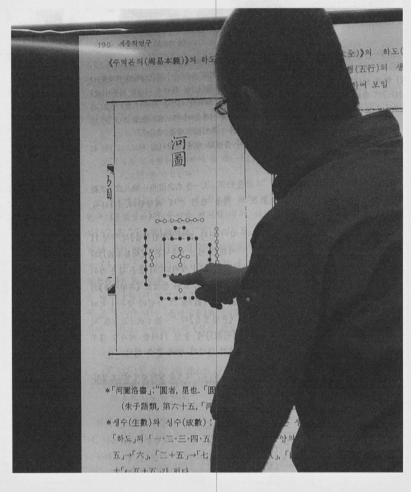

Ahn Sang-Soo

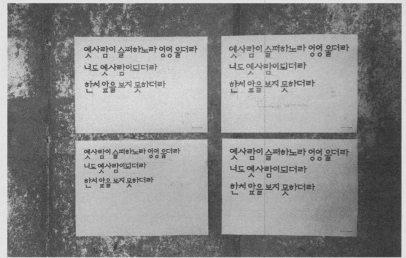

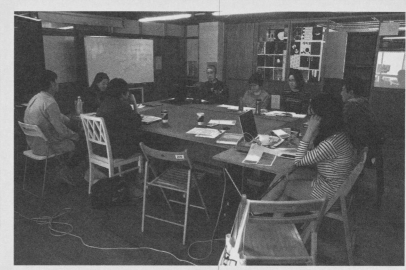

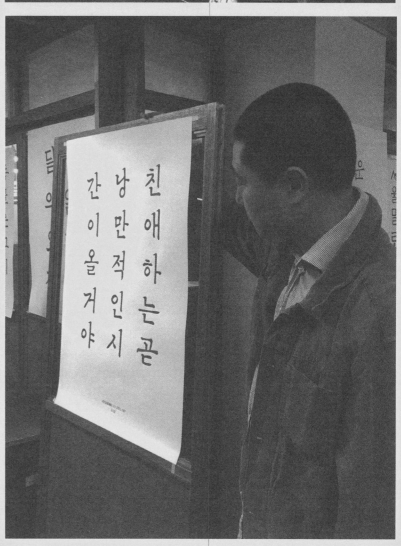

Why is writing important in a designer's education? How do you integrate writing in studio practice?

It depends on the designer how much they will go on to integrate writing in their studio practice. For some, it is an integral and essential component of their working process, one of the tools through which they iterate their concepts. For others, writing is an output or end-product, one of their modes of communication. But I think what is more important, for all designers, whether they like to write or not, is research: the ability to ask pertinent research questions, to identify and evaluate multiple sources in order to amass data, to analyze and interpret that data to provide new insights and contribute to knowledge. I think it's vital to teach all kinds of research skills and methods, derived from the humanities and social sciences, but also those that are native to design. But it's not only about research skills; part of this aspect of a designer's education should be about encouraging her to be aware of, and to engage in, social and political issues. From these she can identify a personal research territory that is urgent and timely, and can be used to fuel her work and to distinguish herself, as an emerging designer, from the increasing numbers of graduates each year.

Since 2017, you have been a Professor at the Royal Academy of Art The Hague (KABK). From a distance, this role seems to differ from your other academic positions. Could you explain what your current role at KABK involves?

Yes, the position of lector, or research professor, is unique to the Netherlands, where there is still a deep divide between university education and vocational academies where art and design are taught. Lectorates are a way to bring university-level research into the heart of art and design education. The one that I run—the design lectorate at KABK—is especially significant and unusual for the ways in which it connects research at Leiden University and at KABK. My role here is two-fold: On the one hand I seek out, encourage and provide a structure for design-driven research being carried out by tutors, heads and stu-

디자인 교육에서 글쓰기는 왜 중요한가? 스튜디의 실무와 글쓰기를 어떻게 통합할 수 있을까?

실무와 글쓰기를 얼마나 통합할 수 있을지는 디자이너에게 달려 있다. 누군가에게 글쓰기는 필수불가결한 작업 과정이고, 글쓰기를 통해 디자인의 콘셉트를 다시 보여줄 수도 있다. 또 다른 이에게는 최종 결과물이나 소통 방식일 수도 있다. 하지만 글쓰기를 좋아하든 싫어하든, 모든 디자이너에게 가장 중요한 능력은 리서치다. 리서치란 적절한 질문을 하고, 다양한 자료를 파악하고 평가해 데이터를 축적하고 분석하여 새로운 통찰을 도출하고, 그에 맞는 새로운 지식을 제공하는 능력을 말한다. 인문학과 사회과학에서 파생된 것뿐만 아니라 디자인 특유의 리서치 기술과 방법까지 모두 가르쳐야 한다고 생각한다. 그러나 디자인 교육은 단지 리서치 능력의 문제가 아니다. 사회적이며 정치적인 문제들을 인식하고 참여하도록 독려하는 것이 중요하다. 이를 통해 학생은 시급하고 시의적절한 개인적인 연구 분야를 발견하고 활용하여 디자인 작업을 발전시키면서 매년 늘어나는 수많은 대학원생 가운데 신진 디자이너로 돋보일 수 있다.

2017년부터 KABK에서 교수로 재직 중이다. 멀리서 보면 교수라는 직함은 당신이 맡은 학계의 기타 직위와 다르게 보이는데, 지금 KABK에서 맡은 역할을 설명해달라.

강사나 연구 교수 자리는 네덜란드 고유의 직책이다. 아직 미술과 디자인을 가르치는 대학 교육과 직업 아카데미 사이의 간극은 깊다. 강사 제도는 대학 수준의 연구를 미술과 디자인 교육의 중심으로 끌어오는 방법이다. KABK에서 내가 이끄는 디자인 강의는 레이던대학교와 KABK의 연구를 연결한다는 점에서 특히 의미 있고 독특하다. 내 역할은 여기서 두 가지. KABK의 강사와 교수, 학생 들이 수행하는 디자인 중심의 연구를 발굴하고 독려하고 구조화한다. 동시에 내 연구 영역에서 디자인, 시간, 환경 사이의 관계에 집중하는 '디자인과 먼 미래'라는 연구를 진행하는 것이다. 이를 통해 지질학적 시간, 폐기물과 쓰레기, 디자인의 비물질화, 순환 경제, 수리와 재사용, 비인간과 디자인, 디지털 쓰레기 그리고 사색적이며 비평적인 디자인에 관해 연구한다. 두 가지 연구를

Alice Twemlow

Research Professor, Royal Academy of Art, The Hague
Author of *Sifting the Trash: A History of Design Criticism*

Alice Twemlow (AGI 2013) is currently a Professor at the Royal Academy of Art The Hague (KABK). Previously, she was a founding faculty member of the Design Criticism MFA at the School of Visual Arts in New York. She is a unique AGI member as much her of professional career has been spent working in the areas of design history and criticism.

앨리스 트웸로(Alice Twemlow, AGI 2013)는 현재 헤이그왕립예술학교(Koninklijke Academie van Beeldende Kunsted, KABK)에서 교수로 재직 중이다. 이 곳에 부임하기 전 뉴욕의 SVA에 디자인 비평 MFA 과정을 도입하기도 했던 트웸로는 디자인사와 비평 분야에서 상당한 경력을 쌓아온 흔치 않은 AGI 회원이다.

dents at KABK. And meanwhile, I develop my own research territory, which focuses on the relationship between design, time and the environment, and is titled "Design and the Deep Future". This theme allows for investigation of such topics as: geological time, waste and trash, dematerialization of design, circular economy, repair and reuse, non-humans and design, digital detritus, and speculative and critical design. In order to develop both aspects of research, I run two research groups, a research club, organize symposia such as Fault Lines, teach courses, curate exhibitions, participate in panels and conferences, write papers, and edit content for an online platform.

진행하기 위해 두 개의 연구 그룹을 운영하고, 연구 클럽과 <Fault Lines> 등의 심포지엄을 구성하며 수업을 진행하고 전시도 기획한다. 컨퍼런스 패널로 참여하기도 하고 논문도 쓴다. 온라인 플랫폼의 콘텐츠를 편집하기도 한다.

<u>Is design history important from a practical training perspective? How do you think design history should be taught alongside studio courses?</u>
I was trained as a design historian, and so I am rather biased about its benefits! But the way that design history often gets taught in design schools is not particularly inspiring. Students often find it difficult to see a connection between the traditional canon-based presentation of design history delivered to them in lectures and the current concerns of their work in the studio. Many schools are aware of this disconnect and seek to bridge the divide between thinking and making, but there is still room for more experimental and imaginative approaches to the integration of historical and theoretical content with design practice. Personally, I prefer taking a theme- or issue-based approach, where a topic can be explored historically, theoretically, through contemporary examples and then carried through into a student's own practice. But of course, design history is not just a supplement to, or support for, the practical training of designers; it is an academic discipline in its own right, a form of historical inquiry that uses designed objects, systems, and discourses and the ways they are produced, distributed, and consumed as its source material and the basis for research.

디자인사가 실무 교육에서 중요한가?
디자인사는 실기 수업과 어떻게 병행해야 할까?
나는 주로 디자인의 역사를 공부한 터라, 디자인사의 이점에 대해 중립적이지 못하다. 디자인 학교에서 가르치는 디자인사는 일반적으로 크게 영감을 주지 못한다. 학생들은 수업 시간에 전통적인 규범을 바탕으로 제시되는 디자인 역사와, 현재의 실무에서 마주치는 관심사 사이의 연관성을 찾기 어려워한다. 많은 학교에서 이를 인식하여 사고하기와 제작하기 사이의 간극을 좁히려 노력한다. 하지만 그럼에도 여전히 역사적, 이론적인 내용과 디자인 실무를 결합하는 실험적이고 창의적인 접근법이 있다. 개인적으로 나는 테마나 이슈에 기초한 방법을 좋아하는데, 어떤 주제를 현대적 예시를 통해 역사적, 이론적으로 탐구하고 나서 학생 자신의 실무로 연결시키는 방법이다. 그러나 당연히 디자인사는 디자이너의 실무 교육을 위한 보조적 역할이나 지원에 그치지 않는다. 이는 독자적 학문 분야이며 일종의 역사적인 탐구이다. 디자인된 사물과 체계, 담론과 더불어 디자인이 생산, 유통, 소비되는 방식을 자료와 연구기반으로 삼는다.

25

She has brought much needed scholarship to the field and we were able to talk about her teaching practice via email. Arranged, conducted and edited by Chris Ro and James Chae.

그녀가 도입한 학문은 디자인 분야에 매우 필요한 것이었다. 이메일 인터뷰를 통해 그녀가 실제로 경험한 교육에 대해 이야기했다. Chris Ro와 James Chae가 인터뷰의 진행, 정리, 편집을 맡았다.

Your practice is demonstrative of the designer as organizer and really shows the potential for a designer to act beyond the studio through activities such as curation and organization. How do you broaden the definition of a designer within the classroom?

I think that the practice of writers, as well as designers, has opened up (both through necessity and desire) to include all kinds of activities. If it fits with someone's research territory or way of working, it can be beneficial to organize events, debates, exhibitions or to explore experimental forms of publishing, for example. But, like writing and research, these activities need to be taught, learned and tested in real-life scenarios; I think it is often underestimated how much goes into organizing a successful seminar or discussion panel, for example. I take care to teach, and give my students the opportunity to take responsibility for, the different elements in arranging an event, such as identifying a timely theme, inviting and briefing the speakers, writing the text to frame the event, promoting the event, preparing a thoughtful introduction, preparing the questions, preparing the PPT, and on the night, hosting, introducing and questioning the speakers.

As for how to enable design education to reflect and support this broader definition of design, it makes sense to start with an analysis of the current media landscape and to identify how and where designers are forging new paths as the curators and organizers of workshops, reading groups, conferences, summer schools, podcasts, and exhibitions, the founders of galleries and publishing imprints, the editors of online platforms, and the instigators of research projects. It might not be practical for a graphic design course to offer training in all these areas, but certainly there should be the opportunity to take electives, or introductory workshops.

We see a growing number of university programs that combine design with journalism (Journalism + Design at The New School, University of Southern California and even parts of Columbia University's School of Journalism). We see the obvious need for

Alice Twemlow

당신이 하는 일은 조직자로서의 디자이너로, 디자이너가 큐레이션과 조직하기와 같은 활동을 통해 스튜디오 실무자 이상의 역할을 할 수 있음을 보여준다. 수업에서는 디자이너의 역할을 어떻게 규정하고 확장하는가?

나는 작가나 디자이너나 스스로가 원하거나 필요하다고 생각한다면, 다양한 활동을 자신의 실무에 포괄할 수 있게 되었다고 본다. 어떤 인물의 연구 영역이나 작업 방식과 잘 맞는다면, 이벤트와 토론 또는 전시회를 조직하고 실험적인 형태의 출판을 시도하는 것이 유익할 수 있다. 하지만 글쓰기와 연구처럼 이런 행위는 가르치고 배워야 하며, 현실적인 시나리오 안에서 실험할 필요가 있다. 가령 성공적인 세미나나 토론 패널을 조직하기 위해 얼마나 많은 노력이 필요한지 과소평가되는 경우가 많다. 나는 학생들에게 행사를 준비할 때 필요한 다양한 요소를 잘 가르치고 그런 일을 맡을 기회를 주려 노력한다. 시의적절한 테마를 파악하고, 연사들을 초청하여 내용을 소개하며 이벤트를 구성하기 위한 텍스트를 작성한다. 이벤트를 홍보하며 소개와 질문 그리고 PPT 준비, 당일 행사 진행, 연사 소개와 질문 등의 일이 여기에 속한다. 디자인 교육이 이렇게 광범위한 디자인의 정의를 반영하고 지원하려면 현재의 미디어 환경을 분석해야 한다. 디자이너들이 워크숍, 독서 그룹, 컨퍼런스, 여름 학교, 팟캐스트, 전시회의 큐레이터와 조직자로, 갤러리와 출판사 창업자로, 온라인 플랫폼 편집자 및 연구 프로젝트의 일원 등으로 어느 분야에서 어떻게 새로운 길을 개척하는지 파악하는 것이 적절하다. 그래픽 디자인 교육 과정에서 이러한 모든 분야의 교육을 제공하는 것은 실용적이지 않을 수도 있다. 그러나 선택 과목 또는 입문 워크숍을 수강할 기회는 반드시 주어져야 한다.

디자인과 저널리즘을 결합한 대학 과정이 늘어나고 있다 (뉴스쿨과 서던캘리포니아대학교에 저널리즘 + 디자인 과정이 있고 컬럼비아대학교 저널리즘스쿨도 부분적으로 도입했다). 미디어와 디지털 출판의 변화를 다루기 위해 그런

such programs to address changes in media and digital publishing, but we are curious to hear if you see more profound connections between the two disciplines.

I, too, am heartened to see an increase in support for such interdisciplinarity. In Amsterdam, a couple of designers with experience in newspaper editing and design have initiated a really interesting new platform for design, art and journalism, called 'ACED' with the aim of highlighting the existing connections between design and journalism and conducting design-led research into developing new models. Many online publications, (nicely exemplified by Quartz), give their reporters the responsibility for producing their own visual content to accompany their writing. I think the New York Times has been leading the way in this respect for a while now, with its excellent data visualizations that are, in effect, a new variant of journalism, with just as much reporting and communicative craft involved as in the production of a written article. In some genres, such as profiles, features and critiques, writing feels like the best way to communicate the nuances and details of the phenomenon being described and analyzed, but writing is not always the best way to tell a news story, as evidenced by the more widespread use of video, audio, image sequences, data visualisations, social media reports and so on. In the coming years I think we are going to see much more imaginative multi-media fusions of image, data, writing, sound and design being used in journalism.

You mentioned in previous interviews that you try and teach more innovative visual storytelling methods in the MA in Design Curating & Writing at Design Academy Eindhoven. Could you elaborate?

Well, this interest began at D-Crit, the Design Criticism MFA at the School of Visual Arts in New York, which I co-founded with Steven Heller and chaired from 2008-2015. Here, I put a big emphasis not only on deep research, but also on the compelling conveyance of argument. With thesis, for example, once the students had researched and written their thesis, the

과정은 분명히 필요해 보이지만, 두 분야 사이에 더 깊은 연관성이 있다고 보는지 궁금하다.

나 역시 그러한 다학제적 접근이 더 많은 지지를 받는 것을 보며 용기를 얻는다. 암스테르담에서 신문 편집과 디자인 경험을 쌓은 몇 명의 디자이너가 'ACED'라는 디자인과 예술 및 저널리즘에 대한 새롭고 아주 흥미로운 플랫폼을 시작했다. 디자인과 저널리즘 사이의 연결성을 다지고 디자인 주도의 연구를 통해 새로운 모델을 개발하기 위해서다. 다수의 온라인 출판물은 ≪쿼츠≫가 좋은 예인데, 기자에게 본인의 기사에 들어가는 시각 콘텐츠를 일임한다. ≪뉴욕타임스≫가 사실상 저널리즘의 새로운 변수인 탁월한 데이터 시각화를 통해 이런 부분을 선도해왔다고 생각하는데, 기사 작성처럼 시각 자료에도 그 정도의 보도와 소통의 기술을 적용한 것이다. 프로파일, 특집 기사 및 비평 등 일부 장르에서는 현상의 뉘앙스와 세부 사항을 설명하고 분석하여 전달하는 가장 좋은 방법이 글로 쓴 기사일 수 있다. 하지만 글만이 언제나 뉴스를 전하는 최선의 방법은 아니다. 비디오와 오디오, 이미지 시퀀스, 데이터의 시각화, 소셜 미디어 보도 등이 점점 더욱 광범위하게 사용되는 것에서 알 수 있다. 앞으로는 이미지와 데이터, 글과 사운드 및 디자인으로 구성된, 훨씬 더 상상력 넘치는 멀티미디어 융합이 저널리즘에 사용될 것이라 생각한다.

이전 인터뷰에서 에인트호벤디자인아카데미 디자인 큐레이팅과 글쓰기 석사 과정에서 보다 혁신적인 시각적 스토리텔링 교육을 시도했다고 언급했다. 자세히 설명해달라.

뉴욕 스쿨오브비주얼아츠의 디자인 비평 석사 과정인 D-Crit 과정에서 처음으로 관심을 갖게 되었다. 나는 이 과정을 스티븐 헬러와 함께 시작했다. 2008년부터 2015년까지 학과장으로 재직하기도 했다. 나는 깊게 파고드는 연구뿐 아니라 본인의 논지를 설득력 있게 전달하는 방식도 중요하게 생각했다. 예를 들어 학생들이 연구를 거쳐 논문을 작성한다. 그러고 나면 다음 단계는 핵심 주장이 무엇인지, 그리고 그 논증이 누구에게

next step was to figure out precisely what its core argument was and who they wanted that argument to reach. Based on this they would then choose an appropriate vehicle through which to tell their story. We built up a fantastic range of methods over the years, ranging from reality shows, conspiracy theories, and documentaries, to pop-up exhibitions in bodegas, augmented reality insertions into museums, and Spotify lists. At Design Academy, when I was head of Design Curating and Writing MA, I continued to encourage students to explore a wide variety of media such as meme curation, choose-your-own-adventure chat-bot coding, open-source collaborative editing, interactive dashboards that responded to, and supplemented live discussion and so on. Now I am interested in expanding and refining the list of design-specific research methods, such as mapping, prototyping, scraping and drawing.

On the topic PhD's in Design, what is their place and purpose? Are they just requirements for academics? Or are they real opportunities to bring scholarly depth to the discipline of graphic design? (We would like to focus this question around graphic design for concision and not to confuse other disciplines like architecture)

It think that design-focused doctoral research has the potential to make a great contribution to graphic design knowledge, but also well beyond it to society and culture at large. Studies of, with and through design—whether they are historical or theoretical or practice-led—can expand and refine the discourse and the intellectual milieu within which practice operates and contribute new modes and methods of practice. They can also elicit new insights and understanding for all of us. The extent to which this happens depends on the quality of the framing and teaching of the PhD program, and on the ways that such programs seeks to engage the public in their process and findings. If a PhD is undertaken purely to fulfil an academic requirement, then that's probably all it will be, but considering how time-consuming and damn hard it is to complete a PhD, it more

Alice Twemlow

도달하기를 원하는지를 정확하게 파악해야 한다. 이를 바탕으로 학생들은 자신의 이야기를 전달하는 적절한 수단을 선택한다. 우리는 리얼리티쇼, 음모론 및 다큐멘터리부터 식품 잡화점에서 하는 팝업 전시회, 박물관에 증강 현실 도입하기 및 음악 스트리밍 서비스 스포티파이의 목록에 이르기까지 수년 동안 기상천외한 방법을 개발했다. 디자인 아카데미에서 내가 디자인 큐레이팅과 글쓰기 석사 과정의 학과장이었을 때, 학생들에게 밈 큐레이션, 선택형 채팅 봇 코딩, 오픈 소스 협업 편집, 실시간 토론에 반응하고 이를 보완하는 인터랙티브 대시보드 등 다양한 매체를 탐구하도록 장려했다. 최근에는 매핑, 프로토타이핑, 스크래핑 및 드로잉 같은 디자인 특정적인 연구 방법 목록을 확장하고 개선하는 데 관심이 있다.

디자인 박사 학위의 위상과 목적은 무엇인가? 단지 학계의 요구 사항인가, 아니면 실제로 그래픽 디자인 분야에 학술적 깊이를 부여할 기회인가? (오로지 그래픽 디자인 분야에 초점을 맞춘 질문이다.)

디자인 중심의 박사 과정 연구는 그래픽 디자인 지식에 크게 기여할 가능성이 있다. 또한 이를 넘어 사회와 문화 전반에 걸쳐 기여할 수도 있을 것이다. 역사적이든 이론적이든 실무 중심이든 디자인의, 디자인을 활용한 그리고 디자인을 통한 연구는 실용이 담긴 담론과 지적 환경을 확장하고 다듬어 새로운 방식과 실천 방법을 내놓을 수 있다. 우리 모두에게 새로운 통찰력과 이해력을 이끌어 낼 수 있다. 이는 박사 학위 프로그램의 구성과 교육의 질 그리고 그러한 프로그램이 과정과 결과에 대중을 참여시키는 방법에 달려 있다. 만약 전적으로 학문적 요구 사항을 충족시키기 위해 박사 과정을 밟는다면, 거기에서 그칠 것이다. 하지만 박사 과정을 완료하는 데 얼마나 많은 시간과 노력이 소요되는지 고려하면 박사 후보자는 지식에 의미 있는 기여를 하고 그 지식을 가능한 한 영향력 있는 방식으로 공유하고 싶을 것이다. 이러한 점에서 디자이너는 의사소통에 대한 경험과 전문 지식을 통해 다른 분야의 학자보다 큰 이점을 누릴 수 있다.

likely that a candidate will want to make a significant contribution to knowledge and figure out a way to share that knowledge in as impactful a way as possible. In this respect, designers have a great advantage over other academics because of their experience with and expertise in communication.

<u>You have been the catalyst for some significant paradigm shifts within design education, particularly with the development of and inclusion of design writing and criticism. Where do you see this going next? What could be a truly ideal design school for you moving into the future?</u>

Thank you! It is true that I have been a consistent advocate for the inclusion of writing, criticism, curation and research in a designer's education, but the reason I do it is not just to change design education or to improve the way design is practiced. The Masters programs that I have initiated and chaired, and the summer intensives and many courses I have taught over the years are pitched and constructed for students and participants from all kinds of backgrounds. Some are designers, but others come from humanities and the sciences or from careers in journalism and curation. I believe that using design as a lens through which to question society is an essential component of critique, and needs to be taught.

I love the question about an ideal design school of the future. For me, this would be a hybrid space between the university and the design academy, where students from all different backgrounds can engage with design, not as a vocational subject to be trained in, per se, but rather as a branch of intellectual inquiry (somewhere between the humanities and the social sciences). Here the particular qualities and capacities of design methods would be used to interrogate social issues and simultaneously students would be able to direct their inquiries into design as subject matter, to investigate the social, political and environmental implications of design as a process, a product and as a value system. In character, this school would probably something more akin to a research institute, since I foresee fruitful connections with industry, govern-

29

당신은 디자인 교육 분야에서 특히 디자인 글쓰기와 비평을 발전시키고 도입하는 일과 관련하여 중요한 패러다임 변화의 촉매제 역할을 해왔다. 이 부분이 앞으로 어떻게 진행되리라 보는가? 미래를 위해 진정으로 이상적인 디자인 학교는 무엇일까?

나는 디자이너 교육에 글쓰기, 비평, 큐레이션 및 연구를 도입하려 노력했지만 단순히 디자인 교육을 변화시키거나 디자인의 실천 방식을 개선하려는 것만은 아니었다. 내가 시작하고 이끌었던 석사 과정과 지난 수년 동안 가르쳤던 여름 집중 과정 및 많은 교과 과정은 매우 다양한 배경을 가진 학생과 참가자 들을 대상으로 구성되었다. 일부는 디자이너이지만, 인문학과 과학 분야 출신이나 언론과 전시 기획 경력자들도 있었다. 디자인이라는 렌즈를 통해 사회를 바라보고 의문을 제기하는 것이 비평의 필수 요소이며, 이것을 가르쳐야 한다고 생각한다. 미래의 이상적인 디자인 교육에 관한 질문은 정말 마음에 든다. 내가 보기에 이것은 대학과 디자인 학교 사이의 하이브리드 공간으로, 매우 다양한 배경을 가진 학생들이 그 자체로 숙련을 요구하는 직업 과목이 아니라 오히려 학문적 탐색의 한 갈래로 (인문학과 사회과학 사이의 어느 지점으로) 디자인에 참여할 수 있는 곳이다. 여기서는 디자인 방법론의 특별한 자질과 역량이 사회적 이슈를 조사하는 데 사용되며, 동시에 학생들은 질문을 소재로 디자인할 수 있고, 디자인이 프로세스와 제품과 가치 체계로서 가지는 사회적, 정치적, 환경적 함의를 조사할 수 있을 것이다. 이 학교는 업계와 정부, 기타 단체 및 NGO와 유익한 관계가 예상되기에, 특성상 연구 기관에 가까워질 것이며, 참가자들은 경력을 시작하는 단계뿐 아니라 추후에도 이 기관에 관여하고 싶어할 것 같다. 역동적인 디자인 교육에서 두 가지 가장 큰 장애물은 관료주의와 부동산이다. 따라서 내가 생각하는 학교는 관리행정 비중이 매우 적고 독자적인 건물에 묶이지 않을 것이다. 학생들은 반드시 연속적으로 수강할 필요 없이 누적 학점으로 학위를 취득할 수 있다(일정 또는 재정 상황에 따라 1년 단위로 수강이 가능하다). 모든 행정과 재정은 투명하며 오픈 소스로 학생과 교수 모두가

ment, other organizations and NGOs, and I would imagine that participants might want to engage with this later in life, and not only at the beginning of their careers. The two biggest obstacles to dynamic design education, as I see it, are: bureaucracy and real estate. Therefore, my school would be very admin-light and would not be tied down by proprietary buildings. Participants can earn degrees cumulatively and not necessarily sequentially (so that they can take a unit a year, as their schedule/finances allow). All administration and finances should be transparent and open-source, a shared responsibility of students and teachers alike. And we don't need to be tied down to a particular building; we can make arrangements to use the facilities and resources of existing labs, maker spaces, libraries and collections. As you can see, I'm quite enthusiastic about this! I'm already testing out some of these ideas in various contexts, including a Design and the Deep Future elective for humanities and social science students at Leiden University. I also run a Teaching Tools Research Group at KABK where several participants are researching new and more inclusive, decolonized, and intersectional approaches to design education. So, watch this space!

You have been integral to the shaping of design education in three very different education environments from the UK, to the USA and now the Netherlands. This has also provided a very unique and rare point of view as someone with a deep experience and engagement of all three systems. Can you speak to some of your observations from your diverse experiences? What are some fundamental overlaps? differences?

I enjoy the experience of immersing myself in, and learning about, the education systems of different regions. I've also spent time at VCU in Doha, Qatar, University of Sharjah in the UAE, and Monash University, Melbourne, and am external assessor for the Visual Culture BA at NCAD in Dublin. There are challenges and opportunities with each context. The US has the big problem of huge student fees but it has the advantage of many instances of close and mutually beneficial relationships between universi-

Alice Twemlow

공동으로 책임진다. 그리고 우리는 특정 공간에 묶일 필요가 없다. 기존 연구실, 제작 공간, 도서관 및 컬렉션의 시설과 자원을 사용할 수 있도록 준비하면 된다. 알다시피, 나는 이미 이에 대해 매우 열정적이다. 레이던대학교의 인문사회과학 학생들을 위한 디자인과 먼 미래 선택 과목을 포함한 다양한 상황에서 이미 이러한 아이디어 중 일부를 시험하고 있다. 나는 또한 KABK에서 교육 도구 연구 그룹을 운영하여, 이를 통해 여러 참가자가 디자인 교육에 대한 새롭고 더욱 포용적인, 탈식민주의적, 교차 접근법을 연구하고 있다. 이 공간을 주목해보라!

당신은 영국, 미국, 현재 네덜란드에 이르는 세 가지 매우 다른 교육 환경에서 디자인 교육을 형성하는 데 큰 역할을 했다. 이것은 또한 세 가지 시스템 모두에 대한 깊은 경험과 참여로 독특하고 보기 드문 관점을 형성했을 것으로 보인다. 다양한 경험을 통해 관찰한 점들을 알려줄 수 있는가? 근본적인 공통점은 무엇이고 차이점은 무엇인가?

나는 다른 지역의 교육 시스템에 몰입하고 학습하는 경험을 즐긴다. 카타르 도하의 버지니아커먼웰스대학교, 아랍에미리트연합 샤르자의 샤르자대학교, 호주 멜버른의 모나쉬대학교에 있었고, 아일랜드 더블린 소재 국립예술디자인대학의 시각 문화 학사 학위 외부 평가 위원이기도 하다. 각기 다른 상황은 도전인 동시에 기회이다. 미국에는 엄청난 학비 문제가 있지만 대학과 디자인 학교 사이의 긴밀하고 상호 보완적인 관계라는 장점이 있다(예일대학교 예술대학원과 예일대학교, RISD와 브라운대학교, 파슨스스쿨오브디자인과 뉴스쿨 등등). 영국은 수업 규모가 너무 크며 모험적인 시도가 어려운 관료주의가 큰 산이다. 그러나 디자인이라는 범위 안에서 역사적인 연구를 통합하는 데에는 좀 더 익숙하다. 네덜란드로

ties and design schools (Yale School of Art with Yale University, RISD with Brown University, Parsons with the New School and so on). The UK has the issue of huge class sizes and mountains of bureaucracy which prevent risk-taking, but it has more familiarity with incorporating historical studies within the remit of design. It was a surprise to me to learn, when I moved to the Netherlands, how distinct and separate are the cultures of the university on the one hand, and the design school on the other. Design schools, such as Design Academy Eindhoven, are remarkably resistant to research and engaging with social issues; they prioritize making and self-reflection above all else. And meanwhile, at a course like the Design Cultures MA at Vrije University in Amsterdam, students are expected to engage in design studies far removed from the sites of making and practice. That's why I was so pleased to find my position as design lector at the intersection of Leiden University and KABK, and I'm really looking forward to developing this more fully over the years.

31

오고 나서는 대학과 디자인 학교의 문화가 얼마나 뚜렷이 분리되어 있는지 알고 놀랐다. 에인트호벤디자인아카데미 같은 학교는 사회 문제를 연구하고 참여하는 데 큰 저항감이 있었다. 무엇보다도 제작과 자기반성적 작업을 우선시했다. 한편 암스테르담 소재 브리에대학교의 디자인문화 석사 과정 학생들은 제작 현장이나 실무와 동떨어진 상태에서 디자인 연구에 참여하게 된다. 때문에 나는 레이던대학교와 KABK의 교차점에서 디자인 강의를 하게 되어 매우 기뻤고 앞으로 이를 더 온전하게 발전시키기를 고대한다.

programm

Woche 1, 2—6 11 2015

mo, 2

10:00 Beginn,
Einrichten der Arbeitsplätze vor der
Siebdruckwerkstatt, Ablauf erklären

11:00 Werkstattleute
stellen sich vor: Peter Liebricht & Ben,
Marion, Bodo, Martina Schöbel, Lulu & Caro

12:00 jeder stellt sich vor
kurze Ideenpräsentation, Brainstorm:
Künstlerbuch und Independent Publishing

17:00 Diskussion
rund um Künstlerbücher
jede/r bringt 1 Beispiel, Ergebnisse des Tages

★ während des Tages individuelle Besprechungen

di, 3

17:00 Kati Barath
presents: Stubenhocker Projekt

★ während des Tages individuelle Besprechungen

mi, 4

13:45 Unter dem Radar
Führung: Jan-Frederik Bandel
Treffpunkt: Weserburg pünktlich !

17:00 Fraser Muggeridge &
Eleanor Vonne Brown
present: Künstlerbücher

★ während des Tages individuelle Besprechungen

do, 5

11:00 Matthias Ruthenberg
presents: Künstlerbücher

18:00 Fraser Muggeridge &
Eleanor Vonne Brown:
talk about: Art and Design
and Publishing Spaces
[Raum 4 15.070]

★ während des Tages individuelle Besprechungen

fr, 6

10:00 Zwischenpräsentation:
Stand der Dinge und wie es weiter geht ...

mo—fr,

10:00 bis open end
Ort: Flurbereich vor dem Siebdruck
hochschulöffentlich

Woche 2, 9—13 11 2015

mo, 9

17:00 **Anna Lena von Helldorff:**
talks about: Kooperation
in Künstlerbüchern

★ während des Tages individuelle Besprechungen

di, 10

11:00 **Mona Schieren:**
talks about: Zum Buch
von Richard Tuttle
über die Künstlerbücher
von Agnes Martin

17:00 **Samuel Nyholm**
presents: Künstlerbücher

★ während des Tages individuelle Besprechungen

mi, 11

10:30 **Mona Schieren:**
talks about: „Response
to Agens Martin"
[Theorieraum]

14:00 **Marion Bösen**
presents: Künstlerbücher

18:00 **Eva Weinmayr:**
talks about: Publishing
as intervention
[Auditorium]

★ während des Tages individuelle Besprechungen

do, 12

__:__ feedback: Eva Weinmayr
__:__ prepair: Endpräsentation

★ während des Tages individuelle Besprechungen

fr, 13

12—14:00 **Endpräsentation**
[Bibliothek]

Anna Lena von Helldorff

Co-Founder of KV-Art Association of Contemporary Art Leipzig
Founder of Collective Studio Beuro Total

A schedule outline for a two week workshop
program on independent publishing in 2015 by
the University of Arts Bremen. The theme for these
workshops is Artists' Books and "publishing as
artistic practice."

2015년 브레멘예술대학에서 있었던 독립 출판에 관한
2주 워크숍 프로그램의 일정 개요이다 . 이 워크숍의 주제는
아티스트들의 책 그리고 "예술적 실천으로서 출판"이다.

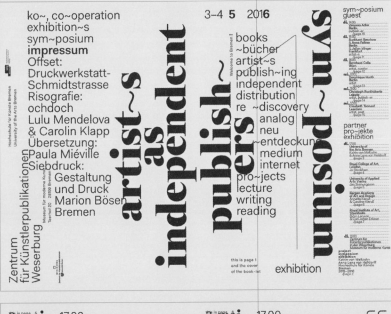
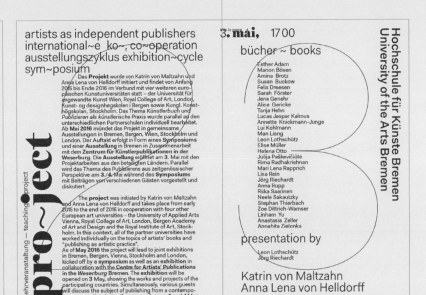
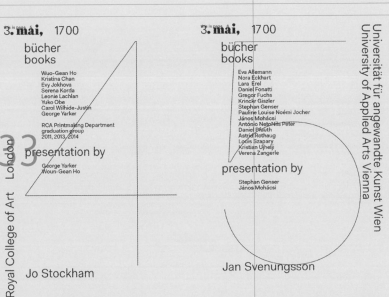
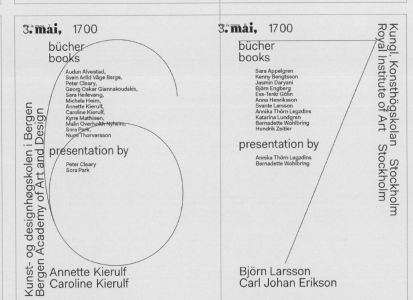
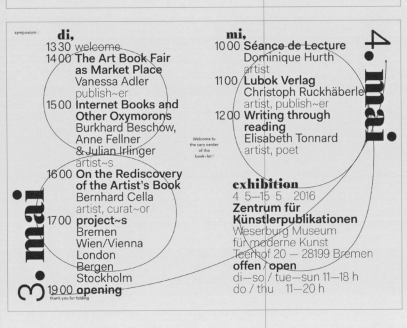

The 2016 version of the independent publishing workshop as a collaboration between the University of Arts Bremen, University of Applied Arts Vienna, Royal College of Art, London, Bergen Academy of Art and Design and the Royal Institute of Art, Stockholm.

2016년의 독립 출판 워크숍은 브레멘예술대학과 비엔나응용미술대학, 영국 왕립예술대학, 베르겐종합예술아카데미 그리고 스톡홀름 소재 왕립미술대학의 컬래버레이션이었다.

RESET THE PRESET

Die typografische Organisation von Text und Zeichen
kann als dramaturgische Tätigkeit betrachtet werden.
Im Fokus des Seminars steht die Bearbeitung eines Textes
der zu einer (typografischen) Aufführung gebracht werden soll.
Dabei geht es vor allem um die Bearbeitung der 'Voreinstellungen'
durch die Text in Erscheinung tritt.
Welche Voreinstellungen entsprechen einer bestimmten Vorstellung?
Wieviele Protagonisten erzählen die Geschichte? Welche Rolle spielt
das Bildhafte?
Wieviele Szenenwechsel finden innerhalb der Aufführung statt?
Welche physischen und zeitlichen Räume bedingen und beeinflussen
die Aufführung?
Welche Teile eines Textes bilden die Konstante und welche erhalten
einen einmaligen Auftritt?

A

RESET
THE
PRESET
1

FR, 12.4.
SA, 13.4.

34

Andere Designmethoden
* **Ein Design entwerfen**
* ~~Eigenes Design hochladen~~
* **Mit leerer Vorlage beginnen**
* ~~Einpassendes Seitenteilen~~

Auf der Seite http://www.vistaprint.de
kann unter bestimmten Voreinstellungen
jedermann seine Vorstellungen
einer Visitenkarte eigenständig gestalten.

Für das erste Treffen von RESET THE PRESET
entwirft jeder 1 Visitenkarte mit der er/sie
sich mit relevanten Informationen/Daten
dem Kurs vorstellt. Dabei sind nur folgende
Voreinstellungen und keine Bildmotive (!)
zu verwenden:

„Ein Design entwerfen"
„Mit leerer Vorlage beginnen"

→ Ausdruck eines Screenshots!

B

Anna Lena von Helldorff

An outline for a seminar/workshop where aspects
of the theater are applied to typography—the
relationship between words and the stage.
A: Course introduction.
B: A short exercise using typography instead of
images or symbols for a name card.

극장의 양상이 타이포그래피에 적용되는 세미나/워크숍의
개요—단어와 무대 사이의 관계
A: 코스 소개
B: 명함에 이미지나 기호 대신 타이포그래피를
사용하는 간단한 연습

Manuskript
als
Material

Typografische
Tatsachen
+
Topografie
der Typographie,

Notiert Eure Anmerkungen, Fragen und
Fragezeichen innerhalb der Textfläche.
Das weitere Textmaterial – Crystal Goblet,
Reader-texte – kann zur Klärung
bestimmter Fragen, zu Gegenüberstellungen
oder Ergänzung hinzugenommen werden.
Ziel ist es, den Text weiter zu bearbeiten,
ihn in Frage zu stellen und sich anzueignen.
Überlegt Euch dabei verschiedene Ansätze
und Möglichkeiten durch die der Text
zu einer Aufführung gebracht werden kann.

Wieviele Protagonisten
erzählen die Geschichte?
Welche Rolle spielt das Bildhafte?
Wieviele Szenenwechsel finden
innerhalb der Aufführung statt?
Welche physischen und zeitlichen Räume
bedingen und beeinflussen die Aufführung?
Welche Teile eines Textes bilden
die Konstante und welche erhalten einen
einmaligen Auftritt?
Dabei geht es vor allem um die Untersuchung
der ‚Voreinstellungen' (formal wie inhaltlich!)
durch die Text in Erscheinung tritt.
Welche Voreinstellungen entsprechen der
Vorstellung?

← reader

programmatische
Begleittexte

3 Programme
entwerfen
Karl Gerstner
→ Pro-Programma-
tisches,
→ Programm
als Denkleher:
hier vor allem:
„morpho-
logischer
Kasten"

TYPOGRAPHY
EMIL RUDER, 1967
→ Einleitung
→ Gliederungen
→ Kontraste

Element
und Erfindung
El Lissitzky

Gestalt und Funktion
der Typographie. Albert
Kapr und
Walter Schiller,
VEB Fachbuchverlag
Leipzig 1983
→ Einleitung
→ S. 13 / S. 15
→ Assoziationen als
Folgeerscheinungen
der typografischen
Gestaltung

Satztechnik
und Gestaltung
Fachbuch,
(Erstausgabe 1945)
→ SPRACHLICHES

C

RESET
THE
PRESET
5

*Beschreibung
des Vorhabens!*

KISS*

veranschaulicht *Eure Idee* in Verbindung
von *Form, Funktion und Erscheinung.*
skizzenhaft, als manuskript!
*das Vorhaben der Aufführung
sichtbar machen,*
Beschreibung der Aufführung
durch Zeichen und typografische Mittel;
Typografie = *Verhältnisse sichtbar machen!*

Welche *Voreinstellungen*
— formal wie inhaltlich! —
bringen den Text
zur Aufführung?

Aufführung
==========

welches
format?

wer ist das
publikum?

welche
Voreinstellungen
bringen format
und publikum mit?

aus welcher
perspektive
wird das
textmaterial
aufgeführt?

in welcher
(ver)fassung
wird der text
veröffentlicht?

welche
*schriftliche
fassung*
begleitet / ergänzt
die aufführung?

welche
typografischen mittel
charakterisieren die
eigenschaft
der aufführung?

(wie) werden
*Fragen /
Ergänzungen /
Änderungen*
sichtbar?

reset the preset
=
das textmaterial
zu einer
aufführung
bringen

**KEEP
IT
SIMPLE
&
STUPID!*

D

RESET
THE
PRESET

Typografische
Tatsachen

Topografie
der Typographie,

Fragen
an den Text

z.B.

36

Struktur:
wie entsteht die
Überlegenheit
des Autors dem
Leser gegenüber?

Struktur:
wieviele „SIE"
werden
angesprochen?

Struktur:
ist die
„Topografie
der Typografie"
eine (Auf-)
forderung?

Struktur:
sind die „typog-
rafische Tatsa-
chen" eine (Auf-)
forderung?

Struktur:
(wie) können
„typografische
Tatsachen" und
„Topografie der
Typografie" im
Dialog stehen?

Struktur:
Sind die
Beispiele
Zaubertricks aus
dem off?

Struktur:
bzgl: Einleitung
sorgt Verwirrung
für
Aufmerksamkeit?

Struktur:
wieviele ver-
schiedene Arten
an Beispielen
gibt es?

Struktur:
brauchen die
„typografischen
Tatsachen" die
Beispiele?

Inhalt:
Ist der Text
visionär?
→ Elektro-
bibliothek

Inhalt:
(wie)
kann man das
letzte Beispiel
HEUTE noch
verstehen?

Inhalt:
(wie)
ist das letzte
Beispiel zu
verstehen?

Inhalt:
was bedeutet die
Elektro-
bibliothek?

Inhalt:
was beinhaltet
die Elektro-
bibliothek?

Ausdruck:
widerspricht
sich der Text?
„...die Sprache
ist mehr als
nur..."
„...und bloß
Mittel der..."

Ausdruck:
Was bedeutet
„super-
naturalistische
Realität"?

Ausdruck:
wer wird
durch "SIE"
angesprochen?

Ausdruck:
was bedeutet
"Schriftsteller
- einer der sich
der Schirft
stellt" ?

Ausdruck:
wie versteht sich
"Zug- und Druck-
sapnnungen" im
Bezug auf den
„Buchraum"?

Ausdruck:
was meint das
„bioskopische
Buch" ?

Ausdruck:
„das Buch
als Zelle"
→ Organsimus

Ausdruck:
was meint
„typografische
Gebilde"
im Bezug auf
Typografie?

Ausdruck:
was ist das
„vervoll-
kommnete Auge"?

Aussage:
„die Sprache ist
nicht
bloß Mittel der
Gedankenüber-
tragung"

Aussage:
formuliert das
letzte Beispiel
der Typografi-
schen Tatsachen
einen Ausblick?

Aussage:
verändert
Gestaltung
Bedeutung von
Inhalt ?

Aussage:
wird das Auge
durch den Satz
vervollständigt?

Aussage:
warum wird
„Sehen" und
„Hören" explizit
getrennt?

Aussage:
„unser Auge wird
vom Umfeld
geprägt"
→ Voreinstellung

Aussage:
Typografie ist
nicht statisch

Aussage:
was ist die
Fläche?
was sind die
Grundrichtungen
der Fläche?

Aussage:
Soll sich der
Schriftsteller
um die Typografie
kümmern?

Aussage:
sind die
„typografische
Tatsachen" eine
Folge aus der
„Topografie der
Typografie" ?

Aussage:
formuliert die
Listung der
8 Punkte in der
Topografie der
Typografie einen
Ausblick?

Aussage:
was ist „super-
naturalistische
Realität

Sprache:
wie klingt
„Topografie der
Typografie"?
welche / wieviele
Stimmen kann der
Text in der
Vorstellunfg des
Lesers erzeugen

Sprache:
wie klingt „typo-
grafische Tatsa-
chen"?
welche / wieviele
Stimmen kann der
Text in der
Vorstellunfg des
Lesers erzeugen

Sprache:
„prächtig trainiert"
„Gedankengebilde"
„typografische Plastik"
„lebendige Sprache"

Sprache:
Sätze wirken
unvollendet?

Sprache:
veraltete Texte?
Beispiele:
„Tintenfass,
Gänsekiel,
Hamurabitafeln"

Anna Lena von Helldorff

This is a list of questions dealing with themes of
structure, language, content, speech, statements
and expression as part of this workshop/seminar.

이 질문 목록은 본 워크숍/세미나의 일부로서 구조,
언어, 내용, 연설, 진술 및 표현이라는 주제를 다룬다.

„Der Leser bestimmt den Inhalt der Nachricht"

sehen

sprechen

Was siehst du? Mit welchen Begriffen kannst du es beschreiben?
Welche **Begriffe/Worte** aus der Beschreibung beziehen sich inhaltlich auf Gestaltung als Tätigkeit?

Wie kann die **Aussage** eines bereits in/aus anderem **Kontext** formulierten **Zeichens** durch **Veränderung** in den **Kontext** von **Gestaltung** gesetzt werden? Durch <u>Hinzufügen</u> und <u>Wegnehmen</u>, Wiederholung einzelner <u>Elemente</u>, aber vor allem durch die <u>Kombination der Zeichen</u> (oder Teilen davon) mit **Worten/Text** sollen Aspekte der Gestaltung (eure Aspekte!) <u>lesbar</u> und <u>sichtbar</u> werden.

Ziel ist nicht, ausschliesslich 1 neues Zeichen zu finden, sondern durch **Variation** und **serienhaftes Arbeiten** eine **Sammlung** an **Versuchen** und **Kombinationen** schnell und **ohne Bedenken** zu erarbeiten.

Jede Kombination soll auf 1 Blatt stehen, so dass sie dann beliebig untereinander kombiniert und zu einer (vorher nicht geplanten) **Erzählung** werden!

Welches **Element**, welche **Teile** des Zeichens können zum Ausdruck für **gestalterische Tätigkeit** werden?

Mit welchem **gestalterischen Mittel** kann ich diese **Auswahl artikulieren**: ausschneiden, betonen, wiederholen, mit einem anderen Fragment kombinieren etc. … und welche **Begriffe/Worte** können diese Auswahl **sprachlich explizit** machen?!

Versucht die **Schritte** von 1 Blatt zum nächsten **sichtbar** zu machen, arbeitet in **schwarz weiß** und **analog**, versucht flüssig zu arbeiten und nicht vorher zu planen sondern sich nur aus dem Sichtbaren zu arbeiten.

A collection of thoughts about the process of questioning and impulses in the encouragement of different thinking. Asking about what you are seeing and how words are describing both design and the processes of design. How can a statement be applied to another context through addition or subtraction, repetition and a combination of signs.

질문 과정과 다른 사고를 장려하는 자극에 대한 생각 모음이다. 당신이 보고 있는 것에 대해, 그리고 디자인과 디자인 과정을 어떠한 말로 설명하는지에 관하여 질문한다. 어떻게 더하고 빼고 반복하고 부호를 조합하여 하나의 진술을 다른 문맥에 적용할 수 있는가이다.

Masks tasks - A work shop on masks, identity and having fun
held by Ariane Spanier and Maria Nogueira
May 2018 at ESAD Porto, MA communication design
Invited by Andrew Howard

Day 1
Morning (shorter tasks)
1.) Warmup - quick self portrait of your mood today (10 min, A4)
2.) Make a Paperbag mask (20 min)
3.) make a mask in Super short time (2 minutes)
4.) Make a mask only by ripping, folding or crumbling paper
5.) Make a mask only using geometric shapes (one or two), use only black and
white
6.) Two people make two masks that are a duo, in dialogue with one another
(listening & speaking, aggressive & scared, twins, cat & dog, couple etc.)
7.) make an interactive mask. can someone open it? does it have a secret message?

Lunch
Afternoon:
8.) Design a mask of a new god (beauty, capitalism, freedom, peace...)

Day 2
Morning
continue with
Design a mask of a new god (beauty, capitalism, freedom, peace...) until noon.

form groups and decide how to present the masks, put it into context.

resulted in:
- video
- "mask-walk"

Ariane Spanier

Creative Director Fukt Magazine
Permanent Juror, Kieler Woche Poster Competition

Ariane conducted a workshop on masks and identi-
ty at ESAD(Escola Superior de Artes e Design) Porto in
May of 2018. This workshop consisted of two days
where participants were tasked with creating sev-
eral different kinds of graphic masks that reflected
identity, duality, interactivity, societal themes, etc.

아리안은 2018년 5월에 ESAD 포르투에서 가면과
정체성에 대한 워크숍을 했다. 이 워크숍은 이틀 동안
진행되었는데 참가자들은 정체성, 이중성, 상호작용성,
사회적 주제 등으로 여러 종류의 그래픽 가면을 만드는
과제를 수행했다.

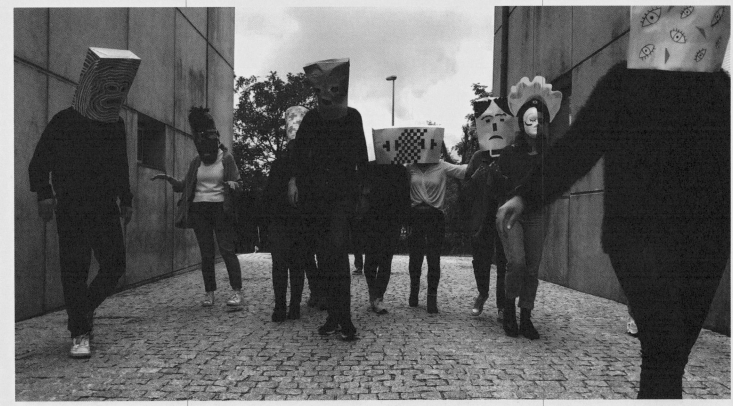

39

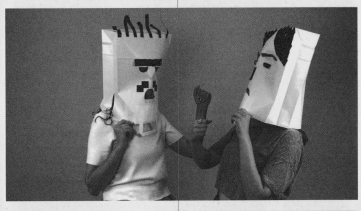
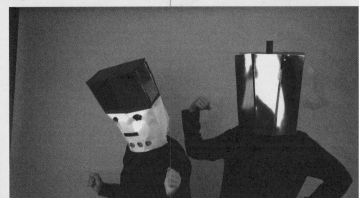

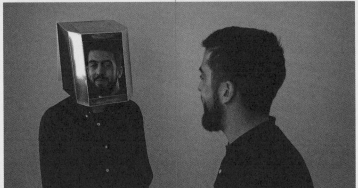
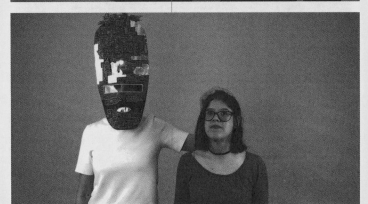

Stills and documentation of the workshop.　　워크숍 스틸 사진과 기록

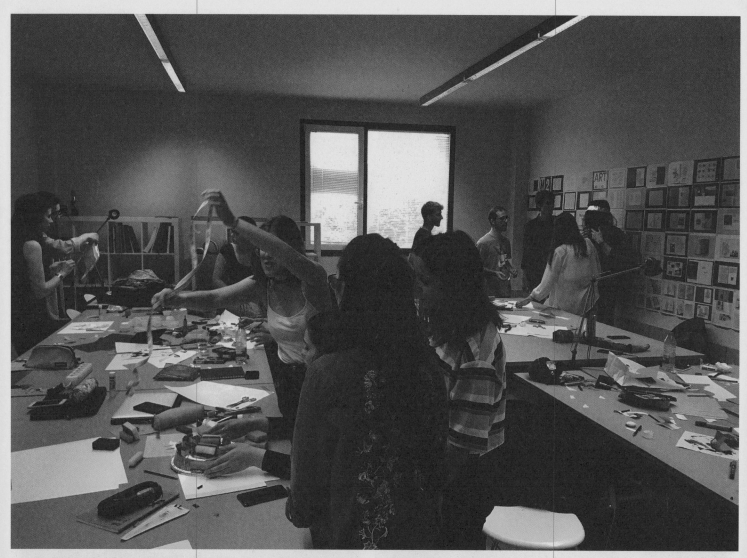

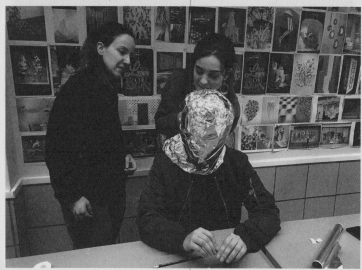

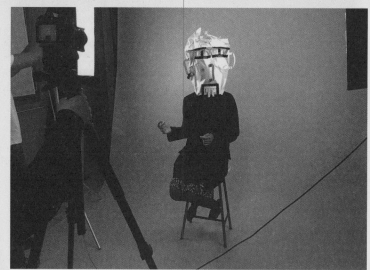

Ariane Spanier

Behind the scenes of the masks being constructed
and later applied and documented.

가면을 만들어 적용하고 기록하는 모습

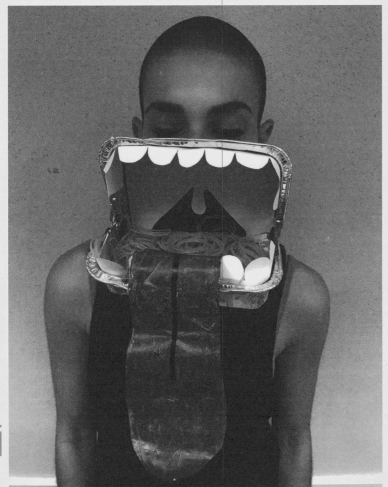

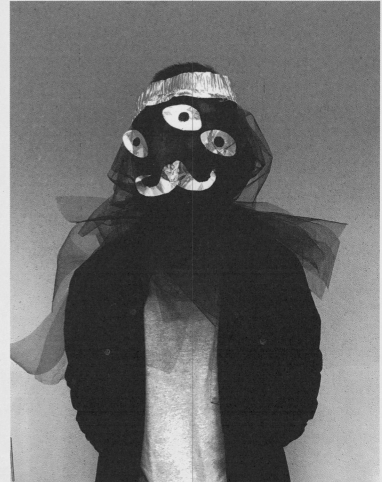

41

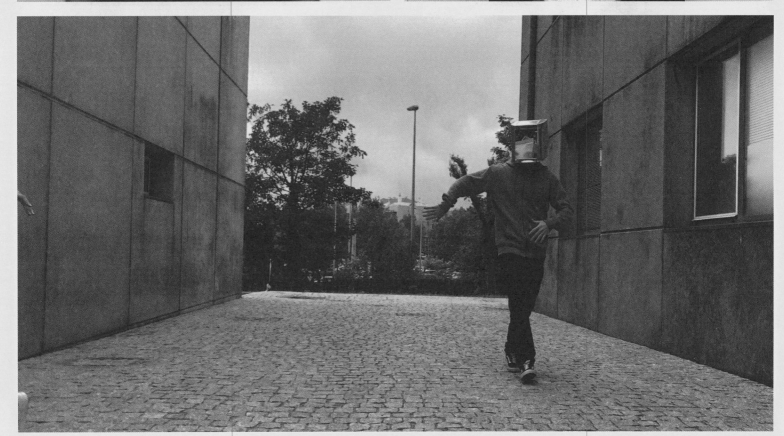

Some of the resultant masks modeled and displayed by their creators.

결과물로 나온 가면들 일부는 만든 사람이
모델이 되어 전시하기도 했다.

G/N
graphic
narrative
2018

Cho Hyun

Assistant Professor, Korea National University of Arts
Founder S/O Project

Documentation of a two-semester long course that
takes students from fundamental 2-dimensional
form to more complex visual narratives and sys-
tems. Over the two semesters, students learn basic
graphic forms, patterns, sequences, typography
and narrative.

두 학기에 걸쳐 2차원의 기초 형태를 좀 더 복잡한
시각적 서사와 체계로 발전시켜나가는 수업의 기록이다.
두 학기 동안 학생들은 기초적인 그래픽 형태, 패턴, 시퀀스,
타이포그래피와 내러티브를 학습한다.

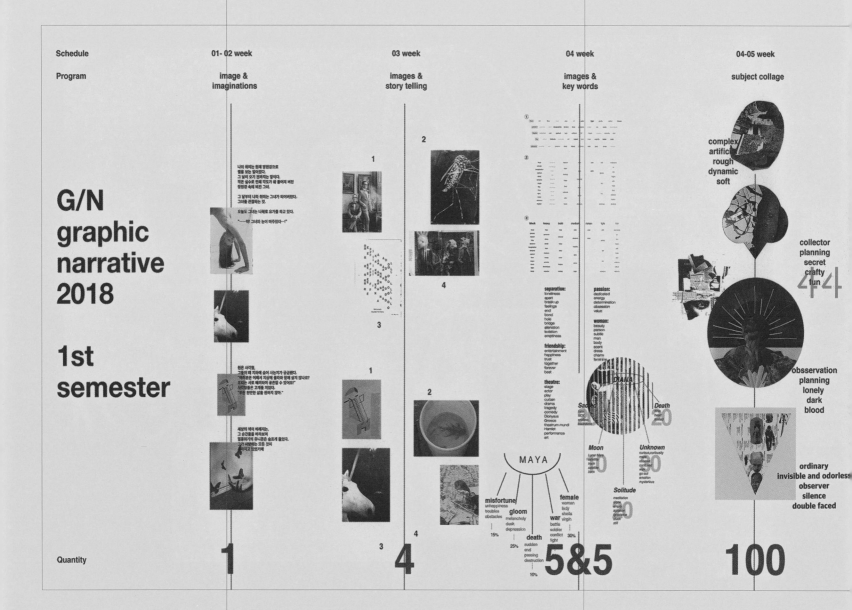

Schedule	01- 02 week	03 week	04 week	04-05 week
Program	image & imaginations	images & story telling	images & key words	subject collage

G/N graphic narrative 2018

1st semester

Quantity	1	4	5&5	100

Cho Hyun

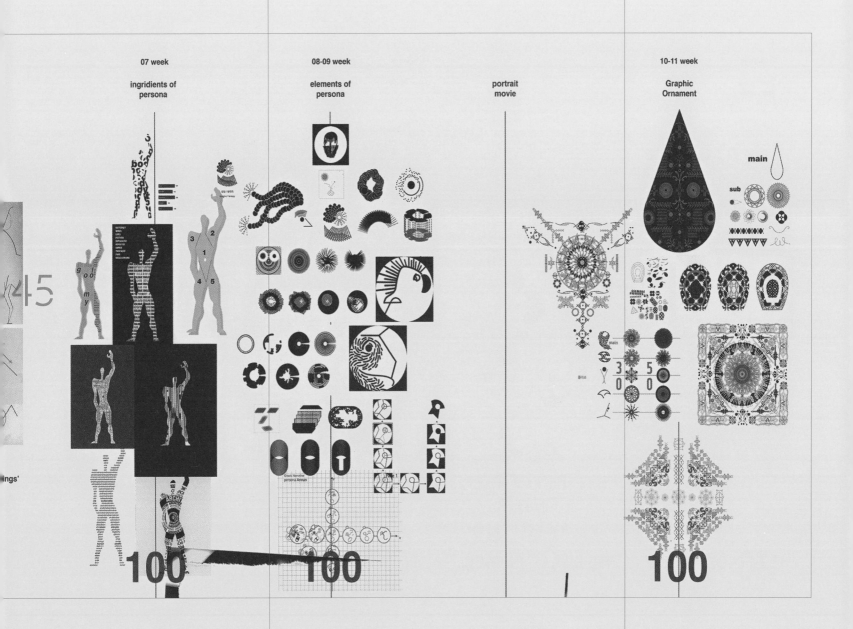

07 week

ingridients of
persona

08-09 week

elements of
persona

portrait
movie

10-11 week

Graphic
Ornament

main

sub

45

100 100 100

**Typeface &
Messagee**

Story Book

Secret Baguette Plan

Narcissm

The Black Kid

G/N
graphic
narrative
2018

2nd
semester

26

6

Cho Hyun

A timeline showing the sequence of the semester
and some of the results of this process.

학기 진행 순서를 보여주는 타임라인과
이 과정의 결과물 가운데 일부이다.

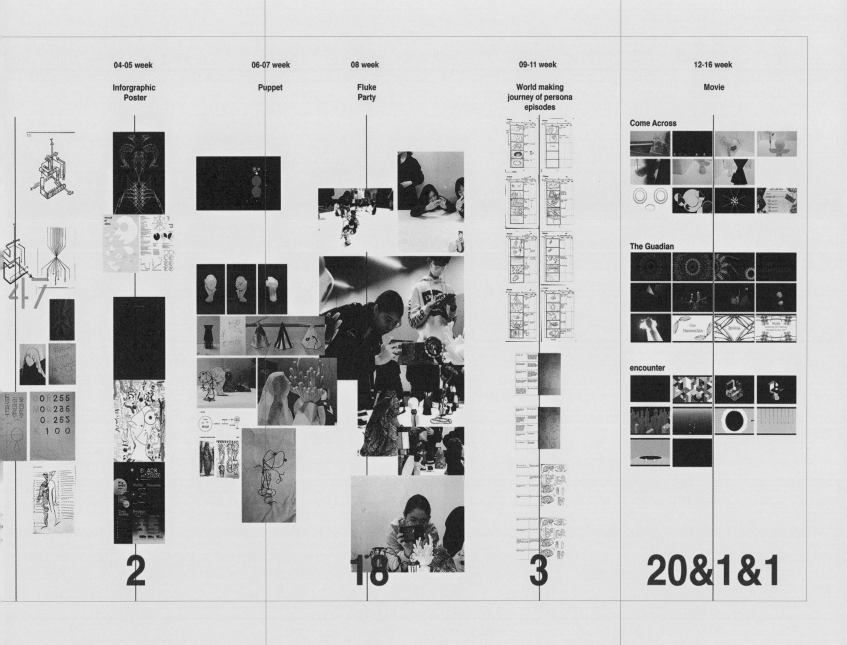

04-05 week

Inforgraphic
Poster

06-07 week

Puppet

08 week

Fluke
Party

09-11 week

World making
journey of persona
episodes

12-16 week

Movie

Come Across

The Guadian

encounter

2

18

3

20&1&1

FUTURE PERFECT: FUTURE POSTERS

INTERACTIVE GRAPHICS ONE

PROJECT TWO

For the first project we explored using typography and content for different methods of reading and interaction. We explored different approaches to text as well as thoughts on the intersection between new media and traditional graphic design. For this project we will be continuing some of those themes. In recent years we've seen the poster come to life in ways that we previously could not have imagined. Thanks to social media and digital platforms, the poster has regained a certain significance as an identifier and symbol. For years people have been saying that the poster will soon be extinct. But it appears the poster is here to stay. We've seen a recent influx of moving posters that fill our Facebook feeds with entirely different sensations and atmosphere. It is an exciting time to contemplate what the next poster will be.

For this project I would like you to re-think what the poster is now and see how it can come to life in different ways. Now that you have learned some tools for interaction, perhaps the future poster is something interactive, something that can be moved, touched, placed, composed, etc. See what you can do with the poster that has not been done before. I would also like for you to consider movement in this project. Movement has become something very vital to our digital interactions and experiences. How do we utilize movement to enhance traditional media?

For this project I would like you to use MUSE and create an exhibition of posters. These posters will be posters that you design and create. The subject of this exhibition is the FUTURE OF THE POSTER. I would like you to explore new and different ways to consider the poster. The very basic platform you can use is moving or motion posters. We'll be starting with that. But I also want you to consider interactive posters or physical posters that change the way we think about what a poster could be. Similar to the first project, I would like this to challenge some of our existing conceptions of what a poster could be.

PROCESS

FORMAT/MEDIUM

Similar to the last project, I would like you to set up a domain and space on the web to make a digital exhibition. I would like you to think about the exhibition method and how to show your posters in the most convincing and experiential way. So this project has two components. You are designing an exhibit space for posters and you are creating the posters themselves. So select another free domain name and set up another space on the web and create an exhibition.

The exhibition title, can just use something like:
FUTURE POSTERS
NEXT: POSTERS
POSTERS TOMORROW & TOMORROW
FUTURE PERFECT
FUTURE PERFECT: POSTERS, POSTERS, POSTERS

6.12 - 7.24, 2017
WWW.YOURWEBSITE.GA

Or you can choose whatever title you want. The content of the posters can advertise or promote your exhibit. It can use your title, dates and your website address. The posters can be any size, any format you wish. Remember, what is the future of the poster? You can decide. Typically for web posters, I use the size 600x800 or 600x900. You can decide this freely.
Due date: 6.12

VISUAL COMMUNICATION DESIGN

HONGIK UNIVERSITY

GRADUATE LEVEL

A

PROJECT 2
FUTURE SPEAK
We Invented the......

As we move towards an increasingly unclear and unpredictable future, we as designers and creators hold the keys to what this might be. We are the inventors. We are the originators. We are the ones who will push for change. These next three projects will focus on this theme. How do we create something new? How do we use our existing tools and platforms to do this? How can we create something that only we can create?

For this next project I would like you to consider language and the future. There is a popular culture concept known as 'wordism' which refers to the generation of languages that have no base. Languages that came from nowhere. I would like you to create a language of the future. Words from the future. A language that does not exist. Please create a set of words or expressions from the future.

I would then like you to use these words or expressions and then create a new set of letterforms to match the word and the content. For this project we will be utilizing techniques in digital lettering. Lettering can be a very tedious and complicated endeavor. This project seeks to analyze ways in which various techniques of lettering and particularly, future lettering, can be utilized within your own processes.

As we continue this discussion on amateurism and professional design, a large gap occurs when the designer is actually able to make his/her type completely from scratch. This does not mean making a new typeface entirely from the beginning. But this means in certain instances making type that you can use in small amounts and when you need them. This happens most often in, perhaps practical situations like branding or identity design. But this can take place in almost all instances of design. The ability for you to create type on your own will become an asset that you can use for the rest of your life.

For this project I would like you to bring your words/expressions and create a way to present them. You may do a book. You may design a series of posters. You may do some kind of animation. Whatever medium you wish to get better at or try something new with.

I do recommend working with just one word at a time. You can do combinations of more than one word but these can be difficult to work with sometimes. For these lettering studies, the techniques can be applied to any language. You may feel free to use English or Korean as a base. If you need additional text(for example on posters), just let me know and I can provide this for you.

DETAILS
Create a minimum of 5 or more words/expressions.
Medium is up to you. Figure out the best way to show your typographic work.

This project will be part of a larger project. So as we progress, I will tell you about the next due date but consider this the end of the month, begining of November.

48

B

Chris Ro

Associate Professor, Hongik University
Chief Curator, *Typojanchi 2015: The City and Typography*

Two projects contemplating the future.
A: An interactive/motion project examining the future of posters as well as the future experience of posters that move beyond physical or analog contexts.
B: A project examining new forms, letterforms and digital lettering under the pop culture concept of 'wordism.'

미래를 생각하는 두 가지 프로젝트
A: 물리적 혹은 아날로그적인 맥락을 넘어서는 미래의 포스터와 그것에 대한 경험을 시험해보는 인터랙티브/모션 프로젝트
B: 'wordism'이라는 대중 문화 개념에 따라 새로운 형태와 글자꼴 및 디지털 레터링을 검토하는 프로젝트

C

Typotecture

This project will be study of form, typography and conveying the essence of a concept or figure. For this project, architecture will be the background concept. This project will simulate a potential project in the future where you must use type and image to convey an idea or concept as well as research. For this project, I have given you a list of architects below. Please select one of these architects and design a poster or book about this architect. Please research the philosophy of this architect as well as the physical form this architect works with. Then design a poster and/or book that reflects your research.

As you move forward in your design careers, working with type and typography will become a large part of how you communicate your ideas to the public. How you communicate with type is limitless and the ability to express yourself in type is one of the most powerful tools of graphic design. Similarly, working with images will become a larger part of how you can communicate your ideas to people who sometimes respond directly to images and visuals. We will continue to develop these in this project with a strong emphasis on hierarchy and meaning.

Requirements

Out of the following 3 requirements, please design 2 of your choice:
POSTER 1: A poster made using typography only. Please create a typographic construction with the Architect's name. Please try to express your research of the architect only using typography.
POSTER 2: A poster using images only. Please create an image based poster with images of the architect's work. Please try to express the findings of your research only through images.
BOOK: Please create a small book that houses some of your research or findings. You may use content from Wikipedia, or other sources on the internet or from the library. Maybe even an interview with the architect. Please cite your sources. The book must conceptually show your architect through layout and typography.

You can definitely do all three if you wish. If you do all three, it is better for your development. But I also want you to manage your time and health!

Poster size: A2
Book size: A4 or less. Book should be a manageable page count. I would say, 16 pages or less.
If you would like to use additional text on your poster or book, please use the following:
ARCHITECTS & PROCESS
Structure, Form and Concept

Architects

Please select one of the following architects that you will research. Each one of these architects has buildings here in Korea. Please research these buildings and convey this architect's philosophy and ideas in a poster and/or book.

In the past, designers have typically chosen foreign architects. I would like to challenge yourself and choose a local architect if possible. There is lots more information and the research can be more in depth and emotional with these architects.

Morphosis
Zaha Hadid
Tadao Ando
Yoo Kerl: IARC
Kim Swoo-geun
Cho Minsuk: Mass Studies

49

D 1

SP

20—

18

D S

Project 4
Impossible Books

For this project, I would like you to construct and design a physical book.
But I would like you to create a new kind of reading experience.
I would like you to create an impossible book.
We have seen and heard rumours for quite sometime about the death of the book. Our move towards digital media has definitely created a large stir. But I feel that with the traditional book, we have an experience that many people will continue to cherish. It is the hands on, tactile experience that cannot be re-created so far in digital.

But I also feel that our books have had the same format for a long time. I wonder can we challenge this structure? Can we challenge the typical patterns of reading? Can we challenge what our concept of a book could be?

For this project, I would like you to start making and constructing with your hands. I would like you to create prototypes for potential books. But I do not want you to think about the content or the idea of the book. Just see what happens when you start prototyping immediately with absolute freedom and peace of mind. This first week, please buy paper, and various materials and see if you can start constructing a new kind of book experience.

After you have discovered a format you like, I would then like you to design a small book using this structure as your base. At this point, I would like you to find content that would fit this book. The content is totally free, but I would like you to find content that would fit your new found form and reading experience. You can use any of the content from the first three projects. E-Flux Journal, your analog library or your laziness project. You may also create content from existing sources online. The Gutenberg Project (http://www.gutenberg.org) is a free resource where you can download contents from thousands of books. Alot of this content is free because it was created before copyrights were enforced. So please feel free to find something that will fit your book.

The materials and construction of your book are entirely up to you. But remember, we have just four weeks for this project. So time is very important. If you come up with an interesting prototype, and do not have time to work with the content or layout, I will be fine with this. So no stress. Just see what you can do. But again, feel free to think very freely about how we read.

If there is one rule, I would say this book has to have an analogue experience. Something where we can touch, experience, and read physically. You can incorporate digital moments or digital ideas, but I would like you to again, master and experience the joys of prototyping. Please try this.

The project is due on the last day of the semester:
June 7th.

1

SP

20—

18

A second year undergraduate project and a first year graduate level project.
C: A project involving research of an existing entity and how to express that through type and image only.
D: A project challenging students to break their traditional understanding of the left to right reading experience and the analog book.

학부 2학년과 대학원 1차 수준의 프로젝트
A: 기존 실체와 활자와 이미지만을 사용해서 표현하는 방식에 대한 리서치 프로젝트
B: 학생들이 왼쪽에서 오른쪽으로 읽는 경험과 아날로그 책에 대한 전통적인 이해에서 벗어나는 도전을 해보는 프로젝트

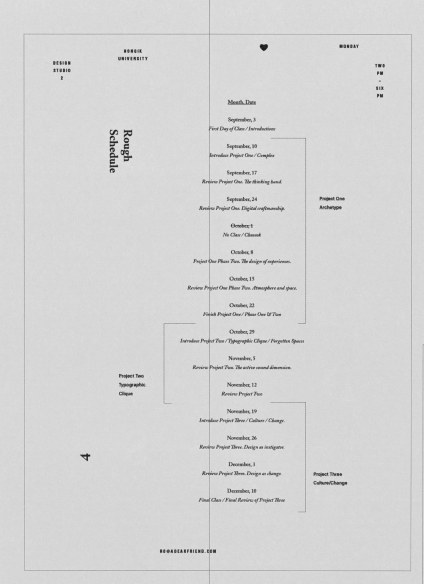

DESIGN
STUDIO
2

HONGIK
UNIVERSITY

MONDAY

TWO
PM
–
SIX
PM

Rough
Schedule

Month, Date

September, 3
First Day of Class / Introductions

September, 10
Introduce Project One / Complex

September, 17
Review Project One. The thinking hand.

September, 24
Review Project One. Digital craftmanship.

October, 1
No Class / Chuseok

October, 8
Project One Phase Two. The design of experiences.

October, 15
Review Project One Phase Two. Atmosphere and space.

October, 22
Finish Project One / Phase One & Two

October, 29
Introduce Project Two / Typographic Clique / Forgotten Spaces

November, 5
Review Project Two. The active second dimension.

November, 12
Review Project Two

November, 19
Introduce Project Three / Culture / Change.

November, 26
Review Project Three. Design as instigator.

December, 3
Review Project Three. Design as change.

December, 10
Final Class / Final Review of Project Three

Project One
Archetype

Project Two
Typographic
Clique

Project Three
Culture/Change

RO@ADEARFRIEND.COM

4

E

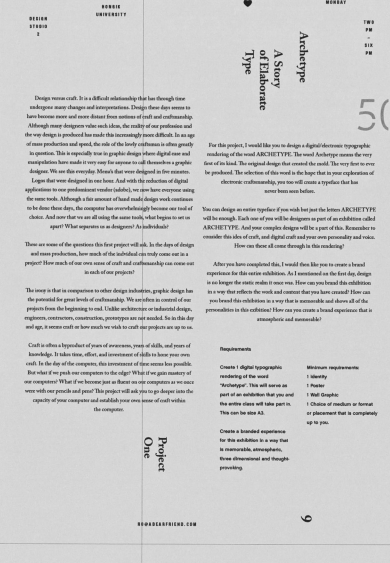

DESIGN
STUDIO
2

HONGIK
UNIVERSITY

MONDAY

TWO
PM
–
SIX
PM

Archetype
A Story
of Elaborate
Type

50

Design versus craft. It is a difficult relationship that has through time undergone many changes and interpretations. Design these days seems to have become more and more distant from notions of craft and craftsmanship. Although many designers value such ideas, the reality of our profession and the way design is produced has made this increasingly more difficult. In an age of mass production and speed, the role of the lowly craftsman is often greatly in question. This is especially true in graphic design where digital ease and manipulation have made it very easy for anyone to call themselves a graphic designer. We see this everyday. Menu's that were designed in five minutes. Logos that were designed in one hour. And with the reduction of digital applications to one predominant vendor (adobe), we now have everyone using the same tools. Although a fair amount of hand made design work continues to be done these days, the computer has overwhelmingly become our tool of choice. And now that we are all using the same tools, what begins to set us apart? What separates us as designers? As individuals?

These are some of the questions this first project will ask. In the days of design and mass production, how much of the individual can truly come out in a project? How much of our own sense of craft and craftsmanship can come out in each of our projects?

The irony is that in comparison to other design industries, graphic design has the potential for great levels of craftsmanship. We are often in control of our projects from the beginning to end. Unlike architecture or industrial design, engineers, contractors, construction, prototypes are not needed. So in this day and age, it seems craft or how much we wish to craft our projects are up to us.

Craft is often a byproduct of years of awareness, years of skills, and years of knowledge. It takes time, effort, and investment of skills to hone your own craft. In the day of the computer, this investment of time seems less possible. But what if we push our computers to the edge? What if we gain mastery of our computers? What if we become just as fluent on our computers as we once were with our pencils and pens? This project will ask you to go deeper into the capacity of your computer and establish your own sense of craft within the computer.

For this project, I would like you to design a digital/electronic typographic rendering of the word ARCHETYPE. The word Archetype means the very first of its kind. The original design that created the mold. The very first to ever be produced. The selection of this word is the hope that in your exploration of electronic craftsmanship, you too will create a typeface that has never been seen before.

You can design an entire typeface if you wish but just the letters ARCHETYPE will be enough. Each one of you will be designers as part of an exhibition called ARCHETYPE. And your complex designs will be a part of this. Remember to consider this idea of craft, and digital craft and your own personality and voice. How can these all come through in this rendering?

After you have completed this, I would then like you to create a brand experience for this entire exhibition. As I mentioned on the first day, design is no longer the static realm it once was. How can you brand? How can you brand this exhibition in a way that reflects the work and content that you have created? How can you brand this exhibition in a way that is memorable and shows all of the personalities in this exhibition? How can you create a brand experience that is atmospheric and memorable?

Requirements

Create 1 digital typographic rendering of the word "Archetype". This will serve as part of an exhibition that you and the entire class will take part in. This can be size A3.

Create a branded experience for this exhibition in a way that is memorable, atmospheric, three dimensional and thought-provoking.

Minimum requirements:
1 Identity
1 Poster
1 Wall Graphic
1 Choice of medium or format or placement that is completely up to you.

Project
One

RO@ADEARFRIEND.COM

9

F

Chris Ro

A third year level course schedule and project description.
E: Semester schedule/outline.
F: A project exploring the concept of craft within the digital environment and the exploration of never before seen type through this mechanism.

3학년 수준 코스 일정 및 프로젝트 설명
A : 학기 일정 / 개요
B : 디지털 환경 안에서의 공예 개념을 탐구하고
이 매커니즘을 통해 이전에는 볼 수 없었던
유형을 탐구하는 프로젝트

51

01 **Basic studies, typography** Kunsthochschule Kassel, 1994

 Letters

02 Add, decompose, subtract letters (Petra Schultze)

03 Print, emboss letters (Petra Schultze) Figure 1

 Scripture and perspective

04 Letters outside

05–06 Letters inside Figure 2

07 Letters deconstruction

08 Letters folded (Petra Schultze) Figure 3

09 Letters ball print (Maike Truschkowski)

10–12 Letters on the way Figure 4

 B: in Greece (Rena Chrysikopoulou)

 C: in Germany (Ursula Strohwald, Maike Truschkowski)

 G: in France (Stefani Konrad)

 R: in Brazil and in the USA (Birke Küszter)

 S: in Italy (Stefan Schulte)

 Y: in Spain (Yvonne Fein)

13 **Editorial design**, Kunsthochschule Kassel, 1994–2004

 »ÜberSchrift«: type designers and typographers

 (The word »ÜberSchrift« has two meanings in German:

 a) on writing, b) headline

 The task includes research, concept, text, design and production of a magazine.

 Volume of booklets 16 pages, format 21.5 x 28 cm

14 Johannes Gutenberg (Henrich Förster)

15 Justus Erich Walbaum (Stefani Konrad, Petra Wierzchula)

16 El Lissitzky (Natalie Wandke) Figure 5

17 Otl Aicher (Armin Illion, Stefan Klopprogge-Härtel)

18 All issues Figure 6

52

Christof Gassner

Former Professor, Fachhochschule Darmstadt
Co-Founder and Art Director of Öko-Test Magazin

A outline of courses on typography and editorial design taught by Christof Gassner at Kunsthochschule Kassel. Presented alongside results from several other courses on subjects such as typography and editorial design. The results reflect Gassner's pedagogy of experimental typographic form.

카셀미술대학교에서 크리스토프 가스너가 가르치는 타이포그래피와 편집 디자인 강좌의 개요이다. 타이포그래피와 편집 디자인 같은 주제를 다룬 여러 다른 수업의 결과물과 함께 발표되었다. 이 결과물은 실험적인 타이포그래피 형태에 대한 가스너의 교육학을 반영한다.

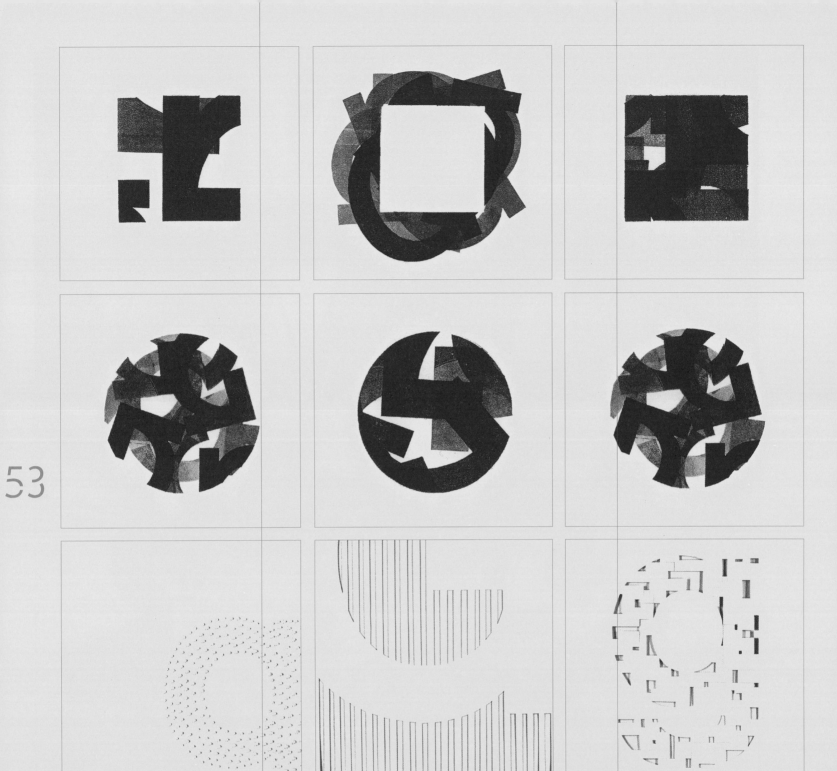

Figure 1

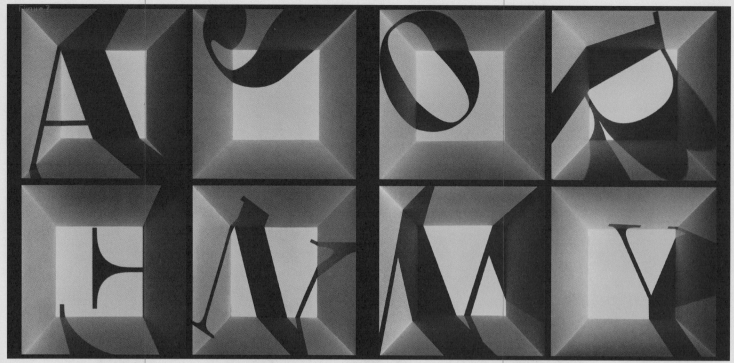

Figure 3

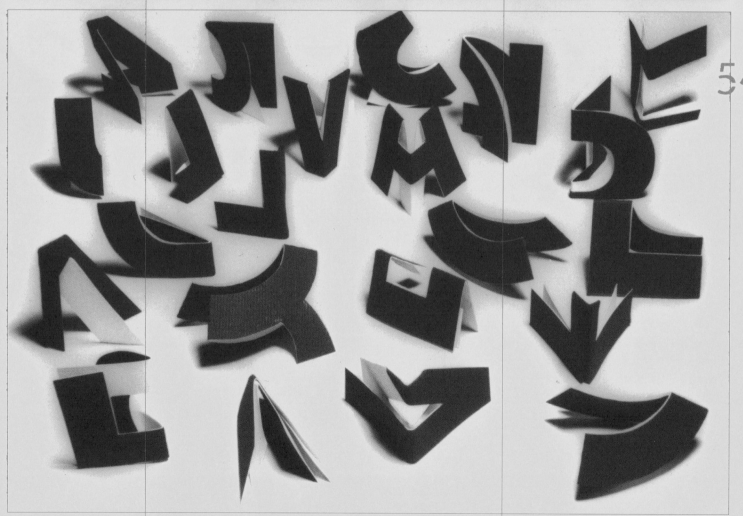

54

Christof Gassner

Corresponding figures from the outline from the
previous page.

앞 페이지 개요에 해당하는 다양한 결과물

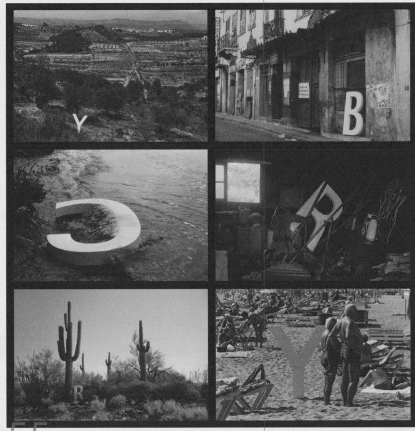

Figure 4

Figure 5

Figure 6

If, Then, Now, Next ...
Thoughts on the future of design education
_____Hilary Kenna and David Smith

Dr. Hilary Kenna, Lecturer in Design and Digital Media and David Smith, Senior Lecturer and Acting Head of the Faculty of Film, Art and Creative Technologies; both at IADT, reflect on their experience as they consider the future of Design Education.

We look at the present through a rear-view mirror. We march backwards into the future.
_____Marshall Mc Luhan[1]

IF

What if you were asked to imagine the future of design education? All kinds of images might come to mind, not least of which might be a paperless virtual studio, perhaps operated via voice and gesture like an iconic scene from *Minority Report* or *Iron Man*, where complex holographic interfaces promise boundless creative possibility. However, you might also wonder about what new types of products and services designers will create in the future and how we will consume and use them.

We see images of future user interfaces (FUIs) in movies that seem far-fetched, but if we viewed where we are now from even a decade ago, these future images are not so incredible. Consider, just ten years ago, there were no iPhones, iPads or AppStores! Now a design and digital publishing revolution has emerged around them. The ubiquity of mobile computing and broadband wifi has irrevocably changed how we consume information – and, by extension, the practice of design – forever.

This article takes a brief look at design education from our experience at IADT through the lens of designing, developing and delivering a four-year undergraduate programme in Visual Communication Design over the last fifteen years. Reflecting on this experience, we consider how design practice has changed during this time, and speculate on the future opportunities for design education as we see it.

THEN
We started teaching just before the millennium, when the landscape of graphic design or visual communication practice and education was very different from what it is today.

In 2000, graduates of graphic design, visual communication or communication design called themselves 'graphic designers' and the vast majority of their output was published in print. Graphic design for print, though still a relatively young discipline compared with other professions, was well established and understood. However, from an audience perspective (despite daily consumption of print media), it could be argued that few people could actually tell you what graphic design was.

At this time the role of screen media in graphic design was also very different. Smart phones and tablets weren't invented, and mobile computing and wifi were nothing like as pervasive as they are today. Design jobs in screen media were on the increase however, as digital agencies and software companies began hiring graphic designers as web and interaction designers. There was a growing range of opportunities to be found in motion graphics for advertising, television and film. Screen-based media offered an exciting new area to work in but for many graphic designers it was still a 'new kid on the block' to be wary of. Within design culture, screen-based media was perceived to be predominantly 'tech-led' with design considerations (and opportunities) subordinate, if not lost, to technology. Pushing the design agenda in a tech-centric industry was difficult and not for the faint-hearted designer. A consequence of this tech-centricity was that designers were slow to migrate to screen-based media for this and other reasons.

Around this time, much of the innovative screen work began to emerge outside the traditional field of graphic design in places like MIT (through the work of John Maeda, Ben Fry, Casey Reas, David Small, Peter Cho), or from tech-led, non-traditional designers such as fine artist Joshua Davis (of Praystation fame) and Japanese artist/designer Yugop Nakamura. The design community began taking notice and critical debate around design for digital media appeared in a plethora of print and online articles and new books on the subject. Notable early trailblazers such as Malcom Garrett, The Tomato Collective and studios like Spin in the UK showed how it was possible to work fluidly across print and emergent digital media. They and others like them proved that traditional methods could be blended with new practices and that the future of graphic design *might* be multi-disciplinary.

In 2000, graphic design education was exciting and optimistic. There was much to learn (and teach) about the expanding horizons of design in a digital world. Bringing forward the value of traditional design principles and developing new ones in parallel presented a stimulating challenge for design educators. Digital media was revolutionising the ease with which one could practice in new areas such as motion graphics, animation, web and user interface design. Meanwhile, the internet provided a platform to publish new design work on a world stage and enabled designers to connect with each other in ways not possible before. For traditionally-educated designers and new entrants alike, there was a steep learning curve to gain the requisite skills to practice in the wider field that graphic design was expanding into.

56

18

David Smith

Founder and Principal of Atelier Projects
Former Programme Chair at IADT, Dunlaoghaire

Dr. Hilary Kenna and David Smith, both educators at Institute of Art, Design + Technology in Dublin, Ireland reflect on their experiences as they consider the future of Design Education. First Published in *Campaign, the Journal of the Institute of Creative Advertising & Design*, Issue 12, May 2016, Dublin, Ireland.

아일랜드 더블린의 예술, 디자인+기술 대학의 교육자인 힐러리 케나 박사와 데이비드 스미스가 자신들의 경험을 토대로 디자인 교육의 미래를 조망한 글이다. 2016년 5월, 더블린의 ≪Campaign, the Journal of the Institute of Creative Advertising & Design≫ 12호에 처음 발표되었다.

IADT was ambitious to embrace this change and to be at the forefront of creating a new design programme that addressed the future shape of our discipline. In 2000, we believed that the language of the screen – narrative, motion, interactivity – needed to be integrated more fully alongside traditional media, namely print and the application of graphic design in spatial environments. On screen, the conception and crafting of new messages and experiences demanded a deeper engagement with audience to understand how they interacted with, accessed and used information. This prompted us to re-examine traditional core subjects such as typography, screen-printing, image-making and photography in the expanding context of graphic design that integrated applications across print, screen and space.

Our vision was that design education should take on the mantle of integrating multimedia languages with traditional graphic design in order to create a 'holistic' visual communicator who was media agnostic. Graduates would be designers first and foremost, flexible and adaptable, able to apply their skills in any context – be it print, screen or space. Hence the ethos of the design programme at IADT was born. In 2002, we launched a new four-year degree programme in Visual Communication Design that has been running successfully ever since.
——

Innovation is a contact sport that requires a rich mixing and mingling of people, information, ideas and collaborative processes.
____Eric Von Hippel (MIT)[2]

NOW

Taking the last decade into consideration, the design programme at IADT can be viewed as a microcosm of the changes seen in the broader design industry.

The programme is built on three core tenets that we felt were critical to the changing nature of design practice at the time, but which we hoped would have longevity into the future. They are:

Design Principles – for print, for screen, for space.

Theory and Practice Integration – integrated critical and contextual studies within the studio and in the historical/ theoretical part of the programme.

Interdisciplinarity – progressively mixing and blending principles and practices across print, screen and space at each stage of the programme.

While these tenets may seem commonplace today, in 2002 this combination distinguished IADT's Visual Communication programme from other courses of study. In particular, the concept of inter-disciplinary or trans-disciplinary practice was far from established as a relevant and necessary pathway or concept, at undergraduate level here in Ireland or abroad. Combined with design principles, theory and criticism, these core skills provide deep understanding of current and historic practices which are essential for designers to effectively contextualise their ideas and their work.

In reimagining the programme at IADT, we had to reimagine our teaching practices. This change in pedagogy could not have occurred if the lecturing team[3] had not displayed immense confidence in exiting their "disciplinary silos" and embracing a more fluid and varied teaching practice. In practical terms, every design project and problem recognised the value in diversity of experience, and diversity within practice. As teachers we needed to assimilate multi-disciplinary ideas and so we worked together to integrate our various specialisms into a pluralist pedagogic approach. In our classrooms today, design processes and solutions for print, screen and space thrive alongside and mutually inform each other in the service of visual communication. Equally, theoretical, critical and contextual studies which run in parallel with studio practice, offer key points of cross-over and integration throughout the course.

To this day, underpinning all of this is an emphasis on the core activity of iterative and practical making. We believe that the resolution of all design problems comes through the visualisation of ideas, speculating, sketching and making of design proposals, prototypes and final presentation outcomes. For assessment and evaluation of design work, individual student presentation, group critique and peer review are the core methods we use. We strongly promote an evidence-based culture of design that is demonstrated through the tangible practical process used and the practical outcomes produced. These empirical practices are fundamental to the success of all learning and attainment achieved within the programme.

In advocating a strong bias towards practice we cannot ignore the problem of skills acquisition. While it is tempting – especially in an increasingly complex digital environment – to stuff the curriculum of a design programme with skills-based workshops, it should never be at the expense of core design skills. The never-ending list of new technical skills to acquire is impossible to cover and unsustainable because technology continues to change so rapidly. We have opted for a learn-by-doing (as required) approach, where students are taught basic technical principles but acquire advanced and expert technical know-how, on a need-to-know basis, based on the job in hand (so to speak). Tools don't solve problems, people do and we believe design education should not focus on technical skills.

Students are exposed to a variety of critical design concepts, theories, methodologies, processes and practices in the pursuit of solving design problems for others or expressing something to others. As a diverse cohort of staff and subject experts, we do not subscribe to a single approach or perspective on design. Admittedly though, there may be an underlying modernist ethos that permeates our design studios, creating a tension between pragmatism and poetic expression, resulting in outcomes that we believe are beautiful but purposeful; innovative and essential.

The diversity of our programme curriculum is best demonstrated in the eclectic graduate pathways of our alumni which span multi-national corporations, international creative agencies and boutique studios in a wide range of sectors across the globe.
——

57

The essay discusses the beginnings of their careers as design educators in the late 90s, early 2000s and how IADT has gone from a program of 'graphic designers' to designers with a traditional base who can adapt to changing conditions.

90년대 후반과 2000년대 초 디자인 교육자로의 커리어 시작을 회고하며 IADT 가 '그래픽디자이너' 중심 프로그램에서 전통에 기반을 둔 환경 변화적응에 용이한 교육프로그램으로 변화하였는지 이야기한다.

01

02

03

04

↑ Selected works from *#FutureProofed 2015*, IADT Visual Communications Graduate Exhibition: 01 *BECCY*, Biologically Engineered Crowdsourced Creations Yay, Jack Collins, 02 *RWC 2023*, Interactive advertising for Rugby World Cup 2023, Kelan O'Nuallain, 03 *Verses*, Interactive Poetry Festival, Pierce Cunnane, 04 *Rising Shadows 1916*, Interactive City Experience, Aisling Darcy.

NEXT

In 2016, design as a profession has become mainstream and is generally better understood. It is fair to say that visual communication graduates are no longer perceived solely as 'graphic designers' (which suggests a print-bias association) but also as user experience (UX) and user interface (UI) designers; as motion designers, web designers, design researchers and design strategists.

New roles for designers are cropping up in all sectors in an era where 'design thinking' is lauded as a paradigm for innovation strategy in business, thanks to evangelists like IDEO CEO Tim Brown, and founder of Stanford's D-School David Kelly. It is arguable, however, that the explosion of design thinking and its popular application in business has created the perception that anyone, regardless of experience or role, could 'practice design'. For example, many of the tools and methodologies attributed to design thinking have enabled non-designers to successfully assimilate and use a sort of 'meta–design practice'.

Whether we see this democratisation of design positively or negatively, design is now placed firmly on the business and public agenda. Globally, the trend in 'design-centric' organisational change is becoming almost a rite of passage for large companies striving to innovate, following in the wake of Steve Jobs and Apple becoming the most successful company in history. In January 2015[4], Apple had the most profitable quarter of any company ever with 18 billion dollars in profits.

Design is more than the aesthetics and artifacts associated with products; it's a strategic function that focuses on what people want and need and dream of, then crafts experiences across the full brand ecosystem that are meaningful and relevant for customers.
____Mauro Porcini,
PepsiCo's Chief Design Officer[5]

So, what does this mean for design education? It seems clear that other disciplines are transporting design methods and theories into educational programmes for other professions. Stanford's D-school is the most famous international example, closer to home examples such as Maynooth's and UCD's design innovation centres are making progress towards assimilating these methodologies into established business and creative programmes of study. They are theorising what has traditionally been a practice-based, tacit discipline. This train of development is also evident in industry as large international companies continue to invest in becoming design-centric organisations and try to leverage design thinking as a means for driving innovation. In 2013, IBM declared $100 million investment in building a massive design organisation as they strive to 'modernise enterprise software for today's user' and to recruit 1,000 designers to help them do it.

However 'design thinking' as a catalyst for innovation in business is no longer new(s) and as a practice it may have plateaued over the last five years. Yet, at IADT we still recognise the essential value and need for what we would classify as 'designerly ways of doing' or as we prefer to describe it 'design thinking through practice'.

As we move forward into this millennium, the problem for design is the superficial way in which it is being appropriated by business as a method for strategic development. Design is not a just a methodology acquired on a two-week training course which can be applied instantly in the pursuit of creating a culture of innovation and change. Design applied for strategic development must have tangible outputs, otherwise it remains in danger of becoming just that, a strategy of design rhetoric. This is the gap where future design education has an important role to fill – through integrating design as a strategic driver with the practice of (evidence-based) making firmly at its core.

Human computer interaction scientist Don Norman writes:

Many [design] problems involve complex social and political issues. As a result, designers have become applied behavioral scientists, but they are woefully undereducated for the task. Designers often fail to understand the complexity of the issues and the depth of knowledge already known. They claim that fresh eyes can produce novel solutions, but then they wonder why these solutions are seldom implemented, or if implemented, why they fail. Fresh eyes can indeed produce insightful results, but the eyes must also be educated and knowledgeable. Designers often lack the requisite understanding. Design schools do not train students about these complex issues, about the interlocking complexities of human and social behavior, about the behavioral sciences, technology, and business. There is little or no training in science, the scientific method, and experimental design.[6]

Norman argues that a designer's creativity is not enough to solve real world problems and that designers must use analytic and scientific methods to inform their solutions. The problem with Norman's argument is that it also highlights the shortcomings of a purely scientific approach to enabling the creative speculation. If designers are to think beyond the quantifiable constraints of a problem in order to find new and innovative solutions, they must go beyond the rational. Creative speculation is only realisable through the practice of making, prototyping and iterating tangible outcomes. It is practice after theory, but perhaps the predictable irrational approaches after objective analysis is what produces unexpected outcomes. Design based solely on user-centred analysis may have a clear functional bias, but it may also lack the expressive qualities that equally contribute to the overall user experience and satisfaction.

58

20

David Smith

They also discuss what might be next. They have built and value at IADT a very making centered approach. 'Design thinking through practice' is how it might be observed. This has been a long standing theme at IADT that design is just as much practice based as it ever was and they continue to make efforts to integrate this into the evolutions that have taken place and are taking place next.

이 글에서 그는 교육의 미래를 조망한다. IADT는 제작 중심의 방법에 가치를 둔 교육 과정을 개발하였으며 이는 '실무를 통한 디자인사고'라 할 수 있다. IADT의 교육 철학은 항상 디자인은 실무를 중심 축으로 두고 실습과 현재 그리고 미래 적응을 위한 진화를 통합하고자 하는 노력을 지속하였다.

59

Another rational and analytic approach to design is 'data-driven' design. Essentially, this relates to the recording, collection and analysis of data relating to how users (audiences) use and consume products and services. Data analytics is a pervasive practice in all web, app, software and services design. The collated analysis of data from user interactions produces an analytics report, which provides insights into user/customer behavior. Data-driven design works reactively to the evidence found in the data, and products/services are designed following what are known truths about the users' likes, dislikes, behaviours, habits, geo-location, demographic profile etc. Harvard Professor Clayton Christiansen, a leading expert on disruptive innovation, believes that a data-driven approach is doomed to failure because it focuses only on the past and does not equip graduates to create solutions to future problems. In his words, using this approach, 'we condemn our graduates to take action when the game is over'.[7] The counterpoint to this approach is to use a data-driven design approach throughout the design and prototyping process where design experiments can be tested and measured in advance of production. However, designing to a purely user-driven agenda is a well-known impediment to innovation, as the old Henry Ford maxim goes 'If I asked people what they wanted, they would have said faster horses'.

In 2016, in the midst of rapid technologically-driven social and economic change, we are thinking about what's next for design. How can we move our making-centric approach to the next level? How can higher-order thinking, strategic vision and other complementary practices be brought together in a new form of prospective design practice that will not only solve current design problems but anticipate and potentially invent solutions for ones that don't exist (yet).

Design is a broad and expanding discipline (when viewed through the lens of visual communication) and it still requires undergraduate education to teach basic principles (conceptual and practical) across core media. This takes time, because design is a practical endeavour and you have to practise to be able to do it, and to practise a lot to do it well. Reading and writing about it, or critiquing it, is not a sufficient design education. As design becomes increasingly embedded in our lives, through the products and services we use and experience, design problems become ever more intricate and multifarious. Designers have to consider and analyse context, evaluate competitive offerings, identify the gaps for improvement and innovation but ultimately have the ability to shape and realise design into a tangible outcome(s).

We think design education of the future will encompass more intimate engagement; with audiences and users, with storytelling and speculation, with new methods of visualising and interacting with information, and with a deeper understanding of how far design reaches into a problem (from inception to completion). Design graduates must understand their role in a team, not only as a collaborator but as a key contributor, an opinion leader and an influencer.

Design critic Alice Rawsthorn argues that:

Design must also become more compassionate. Old school design was defined by certainties, as you would expect of a culture that was fired by modernists fervor and intent on improving the lives of millions of people by dint of standardization. At its best, this culture was plucky and optimistic, but also erred towards arrogance, obduracy and boosterism. Those qualities will prove even more damaging in the future. Design needs to become more empathethic, and better attuned to the frailties that defy rational analysis yet determine so many elements of our lives... And design needs to be both bolder and humbler. Designers should never be censured for ambition or courage, both of which will be required in abundance if they are to aim higher in terms of the scale and intensity of their work. Yet they must also exercise restraint in accepting design's limitations.[8]

To meet these bold challenges, we believe designers must be taught, and must learn to speak (make) in a visual language not just a verbal one as we live in a multimedia image-driven world. Fluency in multimedia and visual language combined with critical analysis, and the ability to articulately present their design evidence (tangible outcomes) is key for any designer of the future. The hand, eye and brain are the most valuable assets that designers must develop, hone and nurture through their education. Their importance, in the practice of making visible design outcomes, should not be undermined by new theoretical or technical processes that have found currency in the complex digital world we live in. Rather, design practice should continue to build and grow demonstrably around them.

It is therefore central to the future of design education, despite whatever new methodologies and approaches it appropriates, that the continued practical endeavour of visible making remains a core activity, albeit in a changing world dominated by complex relationships between technology and audience.

_____1. Marshall McLuhan and Quentin Fiore, *The Medium is the Massage: An Inventory of Effects*, co-ordinated by J. Agel. New York, London, Toronto: Bantam Books, 1967.

_____2. Eric Von Hippel, http://theculturecompany.co.uk/?page_id=24 (accessed on September 5, 2015).

_____3. IADT Visual Communication Lecturing Team: Shirley Casey, Peter Evers, Gerard Fox, Ron Hamilton, Alastair Keedy, Hilary Kenna, Linda King, John Montayne, Phil Sheehy (retired), Elaine Sisson and David Smith.

_____4. Greg Kumparak, 'Apple just had the most profitable quarter of any company ever.' *Tech Crunch* web blog (January 27, 2015). http://techcrunch.com/2015/01/27/applejust-had-the-biggest-quarterly-earnings-of-any-company-ever/ (accessed September 20, 2015).

_____5. James de Vries, 'PepsiCo's Chief Design Officer on Creating an Organization Where Design Can Thrive.' *Harvard Business Review* (August 11, 2015). https://hbr.org/2015/08/pepsicos-chief-design-officer-on-creating-an-organization-where-design-can-thrive (accessed September 7, 2015).

_____6. Don Norman, 'Why design education must change.' *Core77* web blog (November 26, 2010). http://www.core77.com/posts/17993/why-design-education-must-change-17993 (accessed September 7, 2015).

_____7. Clayton Christensen, 'How will you measure your life?' Linked In Lecture Series (July 24, 2012). https://www.youtube.com/watch?v=5DwYcNr0Nuw (accessed September 7, 2015).

_____8. Alice Rawsthorn, *Hello World: Where design meets life*. London: Hamish Hamilton, 2013.

21

As a Studio Principal at Atelier, a design advocate with the AGI and the 100 Archive and Head of the Faculty of Film, Art and Creative Technology at IADT, David Smith has plenty of reasons to contemplate how graphic and communication design is changing. He speaks to the author about the transition from traditional visual communication practice to the realm of 'Graphic Designer 2.0'.

What do you mean by Graphic Designer 2.0?
In simple terms it is about the next iteration of graphic design practice. It is a conversation I have been rehearsing for sometime now with colleagues in the AGI, IADT and the 100 Archive.

Design is always in flux and historically graphic designers – I prefer communication designers – were quick to abandon their traditional discipline and embrace whatever was the emerging area of practice. Currently UI/UX is a burgeoning growth area that many 'lapsed' graphic designers are turning to, but this is nothing new. We've historically seen graphic designers transition from analogue to digital; print to interactive; static to motion.

What enabled these practitioners to successfully adapt was their grounding in the fundamentals of graphic and communication design. These 'new breeds' were not outstanding designers for motion/interactive/insert preferred practice here *in spite* of their traditional design experience but rather because of it. However, too often these emergent practitioners failed to acknowledge the foundational aspect of their graphic design experiences.

Ezio Manzini of Politecnico di Milano speaks of two modes of design: conventional mode ('We do it like this because we have always done so') is a mode of practice where 'tradition guides us' and is analogous with mastery achieved over time. It is typically concerned with craft and while it accepts innovation, it is assimilated slowly. The second mode, design mode, integrates critical, creative and practical skills, all with a focus on imagining and dealing with challenges and opportunities that correct or improve existing issues or imagining and tackling something that may not even exist. Manzini acknowledges that both modes have been able, and continue, to happily co-exist, but in an increasingly 'connected world' design mode dominates (Manzini, 2015). A consequence of this is that traditional ways of practice (or craft) are rarefied and increasingly lost.

Graphic Design 2.0 encapsulates all of the traditional skills and expertise, but also assimilates and acknowledges the increasingly broad range of skills and cognate disciplines designers require, to work on advanced communication design projects. Current and future design problems are increasingly more complex. Making such complexity simple, accessible or more comprehensible naturally requires advanced critical and practical skills. Graphic Designer 2.0 will typically have an advanced understanding of 'digital', be strategic in outlook, they will combine the necessary critical and creative thinking to negotiate the complexities they face, and they will consistently speculate on new ways of thinking and doing to achieve this.

Where has Graphic Designer 2.0 come from?
In many cases I think this is a natural evolution for many designers who have remained motivated and curious about their own practice and emerging practices. The issue for these individuals is that the moniker 'graphic designer' will always be too inadequate to effectively communicate the breadth of expertise and value they offer. It is often easier to

David Smith

In conversation with Aideen McCole about the transition from traditional practice to the realm of 'Graphic Designer 2.0', a term coined to describe communication designers whose role adapts dynamically as both the design practice and surrounding world continue to evolve. Published in *Iterations*. First Published in *Iterations—Journal and Practice Review*, Issue 6, February 2018, Dublin, Ireland.

전통적 작업방식에서 '그래픽 디자이너 2.0 (커뮤니케이션 디자이너의 작업과 환경 변화 때문에 역할이 진화함을 표현하기 위한 조어)'으로의 변화에 관해 에이딘 맥콜과 나눈 대화 중 일부이다. 2018년 2월, 더블린의 《Iterations – Journal and Practice Review》 6호에 처음 발표되었다.

label oneself a 'motion designer' or 'UI designer', or for that matter 'editorial designer' in my own case. Such labels often have currency and clarity but are equally narrow in scope relative to how Graphic Designer 2.0 practices.

Who are the practitioners doing particularly interesting things in this area?
This a little difficult to answer as there are many outstanding designers who occupy this space who have not trained or been educated as graphic designers in a conventional way. In mentioning the following I do so knowing that they have a very traditional background – and apologies for the Dutch/German bias. Daniel Gross and Joris Maltha of Catalogtree, Jeroen Barendse, Thomas Castro, and Dimitri Nieuwenhuizen of Lust and LUSTlab, Eddie Opara at Pentagram and Niels Schrader are all making really interesting work in this area. Before Opara joined Pentagram Lisa Strausfield was making equally progressive digital and interactive work at Pentagram. Ex-ProjectProjects designer Rob Giampetro now of Google Design has transitioned expertly from his former role as an editorial designer into an interaction design lead and technology advocate through Google Design's SPAN conferences and outputs.

Also in New York I think 2 x 4 are possibly the best example of a large agency that has seamlessly evolved from Graphic Design 1.0 to design Graphic Design 2.0, partners Micheal Rock, Susan Sellers and Georgianna Stout excel in translating innovative ideas across all media and environments.

Staying with experiential design, Conny Freyer and Eva Rucki of Troika – both RCA communication design graduates – are among those who I feel have moved or evolved their practice furthest in respect of where design and technology intersects today.

Coming from a completely different perspective I think that Richard van der Laken epitomises Graphic Designer 2.0 through action and debate. I think his conference 'What Design Can Do' fully demonstrates the breadth of opportunity and influence Graphic Designer 2.0 can aspire to. And obviously I can't ignore the technologists shaping and redefining graphic design practices – Ben Fry and Casey Reas creators of Processing, and Yugo Nakamura of Tha Ltd / Yugop immediately spring to mind.

Has Graphic Designer 2.0 developed out of a wealth of new opportunities, or a lack of traditional ones?
Neither, to be honest. As I suggested earlier both traditional and emergent practices happily co-exist. Discrete opportunities have always existed and will continue to exist for Graphic Designer 1.0 and Graphic Designer 2.0 respectively. However, I think we are now at the point where the convergence of design and technology is arguably complete and new blended opportunities are flourishing.

A word of caution though, is that like every product or digital 'thing', aspects of Graphic Designer 2.0's practice are inherently obsolescent: open source frameworks, visual resources, pattern libraries, proprietary platforms, increasing automation etc will all alter or reduce the extent of concrete outputs designers are responsible for in the future, hence the need to emphasise the value of critical thinking and strategic capabilities.

The emerging design disciplines are full of designers and creatives of all sorts: are graphic designers better suited or more adaptive to these roles than others?
I am going to say yes as the key word here is *adaptive*. I think graphic designers are often

David is often referring to designers who span the spectrum. While rooted and grounded in traditional graphic design, these designers are just as prolific in digital design environments that make active use of technology.

데이비드 스미스는 폭 넓은 작업을 아우르는 디자이너로 알려져 있다. 전통적 그래픽 디자인 토대로 이런 디자이너들이 디지털 디자인 환경에서도 기술을 적극적으로 사용하며 풍성한 작업들을 지속하고 있다.

more responsive to emergent challenges and opportunities than other designers. I think Graphic Designer 2.0 is naturally adaptive, flexible and inherently comfortable dealing with abstract and complex concepts. As communication designers they have the core skills to interrogate and communicate abstract and speculative concepts to clients and other audiences.

How does design education in Ireland need to respond to the development of the Graphic Designer 2.0, and how has it responded so far?
I can only comment from my perspective at IADT. As an Institute of Art, Design and **Technology** I think we have been better placed to integrate a broader set of cognate disciplines into our 'traditional' design programmes. I think the calibre and demand for our graduates – across multiple sectors – indicates that we have some strong foundations in place. We have an emerging cohort of students who are truly digital natives and if they pursue a digital-first practice that is rigorous and informed by the core fundamentals of graphic design, they will excel. That said, every school, IADT included, has a responsibility to evolve to meet the changing needs of a discipline in constant flux. The challenge for education is to simply keep up with the pace of change in a sustainable way. It would be very easy to jump on the bandwagon and grasp at all of these emerging opportunities in a superficial way. However, creating sustainable and credible design programmes takes time. The reputation and standing of the current Visual Communication programme at IADT was built over 15 years. No school can afford to take this amount of time to respond to changes in the profession, so I am an advocate for establishing expert programmes that only require incremental changes year on year as opposed to having to manage radical changes.

Is Graphic Designer 2.0 developing differently in Ireland than in other countries?
Considering the strong international bias in the my list of practitioners the answer has to be yes. Are there practitioners working in a similar way in Ireland? Again, yes. However, the opportunities for independent designers and traditional agencies to transition and practice in this manner are currently quite limited. Partially due to scale and capacity, but mostly due to the less than progressive understanding of what graphic designers actually (can) do…

What impact does the development of the Graphic Designer 2.0 have on traditional graphic design in Ireland, and how should the industry respond?
I think the demand for Graphic Designer 2.0 is so high that the traditional design sector is already suffering. It could even be too late for the industry to respond (?) – something that concerns me greatly. With the likelihood of IBM, Accenture and Deloitte, amongst others, to be the largest employers of graduate designers in Ireland for the near future at least, Graphic Designer 2.0 will be in great demand. As these companies typically practice in 'design mode', Graphic Designer 2.0 will see their critical, collaborative and strategic skills greatly enhanced but see their traditional skills diminish. In the short term at least, Manzini's 'conventional mode' of practice may end up being the domain of the traditional agency. Whom in effect will become finishing schools for Graphic Designer 1.0 as they evolve into 2.0 practitioners.

Manzini, E. (2015) *Design, When Everybody Designs,* MIT Press.

62

David Smith

Some designers who he sees as occupying this space are Eddie Opara from Pentagram, the design studio LUST and 2x4 to name a few. These practices have expanded their attention and application of technology in a way that informs their excellence in traditional graphic design.

그는 펜타그램의 에디 오파라, 디자인 스튜디오 러스트, 투바이포 등을 좋은 예로 든다. 이들의 작업은 시야를 넓히며 기술적용을 통해 전통적인 그래픽 디자인을 더욱 훌륭하게 소화해낸다.

63

BABYLON DESIGN SCHOOL
Blue Sky Research &
Action Design

Babylon Design School is not an institution.	It's an experience.
The whole world is Babylon!	According to Genesis, the golden age of the ancient civilization of Babylon declined after God disrupted the language and people could no longer understand one another. The failure of communication led to the collapse of social structures and subsequently of the entire culture.
	In today's globalized world ineffizient communication more than ever is a major source of conflict and trouble. We talk, but we don't understand. We debate, but we don't receive the message. We process information, but we don't comprehend the meaning.
	For a bright future we need advanced concepts and multi-sensory models of communication. Research and education in transcultural communication design is necessary to foster diversity and to cultivate cooperative relationships. And we need to learn empathy, which is the foundation of peaceful human interaction!
Babylon Design School	is a playground for passion, fantasy and creativity. It was conceived by Elisabeth Kopf, who has been training "Experimental Project Design" at the University of Applied Arts Vienna since 2004. A variety of self-initiated art and design projects have been realized by small teams of students as well as by big teams in collaboration with other universities of art, design and science. Project-related partners were educational institutions, such as the Academy of Fine Arts Leipzig, the Mimar Sinan Fine Arts University Istanbul, the National Taiwan Normal University, and others.
	Project-related alliances with external experts widen the range of disciplines and experiences of the educational programme. Design students become engaged with design professionals, artists, scientists, researchers, musicians, philosophers, historians, psychologists, medics, cultural managers, curators, media experts, marketing experts, publishers, editors, producers, and many more.

babylon-design-school.com

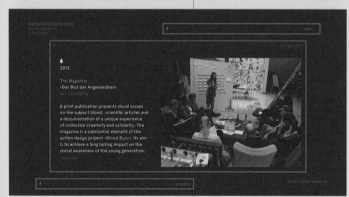

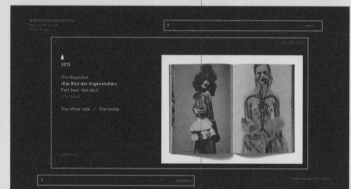

Elisabeth Kopf

Founder Babylon Design School
Co-Founder of Alphabet of Life—Nature's Learning Lab

BABYLON DESGN SCHOOL—In 2010, Elisabeth Kopf initiated the educational experiment 'Babylon Design School' at the University of Applied Arts Vienna. Its mission is to burst the boundaries of graphic design and to mentor an intrinsic, holistic and integral approach to communication and design. Every theme of the program is related to previous themes and thus contributes to the creation of a bigger picture.

바빌론디자인스쿨—2010년에 엘리자베스 코프는 빈응용미술대학에서 '바빌론디자인스쿨'이라는 교육적 실험을 시작했다. 그 실험의 미션은 그래픽 디자인의 경계를 허물고 소통과 디자인에 대한 본질적이고 종합적인 접근법을 멘토링 하는 것이다. 프로그램의 모든 주제는 이전의 주제와 관련이 있기 때문에 더 큰 그림을 만드는 데 기여한다.

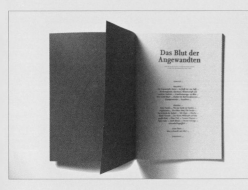

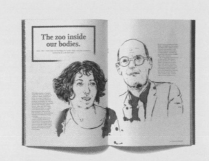

65

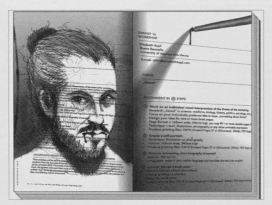

Different generations of students have been working on subsequent series of topics, such as Design to Make Trouble, Bursting Boundaries, Action Design, Blood, Healing, and Ask Nature. The following examples show some results of the research on the subject Blood and from the project *Ask Nature*. It's a glimpse of the abundant archive of the Babylon Design School.

다양한 세대의 학생들이 '문제를 일으키는 디자인' '경계 허물기' '액션 디자인' '피' '힐링' 그리고 '자연에게 묻는다' 등의 후속 주제들을 가지고 작업해왔다. 다음의 예는 '피'라는 주제와 '자연에게 묻는다' 프로젝트에서 나온 몇 가지 연구 결과이다. 바빌론디자인스쿨의 풍성한 아카이브를 엿볼 수 있다.

BLOOD—At Workshops in Austria and Turkey the research on the topic of Blood had a deep and very personal impact on students with different cultural backgrounds. The creative output of this process was published in print and online, and eventually an awareness campaign for blood donation was launched together with a blood drive at the campus in Vienna.

피—오스트리아와 터키의 워크숍에서 피를 주제로 한 연구는 문화적 배경이 다른 학생들에게 깊고 매우 개인적인 영향을 미쳤다. 이 과정의 창의적인 결과물은 인쇄물과 온라인을 통해 발표되었고, 결국 이와 함께 비엔나 캠퍼스에서 헌혈에 대한 인식 개선 캠페인이 시작되었다.

Alphabet of Life

An alphabet is a fantastic system which enables us to write and read, and to learn to understand the world in which we live. The "Alphabet of Life" is a metaphor for learning from the best of all teachers: from Nature. Why not just ask Nature upon which principles life works and what strategies are best to create a life-friendly and sustainable world? The goal of this project is to evolve a new vocabulary of design which is deeply connected with Nature and inspired by her genius.

Nature's Learning Lab

The transdisciplinary Learning Lab brings together scientists with designers, architects, engineers, craftspeople and artists, professionals with students and laypeople, and business people with inventors. A pioneering program of research and education constitutes the quality and characteristics of the Learning Lab where Nature is the guide through the cosmos of challenges. What are Nature's best designs and how can we emulate them? How do ecosystems function and what can we learn from biological processes? What methods can we apply to take Nature as a model for innovation and design?

In order to explore the potential of Nature-inspired design and innovation the Learning Lab investigates different Nature-based approaches, methods and philosophies. During the first research phase the focus was on "Biomimicry". Other approaches will be subject matter for further research activities in the near future, such as "Cradle to Cradle", "Circular Design", "Permaculture" etc.

Biomimicry

Biomimicry is an approach to innovation that seeks sustainable solutions to human challenges by emulating nature's time-tested patterns and strategies. The goal is to create products, processes, and policies—new ways of living—that are well-adapted to life on earth over the long haul. The core idea is that nature has already solved many of the problems we are grappling with. Animals, plants, and microbes are the consummate engineers. After billions of years of research and development, failures are fossils, and what surrounds us is the secret to survival. (Biomimicry 3.8, Dayna Baumeister)

26 Life Principles

Based on the recognition that Life on Earth is interconnected and interdependent, and subject to the same set of operating conditions, Life has evolved a set of strategies that have sustained over 3.8 billion years. Life's Principles represent these overarching patterns found amongst the species surviving and thriving on Earth. They are lessons from Nature and represent the sustainability benchmark as part of the Biomimicry Thinking Design Process.

The Alphabet of Life in the Ecosystem of a Tree

Evolution is a history of change and adaptation, and Nature offers a gigantic repertoire of life strategies. But what are the principles that make it possible for organisms to survive and thrive? In order to illustrate Life's Principles the Learning Lab team of scientists, designers and Biomimicry experts have searched for examples in the ecosystem of a tree.

3

The Creative Lab

A deep desire to reconnect with Nature has brought together people from across Europ to meet, learn and work together in the woods and mountains of Bregenz Forest. The Alpine region in the west of Austria is famous for it's beautiful Nature, for outstanding craftsmanship and for a strong affinity to design. Hosted by Werkraum Bregenzerwald, the alliance of the local craftspeople, Nature's Learning Lab evolved into a hub for excessive creativity and collaborative innovation.

The Project's Genesis

It was a tiny big bang when the two designers and educators Elisabeth Kopf and Regina Rowland teamed up together with their students from the University of Applied Arts Vienna and the University of Applied Sciences Burgenland for the first time in 2013. The continuous collaboration of the two pioneers soon generated a field of gravity and attraction to people who were interested in Nature, design and innovation. Driven by curiosity and motivated by the wish for an outdoor learning studio, they connected with Thomas Geisler, the managing director of Werkraum Bregenzerwald who commissioned the design of an exhibition about Nature-inspired crafts and innovation. The research and education project was funded by the Austria Research Promotion Agency (FFG), and together with the architect Claus Schnetzer, the biologist Timo Kopf, the craftsman Helmut Fink and many others Nature's Learning Lab was conceived. In summer 2018, it opened its doors for a broad audience. Eventually, dozens of scientists, designers, craftspeople, engineers, artists and innovators were involved, and many students as well as countless participants of workshops, excursions and special events have contributed to the evolution of the "Alphabet of Life."

Nature's Lab Design Projects

See some examples of the "Alphabet of Life " design innovations in this presentation.

4

Elisabeth Kopf

ASK NATURE—Starting point of the educational goal to put Nature into the focus of the young designers' minds was Biomimicry—a philosophy and design method with Nature as a model, mentor, and measure for sustainable innovation. The first lesson of this design approach is to re-connect with Nature. Therefore, the design teams moved into the woods, and the classroom was exchanged with an outdoor studio.

자연에게 묻는다—젊은 디자이너들의 마음 중심에 자연을 두게 하려는 교육 목표의 출발점은 '바이오미미크리', 즉 생체모방이었다. 이는 자연을 모델, 멘토 그리고 척도로 삼아 지속적인 혁신을 추구하는 방법이다. 이러한 접근법의 첫 번째 가르침은 자연과 다시 연결하는 것이다. 그래서 디자인 팀이 숲으로 옮겨가고 강의실과 야외 스튜디오를 오가며 수업이 이루어졌다.

26 Life Principles
Biomimicry DesignLens

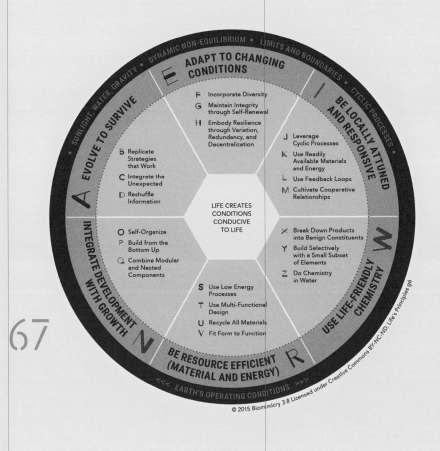

BIOMIMICRY 3.8
biomimicry.net | asknature.org

67

5

»The Alphabet of Life in the Ecosystem of a Tree«

Scientific project
Research and selection of 26 outstanding examples of Nature
representing the 26 Life Principles

Nature's model
The ecosystem of a tree

Life Principles
All Life Principles from A to Z

Visual art & exhibit
26 iconic paintings and a hanging tree

Concept: Elisabeth Kopf, Regina Rowland, Thomas Geisler
Scientific concept and research: Timo Kopf
Biomimicry expertise: Regina Rowland, Elisabeth Kopf
Paintings: Monika Ernst, University of Applied Arts Vienna, Class for Graphic Design
Hanging tree: Claus Schnetzer, Elisabeth Kopf, Helmut Fink, Daniel Meusburger, Thomas Geisler
Scientific consulting: Birgit Gschweidl, Christian Rammel

6

26 Life Principles
in the Ecosystem of a Tree

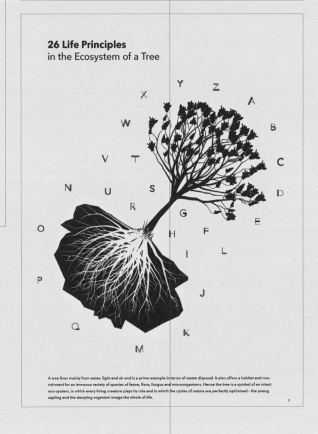

A tree lives mainly from water, light and air and is a prime example in terms of waste disposal. It also offers a habitat and nourishment for an immense variety of species of fauna, flora, fungus and microorganisms. Hence the tree is a symbol of an intact eco-system, in which every living creature plays its role and in which the cycles of nature are perfectly optimised – the young sapling and the decaying organism image the whole of life.

7

Nature turned into a learning lab, and what has begun as an academic course at the university eventually evolved into a summer program where transdisciplinary teams of students, professionals and laypeople learn and work together.

자연이 학습 연구실로 바뀌었으며 대학에서 교육 과정으로 시작한 것이 결국은 학생, 교수, 일반인이 초학제적 팀을 이루어 함께 배우고 작업하는 여름 프로그램으로 발전했다.

BIOMIMICRY—A core element of Biomimicry are the 26 Life Principles. The Alphabet of Life is a metaphor and a poetic expression for love of Nature. The structure of an alphabet serves as a system for communication and guides the learning process.

바이오미미크리—바이오미미크리의 핵심 요소는 스물여섯 가지 생명의 원리이다. 생명의 알파벳은 자연에 대한 사랑을 나타내는 은유이자 시적 표현이다. 알파벳의 구조는 커뮤니케이션을 위한 체계 역할을 하고 학습 과정의 지침이 된다.

T

is for

Tom-tom-, hack and grip design

T

Life's Principle
Use Multi-Functional Design

Example in Nature
Woodpeckers *(Picidae)*
Beak tool

The versatility of the woodpecker's beak offers multifunctional options of use as a gripping, hacking and drumming tool. It is used for hacking when searching for fodder, in building nest hollows and in quarrelling and fighting, as tweezers for picking up food, as a tool for plumage-grooming, and to turn its eggs in its nest; it also enables the bird to produce a loud drumming sound, a self-promotional signature tune to gain attention. And last but not least, the woodpecker feeds, drinks and sings with its beak.

Design Principle
Meet multiple needs with one elegant solution.

The woodpecker in the tree habitat
Abandoned woodpecker holes play an important role in the woodland eco-system: owls, tits, tree bumblebees, bats and squirrels use them as sleeping place, nursery, and hibernation quarter or seek shelter and refuge in them. In this way woodpeckers support species diversity of the forest.

Z

is for

Zest through Water

Z

Life's Principle
Do Chemistry in Water

Example in Nature
Tree, e.g. grey alder *(Alnus incana)*
Xylem and phloem

The tree transports the products of photosynthesis (sugar) and substances from the soil dissolved in water through two transportation systems that are separate from each other, xylem and phloem. Xylem ensures that vital substances are transported from the root area into the tree crown. It fills up with water from the ground through capillaries and maintains the water flow by constant condensation in the foliage area. Phloem enables sugar translocation from the leaves to the storage cells in the roots. This is effected by force of gravity. No energy is consumed for the total process of translocation.

Design Principle
Use water as solvent.

Xylem and phloem in the tree habitat
The conducting cells ensure substance translocation within the organism of the tree and enable growth in voluminous dimensions.

Elisabeth Kopf

ALPHABET OF LIFE—Every letter of the alphabet stands for one Life Principle. The 26 examples in the ecosystem of a tree(i.e. the woodpecker's beak and the tree's xylem and ploem) are a special selection that exemplifies Life Principles. They stand in for millions of other examples found in nature.

생명의 알파벳 — 알파벳의 모든 글자가 '생명의 원리'를 나타낸다. 나무의 생태계 안의 스물여섯 가지 사례 (즉, 딱따구리의 부리와 나무의 목관부와 체관부)는 생명의 원리를 보여주는 특별한 사례이다. 이는 자연에서 발견되는 무수히 많은 다른 예를 대변한다.

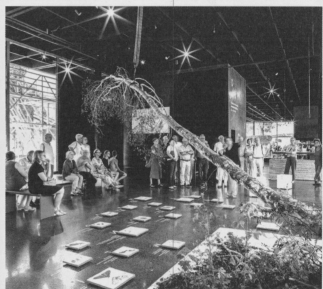

69

NATURE'S LEARNING LAB—Nature offers various ways of exploring and learning. It is essential to not only share the experiences with innovation teams but more so with a broad audience

자연 학습 실험실—자연에서는 다양한 탐구와 학습 방법이 가능하다. 그 경험을 기술 혁신 팀뿐 아니라 폭넓은 청중과 더 많이 공유하는 것이 필수적이다.

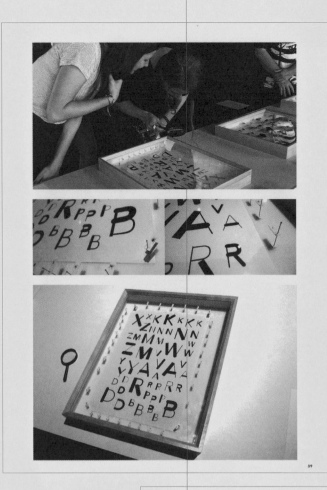

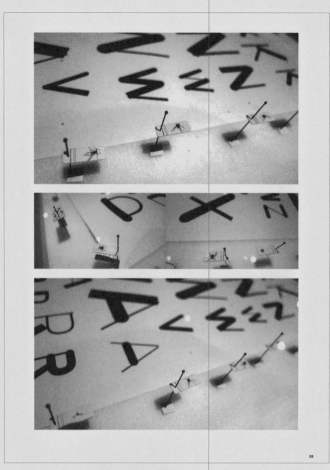

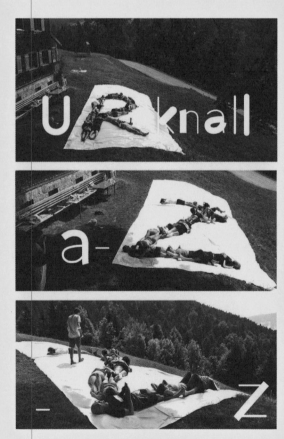

U R knall

a —

— Z

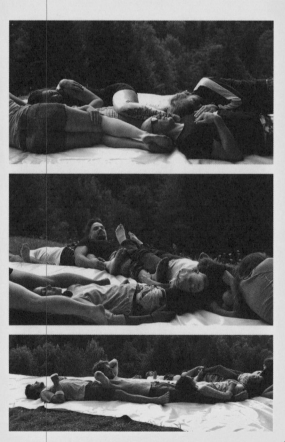

Elisabeth Kopf

NATURE-INSPIRED DESIGN—Even a tiny animal like a plant louse can become the inspirational model to design a new font. The Alphabet of Life describes how Nature thrives and how we can learn from her strategies, her principles, and her genius.

자연에서 영감을 얻은 디자인—진딧물 같은 작은 곤충도 새로운 폰트를 디자인에 영감을 주는 모델이 될 수 있다. <생명의 알파벳>은 자연이 번성하는 방식과 우리가 자연의 전략, 원리, 천재성을 통해 배울 수 있는 방식을 묘사한다.

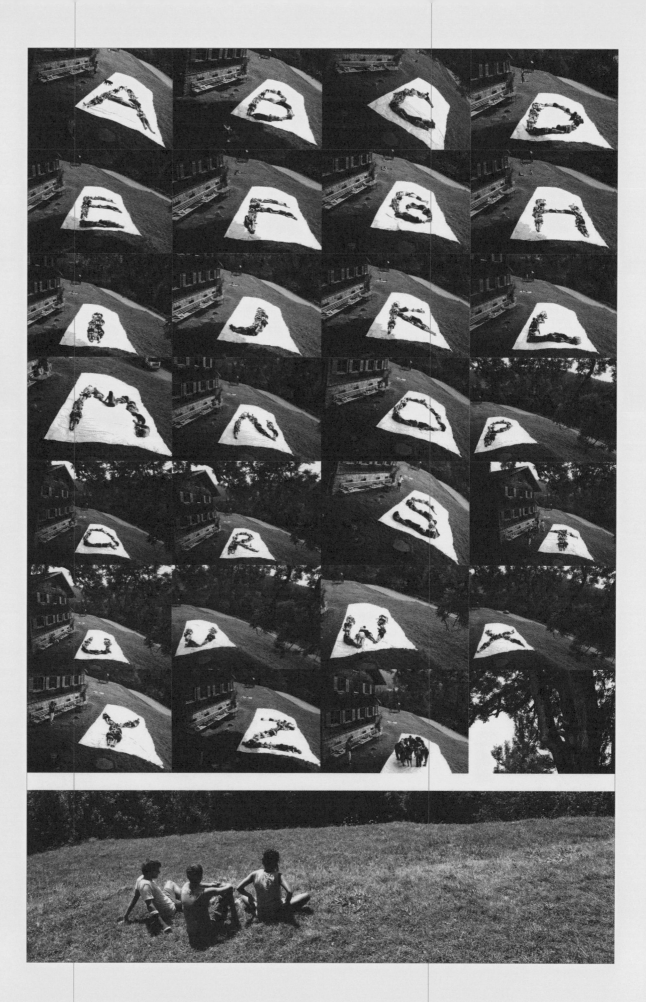

CCA / MFAdesign
Post-image: rendition, consumption & automation / SPRING 2018 / SYLLABUS
ERIK ADIGARD

POST-IMAGE INTRODUCTION

200 millennia ago, we may speculate, there was no reality other than raw organic nature. The world was free of pictorial representation. Today, the environment we live in is nearly entirely framed and made by image.

After a 20th century of engineered scarcity and mass production, capitalism had mutated into a nebulous "hypereconomy" where acceleration and individual production are the fabric of our existence while the images we produce are the ecology in which we live.

An exponential output of innovations has exploded into a frenetic economy of on-demand customization, crowd-sourcing and autonomic generativity. Each day we are enlisted to conceive and consume more images than all of the physical things being produced. To meet our seemingly limitless consumption capacity, neo-capitalism has merged things and images into a new stream of symbolic commodities that could be called "thingmages"—that is where things are virtualized and images are commodified. We now live within a sphere of overabundant representations that have near zero market value but can demultiply ad infinitum and still trigger dopamine reactions, even if only for an instant.

We are presented with a fascinating conundrum of excess capacity of image vs. great scarcity of imagination. It is an opportunity for all designers to intervene.

Post-Image is an interdisciplinary exploration of the rapidly changing ontology and makings of image in today's techno-socio-economics.

By maneuvering between practice and theory, and by raising key questions, this class will help us to best prepare for new design environments:

What are today's relationships between representation and image?

What are the new tools of representation and what alternatives should we consider?

How can interface affordances help us navigate across perspectives where the position of retinas is continually forced into conflicting flows?

Can we invent approaches to image that contribute to effective socio-cultural progress?

Above all, how do representation and image relate to the variables of contemporary design?

Process
Documents, essays, presentation PDFs and relevant links will be made accessible to students through our class website www.postimage.space and our class GoogleDrive.

The class is organized in two main phases:

1. three-week class introduction and context overview

 To make sense of image, we must start with its inception more than 500 centuries ago, and we must consider concepts and readings that include considerations of anthropology, geopolitics, economy, media, technology and other factors. This phase will include quick research assignments combined with group conversations.

2. ten-week student-initiated research

 Through applied, experimental and conceptual research, each student will undertake an interest-specific investigation along topics and mediums they see fit. The outcome will be a speculative project related to each student's core studies in the MFA program. It may be in the form of an info-poster, an installation, a visual essay, a video, an interface, a tool, a physical device or a manifesto.

 The class will then continue as a lab with short post-image presentations and student project reviews.

Key learning objectives
The program intends to relate the practice of design to all aspects of representations by promoting:

• the importance of historical and contemporary precedents and their consequences on design

• speculative thinking and research through ideation and visualization

• experience in translating abstract ideas into compelling visual communication

• a distinctive and personal approach to conceiving representation in design

Guests
Class guests may include practitioners in art, architecture, curating, and others as relevant.

72

CCA / MFAdesign / Spring 2018 / Erik Adigard / eadigard@cca.edu

A

Erik Adigard

Professor, California College of the Arts
Partner at M-A-D

A: A course syllabus for the MFA level course 'Post-image: rendition, consumption and automation' examining the role of the image in contemporary culture. Students are confronted with having to dissect and carefully analyze the culture of images and image consumption that surrounds them today.

A: 현대 문화에서 이미지의 역할을 다루는 MFA 레벨 강좌 '포스트 이미지: 공연, 소비 및 자동화'를 위한 수업 계획서. 학생들은 오늘날 그들을 둘러싸고 있는 이미지의 문화와 이미지 소비를 신중하게 분석한다.

INTRODUCTORY PROJECTS

ASSIGNMENT #1: DIAGRAM PROJECT
Conceive a diagram to convey an interpretation of "IMAGE"
Due January 29

Our first project is an opportunity for you to explore an approach to
the subject of image, as well as to experiment with one of the many
possible techniques of representation: the diagram.

Your diagrammatic approach may be lucid and analytical,
speculative and experimental, or intuitive and poetic. It may be
schematic, conceptual, pictorial, quantitative, and/or other. You
can make it simple or complex, as well as in any medium as long
as your design can remain diagrammatic. You can also draw your
design on the whiteboard.

- Let it go where it takes you.
- OR, relate it to a realm you have selected, i.e.
"photography", "machinima", "urban vernacular", etc.
- OR, simply conceive a diagrammatic definition of the term
"image."

There is no wrong diagrammatic approach. It will all bring insight to
the class.

73

ASSIGNMENT #2. AN INSTANCE OF POST-IMAGE
Visually identify and verbally explain one instance of post-image
Due February 5

In our first two sessions we explored a few key concepts to help us
map a possible approach to the notion of "image" today. We did
so by loosely combining notions of methodology, syntax, taxonomy
and interpretations.

As discussed in our first two classes, the transference of SUBJECT
TO RECEIVER BY IMAGE happens through:

Representation
Symbolization
Iconization & Semiotization
Subjectification & Objectification
Mystification & De-mystification
Mechanization & Scale
Commodification & Capitalization
Accumulation & Dissemination
Automation, Big data & Surveillance
Metabolization & Virtualization
As well as through other factors as discussed in class.

In 1955 Marshall McLuhan said *"It is the framework which
changes with each new technology and not just the picture within
the frame."* It made a lot of sense to focus on technology in the
mid 20th century. But today? Not necessarily.

Emerging technologies will continue to redefine and reposition
image in our lives, but even if our profession may be tied to
technology, we might still want to consider non-technological and
even anti-technological perspectives, as is already being expressed
by various youth movements around the world.

Furthermore, let's remember that the notion of representation/
image includes many types ranging from the pictorial to the
perceptual (e.g. shadows and reflections) not all of which have
been discussed in class yet. Others may be epistemological,
metaphysical and philosophical, as implied in our last class. The
notion of "post-image" is affected by emerging social and cultural
situations, therefore it is in constant shift.

Visually identify and verbally explain one instance of post-image.

1. Find a post-image (it may be a group of images)

2. Build a simple case for your image selection to explain how this
image signals a shift:

- in the way this image was historically made
- in how the subject is depicted (e.g. Snapchat filters)
- in socio-cultural expressions (e.g. urban tags)
- and/or other…

3. Your presentation can be either:

- one print showing the visual(s) + one print with your
rationale (lists, text and/or diagram)
- a larger print where image is combined with your rationale
- a keynote or video if you feel it is relevant

Through this graduate-level course students are
exposed to a variety of readings and thinkers to
expand their understanding of the image. Ultimate-
ly, they are to find a definition of 'post-image' that
is relevant and meaningful.

이 대학원 과정을 통해 학생들은 폭넓은 독서와
다양한 이론을 공부하며 이미지에 대한 이해를 넓힌다.
궁극적으로 관련성이 높고 의미 있는 '포스트 이미지'의
정의를 찾아야 한다.

··

MAIN PROJECT

··

RESEARCH, CREATION AND PRESENTATION OF A POST-IMAGE
Due April 23 / see specific deadlines below

The aim of this project is to use an existing image as "sample" to investigate contemporary concerns:
- in the design of representation
- in the role of representation in design.

You will need to research and explore your "subject" to then reframe it into a new alternate form. We can think of it as a "re-imaging" exercise whose intent and meaning is to reveal contemporary concerns.

You may choose a subject that is important to you. It may be:

- The "Instance of post-image" that you selected in our class.
- An existing CCA project that you want to further explore.
- A subject that relates to a personal interest.
- One of the three topics that I will present on February 5.
- You can change your subject during all of February.

There is no subject that comes without an image, there is no subject too small or insignificant, and there is no subject that we can't turn into an investigation. All images (or designs) are somehow never more than three degrees away from each other. Your only limit is your own capacity and ability to explore, question, analyze, interpret and reconstruct your subject.

Getting lost is part of the discovery. Ideally our venture will take us on paths reminiscent of archeologists, anthropologists, sociologists, detectives or analysts.

This project will combine three key aspects: a research, a creation and a presentation.

RESEARCH*
It will combine four key components:

- A research documentation that can establish the context for your subject.
- a diagrammatic representation of your thesis.
- A short essay (between 200 and 2,000 words) that may be a mix of descriptions, comments and concerns.

CREATION
You will conceive a "post-image" that reframes the subject you have selected (you may think of it as a critique, an innovation, a redesign, a deconstruction, an analysis, etc.

PRESENTATION
Your challenge will be to creatively juxtapose or combine your research and your creation in a way that is informative, thought provoking and produces a compelling project.

Whether on initial instances or on the final day, you can present your case in any way you see fit. Your presentations may combine PDFs on screen, prints on the wall, installations, VR constructs, and/or sketches on the white board.

PROCESS
Our process will be based on iterative cycles, which means that each one of the milestone can and should probably be revisited as you proceed with your project.

Be pro-active in bringing your project-related questions, findings and sketches as often as possible. We will adapt our calendar accordingly. We will run open reviews during every class with the whole group when core issues are being raised.

MILESTONES
1. Your **subject & conceptual approach ideas**
You should bring two to four subject choices to evaluate in class discussions. This will help to reveal the most promising ideas.

Make a short presentation on your chosen subjects/topics. Show a simple body of research so we can best understand the nature and the issues of your project ideas—this may include cultural references such as a text, a theorist, an historical event, creative precedents, etc.
Due February 12

3. Your **diagram**
Due February 19

4. Your "**post-image**" treatment ideas
Due February 26

5. Your **thesis text**
Due February 26

6. Initial research **presentation followed by iterative cycles**
Due March 5

7. Final presentation
Due April 23

*ABOUT THE RESEARCH PHASE
You are free to plan and organize your project research as you see fit, but you should consider these basic components:

- Conduct contextual research, including findings, sources & references.
- List the topics and concerns that relate to your subject while identifying and explaining the specific topics and concerns that will become the foundation of your project.
- Include a bibliography.
- Moodboard and/or diagram(s)
- Catalog your sketches and ideas. They become important presentation components.
- How you plan to present your project—choice of medium(s) and format(s)

Linda van Deursen/Armand Mevis: *I always feel a kind of restlessness, always this need for something new, to make something we haven't seen yet or that you think isn't there.*

74

Erik Adigard

CCA / GD2 / 2016 / Erik Adigard
Making Sense of the City / syllabus (partial)

OVERVIEW

DESCRIPTION

The subject matter for this course will be "the city."

As we enter the 21st Century, cities are where diverse populations and ideas are increasingly concentrated, which makes them fascinating cultural laboratories.

In the words of Rebecca Solnit "A city is a particular kind of place, perhaps best described as many worlds in one place; it compounds many versions without quite reconciling them". As such, we will explore the shapes of our "city": its evolution, its cultural DNA, and what it means to map its physical and cultural spaces.

PROCESS

The course will be comprised of four parts; three sections that are grounded in research where you will explore History, Representation and Territory and a final assignment; Intervention: Driving change through communication where you will rely on your research phases to make an intervention within the region you've been exploring.

The process will involve: research, generative design, sketching, photography, video, web site design, mapping and finally the making of a physical artifact. We will explore and define the boundaries and possible forms, topographic, geographic, cultural, of the "city" we imagine as ours.

With each project, you will need to research and include at least one reference to a thought leader that is relevant to your research. This will be discussed in class.

All of your work will be documented online, using a Weebly web site template.

GOALS

The 21st Century designer faces ever changing environments where the only constant is the need for proactive adaptation.

Our goal is to understand the why, the what and the how of design today. To do so, observation, research, critical thinking and accurate interpretation will be the skills being fostered in the class.

We will explore the interrelated nature of form and concept. We will explore the power of designs in problem resolutions.

In this process, students will further develop confidence in their career objectives.

USE OF ELECTRONIC DEVICES DURING CLASS

Conversations on phones and texting are not allowed in the classroom. Use of headphones is permitted while working independently but not during any group activity

B: A course syllabus for the MFA level course 'Making Sense of the City'. The course asks students to investigate the urban environment deeply and eventually deploy a design solution back into the community.

B: '도시 이해하기'라는 MFA 과정을 위한 수업 계획서. 학생들은 이 과정을 통해 도시 환경을 깊이 연구하고, 그것을 바탕으로 지역 사회에 디자인 솔루션을 도출해야 한다.

PROJECTS / RESEARCH PHASE: MAKING SENSE OF THE "CITY"

Project 1. HISTORY: The past and futures of the city (an archeological approach)

The San Francisco Bay Area has a rich history. What can we learn from its past that can inform how we move into the future? What has happened in the past that has lead to the creation of such vibrant and successful communities as well as to its many new problems? The region faces many problems. Can its past inform feasible resolutions?

Possible areas of exploration: Urbanity, environment, cultural shifts of distinct neighborhoods, evolution of commerce, impact on neighborhood of small shops and emergence of start up "hubs".

Starting with an area of focus, You will gather information on its current form and issues as well as seek historical traces, whether physical or cultural.

You must identify at least one specific meaningful transformation, including evidence of transformation that is both visual and textual.

Phase 1: Research and concepting

You will choose an area of focus within San Francisco where you will research the region's history and current characteristics. Seek out what you see as your area's most meaningful transformation(s). Be prepared to talk about your ideas and share your findings. We will have individual desk crits as well as conversations among the entire class where we review your findings. As much as possible, you must organize your process and documents on your Weebly site.

Phase 2: Deliverable

You will create a six minute Keynote lecture where you communicate your findings to the class. The presentation can include images, videos, diagrams, texts and/or sounds.

Schedule: 3 weeks total

Week 1

Tue 20 Jan: Project 1 Assignment, class brainstorming session

Thu 22 Jan: Initial region findings due, work in class (WIC)

Week 2

Tue 27 Jan: Specific meaningful transformation due, peer review.

Thu 29 Jan: Structure of final presentation due, WIC

Week 3

Tue 10 Feb: Review of final presentation material, WIC

**Thursday, 12 February
Project 1 Due/Final presentation/critique
Project 2 assignment**

NOTE: The content from your final presentation must be placed into your Weebly template.

Project 2. REPRESENTATION: The identity of location through image making (an iconographic approach)

Within your chosen region you will gather all possible representations that are visible today, on any and all possible surfaces, and then curate them into a coherent whole that can be analyzed. Explore the region's "landscape" of visible, old and new images, icons, graffiti, posters, billboards, signage etc. Consider all media types and typologies. The goal is to frame the "image DNA" of your chosen region.

Phase 1: Research and concepting

Re-visit your area of focus. Develop a strategy for gathering the region's "image DNA". Be prepared to talk about your ideas and share your findings. We will have individual desk crits as well as conversations among the entire class where we review your findings. You will present your findings using a Weebly web template: still images, videos, sketches.

Phase 2: Deliverable

Inspired by the "image DNA" you have composed, you will design 12 icons that stand for key aspects of your area of focus. These could be category markers of landmarks, street life, stores, clubs, nature, crime, etc: whatever YOU define as noteworthy. These icons must work together as a set. Consider colors and whether they should be highly figurative or abstract. You will present your icons using your existing web template.

Schedule: 3 weeks total

Week 1

Tue 17 Feb: Initial region findings due, WIC

Thu 19 Feb: Further findings due, WIC

Week 2

Tue 24 Feb: Review "image DNA", peer review.

Thu, 26 Feb: Icon rough studies due, WIC

Week 3

Tue 3 Mar: Review of final presentation material, WIC

**Thursday, 5 March
Project 2 Due/Final presentation/critique
Project 3 assignment**

NOTE: The content from your final presentation must be placed into your Weebly template.

Erik Adigard

Adigard's courses are a mixture of seminar, research and making laboratory. Through this mixture of teaching methods the MFA students are able to come to truly unique and multidisciplinary solutions.

세미나, 리서치, 제작 연구로 구성되는 에릭 아디가드의 수업을 통해 석사과정 학생들은 독특하고 다학제적인 문제해결방법들을 도출해낸다.

MAIN PROJECT

Project 3. TERRITORY: The map as mirror, window, weapon, or art (an ethnographic approach)

You will seek out a distinct cultural zone and explore its characteristics. Begin by analyzing the implications and consequences of these qualities. Are they to the area's benefit or detriment?

Possible areas of exploration: traffic patterns, crime, money flows, distribution of grocery stores vs liquor stores, cultural transitions along transit routes, changes in architecture, noise levels, litter, etc.

Phase 1: Research and concepting

Re-visit your area of focus. Explore as many characteristics as possible so you can run an "audit" on a selected territory. This may include online research, news gathering, interviews and in-situ investigations. Be prepared to talk about your findings. We will have individual desk crits as well as conversations among the entire class where we review your findings.

Phase 2: Deliverable

You will design two maps of the region to capture your findings. You're not being asked to simply replicate conventional maps (transit routes, locations of cafes and restaurants etc.) You must find ways of mapping layers of diverse information within each solution. One map will have a geographic foundation but must be layered with at least three cultural findings. The second map will be purely informational with no reference to the geographic landscape and must have three layers of findings. Although maps can never be completely correct or neutral, as they are personal abstractions of the physical or conceptual world, try to avoid this tendency and stay grounded in your observations as opposed to your intuitions.

The goal is to enlighten your audience by showing them unexpected and interesting patterns you've observed within the physical world in a visually compelling way.

Schedule: 3 weeks total

Week 1

Tue 10 Mar: Initial region findings due, WIC

Thu 12 Mar: Initial region findings due, WIC

Week 2

Tue 17 Mar: Layered cultural findings due, peer review.

Thu 19 Mar: Rough map studies due (2), (WIC

Week 3

Tue 24 Mar: Tight map studies due, WIC

Thursday, 26 March
Project 2 Due/Final presentation/critique
Project 4 assignment

NOTE: The content from your final presentation must be placed into your Weebly template.

INTERVENTION: Driving change through communication

Based on insights gathered from the three previous projects you will propose a physical intervention within one of your areas of exploration.

Possible areas of exploration: A series of posters communicating your findings back to the community; a physical exhibit, an interactive solution that entertains and enlightens.

Possible goals: Uniting a diverse neighborhood, promoting positive change through education, creating an oasis of calm in a troubled area.

Medium: as required by the concept

Phase 1: Research and concepting

Projects 1 through 3 are the foundations for this final project. Use those research phases as guides to determine what approach you will use for your intervention. Reflect upon the possible goals. What does your region need?

Phase 2: Deliverable

The intervention approach is entirely up to you but it must be driven by your earlier findings (projects 1 through 3). You could end up finding a direction from your findings in one of those projects or all three. You may end up using material you've already gathered such as images or text or you might end up heading off in a new direction like designing a physical space.

Schedule: 6 weeks total

Week 1

Tue 31 Mar: Project 1 launch, class brainstorming session

Thu 2 Apr: Compilation of projects 1 through 3 due, work in class (WIC)

Week 2

Tue 7 Apr: Further compilation of projects 1 through 3 due, WIC

Thu 9 Apr: Rough ideas for intervention due, work in class, WIC

Week 3

Tue 14 Apr: Refined ideas for intervention due, peer review, work in class, WIC

Thu 16 Apr: In class form making exercise, work in class, WIC

Week 4

Tue 21 Apr: Single direction for intervention chosen incorporating peer review and form making findings, work in class, WIC

Thu 23 Apr: Refine direction for intervention, work in class, WIC

Week 5

Tue 28 Apr: Refine direction for intervention, work in class, WIC

Thu 30 Apr: Refine direction for intervention, work in class, WIC

Week 5

Tue 5 May: Refine direction for intervention, work in class, WIC

Thursday, 7 May
Project 4 Due/Final presentation/critique

NOTE: The content from your final presentation must be placed into your Weebly template.

READINGS

GENERAL GRAPHIC DESIGN

Graphic Design: A User's Manual / Adrian Shaughnessy

Graphic Design: The New Basics / Ellen Lupton & JC Phillips

The Graphic Artist and his Design Problems / Müller-Brockmann

How to be a Graphic Designer Without Losing Your Soul / Adrian Shaughnessy

Design Wtriting Research / Ellen Lupton

BRAND DEVELOPMENT

Designing Brand Identity: A Complete Guide to Creating, Building, and Maintaining Strong Brands by Alina Wheeler

VISUALIZING INFORMATION

Envisioning Information by Edward R. Tufte

EXHIBIT DESIGN

What is Exhibition Design? by Craig Berger, Craig Berger, Lee Skolnick

CONCEPTUAL DEVELOPMENT

Conceptual Blockbusting / James L. Adams

A Smile in the Mind / Beryl McAlhone, David Stuart

Graphic Design Thinking: Beyond Brainstorming / Ellen Lupton. ed.

Graphic Design Sources / Kenneth J. Hiebert

Problem Solved / Michael Johnson

Visual Intelligence / Donald Hoffman

DESIGN THINKING

Change by Design / Tim Brown

Wabi-Sabi: for Artists, Designers, Poets & Philosophers by Leonard Koren

CULTURE

You Are Not a Gadget / Jaron Lanier

Design and Crime / Hal Foster

Ways of Seeing / John Berger

Environmentally Conscious Design

Cradle to Cradle: Remaking the Way We Make Things / Michael Braungart and William McDonough

PHOTOGRAPHY

On Photography / Susan Sontag

Camera Lucida: Reflections on Photography by Roland Barthes

The Ongoing Moment by Geoff Dyer

ARCHITECTURE

The Poetics of Space by Gaston Bachelard

Learning from Las Vegas: The Forgotten Symbolism of Architectural Form by Robert Venturi

GRAPHIC DESIGN BLOGS

Aisle One

Baubauhaus

Buamai

Colossal

Design Envy

Design Observer

Designers and Books

Grain Edit

idsgn

Imprint

It's Nice That

September Industry

Typographic Posters

Visuelle

TYPOGRAPHY BLOGS

Font Feed

Friends of Type

Good Typography

Typarchive

Typoretum

Typedia

Typeverything

Typetoken

Typographica

Typophile

Type Worship

Welovetypography

DESIGN MOVEMENTS

Lessons from swiss graphic design

The Powerhouse of the New (Bauhaus)

78

Erik Adigard

79

Can you talk about your role at MCAD (Minneapolis College of Art and Design) as both faculty, and now Department Chair?

As chair of the department, I oversee our three areas, Illustration, Comic Art, and Graphic Design, as well as the 2D foundation classes. I supervise both full-time and adjunct faculty, and work closely with them, always looking for ways in which we can improve our curriculum. This sometimes involves collaboration with other majors and chairs, and we have a particularly close relationship with our colleagues in the Media Department. I teach one course per semester and this tends to be an advanced seminar class, but I also enjoy introductory and intermediate level classes. I am also very fond of our 2D foundation classes precisely because they are not design classes per say. I have tired to develop and demonstrate an overriding concept for those classes, which involves an effort to explore and understand the basic knowledge common to all disciplines in art and design: the reconciliation or projected and reflected light. This, combined with a view that one must always understand that problem solving in our contemporary context requires simultaneous solution across static, static narrative, and time based media. This is enough for a life-time of learning and making. I love teaching, and even though I get to do less of it as Chair, I hope I still provide an example to both students and colleagues, not necessarily to follow, but to walk alongside with.

We continue to see some very forward thinking and daring student graduates from MCAD in recent years. This may be similar to the previous question but are there any identifiable seeds to such excellence? Is there a certain approach or philosophy that's unique to MCAD?

I think it's fair to say that our faculty are completely devoted to their students, and we try very hard, across all of our programs, to help students access and develop idiosyncrasies that sometimes lead to a discovery of a so-called voice. We try very hard to make sure they have a broad appreciation for

Erik Brandt

Chair, Professor, Minneapolis College of Art & Design
Founder of Typografika

MCAD에서 교수로서, 그리고 현재 맡고 있는 학과장으로서의 역할에 대해 이야기달라.

나는 학과장으로서 일러스트레이션, 코믹 아트, 그래픽 디자인 등 세 개 분야와 2D기초 수업을 관리하고 있다. 정교수와 조교수를 모두 감독하고, 그들과 긴밀하게 협력하며 우리는 교과 과정을 개선할 수 있는 방법을 함께 찾고 있다. 이 때문에 때로는 다른 전공이나 학과장들과 협업이 필요하다. 우리는 미디어 학부와 특히 친밀한 관계를 맺고 있다. 나는 한 학기당 한 과목을 가르친다. 보통은 고급 세미나 수업을 하지만, 입문이나 중급 수준의 수업도 즐긴다. 나는 또한 우리 과의 2D 기초 수업을 매우 좋아한다. 정확히는 그 자체로 디자인 수업이 아니기 때문이다. 나는 그 수업을 위해 최우선적인 개념을 개발하고 제시하려 했다. 거기에는 미술과 디자인 전 분야에 공통되는 기본 지식, 즉 조화 혹은 투영되고 반사된 빛을 탐구하고 이해하려는 노력이 수반된다. 이는 현대적 맥락에서 문제 해결은 정적인 내러티브와 시간 기반 매체에 걸쳐 동시적인 해결이 필요하다는 것을 항상 이해해야 한다는 견해와 결합된다. 이 정도면 평생 배우고 만들기에 충분하다. 나는 가르치는 것을 좋아한다. 비록 내가 학과장 일을 하느라 그럴 기회가 적어지더라도, 여전히 학생과 동료들 모두에게 모범을 보이고 싶다. 반드시 따라야 하는 것이 아닌 함께 걸어갈 수 있는 모범을 보이고 싶다.

80

최근 몇 년 동안 MCAD에서 매우 진보적인 사고와 대담한 졸업생이 계속 배출되었다. 비슷한 질문일 수도 있는데 그러한 우수성을 드러낼 만한 씨앗이 있는가? MCAD만의 독특한 접근법이나 철학이 있는가?

우리 교수진은 학생들을 위해 전적으로 헌신하고 있으며 우리는 모든 프로그램에 걸쳐 학생들이 특이점에 접근하고 이를 발전시키도록 매우 열심히 돕는다. 이것이 때때로 소위 목소리의 발견으로 이어진다. 우리는 학생들이 더 큰 디자인 세계를 폭넓게 인식하도록 노력하고 그들이 여기서 영감을 찾기 바란다. 우리는 디자이너로서의 생활에 대한 준비를 확실히 제공하는 한편 모험과 실험을 위한 안전한

Erik Brandt (AGI 2012) is currently the Chair of the Design Department at the Minneapolis College of Art and Design (MCAD), where he has been teaching for many years. Brandt has continued to work on commercial and self-initiated projects alongside his teaching career.

에릭 브란트는 현재 미니애폴리스예술디자인대학의 디자인 학과장으로 재직 중이다. MCAD에서 여러 해 동안 강의해온 브란트는 상업적이고 자기 주도적인 프로젝트도 지속하고 있다.

the greater world of design, and we hope they find inspiration in this. We emphasize that while we certainly can provide a preparation for a life in design, we also provide a safe place for risk-taking and experimentation, indeed, helping people understand that learning and failing can be closely connected. I often emphasize that an undergraduate degree is not the end, just the opposite. I like to think that studying design is a study of asking questions, of creating question marks, in a sense, that fellow human beings might interact with or be inspired by. I think we help students understand that a life in design offers an opportunity for continual learning and continual growth.

Can you take us through some of the steps or experiences that lead you to become a design educator as opposed to a full-time practitioner? If you could say you had a particular twist on design education or a very Erik Brandtian way of teaching design, could you talk about some of the qualities that we could identify with?

81

I think it was the inspiration of my own teachers, especially Akira Ouchi and John Malinoski, that lead me toward design education. I had taught other subjects before, but when I completed my graduate education it was a clear path. I hadn't studied graphic design as an undergraduate (I studied Philosophy), but the connections I discovered between the "question asking" I mentioned earlier and form-making were truly compelling and life affirming. Akira would often ask me, when I felt I had done something exceptionally well for example, "Alright, that may be so, but how would you teach someone else how to do what you think you just did, and how would you help them do it well?" From very early on, I followed his advice and tried to think in that way, and I hope I am still following his example. He is now long gone but I still learn from him through that question, every single day. So, I try to teach from my example in a way, not with the expectation that students will do what I do, indeed, I will often say with a smile that it will take them a long time to catch up with me. Instead, I try

장소도 마련하여, 배움과 실패가 밀접하게 연관되어 있음을 강조한다. 나는 종종 학사 학위가 끝이 아니라 그 반대라고 말하곤 한다. 디자인 공부란 질문을 하거나 물음표를 만드는 연구라고 말하고 싶다. 어떤 의미에서는 동료들이 이 질문과 상호작용하거나 여기서 영감을 얻을 수도 있다. 우리는 학생들이 디자이너로서의 생활이 지속적인 학습과 성장의 기회를 제공한다는 사실을 이해하도록 돕는다고 생각한다.

어떻게 풀타임 실무 종사자와 상대적인 위치에 있는 디자인 교육자의 길을 가게 되었는지, 몇 가지 단계나 경험을 소개해주면 좋겠다. 만약 디자인 교육에 특별한 반전이 있거나 당신만의 디자인 교육 방식이 있다면, 몇 가지 특징을 이야기해달라.

디자인 교육을 지향하게 된 것은 내 스승들, 특히 오우치 아키라와 존 말리노스키에게서 영감을 받은 덕분인 것 같다. 전에도 다른 과목을 가르친 적이 있지만, 대학원을 졸업했을 때 길이 분명해졌다.

나는 학부 시절 철학을 전공했고, 그래픽 디자인은 공부한 적이 없다. 하지만 앞서 말한 '질문하기'와 형태 만들기 사이의 연관성은 참으로 설득력 있고 낙관적으로 느껴졌다. 예를 들면 아키라는 내가 뭔가 특히 잘했다고 느낄 때, "알아, 그럴지도 모르지만 방금 당신이 해냈다고 생각한 것을 다른 사람에게 어떻게 가르치고 어떻게 그들이 잘 하게 도울 것인가?"라고 종종 묻곤 했다. 아주 일찍부터 나는 그의 충고를 따랐다. 그렇게 생각하려고 애썼고, 지금도 그의 모범을 따르고 싶다. 이제 스승은 떠난 지 오래지만 지금도 매일 그 질문을 통해 그에게서 배운다. 그래서 나는 학생들이 내가 하는 일을 하게 될 것이라는 기대는 하지 않고, 어떤 면에서 모범을 보여 가르치려 한다. 실제로 종종 미소를 지으며 학생들이 나를 따라잡는 데 오래 걸릴 것이라고 말하곤 한다. 대신 그들이 나처럼 시작하고,
모든 것을 시도하고, 모든 것을 배우고, 만들고, 아무 것도 되는 일이 없다는 사실도 알고 받아들이도록 격려한다. 항상 완벽한 것은 없다.

One particular project of note is Ficciones Typografika, on which Brandt recently published a book. The project invited designers from all over the world to create posters that would be wheat pasted to a physical signpost that also maintained an active presence in cyberspace. We spoke with him about his teaching and administrative roles and how they connect to his practice over email. Arranged, conducted and edited by Chris Ro and James Chae.

한 가지 특별한 프로젝트는 <Ficciones Typografik>인데. 최근 이에 대한 책을 출판했다. 이 프로젝트는 전 세계의 디자이너들에게 가상의 사이버 공간의 표지판에 붙일 포스터를 만들어달라고 요청했다. 우리는 그의 강의와 행정적 역할 및 사람들이 이메일로 그의 실무와 연결되는 방식에 대해 이야기를 나누었다. Chris Ro와 James Chae가 인터뷰의 진행. 정리. 편집을 맡았다.

to encourage them to start as I did, and to continue, trying everything, learning everything, making, to know and accept that nothing is ever done. Nothing is ever perfect.

It is often a cold dark world, reality that is, and it is often the dilemma of an educator to prepare students for this and also to allow for students that opportunity to explore and try things they might not be able to do elsewhere? How do you feel about this?
I feel this issue intimately, as we all do, and I try to talk about it as often as possible with students. I think this current generation is especially aware of these realities, they see the environmental, economic, and political challenges of our time very plainly, I can see how heavy that burden is on them. I don't think there is only one way to prepare ourselves for such challenges, but I do know that learning to understand and to expect failure is a key to any success. Understanding that life has natural rhythms that are not always pleasant is a part of this thinking. This is especially difficult for this generation as they have been groomed to aspire for perfection to be competitive. I think they see through this at some point and that can lead to a very dark place. I often try to say that life, hopefully, is long, and who knows what challenges and rewards lie ahead. The key is to keep working, to keep making, to keep asking questions. More often than not this can be purely for oneself, and that is enough. I still visit with my teacher John, and he always shares his continuing sketchbooks with me. Every time he does, I feel like a student again, and I know that I am nowhere near where I could be. I must keep working too.

Your project Ficciones Typografika is an epic project of persistence, love and an interaction between what was the physical poster and that physical poster in cyberspace. You've mentioned in past interviews that its roots began in your teaching. Can you talk about this a bit? Are there some more specific relationships this project has had with your design pedagogy?

Erik Brandt

현실은 종종 춥고 어둡게 느껴진다. 학생을 이런 현실에 대비시키는 것과, 아니면 그들에게 다른 곳에서는 할 수 없는 일을 탐구하고 시도할 기회를 주는 것 사이에 주로 교육자의 딜레마가 있다. 이 점에 대해서는 어떻게 생각하고 있나?
나 역시 이 문제를 직접적으로 느끼고, 학생들과 가능한 자주 그 이야기를 하려고 한다. 나는 현 세대가 이러한 현실을 특히 인식하고 있다고 생각한다. 그들은 우리 시대의 환경적, 경제적, 정치적 과제를 아주 분명하게 바라본다. 나는 그것이 얼마나 큰 부담인지 알 수 있다. 그러한 도전 과제에 대비하는 단 하나의 방법은 없다고 생각한다. 하지만 문제를 이해하고 실패를 예상하는 법을 배워야 성공할 수 있다는 것은 알고 있다. 삶이 언제나 즐거운 것만은 아니라는 자연스러운 리듬을 이해하는 것도 이러한 사고의 일부이다. 특히 이 세대는 어릴 때부터 완벽한 경쟁력을 갖추도록 교육받았기 때문에 이런 면을 받아들이기가 더 어렵다. 그들이 어느 순간 이것을 꿰뚫어보고 그로 인해 매우 암울한 결과로 이어질 수 있다고 생각한다. 나는 기대를 가지고, 인생은 길고 어떤 도전 과제와 보상이 앞에 놓여 있는지 모른다는 말을 자주 하려고 한다. 핵심은 계속 작업하고 만들고 질문하는 것이다. 종종 이것은 순전히 자신만을 위한 행동일 수도 있다. 그것만으로 충분하다. 나는 지금도 존 선생님을 방문하고, 존은 계속해서 채워가고 있는 자신의 스케치북을 항상 나에게 보여준다. 그럴 때마다 나는 다시 학생이 된 것 같은 기분이 들고, 내가 도달할 수 있는 목표 근처에 이르지 못했음을 깨닫는다. 나 역시 작업을 계속해야 한다.

당신의 프로젝트 <Ficciones Typografika>는 끈기, 사랑 그리고 물리적 포스터와 사이버 공간의 물리적 포스터 사이의 상호작용에 대한 서사 프로젝트이다. 과거 인터뷰에서 그것이 당신의 수업에서 시작되었다고 했다. 이에 대해 좀 이야기해달라. 이 프로젝트가 당신의 디자인 교육학과 더 구체적인 관계가 있는가?
내가 말하는 원래의 '픽션들'은 학생들이 매우 간단한 도구를

The original ficciones, as I call them, were developed in an effort to help students explore scale and form all at the same time using very simple tools. Scaled A0 surfaces (clustered in a thirty-six unit grid) had to be explored with Letraset, by hand. I would encourage students to try and create formal studies that would estrange the letterforms from themselves, something that is quite hard to do as they are very deep in our consciousness. The result would be a conglomerate of ascetic type, or form, and we would work together to select the best ones, scale them up by hand, find new possibilities, and then finally print them at scale. I still use this approach today, it provides a systematic way of thinking that is not limited by the system itself. Ficciones Typografika, at its heart, was actually an extension of my classroom. I had a simple brief, I offered limitations of size, color, and media, and invited people to send their solutions. I like to think that, especially as a teacher, I have an open mind and am especially drawn toward idiosyncratic, personal voices. I like to encourage those voices, as I was encouraged once as well.

83

As you have shifted roles in your career as a design educator from hands on teacher to administrator where do you find yourself heading? What are the unique challenges that you face at MCAD as the chair?

I do feel that the longer I serve as Chair the more attractive oversight and development of curriculum becomes. I feel drawn toward, not giving up teaching entirely, but having more time to both mentor and interact with both students and colleagues to face some of the challenges we are discovering today. I think the single hardest issue for us, as it is all over the world I believe, is how to address to rise of the incredible stress these students feel and experience in the world today. It is distracting to them, and it is unfair to them. I feel we need to find ways for them to slow down in a way, to not expect everything will be perfect right from the start, that they don't need to be perfect, that life is long, and there will be many more paths to walk along.

사용하여 스케일과 동시에 형태를 탐구할 수 있도록 돕기 위해 개발한 것이다. A0 전지 면(36칸 그리드)을 레트라세트를 사용해 수작업으로 탐구해야 했다. 나는 학생들이 글자꼴 자체를 낯설게 보이게 하는 형식적인 습작을 하도록 했다. 사실 우리 의식 속에는 글자꼴이 매우 깊게 자리 잡혀 있어서 이런 작업을 하기가 상당히 어렵다. 결과물로 상당히 정제된 활자 혹은 형태로 이루어진 복합체가 나오면 우리는 가장 좋은 작업을 선정하여 수작업으로 크기를 키우고 새로운 가능성을 발견한 다음 마지막으로 적절한 크기로 인쇄했다. 나는 오늘날에도 여전히 이 접근법을 사용한다. 시스템 자체에 구애받지 않는 체계적인 사고방식을 제공하기 때문이다. <Ficciones Typografika>는 근본적으로 내 강의실의 연장선이었다. 간단한 작업 개요를 제시하고 크기와 색상, 미디어의 제약을 준 다음 학생들이 내놓는 해결책을 기다렸다. 나는 교사로서 열린 마음을 가진 사람이다. 특히 저마다의 고유한 목소리에 끌리는 편이다. 언젠가 누군가 나에게 그랬던 것처럼, 나 역시 그런 목소리를 격려하고 싶다.

당신은 직접 수업을 진행하는 디자인 교육자에서 행정가로 역할을 바꿨다. 자신이 어느 방향으로 가고 있다고 생각하는가? MCAD에서 학과장으로서 직면하는 특별한 도전 과제는 무엇인가?

학과장으로 오래 일할수록 감독하는 일과 커리큘럼 개발이 더욱 매력적으로 느껴진다. 가르치는 일을 완전히 포기하지 않되, 오늘날 우리가 접하는 도전 과제를 직면하기 위해 학생과 동료 들을 대상으로 멘토 역할을 하고 상호작용할 시간을 더 많이 가지는 일이 좋다. 전 세계적으로도 그렇지만, 우리에게 가장 어려운 문제는 이 학생들이 오늘날 세계에서 느끼고 경험하는 엄청난 스트레스를 해결하는 방식이다. 이 때문에 학생들은 산만해지는데 그런 상황은 올바르지 않다. 나는 그들이 어떤 면에서는 속도를 늦추고 모든 것이 처음부터 완벽할 것이라 기대하지 않게 하는 방식을 찾아야 한다고 생각한다. 즉 사람은 완벽할 필요가 없으며, 인생은 길고 선택할 수 있는 길이 여러 가지라는 사실을 발견할 수 있도록 도와주어야 한다.

As educators, one of the most difficult challenges is leveraging the discovery of a 'voice' or way to work in design as well as being a designer that can ultimately serve the industry. You've talked sometimes about this continuous discovery of voice in your career as well as the constant desire to question or create new questions. Can you speak to this concept and how you work with this in your education activities? How do you encourage this type of development and growth in students?

I love looking at students' sketchbooks, I love finding things they didn't intend or necessarily believe in. It's often there that an idea exists, something that could be explored. If someone is left handed, I'll sometimes suggest they should try the right, just to see what happens. It will still be their mark, however clumsy, but there one can often find something unexpected as well. My teacher Akira showed me how to amend type with simple tracing paper one day. I almost fell off my chair. I had no idea one could, or should, do something like this. That forever changed me. In conversation with students, I try to elicit these types of things, to ask if they are asking, what do they see as wrong or right and why? Are they sure the media they are using is helping or hurting their questions? Is the solution hidden in technique or in concept? And it's more difficult than that! Let's say you discover a voice, how did that happen? Is it merely using consistent techniques, and if so, are you still growing? Is it laziness versus voice, for example? Convenience versus exploration? Risk-taking? But such is the beauty and wonder of this discipline, in my way of thinking, it always offers up the possibility for something new, something undiscovered, if, and only if, you are continually asking questions of both yourself and the way one is working.

Erik Brandt

교육자로서 가장 어려운 한 가지 도전은 궁극적으로 산업에 종사할 수 있는 디자이너가 될 뿐만 아니라 디자인 분야의 '목소리'나 작업 방식을 발견하여 활용하는 것이다. 당신은 때때로 자신의 경력에서 이러한 목소리를 지속적으로 발견하는 일과 새로운 질문을 하거나 창조하려는 끊임없는 욕구에 관해 이야기했다. 이 개념에 대해 그리고 교육 활동에서 이 개념을 가지고 일하는 방식에 대해 이야기해달라. 학생들에게 이러한 유형의 발전과 성장을 어떻게 독려하는가?

나는 학생들의 스케치북을 즐겨 본다. 그들이 의도하지 않았거나 어쩔 수 없이 갖고 있는 믿음을 발견하는 것이 좋다. 거기에는 종종 아이디어가, 즉 탐구할 수 있는 무엇이 있다. 만약 누군가 왼손잡이라면, 나는 때때로 단지 무슨 일이 일어나는지 보기 위해서 오른손을 써보라고 제안할 것이다. 결과물이 아무리 서툴더라도 여전히 자신의 흔적이기도 하고, 종종 예상치 못한 것을 발견할 수도 있다. 언젠가 아키라 선생님이 간단한 트레이싱 페이퍼로 활자를 수정하는 방법을 가르쳐 주셨다. 그때 나는 하마터면 의자에서 떨어질 뻔했다. 나는 이런 일이 가능한지 혹은 해야 하는지 전혀 몰랐다. 그 일이 있은 다음 나는 완전히 달라졌다. 학생들과 대화할 때, 이런 종류의 것들을 이끌어내려고 노력한다. 학생들이 질문하고 있는지, 어떤 것을 옳고 어떤 것을 그르다고 판단하는지 그리고 그 이유는 무엇인지 묻고자 한다. 학생들은 자신의 질문이 그들이 사용하는 미디어의 영향을 받는다고 생각할까? 해결책은 테크닉이나 개념에 숨겨져 있을까? 그리고 그보다 어려운 문제가 있다. 목소리를 발견했다고 하면, 그건 어떻게 일어난 일일까? 단지 일관된 테크닉을 사용했기 때문일까? 그렇다면 당신은 여전히 성장하고 있는가? 예를 들어, 게으름과 목소리의 대결일까? 편리함 대 탐구? 모험의 문제인가? 그러나 그런 것이 바로 이 분야의 아름다움이자 경이로움이다. 만일 자기 자신과 일하는 방식에 대해 지속적으로 질문한다면, 항상 새로운 무엇, 발견되지 않은 무엇을 찾을 가능성이 있다고 생각한다.

85

GRD 2010 F15 P001
Using a black ink
pen (Sharpie Fine and
Ultra-Fine are recom-
mended), create quick
typographic variations
of the word "Typogra-
phy" within each one
inch square unit.

Once the grid is
filled, choose the best
constellation (or com-
bination thereof) and
enlarge it, by hand,
in the area on the
right side, also 4x7.

Repeat this exercise
on two more sheets.
(Or more?)

Experiment freely.
Make sure to try
variations of stroke
weight, uppercase and
lowercase, word-
breaks, creating em-
phasis, noise, quiet,
etc. As an old student
of mine once pointed
out, "Limitations are
limitless."

After all three experi-
ments are completed,
scan each sheet at
100%, Greyscale,
300dpi. Save each as
a JPEG. Use this file
format, (insert your
own intitials):

xx_eb_typo_p001_a.jpg
xx_eb_typo_p001_b.jpg
xx_eb_typo_p001_c.jpg

Please create a folder
(Your_Name) of your
files and turn them in
at 1300, Sept. 3

86

A

Erik Brandt

A: Project 1 — A rudimentary exercise instructing
students on drawing letterforms within a defined
grid. This assignment teaches students to visually
breakdown letters into pure graphic form.

A: 프로젝트 1—규정된 그리드 안에서 글자꼴 그리기를
가르치는 기초 연습. 학생들은 이 과제를 통해 글자를
시각적으로 순수한 그래픽 형태로 쪼개보게 된다.

```
--------------------------------------------
GRD 2010 Sec 01 Typography 1
--------------------------------------------
Thursdays 1300 - 1800 Room 416 Professor: Erik Brandt
--------------------------------------------
Office Hours (Room 338) R 1100 - 1200, or by appointment.
--------------------------------------------
email: ebrandt@mcad.edu
--------------------------------------------
web: http://www.typografika.com
--------------------------------------------

Notes: Please use these file formats for your uploaded
submissions.

xx_grd2010_f15_p002_a.jpg
xx_grd2010_f15_p002_b.jpg
xx_grd2010_f15_p002_c.jpg
xx_grd2010_f15_p002_d.jpg
```

```
--------------------------------------------
BEGIN
--------------------------------------------
GRD_2010_F15_P002
--------------------------------------------
Due by 1PM on Sept. 3, 2015; please bring your hard copies and upload
your scanned copies to the P002 folder on our server.
--------------------------------------------
Project 002: Form Studies, an initial micro/macro approach to a broader
project that we will engage later. This approach is formal in nature.
--------------------------------------------
Process: Starting from some of the examples provided during the
demonstration, explore counterform abstraction and emotive communication
using the tools/sheets provided or drawing from observation using
only pencils, mechanical pens, or black ink. Your goal should be to
completely alienate the counterform from the original letterform and
allow it to project its own identity. Take careful note of what you are
finding and try to document these on the sheets provided. Feel confident
in your interests, pursue and reveal them.
--------------------------------------------
Application: Apply some of these sketches within the windows of the
thirty-six unit grid provided starting from the middle four squares
and working outward in any subsequent direction. Explore the struggle
with balance or visual consistency of the whole and the needs of the
individual ambition of each unit.

Develop these sketches within three different environments. First as a
conglomerate cluster (36), then as a larger yet more selective group
(9), then finally, in individual isolation.
--------------------------------------------
Format: Each part will be completed in a 6"x 9" field. Examples and
starter set will be provided. The student may not obscure or go beyond
the edges of each unit on the grid. Each unit is scaled to the main 6"x
9" format, so you may enlarge these exactly to scale. The base unit is
0.75" Wide by 1.125" High. (3/4"W x 1 1/8" H)
--------------------------------------------
Visual Thinking: MicroMacro Emotions
--------------------------------------------
This project is designed to provide an environment for visual thinking
exercises. The goal is not product based per-se, but should be seen as
an opportunity to begin consciously experiencing the development of pure
form while accepting limitation and analyzing our dependence on existing
forms. The student should find confidence in every conceivable thought
or reflection during this process and try to develop the forms as both
parts of a whole and as individual units that respond to those thoughts,
reflections, reactions, surrounding environments, etc. For example, the
student might try different types of music or locations as well as
various visual resources and see if it influences the kind of forms you
produce/emotions you experience. This might be a way toward developing
an orientation in creating form that can respond to detailed observation
and research appropriately.

In general, the student should focus on both searching for and giving
form, all at the same time… as a sword cuts through the air before it
strikes its target, it should already have passed through.
--------------------------------------------
Reminder: Please bring hard copies as well as scanned files to our next
class. File formats are listed in the Notes section above.
--------------------------------------------
END
--------------------------------------------
```

Above: Marika Soulsby, Penn State University.

B: Project 2—This assignment guides the student through the process of drawing and analyzing the micro details of type and applying typographic form on a macro visual system. The assignment brief encourages the students to pay attention to the counterform of letters and the space around letters that define their shape.

B: 프로젝트 2—이 과제는 학생에게 활자의 미세한 디테일을 드로잉하고 분석하여 매크로한 시각 시스템에 적용하는 과정을 보여주며 글자 속공간과 그 모양을 이루는 글자 주위의 공간에 주의를 기울이도록 한다.

GRD 2010 Sec 01 Typography 1

Thursdays 1300 – 1800 Room 416 Professor: Erik Brandt

Office Hours (Room 340) R 1100 – 1200, or by appointment.

email: erik_brandt@mcad.edu

blog: http://www.geotypografika.com

web: http://www.typografika.com

BEGIN

GRD_2010_01_F15_P003

Due by 1PM on Sept. 10, 2015; hard copies as well as scanned files.

Project 003: Das Streifenhörnchen y Los Legos.

Goals: A first exercise in developing type within structural limitations. Originally developed by the great Swiss type educator, Susanna Stammbach, this exercise will challenge your imagination as much as your commitment to craft and precision.

Process: Both sheets should be printed out in bright, garish colors. Using the demo provided in class, complete both exercises using the Turkish phrase: "Ne var, ne yok." After experimenting with forms in both, carefully glue your results on a clean sheet of 11x17 paper, then scan that document and save with our usual 300dpi formatting rule. Your phrase may or may not incorporate a comma, no quotation marks.

xx_grd2010_f15_p003_a.jpg
xx_grd2010_f15_p003_a.jpg

Pay special attention to craft and precision, but challenge your imagination as well.

END

Right: Los Legos (my term), from Susanna Stammbach.

Right: Das Streifenhörnchen, from Susanna Stammbach.

88

Erik Brandt

C: Project 3—An exercise in building letters from modular units using forms from designer Susanna Stammbach.

C: 프로젝트 3—디자이너 수잔나 스탐바흐의 양식을 사용하여 모듈 단위로 글자를 디자인하는 연습.

GRD 2010 Sec 01 Typography 1
--
Thursdays 1300 – 1800 Room 416 Professor: Erik Brandt
--
Office Hours (Room 340) R 1100 – 1200, or by appointment.
--
email: erik_brandt@mcad.edu
--
blog: http://www.geotypografika.com
--
web: http://www.typografika.com
--

--
BEGIN
--
GRD_2010_01_F15_P004
--
Due by 1PM on Sept. 10, 2015; please bring hard copies as well as
scanned files.
--
Project 004: Typographic fiction.
--
Process: (A) Starting from some of the examples provided during the
demonstration, use your Letraset sheet to create typographic fictions
within the same 36-unit grid we used for P002. (B) Purchase your own
sheet of Letraset for creating typographic fictions on another 36-unit
sheet. (C) Scan and label each sheet according to our common format.
--
xx_grd2010_f15_p004_a.jpg
xx_grd2010_f15_p004_b.jpg
--
Try as best you can to create emotive messages, suggestive images, etc.
The forms and fields you create can be completely abstract, but you might
also try a few direct communications using these tools. Keep an eye on
the fact that, while again working at the micro level, you are actually
creating images that can be scaled much larger.
--
END

Above: Liam McMonagle, type fiction, F09.

D: Project 4—A study in creating graphic forms
from letters using Letraset lettering sheets.

D: 프로젝트 4—레트라세트 레터링 시트를
사용하여 글자로 그래픽 형태를 만드는 연구

Finn Nygaard

Former Partner, Eleven Danes and
European Designers Network EDEN

Workshop at the Paju Typography Institute.
This workshop is about a focus on process
through the use of jazz improvization applied to
the formal exercise of working with poster compo-
sition. Each student works within the parameter
of a 100 × 70 cm sheet of paper on which they
will experiment with elements of color, scale and
juxtaposition to produce many experiments that
break free of being result-oriented.

PaTI 워크숍. 이 워크숍에서는 재즈의 즉흥연주 과정을
포스터 제작의 형태 연습에 적용했다. 학생들은
100 × 70cm 크기의 종이를 사용하여 결과보다는 과정
지향적으로 색, 크기, 병치 등의 많은 요소를 실험했다.

PaTI Seoul · Korea 2018

Poster composition · Jazz improvisation

The purpose is to develop and strengthen the graphic design skills and competence working with composition.
We work with and on the poster size to try out effects of our acts.

Poster size: 100 x 70 cm (39.35 x 27.55 inches)
Topic · Jazz improvisation

We put the computers on standby. Vi challenge the full size piece of paper – 100 x 70 cm (39.35 x 27.55 inches)
Jazz improvisation · composition on paper, size 100 x 70 cm.

The aim is to create and experiment with not just one but several/many compositions. Sense the size of the poster and work with it; see what happens, when you add colored fragments to the paper. typographic fragments, Make a composition, that feels right, that convinces you that you are on the right way.

This disciplin is tested and has proven successful; so successful that some students choose to focus working with this phase throughout the workshop!

This workshop is not about the result. Commit yourself to the process, not the goal.

Improvisation is broad term referring to the process of devising an atypical method to solving a problem due to lack of time or resources. In a technical context, this can mean adapting a device for some use other than that which it was designed for, or building a device from unusual components in an ad-hoc fashion. Improvisation as a context of performing arts is a very spontaneous performance without specific preparation. The skills of improvisation can apply to many different faculties, across all artistic, scientific, physical, cognitive, academic, and non-academic disciplines.

The word composition comes from the Latin componere, meaning "put together" and its meaning remains close to this. Writing classes are often called composition classes, and writing music is also called composition. This can also describe things besides writing that are "put together". You could say an abstract painting has an interesting composition. Any mixture of ingredients can be called a composition.

The graphic composition is about building up a poster or a picture in a way so that it presents a motif in the strongest possible way. A good composition catches your attention, leads your eyes to the very elements and the "story" the artist wants to tell. The easiest way to do this is to arrange and place the elements in a way that enhances balance, order and clarity. Rules are, however, made to be broken ... A picture can be composed in a way that provides harmony and balance. It is nice and "safe" to look at. A picture can also be composed in a way that makes it appear unbalanced. When we look at the picture, it gives us a feeling of unease and confusion, the feeling that something is wrong.

The composition can lead the eyes of the viewer to a specific place in the picture/motif. The composition can appear in a way that we sence the depth and the perspective. A picture with depht is usually more interesting to look at than a picture, that appears flat and without depht.

A

Composition
The composition is the name for a pictures configuration, so to speak. The composition is the whole, that puts together the elements of the picture. The composition is created by means of the picture lines. The lines can be figures, the areas where two colors meet/colide, movements, turning directions etc. And the lines can appear due to light, related colors etc.; elements that lead our eyes over the picture/image.

Foreground/"in-between"/background
What is in front, what is in the middle, and what is in the background of a picture?
The most important element is usually placed in the front, bu there might be a purpose putting it back in a way that makes you see it after a while.

Harmony and balance
If a picture is built up on a centered line, and if the two halfs consist of the same number of elements/figures, it attains harmony. The elements/figures are also placed regularly according to the centered line to make the composition balance. Maybe an important element or figure is placed on the line. A symmetric composition expresses serenity and balance.

Diagonals
It adds movement to the picture if it is built up around a line, that runs across the picture from two opposite corners.

Geometry in composition
A picture can be built up/arranged around a geometric figure. E.g. a triangle, a circle, a square etc. A composition built around these elements/figures adds balance to the picture.

The golden ratio / The golden mean
In the 15th century the renaissance painters and artists calculated and made mathematical rules and guidelines for the composition of a picture. The golden ratio is one of these rules. Also referred to as The golden mean.

A picture that is built up according to this this guideline attains balance and beauty. Usually the main figure or the most important element is placed within the area of the golden ratio. There are more math formulas to find the golden ratio. You can e.g. find it by dividing the line into two parts so that the longer part divided by the smaller part is also equal to the whole length divided by the longer part. It is often symbolized using phi, after the 21st letter of the Greek alphabet. our you can divide the long and the short site in three parts, resulting in nine equal areas.

Disharmony / Imbalance
A picture can be built on/with assymetrical forms/elements. There is no balance between/among the elements of the picture, which creates disharmony and/or imbalance.

Locations
In some cases different brain functions make us see or perceive things in a specific way. This fact has an influence on how we see figures and elements in a picture.
The left side of a picture can bear larger and more active elements than the right side. Strong movements almost allways go from left towards right. A person placed in the left side appears more active; a person in the right side has a more receiving appearance – as movement/activity in the picture goes from left towards the right side.

The upper part of a line appears heavier than the lower part. Therefore a picture is better balanced with a lighter upper part. Also keep in mind that colors have different weight. If a figure or an element is light it does not appear as heavy as a dark one. Therefore a big light figure can be placed in the upper part of a dark picture without breaking the balance of the picture.

Perspective that highlights important elements
You can add weigth/importance to a picture e.g. by painting or drawing the most important object as the first. Imagine a picture, where a broken finger on a persons right hand is twice the size of the persons whole left hand – because it takes up a great deal of the persons attention. In ancient paintings you often see, that e.g. the king is painted to look bigger than other persons in the motife.

B

A workshop handout for Poster composition
• Jazz improvizization.
A: A detailed description of the process and
objective of the workshop.
B: Description of graphic composition elements.

포스터 구성을 위한 워크숍 자료와 재즈 즉흥곡
A: 워크숍의 과정과 목적 상세 설명
B: 그래픽 구성 요소 설명

The Golden Ratio

The golden ratio is a way to achieve harmony and balance in a picture.

Find the golden ratio
There are more math formulas to find the golden ratio (Fibonacci).

One way is to divide the area – the long and the short site in three parts, resulting in nine equal areas.

Colors
Composition and balance in a picture is also about colors, light and shadow –
Complementary colors e.g. can provide severe contrasts, that can be useful if a small element has to be balanced with a bigger element.

A strong color in a small area can be outmost effective to attract attention to a motife.

Primary colors
The basic colors from which all colors are made.

Primary colors are red, yellow and blue.

Complementary colors
Complementary colors "excite" each other, they strengthen each others power. At the same time they attain harmony, as all three primary colors are represented.

Yellow to violet (blue + red)
Blue to orange (yellow + red)
Red to green (yellow + blue)

Contradictions
Black · White

Warm colors
Red · Orange · Yellow

Cold colors
Violet · Blue · Green

Plus a wealth of different color tones – mixed by the various colors… mint, turquoise, pink, violet, brown, grey etc.

92

Finn Nygaard

C: Description of the golden ratio.
D: Description of color relationships.

C: 황금비 설명
D: 컬러 사이의 관계 설명

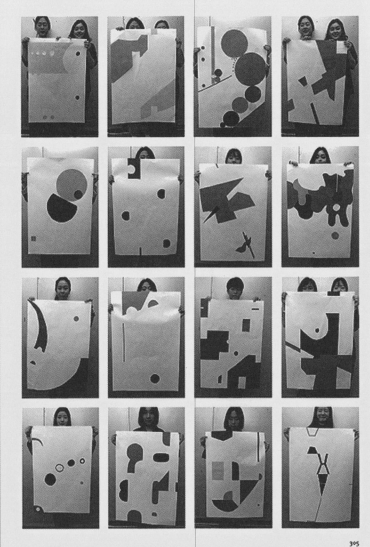

Results and process from the workshop.　　　　포스터 구성 워크숍의 결과 및 과정

The Unity of Heart and Hand:
The Basic Practice on Chinese Typography

心手合一：中國文字設計基礎

Knowledge

知識?

Practical Wisdom

實踐智慧

Koan　　　　　　公案

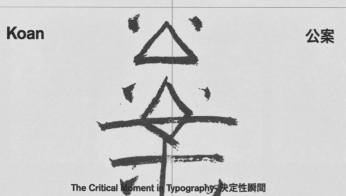

The Critical Moment in Typography 決定性瞬間

Koan　　　　　　公案

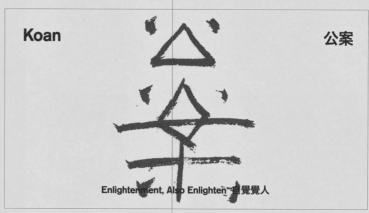

Enlightenment, Also Enlighten 自覺覺人

Education	**Learning**
教	學
效	覺

Enlightenment, Also Enlighten 自覺覺人

Inquiry	**Practice**
參	行

The Unity of Inquiry and Practice 知行合一

Heart	**Hand**
心	手

The Unity of Heart and Hand 心手合一

Import		**Export**
內	=	外
內化		生產

The Everyday Life Practice 日常生活實踐

Hua Jiang

Professor, Central Academy of Fine Arts
Founder and Curator of Ningbo International
Graphic Design Biennial

A lecture detailing some of the work Hua Jiang teaches at the Central Academy of Fine Arts (CAFA) in Beijing. Through this lecture and course Jiang instructs students on the fundamentals and philosophy of Chinese lettering and calligraphy.

화장이 북경 중앙미술원에서 가르치는 작품 중 일부를 상세히 설명하는 강연이다. 이 강연과 과정을 통해 화장은 학생들에게 중국어 레터링과 서예의 기본과 철학을 가르친다.

Return to the Origin	Innovation	一	點畫宇宙，骨氣洞達
反本 =	開新	二	經營位置，分間布白
		三	形勢心印，氣韻生動

The Everyday Life Practice 日常生活實踐

3 Steps

1 **Radical Strokes**

2 **Radical Locations**

3 **Radical Forms**

3 Steps

Orderly	Chaotic	Gu	Jin
正	草	古 =	今
		Past	Present

另一维度

博大 深沈

Zhuo	Qiao	Endless Writing	Endless Construction
拙 =	巧	无限書寫	无限構成
Unskilled	Wise		

博大 深沈 純樸 靈敏

Practical Without Thought 不立文字

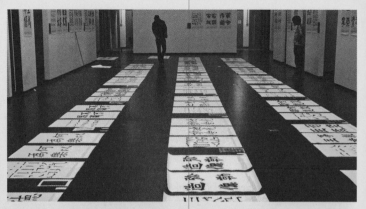

Hua Jiang

Collected in this book is a selection of the rigorous work that students perform while adhering to tenents of Chinese philosophy. This mixture of philosophy and writing practice create an unique learning experience guided by Jiang.

중국적 사상을 바탕으로 학생들이 수행한 엄격한 과제 예시들을 볼 수 있다. 철학적 수행으로 진행되는 서예 연습은 특별한 학습 경험이다.

静

精
精
精

Hua Jiang

Jaemin Lee

Founder, Studio FNT
Adjunct Professor, University of Seoul

Assignment brief and student work for the course Visual Design. Over one semester of student work on two projects with the themes 'Time' and 'Merger' respectively. The output is dynamic, but each student is asked to exlore the themes broadly and rigorously.

비주얼 디자인 수업의 과제 개요와 학생들의 작업이다. 한 학기 동안 학생들은 '시간'과 '합성'을 주제로 프로젝트를 진행한다. 결과물은 역동적이면서도 각 학생이 주제를 넓고 꼼꼼하게 탐구하도록 유도한다.

101

GENETICALLY MODIFIED FUTURA

2018

Level 1

FUTURA is not the same as 100 years ago.

Inspired by genetical modified characters

It becomes more powerful by genetic modification.

A B C D E F G H I J K L M N O P Q R S T U V W X Y Z
a b c d e f g h i j k l m n o p q r s t u v w x y z

DNA MANIPULATION EXPERIMENTS FOR FUTURA

The 15 Min. Slow-Motion T-shirt Exercise

Before you design a T-shirt (or anything else for that matter), try this ridiculously slow exercise, and you will design differently as you would have before.

Jan Wilker, karlssonwilker
New York

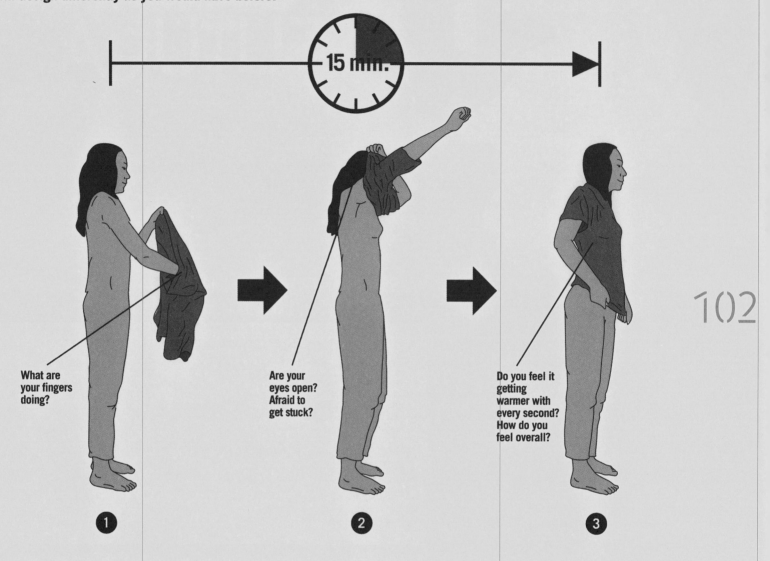

15 min.

What are your fingers doing?

Are your eyes open? Afraid to get stuck?

Do you feel it getting warmer with every second? How do you feel overall?

① ② ③

102

We all have or had a favorite T-shirt. We all have put one on thousands of times, maybe even this morning. We have many of them in our closet right now. So we think we are experts on T-shirts. But we are not. Just take one, and painstakingly slow, put it on, and be alert and aware of every single move you make, how you breathe, your eyes, your ears. Be aware of what you do, why, and how you feel at any second. Say it out loud to class. Be very precise. Nothing is too small not to mention. Why are you going "blind" at some point? Smell? What's private, what's public? How many sides does the shirt have? How many holes? How many secret tubular compartments? You will not have the patience the first time you do it. After the 10th time, you will still find out new things about that seemingly simple piece of cotton.

Founder, Karlssonwilker
Adjunct Professor, Cooper Union, SVA, Parsons

A fun and quirky assignment brief from NYC-based designer Jan Wilker instructs students to slow down and pay careful attention to a routine every day action.

뉴욕을 중심으로 활동하는 디자이너 잰 윌커의 재미있고 기발한 과제이다. 학생들에게 속도를 늦추고 매일 반복되는 행동에 주의를 기울이라고 가르친다.

103

Mariscal Workshop "The other side of the city"
Coinciding with his participation in the AGI Open held in Mexico in September 2018, Javier Mariscal had the opportunity to give the workshop "The other side of the city" with the students of the school CENTRO of design, film and television. Mariscal was able to develop widely one of his great passions: to divulge, communicate and share his experience and work with students.
In the workshop, Mariscal presented and explained to the participants his methods, procedures and tricks to try to give visual form to the city with all kinds of supports and materials. Through sketches, notes, maps, typography ... and using the most diverse techniques, from the paper, pencil and marker to the tablet, the mobile and the programs of drawing and digital animation, the designer guided, as a mentor, the participants in the creation of their own representations of the city of Mexico.
Starting step by step in the definition of urban structure and its evolution throughout history, experimenting with shapes, drawing and materials, exploring all types of media. The students were able to develop their own creations and techniques all with the objective of each participant achieving a final collection of images that was integrated into a personal and coherent portfolio, presented and discussed in a dynamic debate led by Mariscal, which was a rich meeting of ideas and creativity.

Javier Mariscal

Illustrator, Mascot, ROCA
Illustrator, Film Maker, "Chico & Rita" along side Fernando Trueba

Excerpts and summary of the workshop Javier gave at AGI Open Mexico, 2018. The theme of the workshop was urban structures and their evolution through history. Javier introduced workshop participants to his own methods of giving visual form to a city particularly through notes, maps, sketches and typography.

2018년 멕시코 AGI 오픈에서 하비에르가 진행한 워크숍의 발췌와 요약. 주제는 도시의 구조와 역사를 통한 진화였다. 하비에르 마리스칼은 참여자들에게 본인의 독자적 방식으로 기록, 지도, 스케치, 타이포그래피 등을 통해 도시를 형태화하는 워크숍을 진행하였다.

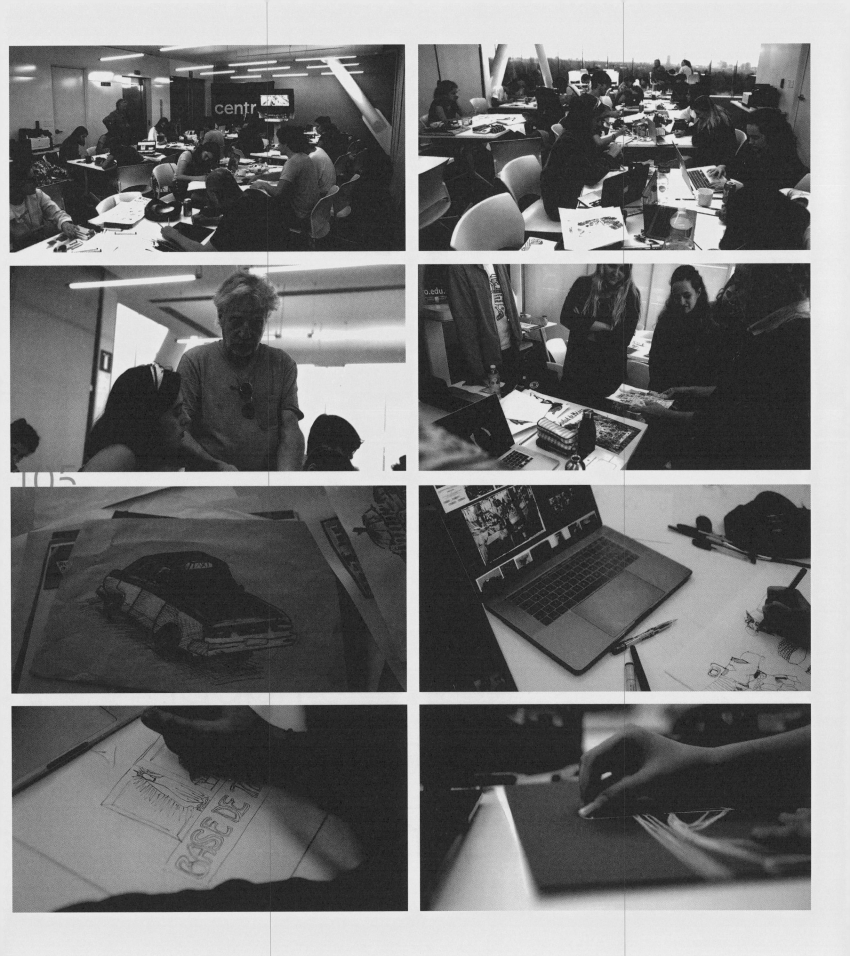

105

Images of the workshop held in Mexico City. 멕시코시티에서 열린 워크숍 이미지

Letters < — > Words **Changing + Transforming** Letterforms

Overview
Exercise 1

**Design with opposite word meanings and their relationship
expressed through typographic style and orientation.**

Objectives

Express the personality and meaning of the words through typographic style,
letterspacing, case, alignment and orientation of placement.

By moving letters, you will learn:

— Relationship of figures: direction, space, connections.
— Interaction of graphic shapes.

— scale	contrast	unity	flow
proximity	hierarchy	rhythm	repetition
— form	empty space	balance	a/symmetry
emphasis	orientation	alignment	

Components

— Choose 1 sets of 2 opposite adjectives from the list below.
— Use only the given font familiy

Assignment

— Consider how the words relate to eachother and create a relationship between
the two in the way that they connect or integrate with eachother.
You are allowed to crop, rotate, reverse out, overlap and bleed the letters.
You are not allowed to distort the font, use any imagery, apply filters or special effects.
Consider all of the terms above and how they relate to the meaning of your words.
I encourage you to push the feeling of the words as far as you can.

Requirements

— Develop the two words individually
— Once ready, place the two words with the given page.
— Print out the paper centered on a horizontal format 8 1/2" x 11" page. No mounting.

See detailed page
for day by day timing,
work, and homework
instructions

Keep track of your process in workbook

106

Dualities / Dichotomies

1 free / confined
2 conservative / liberal
3 private / public
4 local / global
5 past / future
6 insecure / confidant
7 traditional / contemporary
8 harmonious / chaotic
9 youthful / mature
10 secret / exposed
11 bored / inspired
12 healthy / sick
13 natural / toxic
14 private / public
15 anonymous / famous
16 steady / dizzy
17 tired / awake
18 internal / external
19 humble / egotistical
20 wealthy / poor

Exercise 1

Jean-Benoit Levy

Founder of Studio AND
Teaches at San Jose State University and
San Francisco State University

Typography Project 1 — San Francisco State University. An assignment dealing with fundamentals of typographic expression. Through this project students learn how to manipulate and express the meaning of words through basic composition. Levy's assignment brief and syllabus carefully guides through multiple stages of study with the intent of impressing discipline and patience to the craft of typography. The above example is from Xinping Li, San Francisco State University.

타이포그래피 프로젝트 1—샌프란시스코주립대학교 타이포그래피 표현의 기본을 다루는 과제로, 이 프로젝트를 통해 학생들은 기본적인 구성으로 단어의 의미를 표현하는 방법을 배운다. 베누아 레비의 과제 개요와 강의계획서를 살펴보면, 타이포그래피 기술에 대한 규율과 인내심을 기르기 위한 여러 단계의 연습이 있다. 위의 사례는 샌프란시스코주립대학교 리신핑의 작업이다.

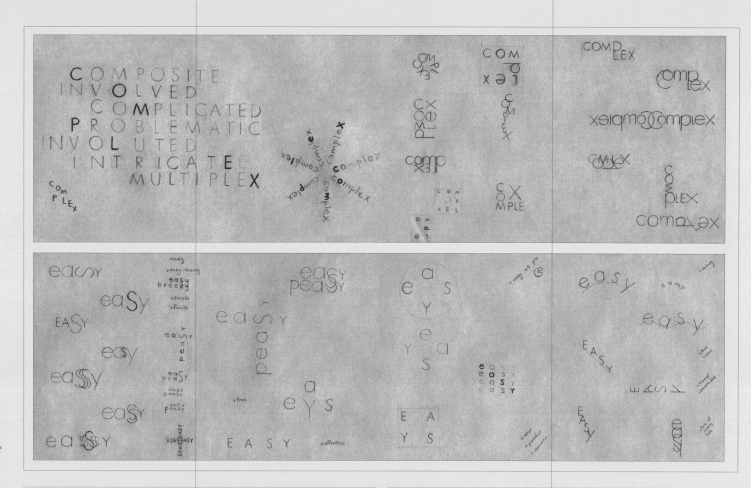

The following pages present several assignments from the Fundamental Graphic Visualization course. Throughout the semester students are introduced to different strategies to create graphic compositions and thereby create meaningful communication. Students beging with basic graphic form, moving on to text and image relationships and finally arriving at storytelling and narrative.

다음 페이지에서 '기초 그래픽 시각화' 과정의 몇 가지 과제를 제시한다. 학기 내내 학생들은 그래픽 구성을 창작하고 그에 따라 의미 있는 소통을 이루기 위한 전략을 배운다. 학생들은 기본적인 그래픽 형태에서 시작하여, 텍스트와 이미지의 관계 그리고 마침내 스토리텔링과 내러티브까지 다룬다.

The examples on the top two rows are from: Mina Kasirifar / San Francisco State University. The lower two examples are general examples of student work whose author is unknown.

왼쪽 두 줄에 있는 사례는 샌프란시스코주립대학교의 미나 카시리파의 작업이다. 오른쪽 두 가지 사례는 작자 미상의 학생 작업이다.

Fundamental Graphic Visualization	Dsgd 63 Tuesday / Thursday	Visual construction Order + Direction	Spring 2017 Project 1 J B L

P. 01
Exercises 1a + 1b

01	Course introduction / Project 1 introduction / In class exercise	
02	Homework / group critique / In class exercise : Composition	
03	Last check + corrections on template / Project 2 Introduction	
04	Delivery + Final presentation + group critique / Bring homework project 2	

January **Thu 26**

Class 1 Course introduction / Fill up form / **Project 1** introduction / In class exercise

In class First: Make 12 different shapes out of 6 dots
Secondly: Make variations with 3 groups of 6 dots according following rules:
Always place dots on the grid line
— 3 same symetrical shapes of dots = Same direction & Symetrical composition
Independent (separated) and Interacting (connected). 4 solutions each = 8
— 3 same non-symetrical shapes of dots = Different directions & Non symetrical compos.
Independent (separated) and Interacting (connected). 4 solutions each = 8
— 3 different shapes of dots placed on the grid = Different shapes @ Different directions
Independent (separated) and Interacting (connected). 4 solutions each = 8

Homework Finalize all 3 families
4 solutions for each category / 2 pages per category (separate v.s connected)
Deliver (printout) 6 pages lettersize / By hand or in Illustrator. **Get work template**

Tue 31

Class 2 Group critique / Present works on the wall / In class exercise

In class — **Ex 1a** : Select 2 best per category. Refine
— **Ex 1b** : Research random composition: Reproduce best random composition

Homework **Ex 1a** : Finalize refinement 2 best. Bring 1 page tabloid with best solutions.
Get final template. Place solutions on it.
Ex 1b : Present 4 compositions (6 dots only, center on grid).
Present on 2 pages of 2 squares each

February **Thu 02**

Class 3 Group critique **Ex 1a + 1b** / In class work

In class — **Ex 1a + 1b** : Group critique for final. **Get final template**
Ex 2 : Project 2 introduction

Homework **Ex 1a** : Prepare final tabloid page on template with all sketches of Ex 1a
Ex 1b : Take a last composition and transform with 5 different values.
Prepare final tabloid page on template with all sketches of **Ex 1b**
Clean up workbook. Place all pages of research
Ex 2 : Bring your black and white portrait
Bring tracing / transparent paper

Tue 07

Class 4 **Delivery + final presentation of Ex 1a + 1b. Deliver workbook.**
Group critique **Ex 1a + 1b**

In class **Start project 2**

Grading

To receive full credit, projects must be turned in when due.

Each class exercise will be graded upon completion and assigned a letter grade according to the University policy, A through F.

Late projects are subject to an F unless prior official excuse have been delivered (Health or Family emergency, Etc.).

Semester projects cannot be re-done for re-evaluation, no exceptions.

Visual construction **Changing + Transforming** Dots + Pictograms

Create basic visual variation based on the placement of primary graphic elements in order to observe and react to the basic rules of visual composition.

Observe and depict the visual relation between different configurations to visualize various graphic results. Analyze the directions that occur in frame.

Work by hand and / or by computer. Keep track of your process in workbook.

Jean-Benoit Levy

109

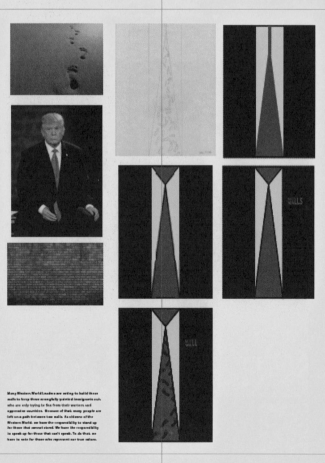

Many Western World Leaders are voting to build these walls to keep these wrongfully painted immigrants out, who are only trying to flee from their warfare and oppressive countries. Because of that, many people are left on a path for more tax walls. As citizens of the Western World, we have the responsibility to stand up for those that cannot stand. We have the responsibility to speak up for those that can't speak. To do that, we have to vote for those who represent our true nature.

Jean-Benoit Levy

Student work results from the Fundamental Graphic Visualization course. The work on the left hand page are students works from P. 01 and the above are samples from P. 06 and P. 07. All project syllabi are also included for reference.

'기초 그래픽 시각화' 수업에서 나온 학생 작업 결과물이다. 왼쪽 페이지는 계획서 1쪽에서 나온 학생 작업이고 위쪽은 6쪽과 7쪽에서 나온 샘플들이다. 참고로 프로젝트 계획서도 소개한다.

Fundamental
Graphic Visualization

Dsgd 63
Tuesday / Thursday

Balance + Rhythms

Spring 2017
Project 6 J B L

P.06

Exercise 6

21	**Ex 6** : Introduction. 3 music excerpts	**Project 5** : Deliver finals
22	**Ex 6** : Visualize 1 music excerpt. Present 3	
23	**Ex 6** : 2 sketches	
24	**Ex 6** : Group presentation. 2 Color compositions	**Ex 7** : Intro
25	**Ex 6** : Final presentation	**Ex 7** : Bring ideas + mood board

April **Thur 13** **Class 21** — Final & presentation **project 5** / Start **project 6** / **Demonstration Moddboard**
Pick up one out of your 3 music excerpts.

In class — Start research. Make two compositions matching your music within the given squares
by cutting / moving black stripes up and down. Stick to the given amount of stripes.
Work on lettersize page. First, black and white only.

Homework **To do** : Visual : Lines : Bring 2 variations. Audio : work and prepare loop to listen.
Bring 1 color moodboard including : 4 color spots / 2 images / 4 possible fonts

Tue 18 **Class 22** — Present moodboard in color. While presenting to the music excerpts in loop.
— Present 2 variations black and white lines. Pick up one, dismiss one.

In class — Add 3 gray value range of lines. Comp. with black + gray : Use also empty white spaces

Homework **To do:** With final loop, make 2 new sketches by using now 3 grays + black + white
Define text (1st level : Title, name of song. Second level: author or band)
Font and text : typography : Use 2 fonts maximum. Integrate into last sketches
Present compositions in one page (larger) = 2 lettersize pages. In black & white

Thur 20 **Class 23** **Group check.** Presentation of the 2 compositions + font and text

In class Personal presentation. Choose one direction. Transform in color. Get final template
Demonstration QR-code

Homework **To do** : Make 2 color compositions. Use 2 different color schemes. On lettersize
Cold / Light / Warm / Dark / Vibrant / Dull / Contrasted / etc... +
Adapt typography in color. Finalize loop. Prepare QR code. Also place on final template

Tue 25 **Class 24** **Group check.** Group presentation of two color-compositions.

In class **Ex 6 : Individual check.** Presentation on template / Choose final version /
Fix text / Finalize
Project 7 : Introduction + Presentation theme. Start sketching. Make moodboard.
Define image style / text content / color scheme

Homework **Ex 6** : Finalize for final presentation. Deliver on youtube. Check QR code
Project 7 : Bring 2 idea-sketches in form of collage / drawing. Use color.

Thur 27 **Class 25** **Ex 6 : Deliver & Final presentation.**

In class **Project 7** : Present Sketch + discuss content. Define style for Ex 7 (Mood board)

Homework **Project 7** : Present color comps. Group critique

111

Grading

To receive full credit, projects
must be turned in when due.

Each class exercise will be graded
upon completion and assigned
a letter grade according to the
University policy, A through F.

Late projects are subject to an F
unless prior arrangements have
been made
(Health, Family emergency, Etc.).

Semester projects cannot
be re-done for re-evaluation,
no exceptions.

Visual composition	**Exploring + Understanding**	**Rhythms**

Create several composition with similar width vertical lines.
Following step by step process, discover the rules of composition.

Discover the steps of creating a random composition out of regular elements

By transforming one image step by step will learn to:

— Discover basic principle of rhythms composition
— Controle a random moment into a composition
— Development of two-dimensional sensitivity
— To work by hand and by computer. Creating a simple composition out of various lines.
— To integrate text

P.06 and P.07, project syllabi and results/process
from the Fundamental Graphic Visualization
course.

'기초 그래픽 시각화' 과목에서 나온 프로젝트 계획서
6쪽, 7쪽과 결과/과정

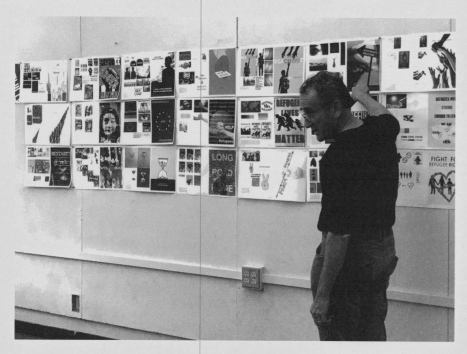

Jean-Benoit Levy

Fundamental Graphic Visualization	Dsgd 63 Tuesday / Thursday	Composition Storytelling	Spring 2017 Project 7 JBL

P. 07
Exercise 7

	25	Ex 7 : Introduction. Discovery of the theme of the poster
	26	Ex. 6 : Final / **Ex 7** : 1 moodboard / 1 concept board. 3 ideas
	27	**Ex 7** : Work presentation. 2 roughs
	28	**Ex 7 : 2 comps**
	29	**Ex 7 :** Final presentation
	30	Ex 8 : Final delivery book + CD + Workbook. Download poster

April	Tue 25	Class 24	**Project 7** : Kickoff presentation
		Title	**Freedom of Movement**
		Pictural	International poster competition. Poster for tomorrow 2017
		Content	Free style related to briefing on http://www.posterfortomorrow.org/en/
		Text	Typesetted : Free text related to briefing
		Fonts	Free
		Colors	Free
		Format	Vertical. 50 x 70 cm at 150 DPI. Work proportionally for sketches.
		Homework	**Bring 1 concept board + 1 moodboard**
	Thur 27	Class 25	**Final Ex 6**
			Ex 7 : Bring 1 concept board + 1 moodboard. Each on lettersize
		Homework	Present 3 sketches / ideas. Personal critique. Choose 2 directions
May	Tue 02	Class 26	Ex 7 : Present 3 sketches / ideas. Personal critique. Choose 2 directions
		In class	Ex 7. Make 2 roughs by hand or collage (rough) + font choices + research Bring all content and documents related to your research.
	Thur 04	Class 27	**Ex 7 : Bring 2 roughs.** Present all documents, font choices + research Printed on lettersize paper. Choose 1 solution
		Homework	**Ex 7 : Make 2 clean comps** (draft) on computer out of chosen solution
	Tue 09	Class 28	**Ex. 7 : Present 2 comps.** Choose one layout
		In class	Ex 7 : Work on final composition according best draft
		Homework	**Ex 7 : Rehersal:** Prepare final variations. Receive template for tabloid.
	Thur 11	Class 29	Ex 7 : present final variations on template and on tabloid Group critiques
		In class	Last changes + refinments. Receive book template and tabloid.
		Homework	Ex 7 : Finalize for final presentation. Delivery page **Project 8**
			Book : Fix last correction on pages.
	Tue 16	Class 30	Ex 7 : Final presentation.
			Workbook ready
			Book : Final delivery book + CD.

Grading

To receive full credit, projects must be turned in when due.

Each class exercise will be graded upon completion and assigned a letter grade according to the University policy, A through F.

Late projects are subject to an F unless prior arrangements have been made (Health, Family emergency, Etc.).

Semester projects cannot be re-done for re-evaluation, no exceptions.

Visual Information	Perceiving + Expressing	Hierarchy v.s. Planes

Create one poster by combining size, value, transparency, color, and content Following step by step process, apply the rules of composition.

Discover the steps of creating a poster out of various graphic elements

By creating this subjective compositions you will learn:

— To compose an expressive image with confidence.
— The process of organizing a content on your own.
— Drafting skills with basic graphic tools. Hand sketch and computer
— Development of formal and spatial sensitivities.

113

Design
The Invention of Desire
Jessica Helfand

MGT 654
Design : The Invention of Desire
Spring 2017

W 02:40pm - 05:40pm
Yale University Art Gallery (unless noted)

Contact
Jessica Helfand

Senior Critic in Design
Yale School of Art

Faculty in Design
Yale School of Management

Office
Evans Hall
165 Whitney Avenue
Room 3560
New Haven CT 06511

Email
jessica.helfand@yale.edu

TA
Mark Perelman
mark.perelman@yale.edu

Overview

Design is now recognized as a decisive advantage in countless industries and a boon to innovation in all fields. But what is design, really? Is it a process or a practice? A product or a platform? And if, arguably, it defies such easy classification, then who wants and needs it, produces and consumes it?

This class will concentrate on addressing the human characteristics that both influence and are impacted by design and which frame, among other things, our perceptions of loyalty, credibility, even leadership. Can design convey false authority? Do the things we make result in unintended consequences? How can we reconcile need against greed, personal voice against public choice?

Combining research, collaboration, and weekly visits to the Yale University Art Gallery, students will address issues of cultural, historical and contemporary consequence to gain a deeper understanding of design's intrinsic value—and its enduring power—as a humanist discipline.

Required

Design : The Invention of Desire
Yale University Press, 2016

Meetings

With occasional exceptions, this class will meet Wednesday afternoons at the Yale University Art Gallery. We will concentrate each week on a chapter in the book and tether each chapter to selected items in the Gallery collections. As the Gallery closes at 5pm, th second half of this three-hour class will meet in a nearby classroom (location TBD).

Jessica Helfand

Founding editor of Design Observer
Teaches design at Yale University

Helfand's work as an educator at Yale University is not limited to the design studio. She has taught a variety of courses in other departments, including this course on design taught to MBA students in the Yale School of Management. This curriculum introduces students to the theoretical and material underpinnings of design and how it is driven by emotional, cultural and commercial desire. From that base, students can then think critically about the role of design and value.

예일대학교의 교육자로서 헬펀드의 일은 디자인 스튜디오에만 국한되지 않는다. 그녀는 예일대학교 경영대학원에서 학생들에게 가르친 이 디자인 과목을 포함하여 다른 학과의 다양한 과정을 가르쳤다. 이 커리큘럼은 학생들에게 디자인의 이론적, 물질적 토대와 함께 그것이 어떻게 정서적, 문화적 및 상업적 욕구에 따라 좌우되는지를 보여준다. 그 기초를 바탕으로 학생들은 디자인의 역할과 가치에 대해 비평적으로 생각할 수 있다.

Indifference toward people and the reality in which they live is actually the one and only cardinal sin in design.

Dieter Rams

115

Week 01: Due January 23
Humility

All illness is visual. We view the afflicted with pity: we're supportive, but removed, and often invisible. But what happens when the tables are turned? Over break, you're asked to inhabit the social stigma and physical alienation brought about, quite simply, by the notion of shame. Can packaging help?

Assignment—Reframing Social Stigma:
Packaging The Unthinkable

Week 02: Due January 30
Fantasy

To what extent does design amplify the authentic in pursuit of the fantastic—and how does fantasy feed our appetite for novelty and delight, for the joy of material acquisition? This week, we'll unpack visual excess, material mystery, and photographic illusion to rethink art versus artifice.

Assignment—Buyer Beware: Reframing Retail
The Epic Lure of the Impulse Buy

Week 03: Due February 06
Identity

Today, in an age of streamlined technology and seductive social media, we've sacrificed individuality for convenience: everyone online looks (and reads) the same. This week we'll look at photographic portraiture, and question the aspirational boundary between pictures and personhood.

Assignment—The Self in the Selfie:
Facebook as Historical Narrative

Week 04: Due February 13
Consequence

How do we reconcile and represent issues of consequence — social, political, moral—and so fundamentally personal? This week we'll consider consequence not as a synonym for after-the-fact impact, but as a cautionary tale. What happens when design gets in the way—when it's the enemy?

Assignment—Birds of a Feather:
Adventures in Biomimicry

Week 05: Due February 20
Compassion

This week: a closer look at the relationship between observation and kindness, and at the paradoxical power of communicating without words. Now that you've each considered the cause-and-effect relationship of design and consequence—do you believe that can empathy be learned?

Assignment—Paying it Forward:
Empathic Gamification

What we learn to do, we learn by doing.

Aristotle

**Week 06: Due February 27
Patience**

Before Siri and emojis and push-button everything, we waited for things, which led to a *more reflective* (and by conjecture, a *less reflexive*) predisposition to most things. In a cultural moment that privileges speed, acceleration, and shortcuts—what can patience teach us?

*Assignment—Bearing Witness:
　　Unpacking Longform Narratives*

**Week 07: Due March 06
Solitude**

In an era that will likely be remembered for its embrace of the group-think, the team dynamic frequently trumps the individual moment. This week, we'll look at the surrealist model of the exquisite corpse, and consider solitude as an unusual source—and a surprising catalyst—for creativity.

*Assignment— Passenger, Pedestrian, Person:
　　The Station Project*

**Week 08: Due March 27
Melancholy**

Designers are sometimes mistakenly understood as arbiters of the future, change-agents who package and polish, promote and spin. We know empirically that there is no light without shadow—but how does design address sadness? This week: the ethics of truthtelling, warts and all.

*Assignment— Against Design Imperialism
　　Formal Interventions from Afar*

**Week 09: Due April 03
Authority**

How does design impact attitude, intention, opportunity—and to what extent does the designed thing confer a kind of permission or authority? We'll begin by considering authority as a kind of visual grammar—from stamps to selfies, fingerprints to signatures, diplomas to passports to Facebook pages—questioning the graphic marks and physical attributes that give these artifacts their fascinating and arguably lasting power.

*Assignment: Visualizing Permissions:
　　Designing the ID Card of the Future*

**Week 10: Due April 10
Memory**

To the extent that design appeals to the future, history can seem like an undertow—nostalgic and stultifying, an impediment to invention. Yet the past can beckon as quite the opposite: it's the key to who we were, helping to contextualize all that's come since—and all that's coming next.

*Assignment—Mapping Origin Stories:
　　Studies in Visual Biography*

116

Jessica Helfand

We all have the same inner life. The difference lies in the recognition.

Agnes Martin

117

Week 11: Due April 17
Desire

How does desire impact the things we want, the things we need—and what does it tell us about who we are as individuals, about who we are as a species? This week: a forensic deep dive into our essential choices, and what those choices say about who we are—and what we want.

Assignment— Evocative Objects:
The List Project

Week 12: Due April 24
Change

Just as biomimicry looks at the rhythyms and processes of the natural world as a model for technology and innovation, alternative idioms can spark new ideas, methods, and directions. This week you are asked to import a model across disciplines: in the end, what is more creative than change itself?

Assignment—Other Voices, Other Rooms:
Imagining a Post-Siri Universe

Week 13: May 01
Final Presentations

For your final project, you will expand on one of the topics from the semester by creating an online exhibition. Here, the idea is to go deep, to excavate a more penetrating and comprehensive narrative through a curated selection of the holdings in the Yale University Art Gallery, and amplified by additional independent research.

Blue : The Syllabus
Blue is the color of Gauloise cigarettes and Tiffany boxes, of dungarees, democrats and the earth from space. It represents fidelity ("true blue") and purity ("blue blood"); value ("blue ribbon") and rarity ("once in a blue moon"). The color of the sky and the sea (and according to Kandinsky, the soul), it embraces the melancholy (having the blues) as well as the musical (singing the blues!) and has inspired generations of philosophers, poets and artists. A royal color in the Twelfth century and a romantic color in the Twentieth, Goethe wrote about it, and so did William Gass; Alexander Theroux commits one third of a volume to the color blue, and Picasso devoted three years to it. Last but by no means least, blue has been Yale's color for nearly 200 years.

What is it about the very notion of blueness that provokes the imagination? This seminar, limited to freshmen only, will explore the cultural and iconic history of blue as both a method and a motive for making work in the studio. Experimenting with writing, photography, collage and short-form digital video, students will work with primary sources in the collections at The Birren Color Collection (at Haas Art Library), The Beinecke Rare Book Library, the Yale University Art Gallery and the Peabody Museum of Natural History, among others, responding to existing artifacts while producing new ones.

Weekly Class Times
Green Hall B-03 unless otherwise noted
Monday Afternoon 1-3:15
Wednesday Afternoon 1-2:15

Hours by Appointment Only
Tuesday Afternoons 3 to 5pm
Evans Hall 3560
165 Whitney Avenue

Unit One: Color as Material
Collection Focus: Birren Color Collection, Haas Art Library

Color, as Josef Albers explains so clearly in his book "Interaction of Color", is almost exclusively a function of context. In these early weeks, we'll look at color in all its varieties: hue and tone, value and saturation, weight and stroke, pigment and density. In the studio and in the gallery, we'll consider examples in which color in general — and blue in particular — informs not only the materiality but characterizes the subject itself, thus framing our inquiry.

Wednesday August 31
Blue: Discussion and Q+A

Friday September 2 (make-up class for the following Monday which is Labor Day)
Opening Lecture
Written Assignment 01: Chipped Blue
Due: Wednesday September 07

Wednesday September 07

118

Jessica Helfand

Students spend a semester with the color blue. Through the course Helfand guide students through the myriad historical and cultural manifestations of the color blue. The seminar course rigorously defines blue in all its forms; from the symbolic to the material and even its abstract meaning in various cultures.

학생들은 파란색을 다루며 한 학기를 보낸다. 헬펀드는 이 강좌를 통해 학생들에게 역사적, 문화적으로 무수히 등장한 파란색을 보여준다. 이 세미나 과정은 모든 형태의 파란색을 깐깐하게 정의한다. 상징적인 것부터 물질적인 것까지, 심지어는 다양한 문화에서 파란색이 가지는 추상적인 의미까지도 다룬다.

[Meet at Haas Art Library, Downstairs]
Visual Assignment 01: Harvested Blue
Due: Monday September 12

Monday September 12
Written Assignment 02: Theroux Blue
Due: Wednesday September 14

Wednesday September 14
Visual Assignment 02: Animated Blue
Due: Monday September 19

Monday September 19
[Visiting Artist: Jeff Sher]
Written Assignment 03: *On Being Blue* (William Gass)
Due: Wednesday September 21

Wednesday September 21
Visual Assignment 03: *Am I Blue* (TK)
Due: Monday September 26

Unit Two: Meaning, Language, Paradox
<u>Collection Focus: Yale University Art Gallery</u>

What are the cultural reference points that drive us to understand the difference between turquoise and teal, sea versus sky? In this unit, we'll look at color nomenclature and etymology — language, semantics, mood and memory — and begin building a body of work that collectively embraces multiple valences in terms of both form and content.

Monday September 26
[Meet at Medical Historical Library, 333 Cedar Street]
Written Assignment 04: Poetic Blue (Maggie Nelson)
Due: Wednesday September 28

Wednesday September 28
Visual Assignment 05: Fugitive Blue (Sun Prints)
Due: Monday October 3

Monday October 3
Critique : Fugitive Blue
Visual Assignment 06: 1492 Blue (The Grid Project, part 1)
Due: Wednesday October 5

Wednesday October 5
Critique: 1492 Blue
Written Assignment 05: TKTK
Due: Monday October 10

Monday October 10 (Columbus Day)

The course ties this type of intense study of a single topic to methods of making work in the studio. The course creates a deep dialogue between historic examples and the student creative responses.

또한 이런 유형의 한 가지 주제에 대한 집중적인 연구를 스튜디오의 작업 방식과 연결시킨다. 이 강좌에서는 역사적인 사례들과 학생들의 창의적인 반응 사이에 심오한 대화가 이루어진다.

[Visiting Artist: David Pease]
 [Meet at The Koerner Center, 149 Elm Street]

Wednesday October 12
Visual Assignments 07 (Recessive) Blue (Photography)
Due: Monday October 24

Monday October 17
[no class]

Unit Three: Realism, Symbolism, Representation
Collection Focus: Beinecke / Special Collections
How has this one color come to symbolize the working class as well as the aristocracy, fidelity as well as pornography? During the next few weeks we'll look at the symbolic as well as the hyperbolic as we consider truth and fiction, high culture and low culture, poetry, persuasion, and propaganda.

Monday October 24
[Meet at The Beinecke Library, 121 Wall Street]
Written Assignment 08: Literary Blue (Hilda Doolittle, Joan Didion)
Due: Wednesday October 26

Wednesday October 26
Visual Assignment 08: Musical Blue
Due: Monday October 31

Monday October 31
[Visiting Artist: Mike Errico]
Written Assignment 09: Musical Blue
Due: Wednesday November 2

Wednesday November 02
[Visiting Artist: BMG]
Visual Assignment 09: Performative Blue
Due: Monday November 7

Monday November 7
Written Assignment 10: Olfactory Blue (Guerlain, Chanel)
Due: Wednesday November 9

Wednesday November 9
Visual Assignment 10: Iridescent Blue
Due: Monday November 14

Jessica Helfand

Unit Four: Truth and Paradox:
Collection Focus: The Peabody Museum

The earth from space, the color of the sky and sea, blue is ubiquitous — yet fragile. Branded by the bluebird of happiness, it's also our shorthand for depression. It's the color of our veins, but not of our blood. It thrives in nature but is altogether absent in food. (Horticulture abounds with blue yet there remains, to date, no blue tulip.) In this final unit, we will weigh scientific evidence against unknowable truths, and consider the contradictory properties of this primary, if quixotic color.

Monday November 14
Written Assignment 11: Mythological Blue (Carol Mavor)
Due: Wednesday November 16

Wednesday November 16
[Meet at Peabody Museum, Room TBA]
Visual Assignment 11: Mineral Blue
Due: Monday November 28

NO CLASS WEEK OF NOVEMBER 21 / THANKSGIVING

Monday November 28
Written Assignment 12: Fragile Blue (Carl Sagan)
Due: Wednesday November 30

Wednesday November 30
Visual Assignment 12: The Cyanometer
Preliminary Ideas Due: Monday December 5

Monday December 05 and Wednesday December 07
Prepare for reviews

FINAL REVIEWS Monday December 12
1 to 4pm

커뮤니케이션 세미나 1　　지도교수 : 정진열　therewhere@gmail.com

다양한 종류, 다양한 층위의 정보들이 넘쳐나는 지금의 시기에 그래픽디자이너는
그러한 정보들을 분석하고 관찰하며 상호간의 관련성을 디자인 언어로 표현할 것을 요구받습니다.
이 수업에서는 대상 사물사이의 관련성, 혹은 우리에게 이미 익숙하게 주어져있는 다양한 법칙,
척도, 규범등을 디자이너의 시각에서 조사,관찰하여 하나의 관점과 맥락안에서 표현해볼 것입니다.

사물들, 장소들, 보이는 것들, 보이지 않는 것들, 시간, 움직임, 그러한 대상들을 관찰함으로서
우리는 어떠한 변화가 일어나는지, 그 변화의 과정과 결과, 그리고 그 의미를 파악하고자 합니다.
대상에 대한 온전한 관찰은 다양한 관점과 시각의 변화, 그리고 현상의 앞뒤관계를 명확히 파악하려는
노력으로 부터 시작됩니다. 사물과 대상에 대해서 적극적으로 개입하는 양태의 한 측면이 디자인의
모습중에 하나라면 그 개입에 우선적으로 요구되는 것은 그러한 사물, 대상을 다양한 시점에서 바라보고
분석하며 판단하고 인지할 수 있는 능력입니다. 디자이너는 그 시점의 변화아래서 대상의 가치와
현재, 그리고 가능성, 미래를 판단하고 실행에 옮김으로서 그 대상에 개입해들어갑니다. 그 가운데서
시각적인 변화와 간섭, 혹은 재조직화등의 방법들을 디자이너의 도구로서 적용해나갈 수 있습니다.

이 수업에서는 그러한 대상과 나 자신의 관계를 보다 폭넓은 각도에서 유동적으로 변화시키면서 관찰하고
그 관찰들을 체계화시키면서 맥락을 이해하는 한편 그것을 다른 맥락과 간섭시키거나 충돌시킬 수 있는
다양한 가능성과 능력의 체화에 촛점을 두고자 합니다. 이러한 태도에 대한 훈련은 사전적인 지식이나
선입관에 의해 형성된 정보들을 배제하는 것에서부터 시작되며 그러한 의식적인 습관적 주관의 배제를
위해서 자신의 실천적 경험과 관찰, 자세히 들여다보기, 멀리서 바라다보는등 다양한 시선의 높이와
폭을 확장하려는 노력이 필요합니다. 그리고 그것이 단순히 하나의 순간으로 멈춰버리지 않도록 하기
위해서 그것을 자기시스템화하고 경험된 것들을 맥락으로 엮어낼 수 있는 조망의 능력이 필요합니다.
그것을 위해서 여러분들에게 자기의 관찰을 꾸준히 기록하는 도큐멘팅, 아카이빙의 체계가 요구됩니다.
기존의 맥락에 대한 분석을 토대로 어떻게 재맥락화시킬수 있는가. 기존의 가치에서 어떠한 다른 가치가
생산될 수 있고 그것이 어떻게 원래의 대상과 관계를 맺을 수 있는가. 이러한 질문들을 통하여 우리는
우리가 속해있는 세상을 좀더 깊이 이해하고 관여할 수 있는 지점을 넓혀나갈 수 있습니다.

122

Founder, TEXT
Professor, Kookmin University

A syllabus and assignment brief for the Communication Seminar 1 course taught by member Jin Jung at Kookmin University. The course teaches fundamentals of observation and making, while combining some of Jung's own personal philosophies on design.

국민대학교 정진열 교수의 커뮤니케이션 세미나 1의 강의계획서와 과제 개요. 이 수업에서는 그의 개인적인 디자인 철학과 더불어 관찰과 제작의 기본을 가르친다.

KMU
VCD
2018

————————

2

Asssignment 1 / Happening (8주)

방학동안 일어났던 것들중 기억에 남는 장면 1가지를 가지고 글을 쓴다.
이때 그 장면에 연계된 구체적인 모든 정보를 표현해볼 것 (시간, 온도, 가격, 메뉴등등)
앞서의 방학때의 해프닝을 토대로 이때 그 장면에 연계된 개인,
혹은 타인의 감정을 충실히 묘사해볼 것 (형용사의 사용에 유의할 것)
배경 상황과 장소등에 유의해서 글을 보강하고 이를 장소위에 시각화시킨다.

1] 오리엔테이션

2] 사건 1 - Writing / Fact / Information

3] 사건 1 - Mapping / Fact / Representation

4] 사건 1 - Writing / Emotions / Motivation

5] Mapping / Emotion / Representation

6] Combine 1 / Role & System

7] Combine 2 / Visual Impression

8] Midterm Review

Asssignment 2 / 규칙 (rule) (7주)

우리의 일상속에는 우리가 의식적으로, 혹은 무의식적으로 따라야할 다양한 규칙들이 존재한다.
그것은 규칙이기도하고, 법칙이기도 하고, 규범이기도 하며 철칙이기도 하고 약속이기도 하다.
그것은 상대적이기도 하고, 강제적이기도하고, 묵언적이기도 하다. 이러한 규칙의 다양한 양상,
표현방법, 집행방법등을 찾아보고 그것을 재해석하며, 재규정, 재표현, 혹은 그것을 하나의 프로세스로
드러내보이는 작업을 진행한다.

Johnny Kelly

Animator and director
Film Grand Prix recipient, Cannes Advertising Festival

MakeShapeChange is a project to get young people thinking about how the world is made around them and where design fits in. The project was commissioned by Pivot Dublin and Dublin City Council to promote wider acceptance and use of design as a tool for positive change. 'Shape' is a short film at the heart of this, highlighting the changes happening around us that we don't ordinarily notice, and how they affect us.

MakeShapeChange는 청년들이 주변 세상과 디자인의 연관성을 생각해보도록 유도하기 위한 프로젝트이다. 긍정적인 변화의 도구로서 디자인이 더 폭넓게 수용되고 활용되도록 피봇더블린과 더블린시위원회의 주관으로 제작되었다. 'Shape'라는 단편 영상은 우리 주변에서 흔히 알아채지 못하는 요소가 우리에게 어떤 영향을 주는지 잘 보여준다.

EXHIBITIONS ABOUT EXHIBITIONS[1]

Each group will curate and realize an exhibition about a historically important graphic design exhibition. This exhibition can be large or small, and can be located anywhere from your studio to a public space as long as it's accessible to the public. It need not only be a historical overview, but could also unearth some unknown aspect of the exhibition, or be a conversation starter, a portrait, a comment, a critique, and could include documentation, reproductions/recreations of works, information about the curators, and any other material that you find, collect, or create that expands our understanding of your subject.

Step one:
Choose an exhibition, use the catalogue as a starting point and begin research.
— Read the text, study the work in the show.—Research any other tangential information you can find about the show and the curators. Note artefacts and/or content you could include
— Prepare short presentation about your exhibition to show to class.

Step two:
Develop curatorial concept and develop a brief statement articulating the story you want to tell.
— Determine possible venues.
— Collect artefacts.

Step three:
Based on your concept, pick a venue and make a selection of at least five objects/images/documents, etc., that articulate your narrative.

Step four:
Create some form of display for these objects in the space.

Requirements:
— You must come up with a title and use graphic design to inform visitors about your show and how to navigate it.
— You must include your catalogue as one of the artefacts.

Exhibition opening/critique:
On the last day, the curators will give a walk-through of the exhibition to the faculty and fellow students.

[1] Jon Sueda, Rhode Island School of Design, Providence, US, 2012

Jon Sueda

Founder, Stripe
Chair, MFA Design, California College of the Arts

A workshop brief given to MFA students at the Rhode Island School of Design(RISD). Sueda's brief asks design students to create a meta exhibition where the content is 'exhibitions' and to deal with the myriad of problems and possibilities that arise from that scenario. The brief asks students to dissect and re-examine the exhibition catalog from the perspective of both the designer and the curator.

로드아일랜드스쿨오브디자인(이하 RISD) 석사 과정 학생들에게 주어진 워크숍 개요이다. 수에다의 과제는 '전시' 내용으로 메타 전시를 만드는 것으로, 여기에서 발생하는 무수한 문제와 가능성을 탐구하도록 한다. 과제 요건은 학생들에게 디자이너와 큐레이터 모두의 관점에서 전시 카탈로그를 해부하고 재검토하는 것이다.

Possible Exhibitions:

Dutch Graphic Design, 2000 (curated by Peter Bil'ak),
Moravian Gallery, Brno
Peter Bil'ak, a Slovakian designer living and working in
the Netherlands, examined the context where design is
made in this exhibition. The show displays work from
contemporary Dutch Designers, but also aimed to reveal
the cultural systems behind the work, primarily the
relationship between the commissioner, the public and the
designer.

Kelly 1:1, 2002 (Featuring Experimental Jetset), Casco,
Utrecht, the Netherlands
Kelly 1:1 is an actual-size reproduction/interpretation
of Ellsworth Kelly's painting Blue, Green, Yellow,
Orange, Red, 1966. The iconic piece is reproduced as 150
A4-sized pieces of colored paper, placed in a grid to
match the precise size of the original. The catalog is a
bound version of the same 150 A4-sized colored pages, and
is a 1 to 1 scale version of the installation. This piece
brilliantly blurs the boundaries between an existing art
work, the installation, and publication. Kelly 1:1
received great critical acclaim and was later recreated
in different permutations for several other institutions.

Graphic Design in the White Cube, 2006 (curated by Peter
Bilak), Moravian Gallery, Brno Instead of
decontextualizing previously-made graphic design work by
displaying it in a "gallery," Bil'ak commissioned 19
designers to make posters specifically for the "white
cube." This show looked critically at the issues of
displaying graphic design in a gallery context and
offered a counterpoint to exhibitions where work is
stripped of its original context, use, and meaning.
.

From Mars: Self-initiated projects in graphic design,
2006 (curated by Adam Macháček and Radim Peško),
Moravian Gallery, Brno
From Mars featured graphic design made between 2001-2006,
that embodied a level of critical autonomy that might be
considered "alien" in comparison to traditional client-

based practices. This exhibition exposed an emerging community of young international designers and signaled a "changing of the guard" in the post-1990s era.

Forms of Inquiry, 2007 (curated by Zak Kyes), Architectural Association School of Architecture, London Forms of Inquiry explored the overlap between critical practices in graphic design and architecture. A selection of international graphic designers were asked to contribute three conceptually linked items: an example of past work, an "inquiry" into architectural subject, and a commissioned print based on that subject. This exhibition received a great deal of attention, traveling to six venues all over Europe, and re-set the standard for an expansive exhibition program dedicated to the exchange of knowledge.

Julia Born: Title of the Show, 2009 (curated by Julia Born, Laurenz Brunner, Johannes Schwartz), Museum of Contemporary Art Leipzig Title of the Show was a large scale installation which exhibited various works by Julia Born as oversized pages of a book on the gallery's walls. The catalog for the show is simply photographs of the gallery (by Johannes Schwartz), which translated the exhibition into book form. This show effectively blurs the boundaries between exhibition and book as independent and distinct spaces.
.
Lux et Veritas (Light and Truth), 2009 (curated by Yale MFA Graphic Design class of 09), New Haven, Connecticut There have been many compelling exhibitions created by the MFA Graphic Design program at Yale. Following the lead of the title Lux et Veritas (Light and Truth), this exhibition was 100% video, showing no actual objects. This show responded to the challenge of displaying diverse graphic design formats like books, installations, films, and websites by translating all of them into a series of projected video loops.

Irma Boom - Biography In Books, 2010 (featuring Irma Boom), University of Amsterdam This exhibition was a sampling of Boom's body of work as miniature thumbnail-size dummies set in grids displaying every spread of each book. This unconventional strategy addressed the inherent

Jon Sueda

difficulty of showing books in an exhibition context while conveying Booms signature approach of creating intricate material tests and binding experiments.

Book Show, 2010 (curated by James Langdon and Gavin Wade), Eastside Projects,
Birmingham England Book Show aimed to examine the physical form of the book through artworks, objects, and structures. It's main reference point was Ulises Carrion's book The New Art Making of Books (1975), that insisted that the material that makes up a book should be evident in its construction. One of the most interesting aspects of this exhibition was the accompanying publication which
was conceptualized as another site for projects in the exhibition and included Carrion's essay, along with newly commissioned work.
.

Graphic Design Now in Production, 2011 (curated by A ndrew Blauvelt, Ellen Lupton), Walker Art Center Graphic Design Now in Production was one of the largest and most ambitious projects of its kind. The show thoroughly covered the state of contemporary graphic design practice by including an enormous range of medias, formats, and diverse types of work. The catalog was an amazing achievement, containing both previously written material and newly commissioned writing by many of the thought leaders in our discipline. To this day it's the quintessential "reader" for contemporary design practice.

You are currently the Chair of the MFA Design program at California College of the Arts (CCA). Could you please describe the department and your role within it?

Mainly, I fulfill the normal duties of the Chair: developing the curriculum, managing faculty, facilitating any visiting artists lectures and workshops, any kind of programming the students are doing and extra-curricular relationships with outside institutions.

When I got the job, we were expanding from a two-year program to a three-year program. It was a great opportunity to address the issues that I felt could improve. What do we need to do with this extra year to prepare students to flourish in an interdisciplinary space? (As the Chair) I was able to totally start from scratch and hire specific faculty members to develop the types of courses that I thought students would need to be productive in an interdisciplinary two-year program. It was a good opportunity to rethink our methods and take some ownership over how we approach design education.

Could you elaborate on origins of the interdisciplinarity at CCA? What were the challenges of integration and what hurdles did you and your faculty face in evolving the disciplines?

The history (of CCA's MFA Design program) goes back to around 2003, when Lucille Tenazas (AGI 1998), started the first MFA Graphic Design program. The first five-to-six years of the program was only graphic design. In 2007, Lucille moved to New York and the incoming chair was Brenda Laurel, who was already running the Media Design program at Pasadena Art Center, which was an interdisciplinary program, or at least starting to experiment with a less discipline-specific (structure). Brenda Laurel and Larry Rinder, who was the Dean [at CCA], came up with this idea of a specifically interdisciplinary program that included graphic, industrial and interaction design. (The program) mirrored what they thought was the future of design practice; [a future where] designers aren't going to stick to their own specific areas, but where different disciplines will work together.

Jon Sueda

당신은 현재 캘리포니아예술대학(이하 CCA)에서 MFA 디자인 프로그램의 학과장이다. 학과와 그 안에서 맡은 역할에 대해 설명해달라.

주로 나는 교육 과정 개발, 교수진 관리, 방문 예술가의 강의와 워크숍, 학생들이 하고 있는 모든 종류의 프로그래밍 그리고 외부 기관과의 특별한 관계 촉진 등 학과장의 일반적인 의무를 다 한다.

내가 그 일을 맡았을 때, 학교는 2년짜리 프로그램을 3년짜리로 확장하고 있었다. 개선 가능하다고 느꼈던 문제들을 다룰 수 있는 좋은 기회였다. 학생들이 학제간 공간에서 잘 성장하도록 준비하기 위해 새로 추가된 1년을 어떻게 운영할까? 학과장으로서 나는 아주 처음부터 시작해서 특정 교수들을 고용하여 2년짜리 학제 간 프로그램에서 학생들이 생산적으로 참여해야 할 과목을 개발할 수 있었다. 우리의 방법을 재고하고 디자인 교육에 접근하는 방식에 대하여 주인의식을 가질 수 있는 좋은 기회였다.

CCA의 학제 간 연계성 기원에 대해 자세히 설명해달라. 통합의 도전 과제는 무엇이었으며, 당신과 교수진은 학문 분야들을 개발하면서 어떤 어려움을 겪었는가?

(CCA의 MFA 설계 프로그램의) 역사는 루실 테나자스가 최초의 MFA 그래픽 설계 프로그램을 시작한 2003년 즈음으로 거슬러 올라간다. 이 프로그램의 처음 5-6년은 그래픽 디자인에 국한되었다. 2007년, 루실이 뉴욕으로 옮긴 후 부임한 학과장이 브렌다 로렐이었는데, 그녀는 이미 패서디나아트센터에서 학제 간 프로그램인 미디어 디자인 프로그램을 운영하고 있었다. 최소한 분야별 구조에 제한을 덜 받는 실험에 착수하고 있었다. 브렌다 로렐과 학장이었던 래리 린더는 그래픽, 산업 및 인터랙션 디자인을 포함하는 분명하게 학제적인 프로그램에 대한 아이디어를 생각해냈다. (그 프로그램은) 그들이 디자인 실무의 미래라고 생각한 것을 반영했다. 그것은 디자이너들이 특정 영역을 고수하지 않고, 서로 다른 분야가 어우러져서 함께 일하는 미래였다.

나는 2007년, MFA 디자인 프로그램 시작과 함께 CCA에서 가르치기 시작했다. 학과장이 되기 전 약 6-7년 동안 교수로 재직했다. 전문적 실무에서는 분야 사이에 장벽이 있어서

Jon Sueda (AGI USA 2016) became Chair of MFA Design at California College of the Arts (CCA) in Fall 2014. Before becoming Chair, he was a faculty member for several years, helping to develop the program as a distinctly interdisciplinary design education. In 2014, he curated the exhibition 'All Possible Futures', which coincidentally influenced much of his thinking behind the education at CCA.

존 수에다(Jon Sueda, AGI USA 2016)는 2014년 가을 CCA에서 MFA 디자인 학과의 학과장이 되었다. 학과장이 되기 전에 몇 년 동안 교수로 재직하며 뚜렷하게 학제적인 디자인 교육 프로그램을 발전시키는 데 도움을 주었다. 2014년에 그는 <모든 가능한 미래> 전시회를 기획했는데, 그것이 우연히도 CCA의 교육 이면에 있는 그의 생각에 큰 영향을 주었다.

I started teaching at CCA in 2007 when the MFA Design program started. I was a faculty member before I became Chair, for about six-seven years. There were a lot of growing pains in the beginning because there are these walls, barriers between the disciplines that exist in real professional practice. At the beginning it was hard to interrogate those conventions, because people weren't used to it. There was some friction sometimes.

I remember I co-taught a class with an industrial designer. He was wanting me to step down for a while and reenter the project later in the term, after he had gotten (the students) to design all the physical work, and then I could teach them how to design the logo to stick on all of it. That was really frustrating and it was an experience I had early on.

Those divisions point out a paradox in design education; combining professional experiences without limiting the possibilities of expanding how design is defined. What were some of the challenges breaking down those barriers between disciplines?
I think the challenge is how do you address disciplinarity or do you ignore it? For a while, we tried to not address ourselves in disciplines and ignored their existence. I had the luxury of seeing the program develop the first seven years before I had to do anything about it. So, it was much easier for me to come in and see what's happening and suggest what might work better.

What we did in 2014, was instead of ignoring disciplinarity, we re-centered on the disciplines, the philosophy being that in order to be an "interdisciplinary" designer, you need to have a discipline. The first year of the three year program (for students who don't have much a design background) is discipline specific, they learn foundations in either graphic design, industrial design or interaction design. They become centered around that discipline in that initial year. The idea being to expand the perimeters of that discipline in the following two years where the curriculum is totally interdisciplinary. The expansion of that discipline, would increase the responsibility of what

처음에는 많은 성장통이 있었다. 처음에는 사람들이 그것에 익숙하지 않았기 때문에, 그러한 관습에 의문을 제기하기가 어려웠다. 때로는 약간의 마찰이 있었다. 어떤 산업 디자이너와 함께 강의했던 기억이 난다. 그는 내가 잠시 물러났다가 나중에 그 프로젝트에 다시 참여하기를 원했다. 그는 학생들에게 모든 물리적 작품의 디자인을 이미 지도했고, 나는 그 이후에 작품에 붙일 로고 디자인 방법을 가르칠 수 있었다. 처음에는 그렇게 불만족스러운 경험을 하기도 했다.

그러한 구분은 디자인 교육의 역설을 가리킨다. 즉 디자인의 정의를 확장할 가능성을 제한하지 않고 전문적인 경험을 결합하는 것이다. 학문 사이의 그러한 장벽을 무너뜨리는 도전 과제들은 어떤 것이 있었는가?
학문 분야를 어떻게 구분하느냐 아니면 무시하느냐가 과제라고 생각한다. 한동안 우리는 자신을 학문 분야 안에서 다루지 않으려고 노력하며 분야의 존재를 무시했다. 나는 조치를 취하기 전에 그 프로그램이 처음 7년 동안 발전하는 것을 바라볼 여유가 있었다. 그래서 내가 와서 무슨 일이 일어나고 있는지 살펴보고 더 좋은 방향을 제안하기가 훨씬 쉬웠다.

2014년에 우리가 한 일은 분야 구분을 무시하는 대신, 학문 분야에 다시 중점을 두는 것이었다. "학제적인" 디자이너가 되기 위해서는 일단 학문 분야가 있어야 한다는 철학이었다. 3년 과정의 첫 해에는 학생들은 분야를 특정 지어서 그래픽 디자인, 산업 디자인 또는 인터랙션 디자인의 기초를 배웠다. 그들은 첫 해에 그 분야를 중심으로 공부하게 된다. 디자인 기초가 별로 없는 학생을 위해서다. 커리큘럼이 완전히 학제적이 되는 다음 2년 동안 그 분야의 경계를 넓히는 것이다. 그러한 분야가 확대되면 그래픽 디자이너가 할 일이나 산업 디자이너가 할 일 면에서 책임이 커진다. 그 지점이 하이브리드적 성격이 개입하는 부분이고, 내가 보기에 상당히 잘 된 것 같다.

전에는 학생들이 구름 속에서 수영하듯이 무엇을 해야 할지

Alongside his teaching, Sueda runs a design and curatorial practice called Stripe SF. We spoke about the challenges developing an interdisciplinary curriculum on the graduate level over Skype. Arranged, conducted and edited by Chris Ro and James Chae.

수에다는 수업과 병행하여 '스트라이프 SF'라는 디자인과 큐레이터 실무 과정을 운영한다. 우리는 스카이프를 통해 대학원 수준의 학제간 커리큘럼을 개발하는 도전 과제에 대하여 이야기를 나누었다. Chris Ro와 James Chae가 인터뷰의 진행, 정리, 편집을 맡았다.

131

a graphic designer would do or what an industrial designer would do. That's where the hybridity comes in and I think it's worked pretty well.

It gives students more barriers to push against, whereas before students were just swimming in a cloud, unsure of what you're supposed to be doing, not knowing what rules to break. Now, the students know what a graphic designer is supposed to do. They can interrogate that. It becomes a lot clearer how to be an interdisciplinary designer once you know the core of your discipline.

<u>What are some specific advantages that come from this re-centering and definition of the various disciplines?</u>

So, the three year program is a way of generate our own students. We kind of crash course (the students) into learning both making skills and critical skills that will allow them to blossom in the two-year program. It's very similar to giving somebody an accelerated undergraduate program in a year, which is kind of impossible. Of the three disciplines, graphic design is probably the easiest to learn all the skills, because many people seem to know the digital tools of graphic design more than how to cut a piece of plywood in half (laughs). The tools aren't as hard and there isn't as much handcrafting.

We expanded the types of tools that a graphic design student might use in relation to the other two disciplines. For example graphic designers will take a typography class and a programming class, but they also have the option to take model making or something that's out of their usual scope if that's what they're interested in. We've added Processing and code-related stuff, just to give an expanded toolset for students so that they get used to the idea of learning things outside of their disciplinary scope.

<u>How have you gone about leading the faculty to support such a direction, particularly for the three-year program?</u>

It was about bringing a faculty together who are comfortable with breaking the walls down a little bit, to get rid of this defensiveness. To be more open

Jon Sueda

모르는 상태로, 어떤 규율을 깨야 할지 알지 못했다. 그러나 이런 접근법은 학생들이 무너뜨릴 장벽을 더 많이 제공한다. 이제 학생들은 그래픽 디자이너가 하는 일을 잘 안다. 그들은 그에 관해 의문을 제기할 수 있다. 일단 자기 분야의 핵심을 알게 되면 학제 간 디자이너가 되는 방법이 훨씬 더 분명해진다.

다양한 분야에 다시 중점을 두고 분야를 재정의하여 얻는 구체적인 이점은 무엇인가?

그래서 우리는 3년 과정으로 프로그램을 운영한다. 학생들이 후반 2년 동안 프로그램에서 능력을 꽃피울 수 있도록 교과목을 (학생들에게) 밀어 넣어 제작 기술과 비평 기술을 모두 가르친다. 이것은 1년 안에 학부 과정을 속성으로 제공하는 것과 매우 유사하며, 거의 불가능한 일이다. 세 분야 중에서 그래픽 디자인이 아마도 기술을 모두 배우기가 가장 쉬울 것이다. 많은 사람들이 합판을 반으로 자르는 방법보다 그래픽 디자인에 사용되는 디지털 도구에 더 익숙한 것 같기 때문이다. 단단한 도구도 없고, 수공예 작업도 그리 많지 않다.

우리는 그래픽 디자인 전공 학생이 다른 두 분야와 관련하여 사용할 수 있는 도구의 유형을 확대했다. 예를 들어, 그래픽 디자이너들은 타이포그래피 수업과 프로그래밍 수업을 듣겠지만, 관심이 있다면 모형 제작이나 평상시 범위를 벗어난 과목을 선택할 수 있다. 우리는 학생들이 자기 분야 범위 밖에 있는 것들을 배운다는 개념에 익숙해지도록, 단지 확장된 도구 세트를 제공하려고 프로세싱과 코드 관련 내용을 추가했다.

교수들이 그런 방향을 지지하도록, 특히 3년제 프로그램을 위해 어떻게 그들을 이끌어갔나?

이 문제에 방어적인 태도를 없애기 위해 비교적 선입견이 없는 교수진을 하나로 모으는 것이 중요했다. 우리가 할 수 있는 일에 대해 그리고 분야 경계선을 거론하지 않는 과제를

about what we could be doing and creating assignments that don't speak to disciplinary boundaries. If you have a class that's about making a specific industrial product i.e. we're going to make lamps together, that is exclusionary to certain disciplines. Whereas, if you say we're going to experiment with light as a material, it opens it up to all disciplines.

We actually have a studio called 'Light Studio' where some industrial designers make experimental lamps and things like that, but graphic designers explore 'light' in a totally different way. In the past, students have built their own image recording devices, light based installations, and used light as a material for other kinds of image making strategies. I don't think we've totally figured it out yet, but I think the longer people have taught in the program they've been able to leverage the possibilities. The program challenges faculty to come up with something that's more context specific. The longer they are part of the program the more they can explore this.

We see a lot of parallels between the interdisciplinarity of CCA's MFA Design program and the exhibition you curated, 'All Possible Futures'. We find this especially true because of how you apply the term 'speculative design' to graphic design practices. We think 'speculative design' and 'possibilities' are strong keywords that could be attached the pedagogical vision at CCA.
When I first started using the term 'speculative design', it was a critical response to the term 'spec work' in graphic design, which is really unconnected to "speculative design." It was funny, because that term emerged and has evolved very quickly, specifically because of the book 『Speculative Everything』 by Dunne and Raby, which came out around the same time All Possible Futures opened. Dunne and Raby had been working in that realm for a while, but it was out of the scope of graphic design, so I didn't hear or know about it. So that term, has a lot more weight now, especially because of that book as well as their amazing work and designers and educators.

창출하는 것에 대해 좀 더 개방적이고자 했다. 특정 산업 제품을 만드는 강의가 있다면, 예를 들어 램프를 함께 만든다면, 특정 분야에 국한된다. 반면에 빛을 소재로 실험한다고 하면 그 수업은 모든 분야에 열려 있을 것이다.

우리 학교에 실제로 '라이트 스튜디오'라는 작업실이 있다. 산업 디자이너는 실험적인 램프 같은 것을 만들지만, 그래픽 디자이너는 전혀 다른 방식으로 '빛'을 탐구한다. 과거에 학생들은 그들만의 영상 기록 장치와 빛 기반 설치물을 만들고, 다른 종류의 영상 제작 전략을 세우는 데 빛을 소재로 사용했다. 아직 완전히 파악된 것은 아니지만, 이 프로그램에서 오랜 기간 가르칠수록 교수들이 가능성을 더 잘 활용하게 된 것 같다. 교수진에게 좀 더 구체적인 상황의 학습을 제시하도록 요구하기 때문이다. 프로그램과 함께한 시간이 길수록, 이 부분을 더 많이 탐구할 수 있다.

CCA의 MFA 디자인 프로그램과 당신이 기획한 전시 <모든 가능한 미래> 사이에 많은 유사점이 보인다. 특히 당신이 그래픽 디자인 실무에 '스페큘러티브 디자인'이라는 용어를 적용해서 더욱 그렇다. 나는 '스페큘러티브 디자인'과 '가능성'이 CCA의 교육학적 비전에 붙일 수 있는 중요한 키워드라고 생각한다.
내가 '스페큘러티브 디자인'이라는 용어를 처음 쓰기 시작했을 때는 그래픽 디자인에서 '스펙 워크(spec work)'라는 용어에 대한 비판적인 대응이었다. 이는 '스페큘러티브 디자인'과는 정말 무관하다. 재미있게도, 그 용어가 등장하고 나서 특히 앤서니 던과 피오나 래비의 책『스페큘러티브 에브리싱』때문에 매우 빠르게 진화해왔다. 그 책은 <모든 가능한 미래> 전시가 시작될 즈음에 출간되었다. 던과 래비는 한동안 그 영역에서 일하고 있었지만 그래픽 디자인의 범위 밖이었기 때문에 나는 관련 소식을 전혀 몰랐다. 그래서 그 용어가 현재 훨씬 더 큰 비중을 차지하고 있는 것은 그 책과 더불어 두 지은이들의 놀라운 작업 그리고 디자이너와 교육가들 덕분이다.

MFA 디자인에 끼친 영향으로 말하자면 '스페큘러티브 디자인'의 지분이 정말 크다! 우리는 실제로 이런 식으로 일하는

As far as the influence on MFA Design, 'speculative design' has had a huge impact!. We regularly bring in a visiting designer once a year who is really working in this way and have them do a workshop with students and establish it as a desirable way to practice (design). We've also started a speculative research course that explores these methods with some depth. A lot of students have become interested in this approach, and it's become a core area of interest for the program for sure.

What are some demographic changes you have noticed or dealt with as the MFA Design program has evolved?

To me it feels like in the last fifteen years there's way more career changers in design, people who want to be designers but don't have design backgrounds. Whereas, when I was in grad school twenty years ago, everybody had an undergrad degree and 3–4 years experience and there'd be one or two wild card people who had other kinds of backgrounds. Now it seems like everybody, like 80% don't have design backgrounds and only 1–2 people have experience.

Another aspect of teaching in an interdisciplinary space is how to deal with design history and theory. Throughout the program we have a series of courses called 'Designed in Context', which are theory, history and critical writing classes. How do you deal with all the disciplines that each have different lenses upon history? Who has the expertise to span that diverse material and make sense of it?

I see that this challenge in general, where many institutions are super concerned with diversifying the kind of material we're teaching and the broadening the references that students have. I'm totally in support of this, but the hard part is that it's a huge challenge to teach design history with a global lens without sacrificing detailed knowledge and leveraging many of the specializations faculty bring to the table. This course is a small microcosm of that issue, but even dealing with the history and theory of three different disciplines, it's really hard to find a coherent narrative.This is a longer discussion, but I think

Jon Sueda

객원 디자이너를 데려와 정기적으로 1년에 한 차례 학생들과 함께하는 워크숍을 열고 바람직한 (디자인) 실무 방법으로 정착시킨다. 이런 방법을 어느 정도 깊이 있게 탐구하는 사색적 연구 과정도 시작했다. 많은 학생이 이 접근 방식에 관심을 갖게 되었고, 이는 확실히 프로그램의 주요 관심사가 되었다.

MFA 디자인 프로그램이 발전하면서 당신이 알아차렸거나 다루었던 인구통계학적 변화는 무엇인가?

내가 보기에 지난 15년 동안 디자인 분야로 진로를 바꾼 사람들, 즉 디자이너가 되고 싶지만 디자인 경력이 없는 사람들이 훨씬 많아진 것 같다. 20년 전에 내가 대학원에 다닐 때는 모두가 학부 학위와 3-4년의 경험이 있었고, 다른 경력을 가진 와일드 카드가 한두 명 있었다. 이제 거의 전부, 80% 정도가 디자인 관련 경력이 없고, 한두 명 정도만 경험자인 것 같다.

학제적 공간에서 가르치는 또 다른 측면은 디자인 역사와 이론을 다루는 방식이다. 프로그램 전반에 걸쳐서 우리는 'Designed in Context'라는 일련의 교과목을 두고 있는데, 이론과 역사와 비평적 글쓰기 수업이다. 역사에 대해 각각 다른 렌즈를 적용하는 온갖 분야를 어떻게 다룰 것인가? 그 다양한 자료를 넘나들며 이해할 만한 전문 지식을 가진 사람은 누구인가?

이런 문제들은 일반적인 현상이라고 본다. 많은 기관이 강의 자료를 다양화하고 학생들이 가지고 있는 참고 자료의 폭을 넓히는 일에 지대한 관심이 있다. 나는 전적으로 이를 지지한다. 하지만 어려운 점은 상세한 지식을 희생하고 교수진이 도입하는 전문 분야들을 활용하지 않으면 글로벌한 시각에서 디자인사를 가르치기가 엄청나게 힘든 도전이라는 것이다. 이 강좌는 그 문제의 축소판이다. 세 가지 학문 분야의 역사와 이론을 다루더라도 일관성을 갖고 서술하기가 정말 힘들다. 이야기하자면 긴 문제이지만, 더 나은 방법으로 목표를 달성할 수 있는 대안적인 교육 구조가 있다고 생각한다.

there are alternative educational structures that might achieve this in a better way.

<u>How do you manage student expectations for professional practice?</u>
The students have really different intentions and diverse goals. There are students who want to have a job at a Bay-Area-based tech company, there are some who want to be academics and make strange projects, there are some who want to start an art practice and want to do artist residencies. There's a huge range of intentions with the students. So, what we've done in the program is diversify types of practices or different ways of working. When I inherited the program we had a 'Business of Design' class, which was very much geared toward that 'shark tank' model where you teach students to be entrepreneurial and develop a product and learn how to pitch it to stakeholders. To me, that's a real thing obviously, but I saw other students who weren't interested in that at all, who wanted to develop a more artistic practice or others who wanted to develop a more research practice. As the program grew, we broke that class into more sections and added other approaches that spoke to these interests.

We have Luka Antonucci of Colpa Press, who's an artist running a publishing imprint in a basement studio space. They work with artists and generate publications and exhibitions. So, he teaches a section of that class [to students] who want to learn how to write an artist grant or how to make a proposal. It's still entrepreneurial, but not in the way that you're pitching to investors, but starting to run a small publishing imprint or bookstore. The goal is to expose students to different kinds of practices.

<u>Lastly, let's confront the reality of CCA being located in San Francisco and at the heart of the technology economy. How have you dealt with this proximity?</u>
I still think that many students come to CCA because of the location. A lot of them see all these tech companies surrounding the Bay Area as future employers, and just want to go to a school that'll feed them into

135

전문적 실무에 대한 학생들의 기대도 있을 텐데, 이를 어떻게 관리하는가?
학생들에게는 정말 다른 의도와 다양한 목표가 있다. 샌프란시스코 베이에어리어 지역의 기술 회사에 취직하고 싶은 학생도 있고, 학자가 되어 독특한 프로젝트를 하고 싶어 하는 학생도 있고, 미술 작업을 시작하여 예술가 레지던시를 하고 싶은 학생도 있다. 학생들 안에서 의도하는 범위가 매우 넓다. 그래서 우리는 이 프로그램에서 실무의 유형이나 작업 방식들을 다양화했다. 내가 이 프로그램을 이어받았을 때, 'Business of Design'라는 수업이 있었다. 학생들에게 사업가적 소양을 가르치고 제품을 개발하며 그것을 이해당사자에게 알리는 방법을 배우는 '샤크 탱크(Shark Tank, 창업 투자 유치 오디션 방송)' 모델에 매우 잘 맞추어져 있었다. 나는 그것이 분명히 현실을 잘 반영했다고 생각했지만 그것에 전혀 관심이 없는 다른 학생들, 좀 더 예술적인 작업을 하고 싶어 하거나 좀 더 연구에 매진하고 싶어 하는 학생들도 보았다. 프로그램이 발전함에 따라, 우리는 그 수업을 더 많은 섹션으로 나누고 이러한 관심사에 맞는 다른 접근법들을 추가했다.

콜파 출판사의 루카 안토누치는 지하 스튜디오 공간에서 출판 임프린트를 운영하는 예술가이다. 다른 예술가들과 함께 일하며 출판물을 내고 전시회도 연다. 그래서 그는 수업의 한 섹션에서 예술가 보조금 신청서나 제안서 작성 방법을 학생들에게 가르친다. 이 부분도 여전히 기업가적이긴 하지만 투자자에게 홍보하는 방식이 아니라, 작은 출판 임프린트나 서점 운영을 시작하는 방식을 다룬다. 목표는 학생들을 다른 종류의 실무에 노출시키는 것이다.

마지막으로 CCA가 샌프란시스코에 있고 기술 경제의 중심에 자리한 현실을 직시해보자. 이런 근접성을 어떻게 다루어왔나?
나는 아직도 많은 학생들이 위치 때문에 CCA를 선택한다고 생각한다. 그중 다수가 베이에어리어 주변의 모든 기술 회사들을 미래의 고용주로 보고 있고, 단지 자기들을 그 기계에 끼워 맞춰줄 학교에 가고 싶어 한다. 그리고 우리는

that machine. And we've resisted. The program leans toward more of a critical lens or a critical practice of design and does not want to become a feeder to a particular industry. We don't have a course that teaches you how to prep proposal boards for making phone apps and stuff like that. We don't teach them that kind of stuff. Hopefully we're training them to be critical of these industries that we're surrounded by and make work that comments upon it rather than affrims what they already do.

It's funny though, because as graduate students, we don't tell them what to do that much, so some students come and they want to get a job at a specific company or any number of companies and want to do really specific things like make apps for phones. So, they work for two years and all you see is an effort to fit into the established norms and not really question their existence.

Then you have these other students who make strange critical work about phone addiction and they make these objects that kind of subvert your understanding of the existing tools or technologies. Ironically those are the students that get hired by the technology companies! (laughs) Those are the students that those companies want to hire.

Jon Sueda

그런 흐름에 저항해왔다. 우리 교육 프로그램은 디자인에서 비평적인 시각 혹은 비평적인 실무 쪽으로 기울어 있으며 특정 산업에 인력 공급원이 되고 싶지는 않다. 우리 학교는 전화 앱 같은 것을 만들기 위한 제안서 준비 방법을 가르치는 수업이 없다. 우리는 그런 것을 가르치지 않는다. 학생들이 이런 산업에서 하는 일들을 긍정하기보다는, 주변의 산업에 비평적인 태도를 가지고 그에 관해 언급하는 작품을 만들기 바라는 것이 우리가 학생들을 가르치는 마음이다.

하지만 재미있게도, 학교에서는 대학원생에게 무엇을 해야 하는지 많은 이야기를 하지 않기 때문에 일부 학생들은 여기 와서 특정 회사 혹은 몇몇 회사에 취직하기를 원하고 전화 앱 같은 정말 구체적인 것들을 만들고 싶어 한다. 그래서 그런 학생들은 2년 동안 공부를 해도 내내 기존 규범에 적응하려 노력하며 존재에 대해서는 의문을 품지 않는다. 그리고 전화 중독에 대해 특이한 비평적 작업을 하는 학생들도 있는데, 그들은 기존의 도구나 기술에 대한 이해를 뒤집는 사물을 만든다. 아이러니하게도 그런 학생들이 기술 회사에 취직한다. 그런 사람이 바로 기술 관련 기업이 고용하고 싶어 하는 학생이다.

137

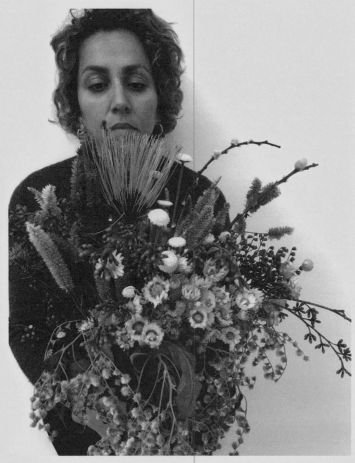

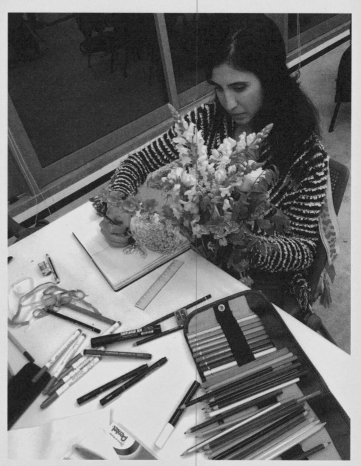

Kiko Farkas

Founder, Máquina Estúdio
Founder, ADG, Brazilian association of graphic designers
Teaches at Miami Ad School

A two-day project where students study and respond to the natural beauty of flowers. After a visit to the local flower market, students use the natural materials of the bouquet to create unique compositions and examine every aspect of the material they are manipulating.

이틀에 걸쳐 꽃의 자연적인 아름다움을 연구하고 그에 적절히 대응하는 프로젝트이다. 학생들은 현지 꽃시장을 방문하고 꽃다발이라는 자연적 재료를 사용하여 독특한 구성물을 창작하며 다루는 재료의 모든 면면을 살펴본다.

EXERCISE OF FLOWERS
1st semester of Graphic Design program
Purpose of the workshop

Awakening and refining the perception thru a real life experience.
Working with real flowers students include other senses than vision. Smell, tactile, audition
are powerfull senses that can give more dimensions to what we see. Can help us discern
more information than we usually do.
Weight, texture, temperature and other impressions interfere in the way we create
knowledge.

Show a few works by artists who have already drawn / painted flowers / plants
Margaret Mee / Van Gogh / Cézanne / Hockney / Japanese etc

Day 1

1. Meeting at 6:00 p.m. at street flower stands to buy flowers.

Each student buys one or two bouquets (cost approximately R$ 50,00 but whoever wants
can buy something with higher / lower cost)
Each student brings a vase from home.
Each student brings a good scissors / cutting tool.

2. We collect all the flowers and vases in my car, plus some students. The others go on
their own motorcycle or track to school.

3. Arrival at school at 7pm. Organization of flowers on a big working table.
Each student must assemble at least two bouquets in their pots (or change pots...)

Throughout the process each one must assemble an A5 (folded A4) booklet to document
the entire process, and create a narrative/book that will be used later. Print and bound it.
Bring on the next day

Remember to illuminate / arrange the bouquets for photographing.

4. Once the bouquets are done the students should choose one and do a structural
analysis of it, observing some characteristics such as:

- verticality / horizontality
- shapes (round, pointed, regular, etc.)
- the way each flower / foliage relates to the other
- if the bouquet is closed or open, circular or triangular (sharp?)
- textures / combinations
- big / small
- beautiful / ugly
etc

Total time day 1: 7 - 11PM

139

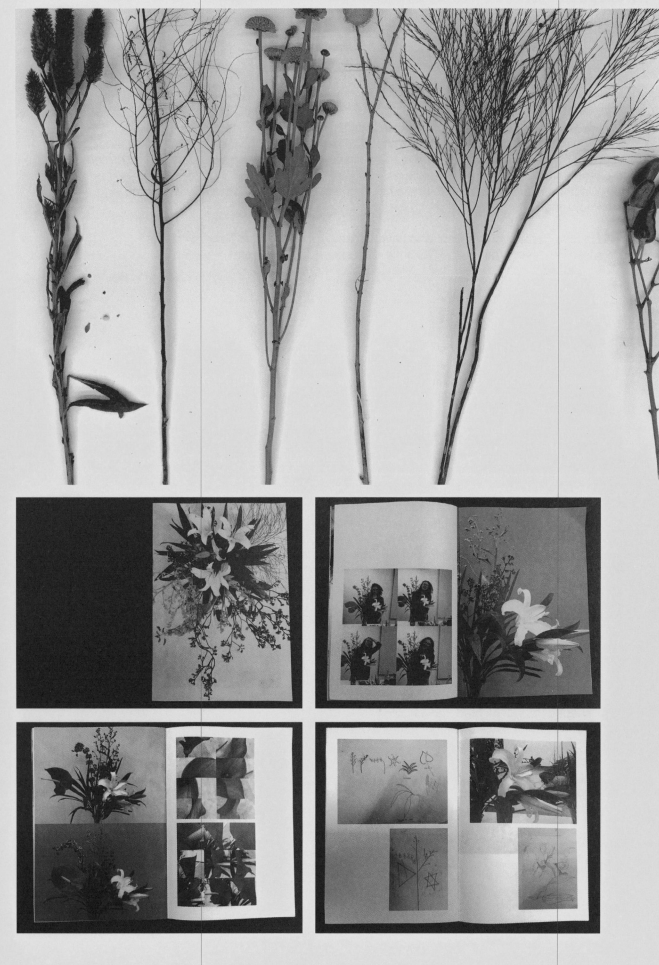

140

Kiko Farkas

Day 2

5. Students should do a chromatic analysis of the bouquet and create a palette with the colors found, relating them. To do this, you can use any color resources you have such as colored pencil, (wax)
markers
water color
acrilic
Pantone (directly in some softwares)
etc

6. After the above work, choose a flower and write, in an A3 leaf, the name of that flower using everything that was seen / learned:

- form
- color(s)
- perfume
- history / tradition
- texture
- size
- structure (thorns / bunches, etc.)

expressing what makes its identity / oneness. (In the case of a daisy, for example, its *daisyness)*

7. Delivery of the printed and bound booklet

8. Exposure and criticism of the work

Total time day 2: 7 - 11PM

141

타이포그래피 워크샵

2008학년도 2학기 신입생 세미나

2008-2	지정일	신입생		49-309
	김경선	ks1@snu.ac.kr / 49-303		

강의개요 　이 수업은 커뮤니케이션디자인 전반에 걸쳐 지속적인 훈련이 필요한 타이포그래피가
공공디자인, 뉴미디어, 영상, 아이덴티티, 광고, 패키지, 일러스트레이션, 출판등
시각디자인 전분야에 걸쳐 초석이 되는 기본 소양임을 교육함과 동시에 타이포그래피에
대한 흥미를 부여하고자 오픈세미나의 형식으로 진행된다.

수업평가 　6회의 출석, 에세이, 호기심 + 마지막 과제

에세이	독후감 : A4 1장		9.24.수 제출
	타이포그래피란 무엇인가?	데이비드 주어리	2008
	What is Typography?	David Jury	2006

수업일정

9.3.수 17:00	오리엔테이션			
9.24.수 17:00	특강1	조현	공개강좌 에세이 제출	309호
10.7.화 17:00	특강2	최문경	공개강좌	309호
10.22.수 17:00	특강3	임진욱	공개강좌	309호
11.5.수 17:00	특강4	고원	공개강좌	309호
11.19.수 17:00	종강		과제 발표	

142

Kyungsun Kymn

Professor, Seoul National University
Director, Typojanchi Biennale 2015

9 semesters of typography workshop classes at faculty of design, Seoul National University in Korea. Every semester, numerous speakers were invited to give talks on typography and the talks were archived and published in book form. Finally the lecture series was combined and published as a single book called The Forest of Typography.

한국의 서울대학교 디자인 학부에서 아홉 학기 동안 진행한 타이포그래피 워크숍 수업이다. 매 학기 타이포그래피와 관련된 여러 강연자를 섭외해서 강의를 진행하였으며 그 기록을 책 형태로 출판했다. 최종적으로 이들 모은 『타이포그래피의 숲』이라는 단행본이 출판되었다.

타이포그래피 워크샵

2012학년도 1학기 신입생 세미나

2012-1	지정일	신입생	49-309	
	김경선	ks1@snu.ac.kr / 49-303		

강의개요 이 수업은 문자를 디자인하거나 다루는 것을 훈련하는 타이포그래피가
예술과 디자인 전분야에 걸쳐 초석이 되는 기본 소양임을 교육함과 동시에
타이포그래피에 대한 흥미를 부여하고자 오픈세미나의 형식으로 진행된다.

수업평가 6회의 출석, 에세이, 호기심 + 마지막 과제

수업일정

3.21.수	1700	오리엔테이션			
4.4.수	1800-	특강1	오진경	309호	에세이 제출
4.18.수	1800-	특강2	조현열	309호	
5.2.수.	1800-	특강3	이영준	309호	
5.16.수	1800-	특강4	이기섭	309호	
5.30.수	1700	종강			

에세이	독후감 : A4 1장	4.4.수 제출
	타이포그래피워크샵 시리즈 중 택1	

타이포그래피 워크샵

2011 학년도 2학기 신입생 세미나

| 2011-2 | 지정일 | 신입생 | 49-309 |
| | 김경선 | ks1@snu.ac.kr / 49-303 | |

강의개요 이 수업은 커뮤니케이션디자인 전반에 걸쳐 지속적인 훈련이 필요한 타이포그래피가
공공디자인, 뉴미디어, 영상, 아이덴티티, 광고, 패키지, 일러스트레이션, 출판등
시각예술 및 디자인 전분야에 걸쳐 초석이 되는 기본 소양임을 교육함과 동시에
타이포그래피에 대한 흥미를 부여하고자 오픈세미나의 형식으로 진행된다.

수업평가 6회의 출석, 에세이, 호기심 + 마지막 과제

| 에세이 | 독후감 : A4 1장 | | 9.14.수 제출 |
| | 타이포그래피의 탄생 | 로빈 도드 | 2010 |

수업일정

9.14.수 17:00	오리엔테이션		독후감 제출	309호
9.28.수 18:00	특강1	김도형	공개강좌	309호
10.12.수 18:00	특강2	김성규	공개강좌	309호
10.25.화 18:00	특강3	신지희	공개강좌	309호
11.9.수 18:00	특강4	문장현	공개강좌	309호
11.23.수 18:00	종강		과제 발표	309호

144

Kyungsun Kymn

typography workshop 08-1

schedule

1 0326 1700 orientation
 wed.

2 0417 1800-2000 talk 1: sulki&min 49-309
 thu.

3 0423 1800-2000 talk 2: yun sunil 49-309
 wed.

4 0507 1800-2000 talk 3: kim doo-sup 49-309
 wed.

5 0523 1800-2000 talk 4: sung jae-hyouk 49-309
 fri.

6 0604 1800 final presentation
 wed.

reference
what is typography david jury 2008 hongdesign
typography emil ruder 2001 ahn graphic

typography workshop 11-2
a big letter project

a
BIg
lettеR

1. 리서치
 - font family 선정 및 조사
 : 한글, 영문 무관, 잘 디자인되었고, 이야기가 있는 것, 손글씨 지양
 : whole family 수집, 사용된 주요작품, 디자인 의도, 역사적 의의 등

2. 작업
 - family중 가장 중요하다고 생각하는 한 글자를 골라 글자의 높이가 30cm 이상되도록 표현
 : 글자를 오리거나, 색칠하거나 이유있는 방법으로 행하고
 : 형태를 똑같이 유지하도록 최대한 노력할 것.

3. 완성 및 제출 - 11.23 수 17:00
 - 리서치 페이퍼 : A4 1장
 - 작업 결과 : 1개

Kyungsun Kymn

The participants of Typography Workshop were several notable designers in South Korea. Jaemin Lee, Kiseob Lee, Jangwoo Kim, Hyun Cho, Jan-ghyun Moon, Woohyuk Park, Sulki & Min, Hyung-jin Kim, Hyounyeol Joe, Doosup Kim, Jinkyung Oh, Moonkyung Choi, Jaewon Lee, Jaehyuk Sung, Jiwon Yu, Byungeol Min, Choongho Lee, Jangsub Lee, Chris Ro.

타이포그래피 워크숍에는 여러 한국의 유명 디자이너가 참여했다. 이재민, 이기섭, 김장우, 조현, 문장현, 박우혁, 슬기 & 민, 김형진, 조현열, 김두섭, 오진경, 최문경, 이재원, 성재혁, 유지원, 민병걸, 이충호, 이장섭, 크리스 로.

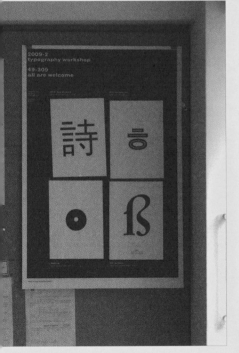

Barry Drugs **Street Signs Project**
Studio Assignment

Cranbrook Academy of Art, 1981

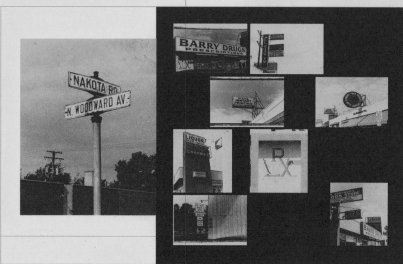

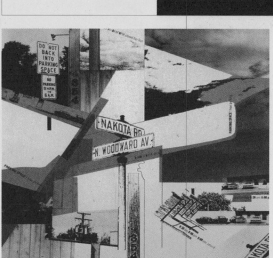

Project: Barry Drugs Street Signs
Student Project: Lucille Tenazas,
MFA Design 1982
Cranbrook Academy of Art,
Professor: Katherine McCoy

Lucille Tenazas

Henry Wolf Professor, Parsons School of Design
Associate Dean, School of Art, Media and Technology

The project revolves around a commercial street in suburban Detroit. Beginning with documentation of the vernacular information at street level, the project evolved into a study of typographic hierarchy utilizing typeset fonts, found text, and images. This pivotal project under the direction of Katherine McCoy became a touchstone for the work Lucille has developed on the use of typography as a powerful vehicle of poetic visual expression.

디트로이트 교외 지역 상가를 중심으로 전개된 프로젝트이다. 이 프로젝트는 거리에서 쓰이는 은어에 관한 정보를 기록하는 것에서부터 조판된 폰트, 발견된 텍스트와 이미지를 이용한 타이포그래피적 위계 연구로 발전했다. 캐서린 맥코이가 지휘하는 이 핵심 프로젝트는 루실이 시적인 시각 표현의 강력한 수단으로 타이포그래피를 사용하면서 발전시킨 작품의 시금석이 되었다.

Project: Lost and Found
(Journey Through a Public Space)
Student Name: Candice Ralph,
BFA Communication Design 2008
Parsons School of Design,
Professor: Lucille Tenazas

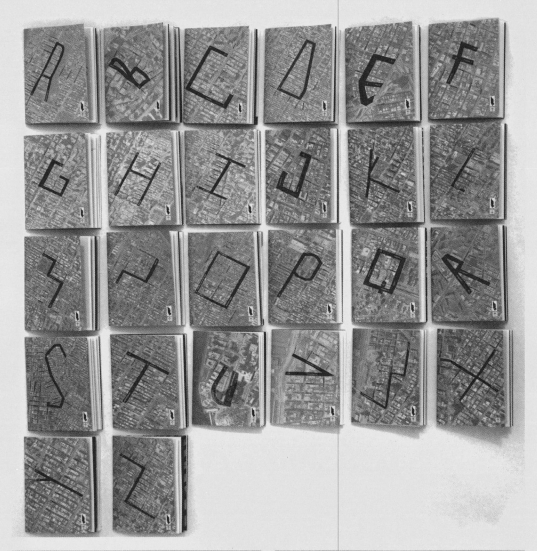

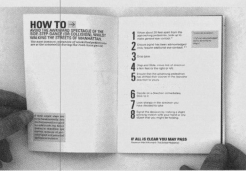

In this project, students are required to purposely get lost and immerse themselves in an unfamiliar environment, develop an awareness of how an analytical approach to interpreting a space can be enriched through our personal, subjective responses.

이 프로젝트에서 학생들은 일부러 길을 잃고 낯선 환경에 몰입하여 개인적. 주관적인 반응을 통해 공간을 해석하는 분석적 접근법이 어떻게 풍부해질 수 있는지에 대한 인식을 발전시킨다.

Candice Ralph started the process by looking at a map of New York City and walked the shape of a single letter of the alphabet. These daily walks were visually documented in 26 booklets reflecting her thoughts and conversations with people she met along the way.

캔디스 랄프는 뉴욕시의 지도를 보면서 알파벳의 한 글자 모양으로 산책을 하는 것으로 프로젝트를 시작했다. 이렇게 산책을 날마다 시각적으로 기록하여 그녀의 생각과 도중에 만난 사람들과의 대화를 반영한 스물여섯 권의 책자를 만들었다.

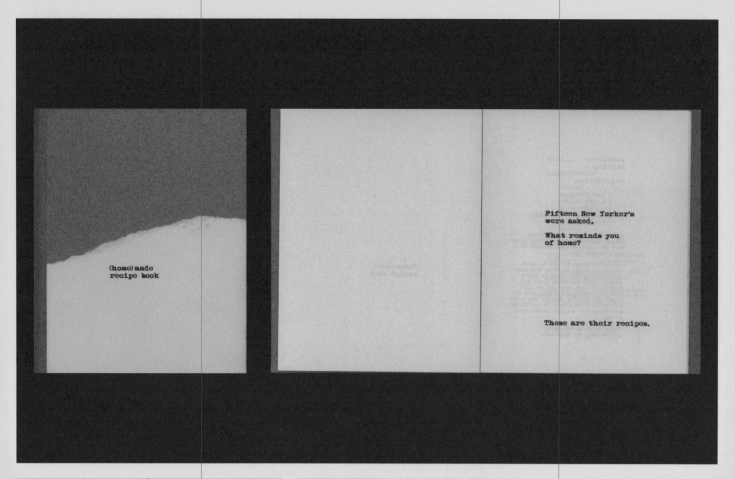

Project: The Designer as a Cultural Nomad
Student Name: Julia Lassen,
BFA Communication Design 2019
Parsons School of Design

The student is called upon to observe their assigned environment closely and create a visual response. As designers, we are often called upon to look critically at an unfamiliar environment, first assessing the situation, and then orienting ourselves within it as we develop an understanding of what was initially foreign territory.

과제를 하면서 학생은 주어진 환경을 면밀하게 관찰하고 시각적으로 반응해야 한다. 디자이너로서 우리는 종종 낯선 환경을 비판적으로 바라본다. 그리고 먼저 상황을 평가한 다음, 처음에는 낯선 영역이었던 것에 대한 이해를 발전시키면서 그 안에서 방향을 정해야 한다.

It is in this mindset that the designer of today is able to engender qualities of community, participation and empathy. Julia Lassen asked various people what reminded them of home and created a *"recipe"* book of these responses. This question created various responses—from the literal to the metaphorical, so that it was not defined strictly by geography.

오늘날의 디자이너는 이러한 사고방식에서 공동체, 참여, 공감의 자질을 발휘할 수 있다. 줄리아 라센은 다양한 사람들에게 무엇이 고향을 연상시키는지 질문하고, 그에 대한 대답을 모아 『레시피』라는 책을 만들었다. 이 질문은 직설적인 것부터 은유적인 것에 이르기까지 다양한 반응을 이끌어냈으며 지리적으로 엄격하게 규정되지 않았다.

Hotels Núñez i Navarro

151

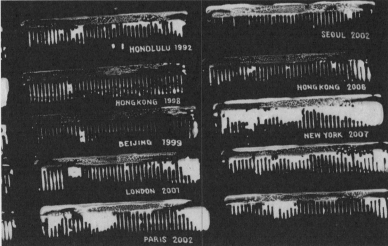

HONOLULU 1992

SEOUL 2002

HONG KONG 1998

HONG KONG 2006

BEIJING 1999

NEW YORK 2007

LONDON 2001

PARIS 2002

Project Name: Form and Process
Student Name: Takaki Miura, BFA Communication
Design 2007
Parsons School of Design

Each student was given an everyday object that served as a starting point for a series of visual explorations. In subjecting the object to intense scrutiny, the students explored its use, context, and layers of meaning. Takaki Miura was given a plastic hotel comb and explored various tactile media to represent it. Leaving behind any computer use, he used the object as a symbol to track his travels, serving as a visual diary of his visits to many cities around the world.

각 학생에게는 일련의 시각적 탐구의 출발점이 되는 일상적인 물건이 주어졌다. 학생들은 대상을 집중적으로 조사하면서 그것의 용도, 맥락 그리고 의미의 층을 탐구했다. 미우라 다카키가 받은 것은 플라스틱 호텔 빗이었다. 그는 이를 대표하는 다양한 촉각 매체를 탐구했다. 컴퓨터를 전혀 사용하지 않았으며, 빗을 자신의 여행을 추적하는 상징이자, 세계 여러 도시를 방문할 때 시각적 다이어리로 활용했다.

152

Lucille Tenazas

Project Name: Form and Process
This student used multiple staples on a single page
to create a form of relief sculpture. Going beyond
the purely utilitarian engages us in a more poetic
and aesthetic viewpoint.

프로젝트: 형태와 과정
이 학생은 한 페이지에 여러 개의 스테이플을 사용하여
양각 조각의 형태를 만들었다. 순수한 실용성을 넘어서
보다 시적이고 심미적인 관점을 취하도록 한다.

ibrida

Sono un mix tra la cultura svizzera

e quella italiana

Sono nata in Ticino

da genitori italiani

Frigerio Giada

153

Project: A Question of Identity
Scuola Universtaria Professionale
Italiana (SUPSI)
Canobbio, Ticino, Switzerland 20

이 프로젝트의 목표는 학생들이 자신의 문화적 정체성을 어떻게 정의하는지 질문하도록 하는 것이다. 스위스처럼 작은 나라에 무려 네 가지 다른 언어 집단이 있는데, 각 지역은 인접 국가가 규정한 언어를 사용한다.

This project aims to confront students with the question of how they define their cultural identity. A small country such as Switzerland is home to four distinct language groups, each area speaking a language defined by the country they are adjacent to.

In recent decades, a new form of identification has emerged which breaks down the understanding of the individual as a coherent whole subject to a collection of various cultural identifiers. In this poster project, the student, Giulia, confronts her dual allegiances to Switzerland and Italy by visualizing the percentage of her affinity in the Swiss national symbol of the cross.

최근 수십 년 사이에 개인을 하나의 동일한 주제가 아니라 다양한 문화적 식별자로 이해하는 새로운 형태의 정서적 공감대가 나타났다. 이 포스터 프로젝트에서 학생 줄리아는 스위스의 국가적 상징인 십자가 안에 자신의 친밀감 비율을 시각화해서 보여주었다. 이는 스위스와 이탈리아 두 국가에 대해 가진 충성심을 직접적으로 표현한다.

護身符

이 프로젝트에서 학생들은 개인적인 경험과 관련된 선택 주제를 시각화해서 대만의 풍부한 역사와 문화를 탐구한다. 예를 들어, 가족이 의식을 수행하는 독특한 방법, 도시의 여러 신화와 관습, 개인적인 기억과 회상 등이다. 이 학생은 다른 도시에 사는 어머니와 주고 받는 편지에 초점을 맞췄다.

154

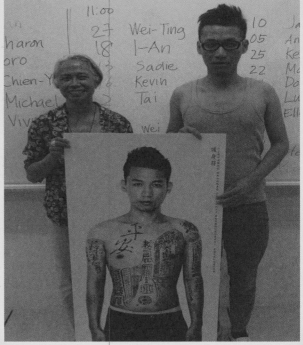

Project: Visual Narrative through Folk Art and Culture
National Yunlin University of Science and Technology, Douliu City, Taiwan 2012

Lucille Tenazas

In this project, students were asked to explore Taiwan's rich history and culture by visualizing a chosen theme that related to their personal experiences, for example: unique ways that their family celebrated a ritual; urban myths and practices; and memories and recollections from their personal histories. This student focused on the exchange of letters between him and his mother who lives in another city.

For the last several years, I have given lectures and conducted workshops in institutions within the United States as well as in cities around the world. As a designer invited to conduct these workshops, I have two goals: the first is to come as a practicing designer and educator, establishing the parameters of a design project and guiding the students through its final presentation and production.

The second is to approach the project as a cultural observer, using the medium of design to address unique cultural situations and conditions. I am interested in developing in my students a point of view shaped by their personal history. I believe that instilling a strong sense of self-esteem leads to a critical outlook toward one's own work. I explore ideas of authorship, process and the relevance of personal experiences in design — devices which are important in developing empathy. If you are aware of who you are, then you can ultimately take on the identities and problems a client may pose, yet not lose your own voice.

155

Increasingly, I have become more and more aware of my focus on process over the design product. Through these workshops, I hope to create a methodology that draws from personal experience as a potent filter with which to view ourselves in our environment and culture at large. As we evolve, we continually assess our role and place in the world and try to apply this in work that is meaningful. With this process, I offer an alternative perspective on the role of design... that it is not merely a way to sell a product, but an opportunity to enlighten, pose questions and offer a way to interact with and understand the world.

By using hand-written calligraphy, the student opens a window into the close relationship he has with his mother, extending to the design of the poster project in actual size and projecting the messages on his body at the final presentation.

손으로 쓴 캘리그래피를 사용하여 어머니와 친밀한 관계를 보여주고, 실제 크기의 포스터 프로젝트를 디자인 하는 단계로 확장한 후 최종 발표를 할 때는 메시지를 몸에 투영했다.

Above: A text about Lucille's teaching philosophy. 루실의 교육 철학에 대한 글

Thinking Through our Doodles

PROPRIOCEPTION

https://youtu.be/zAVNc_0-Ta8

Marc Català

Co-founder of Mucho
Founder, PostGràfica at IDEP

A lecture given at TEDxIESEBarcelona titled
Thinking Through Our Doodles. This talk discusses
the importance of doodles and diagrams and their
direct connection to our thinking and how more
emphasis should be placed on this visual process.
The concept of PROPRIOCEPTION is the ability of
our body to think.

TEDxIESEBarcelona 중 <낙서를 통한 사고>라는 제목의
강연이다. 이 강연에서는 낙서와 다이어그램의 중요성,
우리의 생각과 직접적인 연관성 그리고 이 시각적 과정에
얼마나 더 중점을 두어야하는지를 논의한다. '자기수용'
이라는 개념은 우리 몸이 생각하는 능력이다.

```
(Weight W1) (Rope Rp) (Rope Rq) (Pulley Pa)
(hangs W1 from Rp)
(pulley-system Rp Pa Rq)

(Weight W2)
(hangs W2 from Rq)

(Rope Rx) (Pulley Pb) (Rope Ry) (Pulley Pc) (Rope Rz)
(Rope Rt) (Rope Rs) (Ceiling c)
(hangs Pa from Rx)
(pulley-system Rx Pb Ry)
(pulley-system Ry Pc Rz)
(hangs Pb from Rt)
(hangs Rt from c)

(hangs Rx from c)
(hangs Rs from Pc)
(hangs W2 from Rs)

(value W1 1)
```

157

The following are some of the diagrams presented to illustrate some of these principles. Diagram E and F represent the same information that can be processed differently through space recognition and diagrams.

다음은 이러한 원리를 설명하기 위해 제시된 다이어그램 가운데 일부이다. 다이어그램 E와 F는 동일한 정보를 다이어그램을 통해 다르게 처리하는 것을 보여준다.

F

SPACE
FOR
VISUAL
RESEARCH
2

Spector
Books

Workshop,
Manual,
and Compendium

Markus Weisbeck

Professor, Frankfurt am Main and Weimar
Founder, Design-Studio Surface

Cover of *Space for Visual Research: Workshop,
Manual, and Compendium.*
Published by Spector Books

『Space for Visual Research: Workshop, Manual,
and Compendium』의 표지. 스펙터북스 출간

A PROLOGUE

9 ROUNDTABLE
Casey Reas
Cybu Richli
Martin Venezky
Markus Weisbeck

B EXPERIMENTS & REPORTS

18 KOMMEN UND GEHEN
Elisabeth Pichler
Verena Kalser

28 MARBLE
Florian Bräunlich
Christoph Blankenburg

38 CHROMA KEY FEEDBACK
Johannes Rinkenburger

48 FAKE TV
Florian Bräunlich

58 FLOU, AMAZONE
IMG_8043, W.B.
Moritz Wehrmann

68 THE EGG
Max Salzborn

78 LIVORMORTIS
Katharina Hüttler

88 GIPFEL
Philotheus Nisch

98 NATIVES
Sascha Krischock

108 THE MISSING LINK
BETWEEN THE BAUHAUS
AND BUSTER KEATON
Markus Weisbeck

118 ZERRSPIEGEL
Robin Weißenborn
Samuel Solazzo
Jakob Tress

128 LAYERS
Schmott

138 TESSELLATION
Anna Teuber
Franzi Kohlhoff

C EXCURSUS 1

151 TOOLS OF INSPIRATION
Karl Schawelka

159 AESTHETICS OF PROTOCOL
Sophia Gräfe

D EXCURSION

166 FORM STUDIO
Martin Venezky

176 METHOD—FROM
EXPERIMENT
TO APPLICATION
Cybu Richli

186 MEDIA ARTS MFA &
CONDITIONAL STUDIO
Casey Reas

E EXCURSUS 2

201 THE COSMOS IS A
WORK IN PROGRESS
ASTRONOMY AS
COMMUNICATION
DESIGN: A GUIDE TO
WHAT YOU ARE MISSING
Ken Hollings

205 SPACE ODYSSEY:
A BRIEF HISTORY
OF NOT-KNOWING
Anna Sinofzik

211 SUBJECTIVE GLOSSARY

F EXTRAS

214 MYCARBONCREDITS
Dirk Fleischmann

224 MUTATION
Amos Fricke

G APPENDIX

235 SPACE FOR VISUAL
RESEARCH VOLUME 1

247 BIOGRAPHIES

159

A

ROUNDTABLE
Casey Reas
Cybu Richli
Martin Venezky
Markus Weisbeck

Space itself is expanding, driven at an accelerated rate by dark energy. The Space for Visual Research (SfVR) expands through the exchange of bright ideas.

Conceived as an open platform for continuous creative discourse on graphic image production, the Weimar-based research lab maintains close ties to like-minded practitioners across the globe. Virtually gathered around a digital round table moderated by culture editor Anna Sinofzik **AS***, creative educators Casey Reas* **C.RE** *(University of California, Los Angeles), Cybu Richli* **C.RI** *(Zurich University of the Arts), Martin Venezky* **MV** *(California College of the Arts, San Francisco), and SfVR founder Markus Weisbeck* **MW** *(Bauhaus University Weimar) discuss scavenger hunting, Danish auteur cinema, and the meaning of experimentation in contemporary image making.*

AS: Markus, you started the Space for Visual Research (SfVR) as a platform for experimental image production at the Bauhaus University Weimar in 2013. Much like scientific experiments, it emerged out of an observation of the natural environment—in your case, the field of graphic design. You felt that the culture of designing was "in arrears." What was the matter with it?

MW: Thinking of it now, it was (or is) perhaps less a matter of being in arrears than of being trapped. With the disappearance of many country-specific schools and teaching methods, we have come to see distinct approaches and design languages dissolve. Today, designers across the globe are all using very similar tools and methods. And there is a tendency towards a somewhat synchronized style being paraded by design blogs, which also produces a certain unification of taste. While there has never been a better framework for developing unique design approaches than that which is provided by the web, I feel that many creatives all too readily adopt this sort of foolproof "nice style." With the Space for Visual Research, we wanted to break up that monotony and encourage students to look beyond the blogosphere, and eventually extend their visual vocabulary to develop their own style.

MV: I couldn't agree more, Markus. I try to convince students to avoid looking over their shoulders at what other folks are doing and instead look intently and critically at what is right in front of them. That's hard to do for both students and professionals. Some worry that their work won't be "current" enough. But I persuade them that the tools they are using and the context in which the work will be consumed will always be current—the unalterably forward motion of time takes care of that quite nicely. When students move deeply into formal research, they begin to work "outside of time." Furthermore, they are learning a process for working and a strategy for critique—just one component of a fully formed personal style.

Cybu Richli / C2F:
100 Best Posters—
Germany, Austria,
Switzerland.
Exhibition Poster,
2015

C.RI While the web itself serves as a valuable library, social media does indeed have an immense effect on the opinion-forming process. Design languages are drawing ever closer. There are many followers who go after a certain style and simply copy, without adding much of an individual touch to it. As a lecturer, I find it important to pass a sense of critical distance on to my students to make them cast a critical eye on such

B

Space for Visual Research: Workshop, Manual, and Compendium
A: Table of contents
B: Excerpt of prologue by Casey Reas, Cybu Richli, Martin Venezky, and Markus Weisbeck

시각 연구 공간—워크숍, 매뉴얼과 개요서
A: 차례
B: 케이시 리스, 사이부 리츨리, 마틴 베네츠키, 마르쿠스 바이스벡의 프롤로그에서 발췌

TITLE

The Missing Link Between the Bauhaus and Buster Keaton

AUTHOR

Markus Weisbeck

TIME SPAN

Ongoing project

INTRODUCTION

In the realm of physics, gravity defines the architecture of space at large. Likewise, in image composition it can be used to define spatial relationships. Wassily Kandinsky, for example, used image gravity as a key principle of order in his theories of graphic composition, which were published at the Bauhaus; György Kepes explored the subject in even greater detail during his time as the director of the Center for Advanced Visual Studies at MIT in Cambridge, MA. Merging the art of science with the science of art, this experiment employs the natural force that drags bodies towards the center of the Earth to produce a series of gravitational graphics. True to its timeless title, it reinforces the all-too-often-overlooked connection between Bauhausian compositional theory and a silent film hero, Buster Keaton, who famously grappled with gravity.

PREPARATION

The experiment requires the following custom-made materials: (1) a Perspex plateau with a specific edge height to incorporate a set of geometric forms, allowing them to move without tilting; (2) the geometric forms themselves—that is, a series of squares, triangles, and circles of different diameters, all lasercut from a 4 mm thick white Perspex panel.

MATERIALS AND METHODS

Once the geometric forms are inserted into the Perspex plateau, the latter is lifted on one side. Drawn downwards by gravity, the compositional elements rearrange themselves randomly, seemingly independent of their surface areas. Different compositions are generated and photographed. The image area is defined by the outer edge of the custom-built Perspex plateau.

OBSERVATION

Careful observation reveals that the composition is essentially determined in motion. While an initial series of images captures pin-sharp compositions, it fails to reveal the cinematic moment of their formation. In further photographs, the exposure time is significantly extended. Caused by motion, the resulting blur adds a sense of action and Keaton-esque contretemps.

RESULTS

Blurred in motion, the captured moments merely hint at a final composition. Intentionally hypothetic, they invite interpretation and celebrate processuality, while challenging the contemporary obsession with the perfect outcome.

DISCUSSION

Commonly working with desktop publishing software today, most designers rarely cope with the effects of gravity while working on compositions. That said, the experiment raises the question of how a natural force that determines everyday life in so many ways can be integrated as a compositional tool in contemporary image processing. Arguably, there is always a need for new, well-grounded graphic compositions.

REFERENCES

Kepes, G. (1944). *Language of Vision*. Chicago: Paul Theobald.
Kandinsky, W. (1926). *Punkt und Linie zu Fläche. Beitrag zur Analyse der malerischen Elemente*. Bauhausbuch Nr. 9, Munich: Albert Langen.
Ruder, E. (1958/59). Wesentliches (Fläche, Linie, Wort, Rhythmus) in: *Typographische Monatsblätter*. Olten: Schweizerischer Typographenbund.

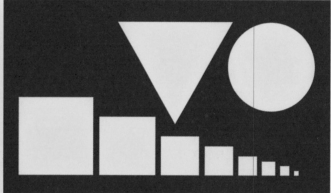

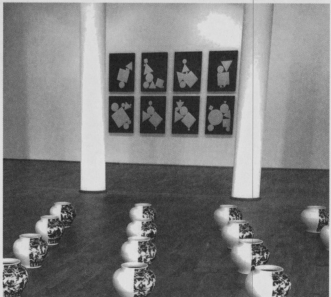

117 B Markus Weisbeck

Markus Weisbeck

Space for Visual Research: Workshop, Manual, and Compendium.
Project Title: The Missing Link Between the Bauhaus and Buster Keaton
An ongoing project that explores motion properties as a conceptual blend of science and art. It is inspired by a perceived conceptual connection between the Bauhausian compositional theory and silent film auteur Buster Keaton.

시각 연구 공간—워크숍. 매뉴얼. 개요서 프로젝트 제목: 바우하우스와 버스터 키튼 사이에 숨겨진 고리 움직임의 속성을 과학과 예술의 개념적 혼합으로 보고 탐구를 진행 중인 프로젝트이다. 바우하우스의 구성 이론과 무성 영화 감독 버스터 키튼 사이의 개념적인 연관성에서 영감을 얻었다.

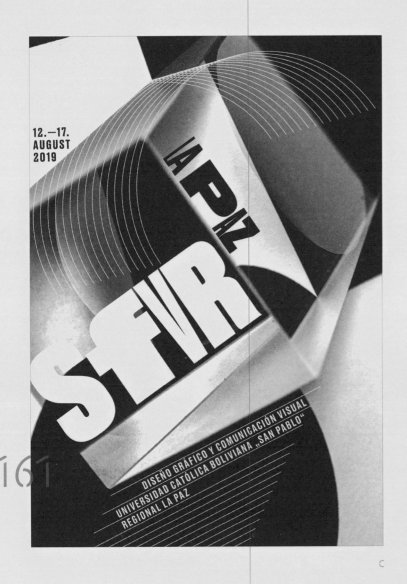

12.—17.
AUGUST
2019

LA PAZ

SFVR

DISEÑO GRAFICO Y COMUNICACIÓN VISUAL
UNIVERSIDAD CATÓLICA BOLIVIANA „SAN PABLO"
REGIONAL LA PAZ

161

C

D

Space for Visual Research: Workshop, Manual, and Compendium.
C: Workshop poster for the Universidad Católica Boliviana.
D: Experiment from "The Missing Link Between the Bauhaus and Buster Keaton"

시각 연구 공간: 워크숍, 매뉴얼, 개요서
C: 볼리비아가톨릭대학교의 워크숍 포스터
D: <바우하우스와 버스터 키튼 사이의 숨겨진 고리>에서 나온 실험

TITLE
Kommen und
Gehen

AUTHOR(S)
Elisabeth Pichler,
Verena Kalser

TIME SPAN
6 months

INTRODUCTION

This project converts heart rates into images. Based on a multi-stage installation that combines digital technology with a set of mechanical self-made devices, it employs the human body as an input device to produce a series of individual pictures. Pacemakers of a semi-automatic, interactive procedure, the pulse rates of a range of participants are translated into abstract compositions that counter the familiar, wavy form. Clearly not conceived to monitor or analyze the participant's medical condition, but rather to visualize the pulse as an inner mechanism that is closely tied to the subconscious, the project proposes very subjective, semi-random renditions of the beating heart's rhythm: images that are created on the basis of human body, without being consciously controlled by it.

PREPARATION

The human heart is a highly sensitive mechanism that routinely responds to all sorts of stimuli; even minor ones have an effect on its rhythm. While some medical research served as a foundation to understand its basic workings, the attempt to visualize the pulse called for an extensive testing and evaluation of a range of tools and technologies. For example, an appropriate recording system had to be found to capture and collect respective data. The development of an appropriate algorithm to process that data required the acquisition of coding skills and a basic proficiency of suitable software applications. Last but not least, the construction of the required digitally controllable image-making devices involved a good deal of research, lots of trials and errors, as well as a readiness to improvise, recombine, and reconfigure.

MATERIALS AND METHODS

The first part of the image-making process is based on a self-made modular system. It comprises five different mechanical devices: a pendulum, a drip mechanism, a rotation plate, a screen, and a pantograph. Assembled on a cube that connects them to an Arduino microcontroller board, the machines are driven by an Arduino stepper motor. Drawing on a previously developed system, they translate a range of common pulse rates (between 30 and 220) into movement and eventually, into a series of analogue images: the pulse rate determines the number of turns per minute, which again determines the image density. In a second phase of the procedure, the resulting images are scanned to be digitally processed: a plug-and-play heart rate sensor called Amped is attached to a person's finger, measuring the pulse rate on site. The sensor then passes the data on to the computer and a specifically programmed algorithm, which refers back to the pre-produced set of analogue images and selects a combination to generate an individual composition for each recorded pulse rate.

OBSERVATION

The installation drops, rattles, and scratches to the beat of the pulse. Colors mix, perpetuate themselves, and merge into unpredictable forms. Although the procedure is regulated by rules, it is impossible to foresee what composition the different pulse rates will produce.

RESULTS

Combining a series of improvised mechanical machines with digital interactive technology, the project manages to put forth an unprecedented, surprisingly idiosyncratic data visualization method. Based on individual heart rates, an algorithm, and a mix of different compositional tools and techniques, no result resembles the other. Directly connected to the image-making devices, a printer puts out the final compositions in postcard format, allowing all participants to take their unique picture home as a very special type of snapshot.

DISCUSSION

While each composition is primarily understood as an image in its own right, the project also aims to provoke thought: based on a consciously complicated setup and a decidedly obscure process, it raises the increasingly incomprehensible issue of visualizing the pulse, a particular personal data type, it questions the ways in which we deal with information, oftentimes putting it out there without even being aware of how it may be used or further processed.

REFERENCES

The mechanical image-making devices developed for the project are inspired by the kinetic art of Marcel Duchamp, Naum Gabo, László Moholy-Nagy, Alexander Calder, the Gutai Group, and the Group Zero.

Markus Weisbeck

Excerpts from visual experiments and their processes, observations and results explained.

시각적 실험과 그 과정, 관찰 내용과 결과 설명 발췌했다.

TITLE
The Egg

AUTHOR
Max Salzborn

TIME SPAN
6 months

INTRODUCTION

Routine blinds us to the beauty of our everyday world. Building on the premise that one of the purposes of art is to impart our sensation of things as they are interpreted and not as they are known, this in-depth graphic study puts the chicken egg into new perspective(s). The project draws inspiration from the work of Swiss photographer, art historian, and educator Hans Finsler, who was one of the leading representatives of the Bauhaus-related movement Neues Sehen (also known as New Vision or Neue Optik) and a true master of turning common objects into abstract compositions. The aim is to defamiliarize the egg and eventually develop a poetic pictorial world based on its material particularities.

PREPARATION

The quest for an appropriate representation method involved a range of preliminary experiments with different illustration techniques, including graphic printmaking and 3D renderings. The eventual choice of photography was determined by the wish to achieve a high abstraction level, while working closely with the object itself.

MATERIALS AND METHODS

The basic setup resembles that of a standard tabletop shoot: an SLR camera, two flashlights, different backdrops, some smaller props, and the object itself. In the first phase, a series of macro photographic test shots in different lighting conditions examine the egg's formal features and the shell's surface. In order to study the object even closer, down to its integral components, the egg is then cracked open, smashed, and chemically treated; soaked in a vinegar bath for several hours, it develops a mucilaginous outer membrane, revealing an unexpected visual potential. It is essential to carefully observe the process in order to determine the appropriate duration of the acid bath: leaving the egg in it for too long would destroy the structure of the shell, while taking it out too early could impair the desired visual effect. The use of a round glass dish instead of a rectangular one helps avoid undesired reflections.

OBSERVATION

The chemical reaction alters the object's surface structure, bestowing it with a whole new visual dimension that makes up for the vinegar solution's acrid smell. The testing of various setups, angles, and lighting conditions yields a variety of possible compositions, all of which portray the egg from unfamiliar perspectives to reveal surprisingly appealing structural particularities.

RESULTS

An exercise in careful observation and lateral thinking, the project once again proves that everyday objects deserve a second look. Presenting a common thing in uncommon ways, it not only scratches the surface of what is possible with macrophotographic means, but more importantly, succeeds in enhancing our perception of the familiar.

REFERENCES

König, T., Gasser, M. (2006). *Hans Finsler und die Schweizer Fotokultur. Werk, Fotoklasse, moderne Gestaltung 1932–1960.* Zurich: Gta.
Mattenklott, G. (1994). *Karl Blossfeldt. Urformen der Kunst, Wundergarten der Natur.* Munich: Schirmer/Mosel.
Liesbrock, H. (2010). *Bernd und Hilla Becher. Bergwerke und Hütten.* Munich: Schirmer/Mosel.
Fiedler, J. (1994). *Moholy-Nagy, László.* Berlin: Duncker & Humblot.

(Further individuals who inspired this project include Bernd and Hilla Becher, August Sander, and Albert Renger-Patzsch.)

E

F

Markus Weisbeck

Excerpts from student participants at workshops
conducted in 2017 and 2018 at PaTI.
E. Work by Kim Hyungjun, 2019
F. Work by Yejin Je, 2019

2017년과 2018년 PaTI 워크숍 참가자 작품
A. 김형진, 2019
B. 제예진, 2019

Excerpts from student participants at workshops
conducted in 2017, 2018 and 2019 at PaTI.
2017, 2018, 2019년 PaTI 워크숍 참가자 작품

G

H

Markus Weisbeck

G. Process images from student participants
at workshops conducted in 2017, 2018 and 2019
at PaTI and the Bauhaus University Weimar.
H. Work by Alba Manjon, 2019 from the SfVR
Workshop <Learning from Hans Hoffmann>

G. 2017, 2018, 2019년 PaTI와 바이마르 바우하우스
대학교에서 열린 워크숍 학생 참가자들의 작업 과정 이미지
H. 알바 마뇽, 2019
<한스 호프만에게 배우기>라는 SFVR 워크숍 중에서

167

Martin Venezky

thoughts on the classroom

Jeff Miller

Jeff was a student in my first form class. His medium of interest was photography, and for the first several weeks he used only 35mm black-and-white film. Although the pictures were uniformly strong, I was curious how Jeff would handle color. His timid acceptance of my challenge left me unprepared for the dazzling work ahead.

Jeff photographed his subjects after they had been imaged through a video camera and displayed on a monitor. This transformation had its own effect on color, but it also permitted Jeff to control the nuances and textures that appeared on the screen.

Jeff began with a set of small children's blocks. When photographed, they suggested an eerily empty architecture watched through a surveillance camera. As fascinating as they were (and I enjoyed them enough to use them to illustrate an article in *Speak*, p. 131) I thought it would be good discipline to remove even more variables. I'm in favor of stripping away the extraneous in order to study specific properties. So Jeff agreed to slowly flatten the image in order to examine it as a series of divisions.

Through carefully measured in-camera multiple exposures, Jeff began adding more color to his palette. To gain confidence in his technique, he limited himself to a monochromatic yellow, slowly building up the range through his final set, pictured in the last two rows.

Jeff shot hundreds of photographs, each one meticulously crafted and studied. These last pictures exhibit a confidence and subtlety that could only have been achieved through dedication to a rigorous and self-disciplined regimen.

I remember
my grade school
teachers **standing before me, and me before them**. These were times of assessment, when we were face to face, cataloging my shortcomings and achievements. Our **presence together embodied more than a report card. The physical manifestation of either pride or shame, and my vulnerability at these moments, made resolutions stick. For me raising a hand, standing to recite, sitting in a circle, and walking in single file** are such deeply human rituals of teaching and learning that I see **bodily presence as the classroom's greatest quality. Respect, humility, honesty, discipline**—all of these can be communicated directly and unforgettably through the physical proximity of student and teacher. We admit to those wiser than ourselves that we are hungry, and look to them to feed us, the less wise, with their knowledge.
**The deference and the nurturing carries much of the work. And after ten years of teaching,
I understand why I can summon up** I admit
the names and faces of distant my bias toward
favorite teachers more clearly than corporeity, the system
the lessons they taught me. that worked for me,
but I cannot grasp how education can succeed any other way. Except under dire circumstances, I have never accepted the idea of a digital classroom. The moment of literally standing by my work or opinion or interpretation has burned itself into my memory. As students learn more and more through games or by-products of entertainment media, they find it hard to break the habit of point and click at higher levels of schooling. Education is a trust. It is a bond we make with our elders and our ancestors. At the risk of sounding bitterly puritanical, it is work to which we apply ourselves bodily.

I leave that student body far behind as I enter the classroom as a teacher. Now, rather than simply react, I am obliged to enable reaction. At first I was ill prepared and uneasy in the spotlight. It took a while to realize that the classroom is not a battlefield, and the students are not the enemy. I had been misguided by colleagues who began all their teaching war stories with, "If only the students would...," and ended with a wish list of adult, professional behaviors. But, at least in my world, effective teaching is as much about me becoming more like my students—that is to say, engaged, excited, curious, and even ridiculous and impatient. I've grown into my role and have taken to the classroom so naturally that it's hard to verbalize the philosophy I've woven together from strands of fortunate successes.

Teaching requires physicality. To my students, I literally embody the profession. I make it a point to be a physical part of the world I describe, so my critiques and lectures are personal dialogues about my real thoughts and experiences. One thing is certain. I never forget that, no matter their age, students are vulnerable when they cross the classroom's threshold. And graphic design, with

(opposite)
Heather Scott
While her classmates seemed to find their area of concentration with ease, Heather's studies bounced from sewing projects to paper cutouts (one of her original objects was a miniature drugstore sewing kit complete with tiny scissors) to typing exercises.

Out of frustration (which can be a fine, though unreliable, motivator), Heather began folding a sheet of paper before jamming it through the typewriter. Eventually she dropped the folded paper into ink and left it to soak. The patterns that emerged echoed some of the darkroom work others were creating. Once she brought the two ideas together, she began to work exclusively in the darkroom applying light and chemistry directly to the folded paper.

Her final studies, rich in their suggestions of organic growth, are the result of delicately poured chemistry.

(left and below)
Louis Schalk
Early in his investigations, Louis scavenged a large sheet of metal out of which circles had been stamped. This cumbersome object became his primary drawing tool, sometimes used as a template for pencil and pen, other times as a resist to poured ink. Over the semester Louis developed a sensitivity to drawing that enabled his work to take on its own character. The care that Louis applied to the drawn line is rare in contemporary design, and the results exhibit power and confidence.

its subjective cross demands of expressiveness and clarity (not to mention originality and cleverness) only magnify the situation.

Some years ago I developed a class on form making, which I'll use as an example of my approach. This class grew out of an observation that the most creative and visually exciting class work seemed to always happen in the early stages of discovery, every other week, when the students were still free from the restrictions of concept and meaning. I wondered what would happen if the experimentation and play simply continued through a series of exercises and critiques of increasing rigor. What if there were no end point, nothing to evaluate beyond the formal quality of the studies?

This way of thinking is not new. The Bauhaus preliminary course, officially introduced in 1919, was acclaimed for its use of careful abstraction to study the formal qualities of materials and processes. Johannes Itten used the class to imbue the visual with spirituality. Later Laszlo Moholy-Nagy introduced a heightened awareness of form making through technology. Training the hand, body, and eye was so important to the Bauhaus faculty that the preliminary course became the foundation for the entire curriculum.

It surprises me that the primary value of these studies has evaporated, touched on in some foundation courses, but quickly forgotten in favor of concept-driven projects and semiotic exercises. I agree with the Bauhaus masters that form is the essential building block of design, although I do not subscribe to any absolute interpretation beyond direct sensation (and even that is modulated by culture). From this sensation trickles emotion and language, and from language flows narrative and meaning, which then flood into identity, society, and the political, commercial, and environmental world. But it all must start with form.

With these thoughts in mind, my class begins with unremarkable objects like paper clips, a spool of thread, or a measuring cup. The students receive their own individual pairings, and I ask them to explore what they've been given. I offer little additional information. They are confused, and I expect that. They are not used to asking their own questions or working without a final goal in mind. What do I mean by "explore"? How should they start? What if they're wrong?

Although my undergraduate students quickly learn to sidestep their doubts, the graduates remain a skeptical bunch, often scoffing at such an elementary exercise. Students at that level are preparing to embrace design as a political and social concern, and they are anxious to get on with it. Even after I explain that the persuasive and ambitious aspects of design are better understood when the physical properties of formal attraction are explored, they can still be unfazed. I am patient, though. These students don't know it (or believe it) at first, but their confusion is a natural first step. Since this class cannot be mastered by past successes in type, color, or composition, it is a fine equalizer for students with different skills and experiences. All are bound together with a common insecurity. A tendency to make nice looking pictures is replaced by the demand that the pictures lead toward discovery. The topic is form, but the class is really about developing methods of investigation and vocabularies for evaluation, tools that will serve the students in every creative pursuit. The keys to the project aren't forged from expertise in paper clips and thread. Rather, they require attending to detail, working meticulously and methodically, and making thoughtful judgments.

At first, students blaze through a battery of ideas. They try a lot of possibilities, only a few of which sustain interest. Eventually they choose an aspect to study with depth—perhaps transparency or buoyancy or gravity. Finally they extrapolate the aspect into abstraction and nuance, as the experiments become

highly focused. It's a logical methodology—broad exploration followed by deep exploration. I suggest that some of them consider process drawing—drawing for the mark making itself, rather than a presumed likeness of the external world—as a way to break free of expectations. (It is telling that the cheapest design tool—the pencil—is the hardest to master. Every mark is a decision determined by a body and relates to every other mark in a physical way.)

All the while the class takes the form of an extended critique. I never know what to expect when the students post their studies on the wall. I challenge them and they challenge me back. Precise articulation becomes a valuable skill. We judge success and quality based on a set of criteria—but what are those criteria and how do we know when we've met them? We talk about controls and variables, what we are looking at and the physical sensation it elicits. They must identify exactly what they are studying—the cropping of a photograph or its subject? The color or its shape? The tool or its result? We denounce vagueness. If a student claims that something is "beautiful" or "cool," I want to know why. What elicits the remark? What makes one study "cooler" than another?

The studies and critiques fill the entire semester, and, if I'm lucky, they reverberate for a lifetime. We go through a physical process. We see and feel the sensations we are trying to describe with words as our eyes remain open to the unexpected. The investigation develops its own momentum and the students end each semester with a sophisticated body of work that is not tied to a style, but is a result of observation and analysis. This is a great creative achievement, especially in the midst of so much stylistic application masquerading as design ingenuity.

What started as an innocent question has come to form the foundation of my teaching philosophy. The students have learned that the discipline and rigor involved in challenging and critiquing themselves is much harsher, frustrating, and uncertain than what is required to obey orders. But it will make them strong. Not everyone will want to work this way, and not every project will be suited for this process. But learning how to set goals, experiment, and then use the results to question and analyze seems to be the best trail away from the dependency of childhood and toward the self reliant road of adulthood. The greatest gifts I can give my students are the directions to this path, and provisions for the journey. The rest is up to them.

Martin Venezky

Founder, Appetite Engineers
Professor, California College of the Arts

An essay discussing the context and process for Martin's form making class. He overviews the roots of this course, his thoughts on education and interaction, and how the course unfolds over the semester and how this work is articulated and dicussed. Originally published in *It Is Beautiful... Then Gone*, 2005.

마틴 베네츠키의 형태 제작 수업의 맥락과 과정을 논하는 에세이. 그는 이 수업의 기초. 교육과 상호작용에 대한 생각, 그리고 한 학기에 걸쳐 수업을 전개하는 방식과 작업을 표현하고 논의하는 방식을 대략적으로 설명한다. 원문은 『It Is Beautiful...Then Gone』(2005)에 발표했다.

Form Studio

CALIFORNIA COLLEGE OF THE ARTS
GRADUATE PROGRAM IN DESIGN
FALL 2018
MARTIN VENEZKY

Introduction

The point is to see, and to wonder what makes you think you see the thing you think you are seeing. And then to make things with deep attention. And then to look at the things you've made and make something further. And then to learn the relationship between what you do, what you make and how you and the world see it. It is an endless cycle. It never stops. It is the foundation for everything else you will do.

Considering form

I'd like to consider form through three lenses: Form and Process, Form and Sensation, Form and Tradition.

Process. Simply put, process puts the focus on the methodology of making. In the past you may have used brainstorming or drawing thumbnails to ignite an idea. Here we are less concerned with cleverness and sudden inspiration, and more concerned with developing systems and conditions. Like other kinds of experiments you will set up controls, produce the work and examine the results. It sounds simple, but each step requires concentration, analysis, and decision making.

At the graduate level, process often trumps result. We are less concerned with judging the qualities of a finished drawing than we are in examining the conditions of its creation and what it suggests as a next step. Each step generates questions that can only be answered with further steps.

Design models. A focus on process is different from most of your experiences so far. Let's consider two different paths of design investigation. We'll call them the business path and the art path.

Surprisingly, most schools prefer to teach the business path. This model thrives in the problem-solving professional world: creating a "thing" (an identity, a book jacket, a website). You have a client, you have an end user. You develop a strategy of research, investigation, testing and analysis. Business and commerce rely on this model, and their success hinges on a quantifiable goal (ticket sales or clicks or units purchased). And each new project builds up your portfolio and expertise.

As experimentation, though, problems arise when the designer cannot help but make a book jacket "look like" a book jacket, that is, creating with the end product in mind. After all, when design is analyzed through surveys, preferences will often fall within the "already familiar." A completely new product, even a good one, will typically be met with resistance. That is our nature. True early adopters are rare.

The art path, on the other hand, relies on a body of work, rather than a single executed result. No single drawing, collage, photograph, type study matters (or can be seriously critiqued) apart from your creative trajectory. A continuously evolving strategy of inquiry results in a collection of work that may not be complete but are connected to each other.

During you time here at CCA — and most likely your time on earth — you will be stretching between these two models. Some will enjoy the tension this sets up, others

maintained and how the ensuing tension forms a discourse. Not to mention the important, but often discounted, relationship between design and the decorative arts, and by extension, its relationship to abstraction and craft. How has technology historically shaped our definition of formal skill, craft and competency. What does "craft" designate in design today and what can we learn from craft as a process of making?

Class Description

For all the preceding hoopla, the project itself will seem dispiritingly simple. Everyone will receive a randomly selected, unique set of materials or objects. From these, you will generate visual experiments and explorations.

Rules. There are some rules. Work only in black & white. Your work must comfortably reside in the 2D world. Your must be able to pin your work on the wall at actual scale. No reviewing work on a screen. These rules will be loosened up as the semester progresses or as your own inquiry naturally leads you past them.

You may use materials that naturally work with your objects. For example, if you have a brush, you can grab some paint, ink, and a surface. If you have ink, you can use receptacles to hold it, liquid to dilute it, and tools to work with it. All of your materials are cheap and easily available. You are encouraged to get more of whatever you have. And you are free to generalize. If you have a brush and ink, you can get lots more brushes in other sizes, and different kinds of ink. How far away from the original material should you go? That will be an important question and will depend on the qualities that interest you. If you have a bag of feathers, I wouldn't immediately start working with a bucket of fried chicken. Each step should be meaningfully related to the work you are doing and the interests it generates. You are developing a personal trajectory of inquiry, not running a race.

Soon you will deepen your investigation. Eventually, you will branch into your own discovery process. There are two tricks to master here: how to start, and how to continue.

Time passages. This class began as an undergraduate elective in Fall 1999. At the time the class was exclusively for 2D designers. There were no digital cameras, no laptops, very expensive scanners and limited color printing. But the technological lack did not compromise the quality of the work produced. After all, no "lack" was perceived since these things were not yet available. In fact, some of the best work ever created for this project happened in those early years.

A number of students used photography, but were conservative in the number of shots, since every roll of film (remember film?) had to be processed and printed. Some of the students were proficient in printing their own black and white photos. Some used other darkroom techniques. Almost everyone at some point used drawing, painting, and printmaking to make compelling and surprising work. The hand was a natural extension of the design process. The work proceeded slowly and carefully, and craft was in the forefront.

Every year since then, students have slowly edged away from the hand and towards the digital, and every year it gets more challenging to convince students to investigate process drawing or printing as part of their working method. At the same time, though, now that the class is a part of the graduate design studio sequence, an injection of students who are comfortable with materials and building and electronics and programming has introduced new skills into the pool.

If you feel ill-at-ease with drawing or markmaking or building, then that is all the more reason to try it here in this class. I promise that as long as you apply persistence and diligence you will make progress.

I will be presenting examples of work that use these techniques to remarkable effect.

Getting started. The objects in the bags are things that you either take for granted and have never stopped to notice or are so weird that you cannot figure them out at all. Really examine them and play with them. What are their properties? What new ones can you discover? What qualities are most intriguing to you? How do the choices you make affect the results? How do these materials intersect with each other? These are the first steps in decision making and analysis.

It is critical to understand the difference between a tool and a material. Most of the items you receive can be used either way. If you perceive something as a tool, it is OK to use it as such. You don't have to pretend that a hammer is not a hammer, but keep your mind open to new ways of using that tool by redefining the rules. Experimentation comes through variations of use. However you might be more interested in the material qualities of that hammer: the wooden handle and the metal, heavily-weighted head. You can then extrapolate further studies based on that relationship using conjunctions of similar materials.

What medium will you choose? Understand that each medium is bound with a set of assumptions — a history and a language that are both cultural and scholarly. How do these expectations affect how we work?

At first you'll probably compile a broad range of options in a number of different media. This is a natural way to begin and I encourage it. As these options accumulate you will need to make choices. On which shall you focus? How do you choose? As you are making things, become self-aware. What are your reactions? Are you trying to judge "good" from "bad"? Or "ugly" from "cool"? What specific criteria do you take into account? Be prepared to discuss these things in critique.

Once you narrow your focus, you will find that your productivity actually increases. This is one of those strange design conundrums — more restriction equals more freedom. But we're getting ahead of ourselves. First you must simply begin.

Class Objectives

Although this class focuses on form, think of it as a foundation for future critical practice, and a valuable form of design research. Here are some of the skills you will gain:

Translation
This class encourages you to explore combinations of tools and media. With each shift, the work changes, and new decisions have to be addressed. For example, how do you translate a 2D drawing into a 3D model? How do you determine its dimensions? What about the areas that we cannot see in the drawing? In each case, there is an increase of detail in some areas and a decrease in others. Keep in mind that media do not have to be addressed in sequence. They can be introduced at different stages in different orders. After constructing that 3D model, you could redraw it, scan it, and then build it again. Crossing back and forth between media is a good way to create unexpected formal languages.

Experimental Process
Experimental work is not about making things "look experimental." How sad it is to see assignments that ask students to experiment by "going wild." If anything, experimentation requires diligence and discipline. Wildness can be an experimental quality if it is applied with care and concentration. And things meant to look wild (i.e. distressed type, rough textures, obscure photographs) are usually anything but. Experimentation implies not knowing the final result, it means working with control, observing and analyzing the results and using that information to make the next informed step. This requires practice, and I'm here to help.

I recommend keeping a journal to detail your process, results, thoughts, issues, and notes. In the past, the undergraduate version of this class has made a finished, designed book of their work, much of which was based on their journals. If, as the class develops, you

Frequently Asked Questions

I already learned this stuff in undergrad. Can I skip this?
You probably already know a lot of these things. At least you think you do. You are anxious to move on. You want to start making a new world, exploring a new language, connecting new communities, do new grad-schoolish things. I understand. But wait. There are some fundamentals so deep and so unexplored that you cannot get to them until you remove all of the stylistic bravado you have learned up to this point. In the idiom of the west coast, consider this a cleansing and rebirth. This may seem humiliating to those whose success has depended on a well groomed style. But it will be liberating to shed the burden of having to be "good" or "cool" and focus on what is right there waiting for you.

Why are you limiting us to 2D abstract work?
When you begin this program, each of you has skills that you have relied on for your career. This class is designed to level everyone's skills by removing most of them: type, color, sketching, model making, etc. You are left with a bare minimum of strategies, and so you are quickly forced out of your area of comfort and security. Once you have developed confidence within limitations, you can slowly add complexity as well as your other skill sets. And you will be on a much stronger footing for all your future work.

How will this class help us in any practical way?
Sigh. In your first semester at this level, I hope you are willing to be impractical. Much of my own teaching (and making) emphasizes the inefficient, difficult, impractical way of doing things. If you are asking this question, though, you are probably still unconvinced. So I will be bringing in examples of designers and artists who have used process, abstraction, and visual sensation to create innovative and startling work.

Why are you always so critical of student work? Are you ever satisfied?
To me, critique is at the heart of this class (and of design practice). Without it, there is nothing to push against, and one tends to repeat past success, which soon becomes a crutch. The critique I present in class is meant to give you the means of developing a difficult dialogue with yourself and among your peers. I am satisfied when a student becomes self critical in an empowering way.

Why are we given these random materials? Why can't we choose our own?
I believe that once you can make something out of nothing — like turning a paper clip into a journey of surprise and delight, then no subject or material will ever be too challenging. In design we are often given subject matter that we have not chosen and that may seem dry and dreary at first. Offering you two materials always provides new intersections of ideas and keeps the class surprising for you and me both.

What have you got against color?
With the advent of sophisticated color printers, digital cameras, and web formats, color has been used more and more by designers to mask bad typography, weak layout and uninspired photography. Color can be a great tool, but its easy attraction can be misleading. I think it is best applied to an already strong design and used judiciously to maximize its impact.

No further questions? Good. Let's begin.

E

F

170

G

H

I

J

Martin Venezky

Results and process from Form Studio in the past.
E: Sam Wick. F, G: Rosanna Yau. H: Agnes Pierscie-
niak. I: Rax Silverburg. J: Jason Mickelson.

과거 '형태 스튜디오'의 결과 및 프로세스
E: 샘 윅 F, G: 로잔나 야우 H: 아그네스 피어사이어니악
I: 랙스 실버버그 J: 제이슨 미켈슨

K

L

171

M

N

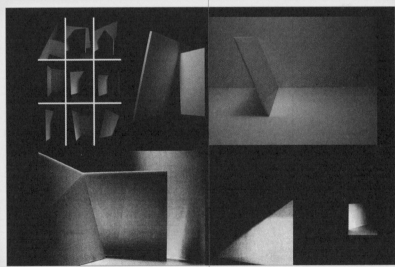

O

P

Results and process from Form Studio in the past. 과거 '형태 스튜디오'의 결과 및 프로세스
K: Matthew Canton. L: Kaz Nakanishi. M, N: Jason K: 매튜 캔턴 L: 가즈 나카니시 M, N: 제이슨 미켈슨
Mickelson. O: Sam Wick. P: Agnes Pierscieniak. O: 샘 윅 P: 아그네스 피어사이어니악

When typography

Dreams
!

Everyone is creative. Because when everyone sleeps, everyone dreams. Are dreams the ultimate creative act?

This thought has always made me wonder. I suppose it depends on how you define creativity, right? Whether or not dreams, themselves, are creative, the dream state can be a terrific tool for generating unexpected results within ordinary systems.

The strategies of your dreams are varied, but they always require some form of *logic*, even if that logic is wholly contained within the dreamed world. That logic can be based on a real-world understanding (impending deadlines, fear of failing) or can contradict the logic of the known world (ability to fly, inability to move).

There is a seamlessness to the dream state ... there never seems to be a pause ... at least we don't remember any. While dreaming, you never have to stop to figure out what should happen next. One story simply moves into the next one. The scenes flow together, unexpected objects and people appear side by side, things come apart or come together with a naturalness that is hard to imitate in our waking life.

Why is it so hard for us to articulate our dreams once we wake? One reason, I think, is that translating into words demands a kind of logic that stifles the free flow of the dream state.

The Challenge
You will be given two bags. One contains a letter and one contains a material. You are to engage these letterforms in a dream state. Will one be dreaming of the other (or of you?) Or will you be the dreamer? You have also given me a list of your interests. Consider those as subjects for the dream. For example, perhaps a spool of thread will dream of stretching its legs, or the letter "g" dreams of life as a vegetarian.

Consider strategies that your dreams have taken — past or present —or imagine strategies based on your own creative impulses. Be able to defend your work by articulating and envisioning an internal logic, narrative, strategy, process, or explanation.

Good Luck.

Seoul Workshop
PaTI
May 2017
Martin Venezky
Q: Workshop introduction.

Day 1

Drawing
!

We will spend the first day drawing our work.

Because of its roots in handcraft, typography can be a form of drawing — consider calligraphy and handwriting.

The wonderful thing about drawing is that it can be anything. It doesn't have to look like anything, the marks don't have to behave a certain way. You are truly free, which can be difficult.

Consider the possibilities of process drawing — that is, drawing that is not based on mimicing an observed world, but is a response to the act of mark making itself, and the process developed to apply each individual mark. Accuracy becomes less important than coherence, recognition less valuable than honesty.

Drawing does not automatically mean "without tools." You can use any number of tools, gadgets and strategies to assist you in constructing your work. Maybe try something you are not used to, or use your materials or your dreams to suggest unexpected ways of making marks.

If you want to use digital drawing, that is fine. But I will challenge you to use it as an adjunct to, rather than a replacement for, the hand. That is, once you've done some work digitally, print it out and draw on the page directly. Or, start by drawing on paper, scan it and continue using digital tools.

Building
!

Look over the drawings you've made on the first day and select at least one series that interests you.

Now build it.

Using only the humble materials of paper, string, adhesive and marking... whatever you can find easily around you... construct a three-dimensional version of your drawing.

This is a form of translation, from one medium to another. The built version will not be an exact copy, but how it differs will be up to you and the 3D logic you apply. Now that you are forced into a three-dimensional world, you will have to decide which aspects of the drawing to delete and which to enhance. How can you use a limited palette of materials for a wide array of specific effects?

Think of a filmmaker who is working on a film version of a novel. She has to make a lot of decisions, many of which were never a part of the original text. She must visualize how exactly a room should look and develop a logic to it. She must visually define characters that were only verbally described. Should she match the sequences in the book, or compress them, or refer to them quickly, or delete them completely? Does dialogue that makes sense in a written form work in a spoken form? What about inflections, accents, movement?

As a designer, being able to translate between media is a valuable and important process, and one that will continually yield unexpected results. The process can move backwards and forwards, between all forms — drawing, scanning, photography, writing, filming. We'll consider more of these soon!

Remember ... you are still dreaming.

Photo-
graphing
!

Now take your built work and photograph it.

Use the camera to explore, not just record.

This is yet another form of translation. Although we don't often think of the camera this way, you will be very surprised at what kinds of new information come forward through a photograph.

Consider lighting, scale, color, background, point of view. Consider motion. Consider how you view the resulting image: screen versus print. What happens if you now draw or build on top of the printed photograph or in front of the screen?

A photograph is different than a drawing or a built form. It suggests a kind of veracity that may be deceiving. For example, we may view an image of a tabletop model and think that it is a photograph of something gigantic. Does that make the photo wrong? Is that a problem or something that can be used to your advantage?

What happened to your original dream? And your original letterform and material? Do you want to reintroduce them into what you're creating now?

You have a lot of decisions to make as you work.

But remember you are still dreaming.

Martin Venezky

Workshop at PaTI . This workshop is about the concept of dreams and creativity. Each student is given a letter and a material that students will engage with in a dream state.
Q: Workshop introduction.
R: Day 1. Drawing processes based upon letter and materials.
S: Day 2. After examining the resulting drawings, students must now build these constructions in 3D.
T: Results must now be photographed.

PaTI 워크숍.주제는 꿈과 창의성의 개념이다. 각 학생은 꿈을 꾸는 상태에 관여하게 될 편지와 자료를 받는다.
Q: 워크숍 소개
R: 첫째 날. 편지와 자료를 바탕으로 한 드로잉 과정
S: 둘째 날. 드로잉 결과물을 검토한 다음 이 구조물을 3D로 구축해야 한다.
T: 결과물을 사진으로 찍어야 한다.

U

V

17

W

X

Y

Z

U : Example of letterforms given to students.
V–Z: Stills from the workshop in progress.

U: 학생들에게 주어진 글자 형태 예시
V–Z: 워크숍 과정 스틸 사진

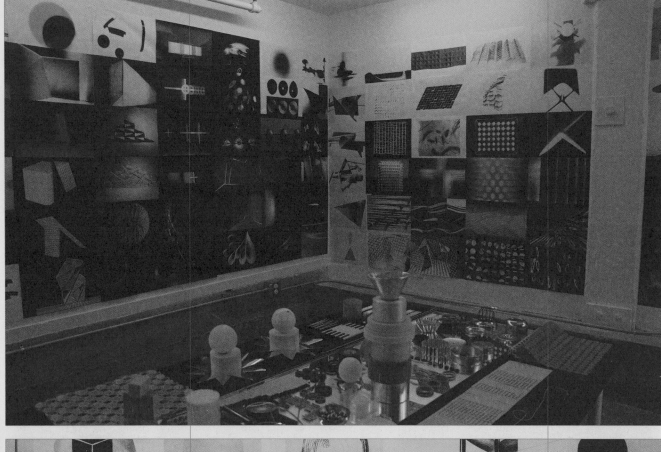

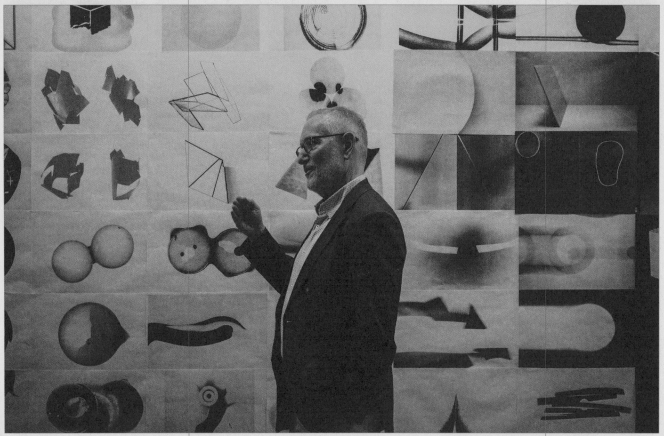

Martin Venezky

Images of an exhibition documenting 20 years of the Form Studio course. The exhibition also contained a range of physical objects that often serve as catalyst in the form experiments taking place in this course. The exhibition took place at the Institute Of Advanced Uncertainty, Hayes Valley in San Francisco, USA. Photography by Lawrence Lander.

'형태 스튜디오' 과정 20년을 기록하는 전시회 이미지. 전시에는 수업에서 형태 실험의 촉매 역할을 한 여러 가지 실제 사물도 있었다. 전시는 미국 샌프란시스코 헤이스 밸리에 있는 불확실성연구소에서 열렸다. 사진: 로렌스 랜더

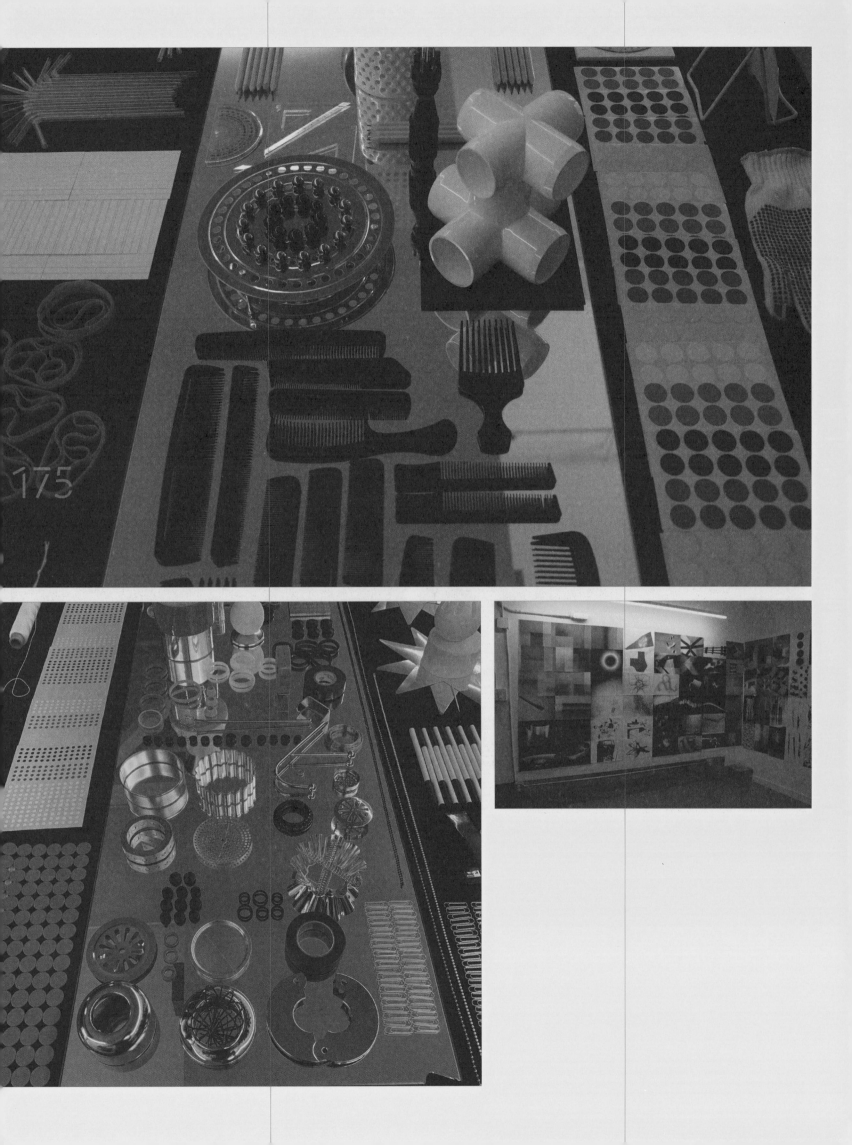

175

A

PostGráfica

Master en Pensamiento Estratégico,
Diseño Gráfico y Negocio Creativo
by **Mucho**

Idep
Barcelona
Escola Superior
d'Imatge i Disseny

B

¿Tiene sentido lo que haces?

C

Mucho
PostGráfica

Qué?

Cómo?

Pensamiento
Crítico

Porqué?

Estrategia
Creativa

**El Placer de
Aprender**

**El Placer de
Comprender**

Inteligencia
Colectiva

Narrativa
Visual

D

PostGráfica

**Pensamiento
Crítico**

De Proveedor ⟶ **A Consultor**

El que recibe el Brief.
Y por tanto, al que le dicen
lo que hay que hacer.

El que Pregunta.
Y por tanto, plantea lo
que hay que hacer.

176

E

PostGráfica

**Narrativa
Visual**

De Grafista ⟶ **A Narrador**

El Que Decora.
Y por tanto, pinta una
cultura ya establecida.

El Que Cuenta.
Y por tanto,
establece una cultura

F

PostGráfica

**Inteligencia
Colectiva**

**De Estudio
de Grafismo** ⟶ **A Estudio de
Consultoria Visual**

Que produce gráfica

Que produce cultura
y conocimiento

Mucho

Design studio in Barcelona, San Francisco, Paris, New York
Founder, PostGráfica masters degree at IDEP

A: An outline document for the PostGráfica
graduate design program at Idep Barcelona, Escola
Superior d'Imatge i Disseny.
B: Does what you do make sense?
C: A chart emphasizing the pleasures of learning
and understanding.
D-G: Transformation themes within critical
thinking, visual narrative, collective intelligence,
creative strategy.

A: 이데프 바르셀로나의 포스트그라피카 대학원
디자인 프로그램의 개요
B: 당신은 논리적으로 행동하고 있는가?
C: 배움과 이해의 즐거움을 강조하는 차트
D-G: 비판적 사고, 시각적 내러티브, 집단 지성,
창조적 전략 안에서의 변화 주제

PostGráfica

Estrategia Creativa

De Diseñador Grafico ⟶ **A Director Creativo**

El que sabe de letras
y colores.

El que sabe construir
y usar la imagen.

G

PostGráfica

Campo Semántico

H

PostGráfica

Diseño Estratégico

La capacidad de planificar estrategicamente:

- Sistemas Morales
- Estructuras de Valor
- Filosofia y Cultura de Marca
- El Análisis de Contextos
- El Análisis de Deseos y Emociones Colectivas
- Nuevos Paradigmas y Asunciones
- El Análisis de Hipótesis Filosóficas
- La Generación de Conocimiento
- La Generación de Significado

I

PostGráfica

Campo Semántico

J

PostGráfica

Diseño Gráfico
La Hipótesis PostGráfica

Plan para generar significado o transmitirlo, para
producir cultura, para construir y establecer
narrativas, o para provocar conocimiento a través
del uso articulado de la imagen.

K

PostGráfica

Campo Semántico

L

H: A diagram showing the existing paradigm that
PostGráfica seeks to depart from.
I: Objectives of a new design planning and strategy,
for example: moral systems, structural values, etc.
J: A diagram of the new PostGráfica model for
design where emphasis is on method, communica-
tion and meaning.

H: 포스트그라피카에서 출발점으로 삼은
기존 패러다임을 보여주는 다이어그램
I: 새로운 디자인 계획 및 전략의 목표
예를 들어 도덕 체계나 구조적 가치 등
J: 방법, 소통, 의미에 중점을 두는 디자인을 위한
새로운 포스트그라피카 모델의 다이어그램

K: The hypothesis of PostGráfica trying to generate
and transmit meaning to produce culture and
establish new narratives through articulation
of image.
L: A diagram showing this hypothesis showing a
succession of plan, meaning, culture, knowledge
and image.

K: 포스트그라피카 가설은 이미지를 표현함으로써
문화를 만들고 새로운 내러티브를 확립하기 위해
의미를 창조하고 전달하고자 한다.
L: 위 가설을 보여주는 다이어그램에는 계획, 의미,
문화, 지식, 이미지가 연속적으로 보인다.

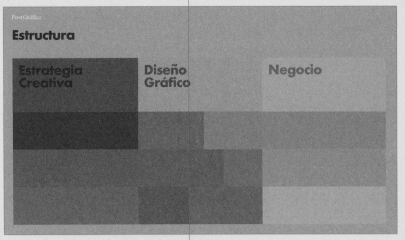

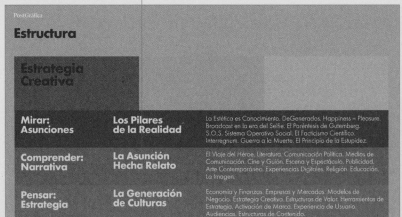

Estructura

Estrategia Creativa **Diseño Gráfico** **Negocio**

M

Estructura

Estrategia Creativa

Mirar: Asunciones	**Los Pilares de la Realidad**	La Estética es Conocimiento. DeGenerados. Happiness = Pleasure. Broadcast en la era del Selfie. El Paréntesis de Gutenberg. S.O.S. Sistema Operativo Social. El Facticismo Científico. Interregnum. Guerra a la Muerte. El Principio de la Estupidez.
Comprender: Narrativa	**La Asunción Hecha Relato**	El Viaje del Héroe. Literatura. Comunicación Política. Medios de Comunicación. Cine y Guión. Escena y Espectáculo. Publicidad. Arte Contemporáneo. Experiencias Digitales. Religión. Educación. La Imagen.
Pensar: Estrategia	**La Generación de Culturas**	Economía y Finanzas. Empresas y Mercados. Modelos de Negocio. Estrategia Creativa. Estructuras de Valor. Herramientas de Estrategia. Activación de Marca. Experiencia de Usuario. Audiencias. Estructuras de Contenido.

N

Estructura

Diseño Gráfico

1 Proyecto: Varias Disciplinas

**Naming
Tipografía
Branding
Packaging
Branded Content
Fast Video
Dirección de Arte
Activación de Marca**

O

Estructura

Negocio

El Arte de Vender: Diseño

El Diseño para generar Modelos de Negocio Creativos

El Arte de Vender: Productos de Diseño

P

Trimestre 1. Agenda

Q

Trimestre 2. Agenda

R

Mucho

M-P: The structure for the three semesters at PostGráfica where they are divided into themes of Creative Strategy, Graphic Design and Business.
Q-S: A specific course schedule showing the three semesters by theme.

M-P: 창의적 전략, 그래픽 디자인, 비즈니스라는 주제로 나뉘어 있는 포스트그라피카의 세 학기 구성
Q-S: 3학기를 주제별로 보여주는 구체적인 과정 스케줄

S

T

U

V

W

X

T-U: Stills from the PostGráfica program in action.
V-X: Diagrams showing a survey conducted during this time asking questions like, 'What does it mean to learn?', 'Can we design emotion?', 'Ethics or aesthetics?'

T-U: 진행 중인 포스트그라피카 프로그램의 스틸 사진
V-X: 이 기간 동안 시행된 '배운다는 것은 무엇인가' '감정을 디자인할 수 있는가?' '윤리학인가, 미학인가?'와 같은 질문을 담은 설문조사를 보여주는 다이어그램

POSTGRAFICA
Preparación para Clases 1er Trimestre

LOOK:
ASUNCIONES
Los Pilares de la 'Realidad'

Asunciones:
¿Qué asunciones vale la pena que un diseñador investigue?
La mirada sobre estas asunciones nos dará una comprensión profunda de nuestro
contexto sociocultural. Las asunciones son los cimientos mismos de la sociedad, de la
realidad que vivimos, de nuestras verdades compartidas, lo que se llama nuestras
realidades intersubjetivas. Las asunciones se relacionan estrechamente con aquellas
cosas a las que les damos valor, y por tanto se relacionan con estructuras de valor.
Nuestras asunciones más intimas pueden producir consecuencias positivas o
negativas, y a menudo son imperfectas y generan nuestras contradicciones más
elementales. Esta mirada sobre las asunciones pone el foco sobre posibles áreas de
conflicto o necesidad, susceptibles de ser abordadas mediante un proyecto. La forma
más profunda de proyecto de diseño es aquel que consigue establecer nuevas
asunciones que cuestionan asunciones viejas, y reformulan nuestra manera de ver el
mundo, y por tanto nuestra interacción con él.

Posibles temas:

Asunciones de la Imagen / Comunicación

- **La Naturaleza del Proyecto** ¿Qué es un proyecto de diseño gráfico? La asunción
 de la Bauhaus y la cultura de la Revolución Industrial: La división entre forma y
 contenido. El proyecto como crítica.

- **El Conocimiento es Estética.** Sin estética no hay significado. Sin estética no hay
 experiencia. Sin cuerpo humano no hay significado. Mark Johnson / John Dewey.
 El medio es el mensaje. Forma y Contenido van juntos. Marshall Mc Luhan. La
 comunicación en la era de los mensajes a la velocidad de la luz.

- **El Formato en Nuestra Cabeza. La comunicación.** Cómo percibimos afecta a qué
 pensamos. El formato afecta nuestro pensamiento. Hoy pensamos más como
 campesinos medievales que como ilustrados renacentistas. El Paréntesis de
 Gutenberg. El libro / La Web / El post / El meme / el emoticono / el video remix.

A

An outline of the themes from the first semester
at PostGráfica. It is divided into three sections,
LOOK: ASSUMPTIONS, The Pillars of Reality,
UNDERSTAND: NARRATIVE, Stories Through
Assumptions, THINK: STRATEGIES IN COMMU-
NICATION, Generating Culture.
A: Assumptions are a founding block of society
that we can challenge and re-think through design
and therefore change the way we view and interact
with the world.

포스트그라피카 첫 학기의 주제 개요
'보기: 추정, 현실의 기둥' '이해하기: 내러티브,
추정을 통한 이야기들' '생각하기: 소통의 전략,
문화 창출'이라는 세 부분으로 나뉜다.
A: 추정은 우리가 디자인을 통해 도전하고 다시 생각하고
따라서 우리가 세상을 바라보고 상호작용하는 방식을
바꿀 수 있는 사회의 초석이다.

UNDERSTAND:
NARRATIVA
La Asunción hecha Relato

Narrativa:
Consideramos narrativa como la construcción de un relato en base a unas asunciones previas o estructuras de valor. Este relato puede construirse en multitud de plataformas mediante disciplinas muy variadas, que van desde las historias mentales que pensamos y nos contamos, hasta mensajes en los medios de comunicación pasando por todas las representaciones simbólicas que nos rodean. Vivimos en relatos. Todo es un relato. La verdad es un relato.
Comprender la construcción de relatos en distintas disciplinas es central para comprender la comunicación y el diseño como un constructor de relatos. Y este además puede tomar prestados estructuras y metodologías de cualquier disciplina para construir relatos.

Planteamiento de Clases de Narrativa.
La Narrativa de las Asunciones: **El Viaje del Héroe**
La Narrativa de las Asunciones en: **Cine**
La Narrativa de las Asunciones en: **Experiencias Digitales**
La Narrativa de las Asunciones en: **Política**
La Narrativa de las Asunciones en: **Medios de Comunicación**
La Narrativa de las Asunciones en: **Redes Sociales**
La Narrativa de las Asunciones en: **Teatro y Artes Escénicas**
La Narrativa de las Asunciones en: **Guión**
La Narrativa de las Asunciones en: **Literatura**
La Narrativa de las Asunciones en: **Televisión**
La Narrativa de las Asunciones en: **Fotografía**
La Narrativa de las Asunciones en: **Ilustración**
La Narrativa de las Asunciones en: **Educación**
La Narrativa de las Asunciones en: **Creencias Religiosas**

181

THINK:
ESTRATEGIA EN COMUNICACIÓN
La Generación de Culturas

Estrategia:
Entendemos la estrategia como un plan meditado para conseguir un fin. Entendemos la estrategia en comunicación como un plan meditado para establecer un cambio cultural. La magnitud de este cambio puede ser mayor o menor. De hecho, los seres humanos generamos paradigmas culturales – visiones del mundo, realidades intersubjetivas – alrededor de todo. Desde las cosas más pequeñas, como un cepillo de dientes o una barra de pan, hasta las cosas más grandes, como la constitución de un país o nuestra forma de ver las cuestiones de género. Estos cambios culturales que persigue la estrategia de comunicación afectaran a como vemos una determinada cosa, y por tanto a como interactuamos con esa cosa, y por tanto a como experimentamos esa cosa, y por tanto a nuestra evaluación de la cosa misma. Si damos por buena la asunción de que nuestro único conocimiento posible de las cosas depende de nuestra experiencia de ellas, se puede deducir que los cambios en los mensajes son también cambios en las cosas mismas. La estrategia en comunicación es la aplicación del pensamiento a un plan para cambiar o establecer un paradigma cultural entre un determinado grupo humano. Para ello es imprescindible la comprensión de las asunciones: la capacidad de evaluarlas, cambiarlas o generar nuevas. Para ello es imprescindible comprender la construcción de valor: la evaluación y estructuración de aquellas cosas a las que decidimos otorgar valor. Para ello es imprescindible la comprensión de la narrativa: de su capacidad y sus métodos para construir relatos habitables basados en las cosas que valoramos.

Clases de Estrategia:

1. **Economía y finanzas** (& mercados financieros): qué es un bien, un precio, el dinero, la bolsa, los mercados, los sectores, la inflación,

2. **Empresas y mercados** (de bienes y servicios): qué es una empresa, y un consumidor? oferta y demanda, precio de reserva, curva de utilidad, elasticidad...

3. **Modelos de negocio** (& repaso global con alguien tipo "BCN Activa)

4. **Crear marcas. La metodología Mucho: Estrategia Creativa:** De valores a imágenes; Círculo de Oro y Manifesto.

5. **Prácticas Circulo de Oro** Clase práctica del círculo de oro con los proyectos de los alumnos. (esta clase fue imprescindible el curso pasado! - tienen que llegar a esta clase con la idea de proyecto clara).

6. **Herramientas de Estrategia** Otras metodologias/herramientas de estrategia para analizar/crear/reposicionar marcas. Plataformas de marca varias, ejemplos reales diversos, clásicos y nuevas tendencias, etc... De todas estas, hay dos taaaan importantes hoy que les dedicaremos una clase específica (aunque en el fondo los

B

C

B: We live in a story, everything is a story, reality is a story. To understand the construction of these stories and different disciplines is central to comprehending communication and design as a storyteller.
C: The way that we communicate is BASED ON how WE see and interact with things. And the WAY we communicate these messages can change the things THEMSELVES.

B: 우리는 이야기 속에 산다. 모든 것은 이야기이며, 현실도 이야기이다. 이러한 이야기와 다른 분야의 구성을 이해하는 것은 스토리텔러로서 커뮤니케이션과 디자인을 이해하는 데 중요하다.
C: 우리가 소통하는 방식은 사물을 보고 그것과 상호 작용하는 방법을 토대로 한다. 그리고 우리가 이러한 메시지를 전달하는 방식이 사물 자체를 바꿀 수 있다.

Reframing the Poster

SPRING 2019
GRAPH 2010-01
3 credits
TH 1:10–6:10
DC 601

Nancy's office hours
Tues. and Thurs.
10:30–12:00
or by appointment
DC 602

Nancy Skolos
nskolos@risd.edu
professor

Nathan Young
nyoung@risd.edu
teaching assistant

GOALS

To research the lineage
and characteristics of
poster design

To push against the poster's
conventional forms and
applications

To explore the poster's
capacity to animate and its
potential interact with
other posters and viewers
in installation

To develop an investigative
agenda for the poster as a
form through immersive
personal experimentation

Ralph Schraivogel, Zurich 2016

INTRODUCTION

This course will invite you to explore future possibilities and contexts
for the poster—as paper and as screen—building on its singular
capacity to transform ideas into iconic picture planes, and examining
the dynamics of typography and image, both still and in motion.
Prompts will progress from individual posters, to sequences, to
site-specific installations that explore the potential for interactive
discourse in public space. Studio assignments will be supported with
presentations and readings about poster history and contemporary
poster design.

STRUCTURE

Class time will be a organized around sharing ideas and reviewing
prototypes. Various critique formats will be incorporated—
entire class, small group, and one-on-one. There will also be in-class
exercises, presentations and tutorials as we go along. You are encour-
aged to continue to work together in your studio as you develop your
ideas outside of class.

The assignments are designed to gradually build understanding of the
goals of the class and leave room for incorporating your own interests.
Please feel free to propose individual adjustments to the prompts.

REFRAME · 1

Nancy Skolos

Professor, Rhode Island School of Design
Founder, Skolos-Wedell

The following are excerpts from Skolos' Poster
Design course. The above shows a course outline
with objectives, evaluation criteria and schedule.

다음은 스콜로스의 포스터 디자인 과정을 발췌한
내용이다. 위 내용은 강의 개요로서, 학습 목표와
평가 기준 및 일정을 담고 있다.

Reframing the Poster: Schedule

SPRING 2018
GRAPH 2010-01
3 credits
Thursdays
1:10–6:10
DC 601

2.14	WEEK 1	Introduction to the Course Show-n-tell: Poster Origins and Archetypes Introduce Assignment 1: Reframing Poster In-class exercise: Collage
2.21	WEEK 2	Show-n-tell: Type and Image Rough Critique: Assignment 1: Reframing Poster
2.28	WEEK 3	Show-n-tell: Object Posters Almost Final Critique: Reframing Poster Introduce Assignment 2: Object Poster Series Optional AE Tutorial
3.7	WEEK 4	Final Critique: Reframing Poster
3.14	WEEK 5	Show-n-tell: Poster History with Tom Wedell Rough Critique Assignment 2: Object Poster Series
3.21	WEEK 6	Show-n-tell: Type as Image and Poster Surface Almost Final Critique Assignment 2: Object Poster Introduce Assignment 3: Typographic Music Poster
3.27		Spring Break
4.4	WEEK 7	Final Critique Assignment 2: Object Poster Work in class
4.11	WEEK 8	Show-n-tell: Poster Situations Rough Critique Assignment 3: Music Poster
4.18	WEEK 9	Almost Final Critique Assignment 3: Music Poster Introduce Assignment 4: Poster Situation
4.25	WEEK 10	Final Critique Assignment 4: Music Poster Discuss ideas for Poster Situation
5.2	WEEK 11	Rough Critique Assignment 4: Poster Situation
5.9	WEEK 12	Final Critique Assignment 4: Poster Situation
5.16	WEEK 13	Exhibition and Celebration. Submit any loose ends.

A

183

REFRAME · 2

PROJECT GOALS

Explore the dynamics of large-scale two-dimensional composition

Test the potential of posters to act as transformative windows and thresholds to ideas

The most important thing in art is The Frame. For painting: literally; for other arts: figuratively—because, without this humble appliance, you can't know where The Art stops and The Real World begins.

You have to put a 'box' around it because otherwise, what is that shit on the wall?

If John Cage, for instance, says 'I'm putting a contact microphone on my throat, and I'm going to drink carrot juice, and that's my composition,' then his gurgling qualifies as his composition because he put a frame around it and said so. 'Take it or leave it, I now will this to be music.' After that it's a matter of taste. Without the frame-as-announced, it's a guy swallowing carrot juice.

Frank Zappa

Assignment 1: Reframing

Kasper-Florio St-Gall 2016 Zhu Chao [Mint Design] Beijing 2016

Our initial assignment will investigate the role of the poster frame and explore how it can be deployed to reshape a poster's meaning.

REQUIREMENTS AND CONTENT

Title: 'Reframing fill-in-the-blank' Can be cultural, social, informational, commercial—topic of your choosing. Use the poster to 'reframe' the idea. Secondary type to support title.

Explore the dynamics of framing using both type and image.

SCHEDULE

2.14	WEEK 1	Introduce Assignment Collage Exercise
2.21	WEEK 2	Rough Critique: Bring in at least three prototypes for digital projection, proportioned to final poster size: 90.5 x 128 cm long approx. 35.5 x 50.5 in
2.28	WEEK 3	Almost Final Critique: Half size: 64 x 90.5 approx. 25.25 x 35.5 in (can be tiled)
3.7	WEEK 4	Final Critique 90.5 x 128 cm long approx. 35.5 x 50.5 in

Estimated material cost: $50.00

B

REFRAME · 3

PROJECT GOALS

Test the meaning and configuration of objects in poster space

Exploit the union of the object+poster's properties of scale, confrontation, and space

Negotiate the tension between the three-dimensional qualities of the object and the two-dimensional qualities of the poster

Use motion to intensify and/or transform the poster's message over time

The longer you look at an object, the more abstract it becomes, and, ironically, the more real.

Lucian Freud

To create one's own world takes courage.

Georgia O'Keeffe

Assignment 2: Object Poster Series

Jacques Carelman's Catalogue d'objets introuvables [Catalog of Unfindable Objects] Paris, 1969

Fourchette à crêpes, Fourchette de sûreté, Fourchette à escargot

Studio Lindhorst-Emme Berlin, Das Kapital ist weg—Wir sind das Kapital! 2018

In this assignment you will be asked to design a series of (at least two) posters that engage the viewer and tell a story or illustrate a subject through objects. Employ motion to enhance the posters' meaning and dynamic presence. Objects and Topic: your choice

Size and number of posters: open

SCHEDULE

3.14	WEEK 5	Rough Critique Assignment 2: Object Poster Series Present digitally
3.21	WEEK 6	Almost Final Critique Assignment 2: Object Poster Show posters with motion Introduce Assignment 3: Typographic Music Poster
3.29		Spring Break
4.4	WEEK 7	Final Critique Assignment 2: Object Poster

Estimated material cost: $25.00

C

REFRAME · 4

PROJECT GOALS

Explore new contexts and interactions for poster design

Mediate poster(s), viewers, and space

And one of the things I noticed pretty early on in art school was that my classmates had no notion of an audience. Right? I mean, growing up with the mother that I did, I learned that when you walk into the dry cleaners, there's an audience waiting for you. You know, maybe it's just the person behind the counter.

David Sedaris

Fikra Graphic Design Biennial, Sharjah 2018 Department of Non-Binaries Christopher Benton

Assignment 4: Poster Situation

Fikra Graphic Design Biennial, Sharjah 2018 Department of Flying Saucers
Adam Linder performing [from AIGA Eye on Design]

Expand Assignment 1, 2 or 3 to be installed in a space and to incorporate interaction. Consider your audience and use the posters to activate the space and engage the viewers. All types of digital devices, drones, etc. can be imagined.

Look at examples of installation and surveillance art.

SCHEDULE

4.25	WEEK 10	Final Critique Assignment 4: Music Poster Discuss ideas for Poster Installation
5.2	WEEK 11	Rough Critique Assignment 4: Poster Installation
5.9	WEEK 12	Final Critique Assignment 4: Poster Installation
5.16	WEEK 12	Submit any loose ends from the semester

Estimated material cost: $25.00

D

REFRAME · 6

Excerpts from Nancy's Poster Design course.
A: Course Schedule.
B: A project examining 're-framing' posters socially, culturally, etc..
C: A project re-examining the concept of the object poster.
D: A project examining posters in space and situations.

스콜로스의 포스터 디자인 과정에서 발췌한 것이다.
A : 수업 일정
B: 포스터를 사회적, 문화적, 혹은 또 다른 방식으로 '재구성하는' 프로젝트
C: 오브제 포스터의 개념을 재검토하는 프로젝트
D: 공간과 상황 안에서 포스터를 검토하는 프로젝트

FALL 2018
GRAPH J223–04
3 credits
Thursdays
1:10–6:10
DC 404

Nancy's office hours
Tuesdays
10:00–1:00
or by appointment
DC 602

Typography III

Nancy Skolos
nskolos@risd.edu
instructor

Eury Kim
ekim06@risd.edu
teaching assistant

INTRODUCTION

Typography III is the culminating course in the department's type sequence and serves to further your knowledge of the principles and fine points of typography, as well as present opportunities for developing a personal point-of-view. Assignments will explore typography as a medium for shaping thought and investigate how type interacts with space, function and time. Even though your individual connection to type will be the focus, the class will be a collaborative laboratory where ideas, constructive critique, and hard work will energize new directions for the discipline.

GOALS

TO DRAW OUT PERSONAL CONNECTIONS TO TYPE
• *as a medium for language, literature and information*
• *as an expression of personality and tone*
• *as composition, form and texture*
• *as a partner with space, time and product*
AND WORK AS A GROUP TO MAKE NEW DISCOVERIES

OBJECTIVES

• Grow capacity for identifying and deploying typefaces
• Explore the relationship between structure, sequence and thought
• Understand the unique characteristics of type and image and gain confidence merging them
• Design with type across various media and reader/user spaces
• Gain experience with tools for generating design prototypes

STRUCTURE

Class time will be a organized around sharing ideas and reviewing prototypes. Various critique formats will be incorporated— entire class, small group, and one-on-one. There will also be related in-class exercises, presentations and tutorials as we go along. You are encouraged to continue to work together in your studio as you develop your ideas outside of class.

The assignments are designed to gradually build understanding of the goals of the class and leave room for incorporating your own interests. You are welcome to propose individual adjustments to the prompts if desired.

III · 1

PROJECT GOALS

Explore the relationship between typographic structure and thought.

Gain confidence merging type and image.

Design is hard, but it does become a more comfortable activity with repetition. I don't know if it is even visible to anyone else, but in my work I am often trying to make a very functional thing, but also to come up with a solution that possesses some sort of ineffable quality, or "soul." This means devising a formal response to the content that comes out of a real appreciation for the subject, with some subtlety, I hope. While I try not to be too obviously "formal," I am always trying to create an overt visual narrative to pull the reader toward the content. To me, building those narratives is both an editing and a design process.

Lorraine Wild

Assignment 2
Editorial Design

Daniela Haufe an Detlef Fiedler, Cyan | Form + Zweck Magazine

Choose an existing magazine or invent a magazine or fanzine about a topic of your choice—news, culture, fashion, etc. or some combination of subject matter. Visit the mezzanine level of the RISD library for inspiration.

Generate and/or gather content from various sources—existing publications, blogs, etc. Be sure to credit your sources.

Design a cover, contents page and layout for one or more articles.

9.27	WEEK 4	Introduce Assignment 2: Editorial Design Lecture: *Type and Image*
10.4	WEEK 5	Small group critiques Assignment 2: Editorial Design Work in class
10.11	WEEK 6	Final critique Assignment 2: Editorial Design Introduce Assignment 3: Information Design

Estimated material cost: $25

III · 5

PROJECT GOALS

Explore the fine points of designing typographic tables.

Design information that is simultaneously legible and engaging—beautiful and useful.

We envision information in order to reason about, communicate, document, and preserve that knowledge—activities nearly always carried out on two-dimensional paper and computer screen. Escaping this flatland and enriching the density of data displays are the essential talks of information design …

Too many data presentations, alas, seek to attract and divert attention by means of display apparatus and ornament. Chartjunk has come to corrupt all sorts of information exhibits and computer interfaces…

Edward Tufte

Assignment 3
Information Design

Studio Joost Grootens Museumindex Van Abbenmuseum Eindhoven

Redesign the schedule for the 18/19 Rhode Island Philharmonic Orchestra Concert Season (attached handout). Feel free to substitute another schedule for a series of events with relatively the same amount of information.

Activate the information with images and symbols/icons as appropriate. Make the schedule come to life and be inviting for the music lover and potential concert-goer.

10.11	WEEK 6	Introduce Assignment 3A: Information Design
10.18	WEEK 7	Rough critique Assignment 3A: Information Design–Print Adobe XD and/or Sketch refresher/Discussion type on screen Introduce Assignment 3B: Information Design–Screen-based
10.25	WEEK 8	Final critique Assignment 3A: Information Design–Print Rough critique Assignment 3B: Information Design–Screen-based Introduce Assignment 4: Typography Across Media
11.1	WEEK 9	Final critique Assignment 3B: Information Design–Screen-based Discuss ideas for Assignment 4: Typography Across Media

Estimated material cost: $25

III · 6

PROJECT GOALS

Design with type across various media and reader/user spaces.

Gain experience with tools for generating design prototypes.

Draw out personal connections to type as an expression of personality and tone; as composition, form and texture; and as a partner with space, time and product.

In today's world, the medium is often just the medium, as content seeks to migrate freely across platforms rather than embody the qualities of a specific medium. "Device independence has become a goal more urgent than the task of crafting unique page layouts.

Ellen Lupton

Assignment 4
Typography Across Media

Philippe Apeloig Quad Cinema Animation 2017

This final assignment is meant to be open for you to work with type in situations and media that you would like to explore. Building on content and/or working methods generated in one or more of the first three projects, develop a typography identity project that exists in at least three media. These could include: print, web, mobile, motion, projection, packaging, interior space.

10.25	WEEK 8	Introduce Assignment 4: Typography Across Media
11.1	WEEK 9	AE tutorial/work in class *Examples type in motion* Discuss ideas: Assignment 4: Typography Across Media
11.8	WEEK 10	Rough critique: Assignment 4: Typography Across Media Show-n-tell: *Type Across Media*
11.15	WEEK 11	Rough critique: Assignment 4: Typography Across Media
11.22	NO CLASS THANKSGIVING	
11.29	WEEK 12	Final critique: Assignment 4: Typography Across Media
12.5	CRIT WK	Individual meetings Review Semester's Work

Estimated material cost: $50

III · 7

Nancy Skolos

Excerpts from Typography 3.
E: Course overview.
F: An editorial design project on content and context.
G: An information design project emphasizing typography and the fine line between the beautiful and useful.
H: A media agnostic typography project for content that is constantly changing.

타이포그래피 3에서 발췌했다.
E: 수업 개요
F: 내용과 문맥에 관한 편집 디자인 프로젝트
G: 타이포그래피 및 아름다움과 유용성 사이의 미세한 구분을 강조하는 정보 디자인 프로젝트
H: 끊임없이 변화하는 콘텐츠에 대한 미디어 불가지론적 타이포그래피

Rhode **Island School of Design**
Graphic Design
DS3 / Fall 2018
Unit 13 / Design Variables
Nancy Skolos

Question: What conditions and forces impact the design process?
How can we innovate within constraints?

Unit summary

Ideas are one thing and what happens is another. John Cage

For designers, creative motivation is generated in partnership with external conditions. Our imagination is stimulated by design problems and their programmatic constraints; our personal passions find a place to intersect with our audiences; and sometimes ideas come to us by pure accident. In this unit we will work in groups to generate design prompts and engage with original design problems by defining and recombining five variables: content, inspiration, limitation, communication medium, and audience.

Learning objectives

- — Develop methods for concept development
- — Gain insight into shaping design problems
- — Cultivate the intuitive aspects of the design process
- — Realize the value of the unexpected
- — Experience the dynamics of group collaboration to strengthen design vision

Assignment

Assignment will be generated from workshop (see below):

Protocol / schedule

Unit 13 Design Variables Introduction [Weds Oct. 24]

Methodology: Workshop and Assignment [Weds Oct. 24]
Each section will be divided into five groups of three or two (using chance operation) who will collaborate for the duration of unit 13.

Workshop
Phase 1: [1:00–2:00pm]
Each group will be assigned one of the following elements and will brainstorm ideas for variables that impact a design project:
Group 1: Content: Subject/Topic. Can include anything you would be excited to be assigned as a topic/subject—social, cultural, commercial, political, informational, etc.
Group 2: Influence or Inspiration. Something personal or accidental that could influence your approach to your work.
Group 3: Limitation/Obstruction. Anything you can think of that if pushed against, could make an interesting result—scale, characteristics (e.g. modular,) material, algorithm, tool, budget, etc.
Group 4: Communication Medium. What form will the solution take? What kind of deliverables are you interested in producing? Be sure it is a realistic scope of work (enough but not too much) for a group to complete with final projects due November 7.
Group 5: Audience/Context. Consider various contexts, locations, and parts of the population who would be the end users/viewers and identify a target group for design. Be specific.
Phase 2: [2:00–2:30pm]
Groups then pass their lists to next group who will then narrow the options for the category to **at least 5** of most promising. The variables from each category will be placed into five piles and each group will pick one variable from each category to define their project.

Examples:

Content: Subject/Topic	Influence or Inspiration	Limitations/Obstructions	Communication Medium	Audience/Context
election	humor	modular	brand	airport travelers
Baudrillard	minimalism	handmade	exhibition	adults over 80
climate change	conditional design	no type	game	middle school students
graffiti art	vernacular	must be square	map	gymnasts
reality	theatre	only spend $10	event	people with dyslexia

Phase 3: After break [2:30–4:20pm]
Groups work in class to develop creative briefs that incorporate their five assigned variables.

Due Mon 10/29 [1:10 Pin-up and walk-about, Section critiques at 2:00]
Each group will generate three A1—594 x 841 mm (23.4 x 33.1 in) posters with each poster mapping and mood-boarding a creative brief for an assignment that embodies the five variables they received. Based on discussion, groups will work to shape a final assignment for themselves by the end of class.

Due Weds 10/31 [11:20–3:20]
Group presentations in 212 to all sections. 5–7 minutes for each group, followed by section critique. The presentation should clearly define your project and show rough design prototypes.

Due Mon 11/5
Dress rehearsal presentations of final projects. Use scale models, digital prototypes or appropriate combination to show how you solved your brief.
Introduce Unit 14.

Final Due Weds 11/7
Unit 13 Final Critique (Location and format TBA)

Recommended Readings

Chance-Imagery George Brecht

Royal Road test

A four day group workshop on the concept of
Design Variables.
I: Workshop overview.
J: Workshop explanation and group division.
Assignment explanation.
K: Schedule and specifics.

디자인 변수의 개념에 대한 4일간의 그룹 워크숍
I: 워크숍 개요
J: 워크숍 설명과 그룹 나누기, 과제 설명
K: 일정 및 세부 사항

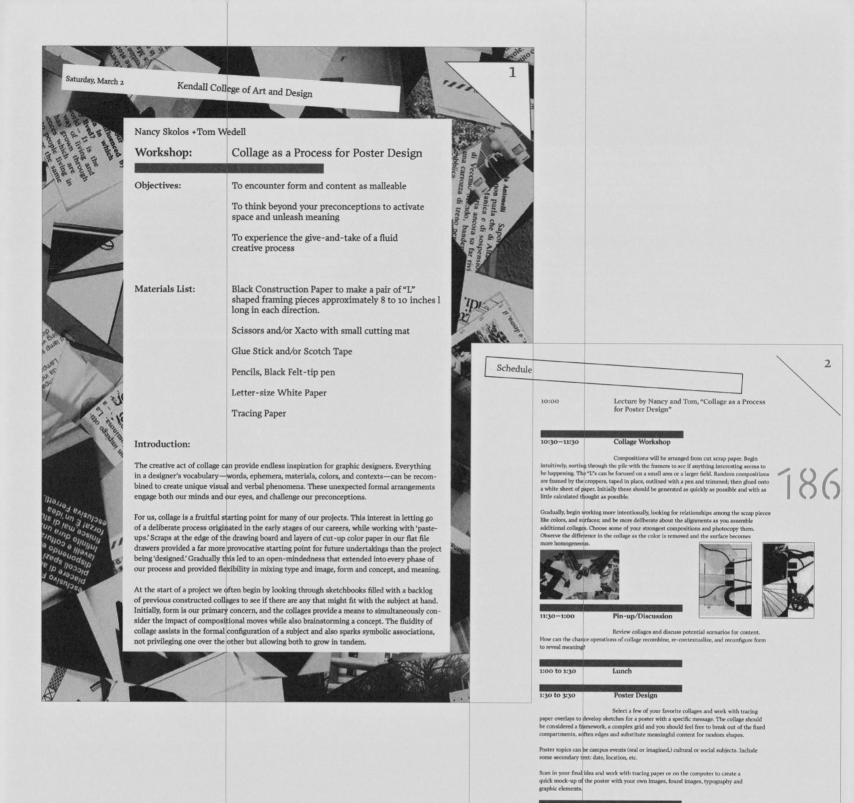

Nancy Skolos +Tom Wedell

Workshop: Collage as a Process for Poster Design

Objectives: To encounter form and content as malleable

To think beyond your preconceptions to activate space and unleash meaning

To experience the give-and-take of a fluid creative process

Materials List: Black Construction Paper to make a pair of "L" shaped framing pieces approximately 8 to 10 inches l long in each direction.

Scissors and/or Xacto with small cutting mat

Glue Stick and/or Scotch Tape

Pencils, Black Felt-tip pen

Letter-size White Paper

Tracing Paper

Introduction:

The creative act of collage can provide endless inspiration for graphic designers. Everything in a designer's vocabulary—words, ephemera, materials, colors, and contexts—can be recombined to create unique visual and verbal phenomena. These unexpected formal arrangements engage both our minds and our eyes, and challenge our preconceptions.

For us, collage is a fruitful starting point for many of our projects. This interest in letting go of a deliberate process originated in the early stages of our careers, while working with 'paste-ups.' Scraps at the edge of the drawing board and layers of cut-up color paper in our flat file drawers provided a far more provocative starting point for future undertakings than the project being 'designed.' Gradually this led to an open-mindedness that extended into every phase of our process and provided flexibility in mixing type and image, form and concept, and meaning.

At the start of a project we often begin by looking through sketchbooks filled with a backlog of previous constructed collages to see if there are any that might fit with the subject at hand. Initially, form is our primary concern, and the collages provide a means to simultaneously consider the impact of compositional moves while also brainstorming a concept. The fluidity of collage assists in the formal configuration of a subject and also sparks symbolic associations, not privileging one over the other but allowing both to grow in tandem.

10:00 Lecture by Nancy and Tom, "Collage as a Process for Poster Design"

10:30—11:30 **Collage Workshop**

Compositions will be arranged from cut scrap paper. Begin intuitively, sorting through the pile with the framers to see if anything interesting seems to be happening. The "L"s can be focused on a small area or a larger field. Random compositions are framed by the croppers, taped in place, outlined with a pen and trimmed; then glued onto a white sheet of paper. Initially these should be generated as quickly as possible and with as little calculated thought as possible.

Gradually, begin working more intentionally, looking for relationships among the scrap pieces like colors, and surfaces; and be more deliberate about the alignments as you assemble additional collages. Choose some of your strongest compositions and photocopy them. Observe the difference in the collage as the color is removed and the surface becomes more homogeneous.

186

11:30–1:00 **Pin-up/Discussion**

Review collages and discuss potential scenarios for content. How can the chance operations of collage recombine, re-contextualize, and reconfigure form to reveal meaning?

1:00 to 1:30 **Lunch**

1:30 to 3:30 **Poster Design**

Select a few of your favorite collages and work with tracing paper overlays to develop sketches for a poster with a specific message. The collage should be considered a framework, a complex grid and you should feel free to break out of the fixed compartments, soften edges and substitute meaningful content for random shapes.

Poster topics can be campus events (real or imagined,) cultural or social subjects. Include some secondary text: date, location, etc.

Scan in your final idea and work with tracing paper or on the computer to create a quick mock-up of the poster with your own images, found images, typography and graphic elements.

3:30 to 5:00 **Poster Critique**

Nancy Skolos

A workshop outline inviting students to explore unexpected and unpredictable relationships and form through collage.

학생들에게 예측 불가능한 관계를 탐구하고 콜라주를 통해 형태를 만들어보도록 하는 워크숍 개요이다.

Color Scheming

SPRING 2019
GRAPH 3211-04
3 credits
Mondays
1:10–6:10
DC 601

Nancy's office hours
Tues. and Thurs.
11:30–1:00
or by appointment
DC 602

Nancy Skolos
nskolos@risd.edu
Professor

INTRODUCTION

Color Scheming, is one of a series of three, four-week intensive workshops that make up the course: Color + Surface. In this segment, we will intensively observe color as both palette and as pattern to build understanding of its richness in application. Working back and forth between swatch palettes and formal pattern designs—analyzing the dynamics among groupings and then prototyping them as two-dimensional sequential designs—will test the resulting effects of color quantity and juxtaposition. Even though your individual connection to color will be the focus, the class will be a collaborative laboratory where ideas, constructive critique and hard work will energize the potential of color in graphic design.

OBJECTIVES

Develop facility with color through immersive experimentation

Gain understanding of the terminology related to the attributes and interactions of color

Examine color's sensate qualities as individual entities and as dynamic systems

STRUCTURE

Class time will be organized around sharing ideas and reviewing prototypes. Various critique formats will be incorporated— entire class and small group, and in-class exercises, presentations and tutorials.

You are encouraged to continue to work together in your studio as you investigate color. Color-aid swatch packs will be provided for use during the duration of the workshop and patterns will be generated using primarily Rhino and Adobe Illustrator to create vector-based frameworks for color experimentation. A visit to the Library's special collections will provide inspiration.

The assignments are designed to gradually build understanding of the goals of the class and leave room for incorporating your own interests. You are welcome to propose individual adjustments to the prompts if desired.

187

COLOR · 1

Schedule: Assignments

SPRING 2019
GRAPH 3211-04
3 credits
Mondays
1:10–6:10
DC 601

TERMS:
Warm
Cool
Primary
Secondary
Tertiary
Complementary
Analogous
Hue
Saturation
Shade
Tint

PROJECT GOALS

Focus wholly on color—its intrinsic properties and interactions

Experiment with the interplay of colors in various adjacencies and quantities

In visual perception a color is almost never seen as it really is, as it physically is. This fact makes color the most relative medium in art.

—Josef Albers

WEEK 1 4.22

1:00 Introduce Color Scheming Segment of Color + Surface
2:00 Field trip to the RISD Library's Special Collections
3:30–6:00 Introduce Assignment: Phase 1: Palettes

IN-CLASS EXERCISE

Carefully leaf through your pack of 314 Color-aid swatches, looking for color groupings. Begin intuitively, first setting aside colors that have visual interest to you. As you continue through the swatches, check each new swatch against the ones you have already chosen. Begin to build small selections of colors, grouping swatches that have synergy.

Experiment with different hues, shades, and brightnesses. You will be looking for a group that has some complementary and some analogous components. Analyze the characteristics of the individual colors and how they relate to result in interesting groupings.

Arrange each group in different configurations, sliding the swatches to view various adjacencies and quantities of color.

ASSIGNMENT: SWATCH SCHEMES

Using the Color-aid pack and this methodology, create a collection of dynamic color palettes.

DUE 4.29

Present a range of at least 20 color schemes with between four and six individual colors. Be prepared to discuss your editing process and also show some discarded groupings.

COLOR · 2

PROJECT GOALS

Learn to consider color selections in tandem with design development

Extend your experimentation with the interplay of colors by testing proximities

The aim is to develop— through experience—by trial and error—an eye for color.
—Josef Albers

Karan Singh For 2014 US Open

Karan Singh for Adobe

Chad Kouri Xerograph Monotype Exercises

Curwen Press Pattern Specimen Book

4.29 **DUE WEEK 2: ASSIGNMENT SWATCH SCHEMES**
Class review swatch palettes: analyze characteristics and relationships— e.g. which colors are primary, secondary, tertiary, complementary, analogous. etc. Discuss color conversion for printing.

Work in class on pattern designs.
https://www.rhino3d.com/download/rhino-for-mac/5/evaluation

5.6 **DUE WEEK 3: ASSIGNMENT: COLOR PATTERNS**
Chose a selection of your favorite color schemes and develop a series of design/ patterns for each using vector graphics generated in Rhino and/or Adobe Illus-trator. The pattern designs will be frameworks within which to deploy the color schemes. For next week show at least two patterns in four color variations (8 total) each 9 in. square. Print on plotter.

5.13 **DUE WEEK 4: ASSIGNMENT: COLOR PATTERN FINAL**
Incorporate your color research and pattern designs into a bound book, poster, three dimensional object, screen-based piece, or deliverable of choice.

Estimated material cost: $25–$50.00

COLOR · 3

RESOURCES

GOETHE COLOR TRIANGLE

ALBERS STUDY

MUNSELL COLOR SYSTEM

COLOR · 4

Oded Ezer Typography
Tel Aviv, Israel

Hebrew Literal Typographic Translations

Assignment: Design a Hebrew version for a non-Hebrew brand logotype (Latin, Arabic, Devanagari, Chinese, Japanese, Cyrillic, Greek etc.).
School: H.I.T (Holon Institute of Technology), Visual Communication Department, Israel
Course: Advanced Typography Class
Instructor: Oded Ezer

By investigating and understanding the very basic structures and architectures of the Hebrew letters, the task is to match — stylistically — the 2 languages, but without forcing the Hebrew to look like English, Arabic or Japanese letters.

Work method:

❶ Decompose original logotype letters and create a palette of shapes:

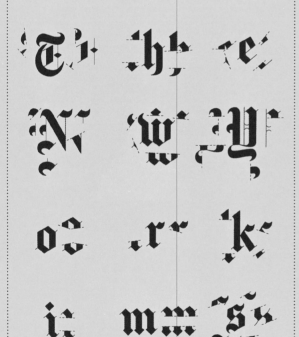

❷ Draw and analize different Hebrew letters' 'skeletones':

❸ Use the palette of shapes and the Hebrew skeletones to create Hebrew version of the original letters:

❹ Finish the design while bearing in mind the typographic rhythm of the original logotype:

Hebrew version by 3rd year student Michal Shani

result

188

result

Oded Ezer

Founder, Oded Ezer Typography, HebrewTypography
Senior Lecturer, Holon Institute of Technology

Israeli designer Ezer asks students to start from a familiar non-Hebrew logo and re-draw it in Hebrew. Through this translation process, students confront the many unique characteristics of Hebrew typography, including the right-left reading direction. This exercise sees students gaining an appreciation of the core structure of Hebrew through the forms of non-Hebrew letters.

이스라엘 디자이너 에제르는 학생들에게 익숙한 비히브리어 로고를 히브리어로 다시 그리도록 했다. 이 번역 과정을 통해 학생들은 오른쪽에서 왼쪽으로 읽는 방향을 비롯한 히브리어 타이포그래피의 여러 가지 독특한 특징에 직면한다. 이 연습을 하면서 학생들은 비히브리어 글자의 형태를 통해 히브리어의 핵심 구조를 이해한다.

Student's work

Hebrew version by 3rd year student Doron Baduch

Hebrew version by 3rd year student Doron Baduch

Hebrew version by 3rd year student Stav Axenfeld

Hebrew version by 3rd year student Daniela Geigner

SEGA סגה

Pinterest פינטרסט

190

Lübzer לובזר

Oded Ezer

Hebrew version by 3rd year student Orly Dekel

Hebrew version by 3rd year student Rotem Dayan

Hebrew version by 3rd year student Lizzy Ezra

Hebrew version by 3rd year student Ben Gilboa

191

Instructions

Think
before you print
this PDF

Patrick Thomas Studio Berlin
Released 05.04.2019

▶ YouTube Spotify Twitter Instagram

위 내용은 패트릭이 자신의 최근 연구를
A4 인쇄 과정에서 더욱 발전한다. 또한 그러한 실험을
공개한 문서 모음에서 나왔다.

Welcome	3
Checklist	4
Why	5
Artwork	6
Print	7
Hang	8
Start	9
Extras	10
Document	11
Gallery	12
Support	13
Bio	14
Legal	15

QR codes
Access more resources by scanning these codes
which you will find throughout the pdf

1. Open smart phone Camera app.
2. Centre QR code in viewfinder.
3. Tap link

Index ←

Welcome and thanks for your interest in Open_collab.
Everything you need to get started is explained here.

This self-run workshop is designed to encourage
dialogue, experimentation and—most importantly—
collaboration between participants. The use of basic,
everyday studio materials makes it simple to set up
and as economical as possible. It is aimed at anyone
with an interest in visual communication, at any stage
of their studies/careers. Some basic type/image-editing
knowledge is required.

Background
In 2012 I began work on a solo exhibition in Düsseldorf,
Germany. My aim was to create unique artworks
using screen printing. The idea was simple: to use the
mechanical print process to combine found elements
in a random way, with a minimum of planning and
composition. I was interested in provoking unexpected
juxtapositions, chance encounters and dialogues,
between elements that would not usually be found
together.

Recently, whilst on a residency in Rome without access
to proper print facilities, it occurred to me that I could
simplify the layering process greatly by using a standard
Din A4 laser printer to overprint images several times
on the same sheet of paper. I have now decided that it
might be interesting to share this way of working.

I hope you find the project constructive, rewarding and
fun and look forward to developing it, with your help.

Patrick Thomas

Professor, Stuttgart State Academy of Art
Author, *Protest Stencil Toolkit*

Index ←

Info pack
—1. Instructions (this pdf)
—2. Grid
—3. Feedback form

Participants
— Optimal group size: 10–20 (recommended age: 18+)

Workspace
—Wifi access (not essential)
—Flat, unbroken wall space to hang wall graphic
—Work tables, chairs, etc.

Materials
—1 (minimum) Din A4 monochrome laser printer
—1 (minimum) replacement black toner cartridge
—Laptops or computers with ©Adobe CC software
—Scanner (alternatively smart phones may be used)
—500 sheets 80/90gm2 white Din A4 laser paper
—Basic drawing materials (black)
—Cutting mats and cutters (for collage work)

Hanging
—Ladder/s
— Digital level & tripod (recommended) or spirit level
—White tack / Scotch Magic tape (or similar)

A public workshop platform created by Patrick
Thomas is furthering his recent studies on A4
printing processes and the beautiful and unex-
pected relationships that take place through such
experiments. The above excerpts are from an open
set of documents that Patrick has allowed to be
downloaded from anywhere, anytime that allow
multiple participants to take part in his workshop.

패트릭 토머스의 공공 워크숍 플랫폼은 그의 최근 연구인
A4 인쇄 과정에서 더욱 발전한다. 또한 그러한 실험을
통해 생기는 아름답고 예상치 못한 관계 역시 마찬가지다.
위 내용은 패트릭이 자신의 워크숍에 여러 사람이
참여할 수 있도록 언제 어디서나 다운로드 가능하게
공개한 문서 모음에서 나왔다.

Why

Index ←

I receive a lot of requests form students and educators asking me to hold workshops. As my time is limited I am only able to give as few each year, which is why I have created Open_collab, a project that can be run without me.

The main aim is to encourage groups of people to collaborate, initially quite possibly without them even realising it. It is aimed at students, educators and professionals at any stage of their careers. It will help participants to appreciate the importance of teamwork, and allow them to view their own work from a new perspective.

The workshop is intense, however it should be of course be enjoyable. It will demonstrate what we are capable of achieving when we work together to reach a common goal. More than the resulting collaborative wall graphic, the most important aspect of the project is the working process.

Good luck, and please be sure to let us know how you get on.

Scan or click this QR code to access Open_collab on YouTube

Please bookmark as more material will be added to the channel

Artwork

Index ←

The Grid
At the start of the workshop the Grid file is given to every participant. It is used to give overall coherence to the final wall graphic. Participants should make copies of the file for each new artwork layer they create.

Each individual layer should respect the grid as much as possible. Also, when the artwork is prepared to print, the grid should be hidden (not printed). Participants must label each of their layers where indicated: Name/Location/Date/Ref. This information is purely for your reference.

Artwork
We recommend that you use ©Adobe CC software where possible to create your artwork. Participants should be encouraged to use a broad range of visual language for each of their layers to give each a different feel: typography, hand-drawn, collage, photography, abstract forms, minimal, detailed, etc.

Important: The artwork should not cover more than 25% of the grid area. Leave plenty of white space to allow the layers to interact.

Likewise, asymetric compositions will result in more interesting combinations between layers

Scan or click this QR code to access 02_oc_grid_05-04-19.pdf

Print

Index ←

The individual files created by each participant are layered by overprinting: running each sheet of paper through the laser printer, usually two or three times or until an interesting composition is achieved. Each sheet will therefore represent the work of 2, 3 or more different participants. Avoid single text/image layers.

The print process should be quite random, do not attempt to plan or compose the results. Layers can, and should, repeat several times so that forms appear in different combinations. For example:

A · B · C

Left: Individual layers

Below: Overprinted layers

A+B · A+C · B+C · A+B+C

Scan or click this QR code to access Open_collab: Overprint simulation YouTube video

Hang

Index ←

It is essential that the individual sheets are hung straight. Therefore it is highly recommended that you use a tripod-mounted Digital level. If this is not possible use a traditional spirit level. Under no circumstances should you attempt to hang 'by eye'.

Do not leave a gap between each printed A4 sheet. Use white re-usable adhesive tack, or Scotch Magic tape.

Optimal wall grid: 8 rows high (where possible). As a general guide, to calculate the wall width add a vertical column for each workshop participant.

For example below shows the recommended size for 20 workshop participants (Total size 238 x 420 cm)

Note: The size of the graphic should (of course) be adapted to the wall space available.

193

The above documents are more specific parameters for the set up of the grid, the printing document and the concept of layering and how it works with the documents.

위의 문서들은 그리드, 인쇄용 도큐멘트와 레이어링 개념의 설정 그리고 그 설정이 문서에서 작동하는 방법에 대한 좀 더 구체적인 변수를 보여준다.

Start

Index ←

Checklist
Make sure you have all necessary materials, etc.
Remember: the Din A4 monochrome laser printer/s
and replacement black toner cartridge/s are essential.

Teams
Nominate a workshop leader/s for general coordination
and to keep an eye on timing. Organise print and
hanging teams (use a rota system).

Subject
Choose a subject for the workshop [see 10 Extras].

Grid
Share Grid files with participants.

Document
Be sure to document every stage of the process.

Timeframe
7 hours approx, roughly allocated as follows:

Extras

Index ←

Subject
A subject must be agreed upon before the workshop
begins—this is completely open.

As a starting point, some basic themes might include:
— De/reconstruct the days news
 (use the day's newspapers as source material)
— Climate change & global warming
— Historical/contemporary quotations
— Gender
— Urban/rural
— Global/local
— Analogue/digital

This list of subjects will grow as we receive your
feedback.

Beamer/projector
A further text or image layer may be added by beaming
onto the final wall graphic

Music
Background music is encouraged during the workshop.
Access a specially compiled Open_collab playlist using
the QR code below.

 Scan or click this QR code to access
Spotify: Open_collab playlist

Document

Index ←

Documentation is an important aspect of the project.
Not just of the final wall graphic, but also of the
process. We recommend that you photograph/film all
stages the workshop for your own reference and also
to share online.

Please include several front-on photographs of the
completed wall graphic, with and without participants
and with as little perspective as possible

We aim to make a publication in the future so please
keep this material safe if you would like your workshop
to be considered for inclusion.

3 levels of documentation:
— Entire wall
— Individual sheets
— Macro details

Gallery

Index ←

In future updates photographs and links will appear
here. Please share your photographs and movies of
Open_collab on social media tagging @open_collab
#open_collab so we can find and repost you.

Open_collab workshop, Chelsea College of Arts, London, UK
March 2019. Photograph: ©2019 Peter Chadwick

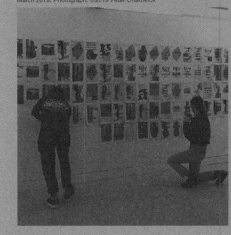

Patrick Thomas

The above documents are more specific logistics
for the workshop including timeframe, documenta-
tion and also display in a physical space.

위의 문서들은 기간과 기록, 물리적 공간 안에서의
전시 등 워크숍을 위한 더 구체적인 실행 계획이다.

195

OPEN_COLLAB 1.0　　　　　　　　　**YOUR NAME**

LOCATION　　　　　　　　　**MM.DD.YY**　　　**REF.: XX**

The above document is an example of the grid file that participants must use with their printer for layering in this workshop.

위의 문서는 이 워크숍에서 참가자가 레이어링을 위해 프린터와 함께 반드시 사용해야 하는 그리드 파일의 사례이다.

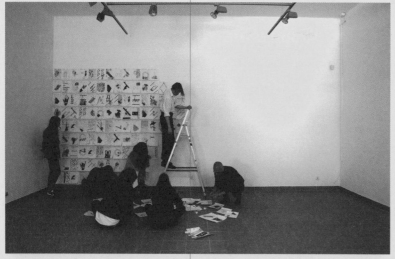
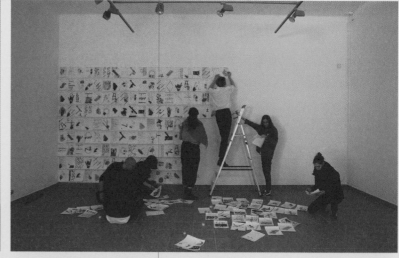
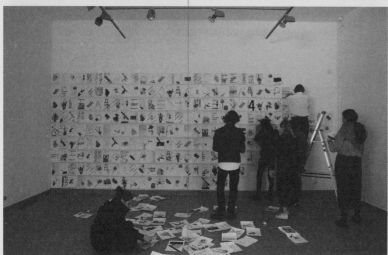
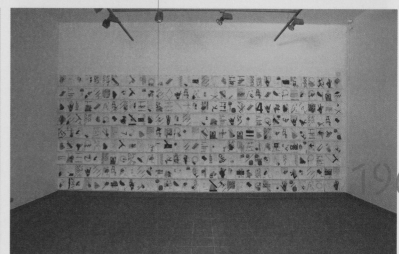

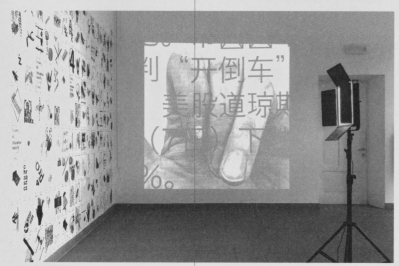
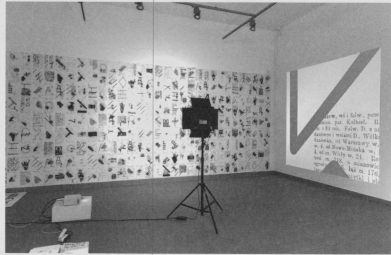

Patrick Thomas

Some results and process photos of an Open
Collab that took place at Warsaw Academy of Arts.
Photo credit: Hanging ©2019 Jonasz Chlebowski
Warsaw Academy of Arts, Poland, April 2019
Students from Klasse Thomas, ABK-Stuttgart
in collaboration with students from ASP-Warsaw

바르샤바예술아카데미에서 이루어진
오픈 컬래버레이션의 결과물과 과정 사진이다.

198

Patrick Thomas

Some stills from the actual prints, layers and
output from the workshop.
Photo credit: Hanging ©2019 Jonasz Chlebowski
Warsaw Academy of Arts, Poland, April 2019
Students from Klasse Thomas, ABK-Stuttgart
in collaboration with students from ASP-Warsaw

워크숍에서 나온 실제 인쇄물과 레이어와 결과물
사진의 일부이다.

199

Pooroni Rhee

Professor, University of Seoul
Recipient, Next Generation Design Leader,
Ministry of Industry and Energy

These are assignments for the 2D Foundation studio for the freshmen at University of Seoul. The students exercise a series of tactile to conceptual and digital assignments dealing with visualization, definition and discussions revolving the concepts of tools, dots, lines, planes, colors, forms, space, dimensions, languages and experiences. The assignments include groups of musical lines, mapping graphic design and unreadible books.

서울시립대학교 1학년 기초평면 수업의 과제이다. 대학에 처음 입학한 1학년 학생들의 1학기의 전공 수업으로, 손을 쓰는 작업부터 개념적이고 디지털적인 방식을 사용하는 일련의 과세들을 통해 도구, 점, 선, 면, 색상, 형태, 공간, 차원, 언어, 경험 등의 개념을 시각화하고 규정하며 토론하는 방식을 실험하고 익힌다. 음악적인 선들의 모임, 그래픽 디자인의 지형도와 읽을 수 없는 책 등의 과제를 진행하였다.

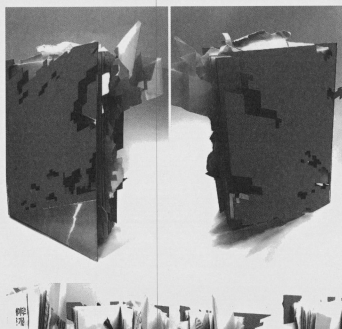

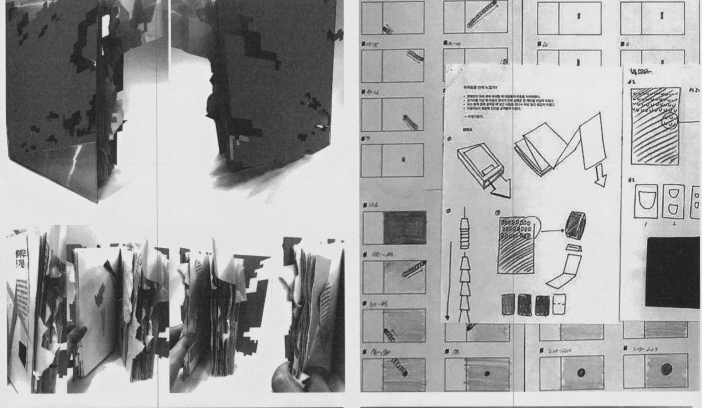

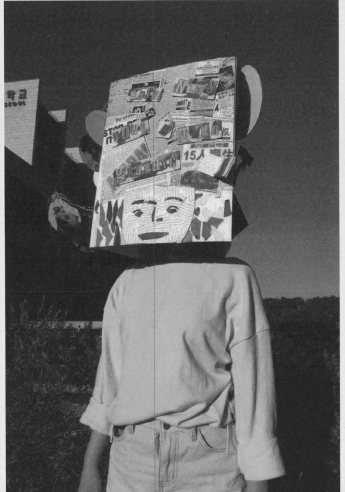

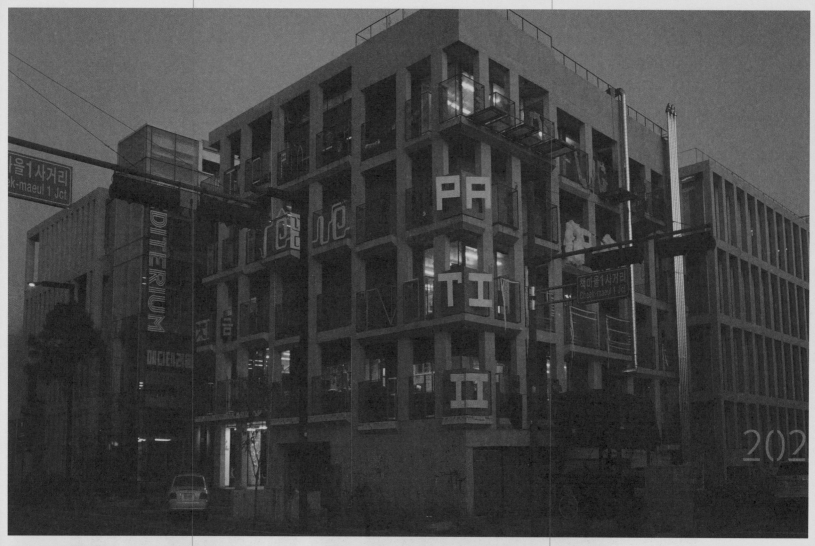

René Knip

Founder, Atelier René Knip
Co-Founder, ARKTYPE.NL

Babylon Workshop at the Paju Typography Institute. Utilizing the PaTI building as a site-specific space, students worked together to design and produce a typographic tower.

PaTI의 바빌론 워크숍. 학생들은 PaTI 건물을 장소 특정적 공간으로 활용하면서 함께 타이포그래피 탑을 디자인하고 제작했다.

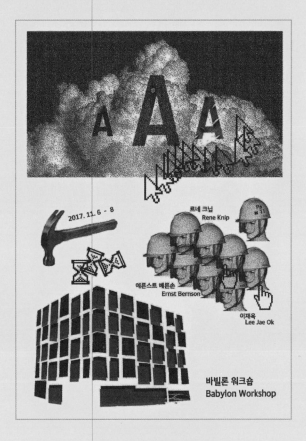

Briefs

Babylon is a workshop to build a type tower using PaTI building. This workshop requires students to think and act as a designer and architect at the same time. Students will be asked to how to think and make graphics and types in the environment so that they practice the sense of space and material as a creator. In the workshop, they researched and experienced physical and material structure of the building. Then, each student chose one word to develop and design their own types for 3D spaces. Finally, they installed them in their own design and material production.

Works and documentation

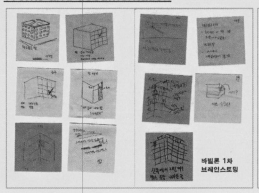

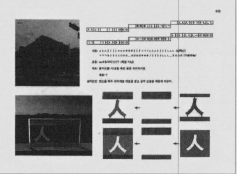

A workshop brief for Babylon Workshop including works and documentation alongside a project description.

프로젝트 소개와 더불어 작품과 관련 기록을 담은 바빌론 워크숍의 개요이다.

**바빌론 1차
브레인스토밍**

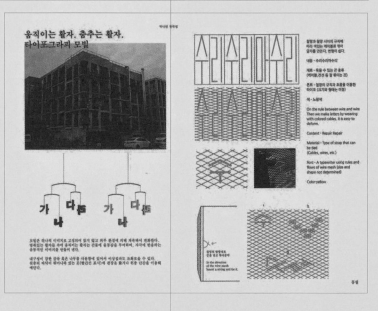

René Knip

Process sketches from the Babylon Workshop at Paju Typography Institute.

PaTI에서 열린 바빌론 워크숍의 과정 스케치다.

It could be any fence in isang house but my class usually work in 3rd floor. So I thought 3rd floor fence would be better to install types.

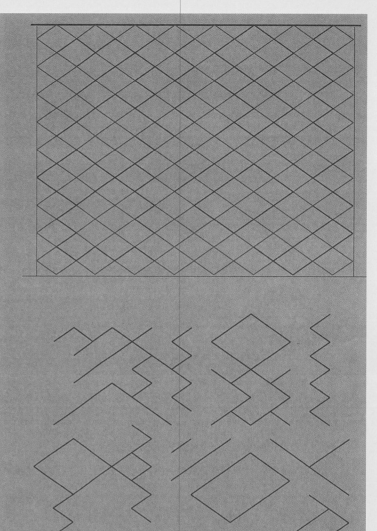

text

'깻잎연합' it means 'perilla leaf union' which our class nickname. The reason why this nickname created was perilla leaf is thin and seems weak. But texture is little rough and have a strong scent. So we thought we have both side like perilla leaf.

material & color

Wrap the fence by green cellophane tape or using spray. I thought grid that have fence and vein of a leafs are similar.

펜스가 가진 그리드 안에 우리 기수의 별칭인 '깻잎연합'을 시각화 했을 때 깻잎의 외형적 특징인 구불구불한 잎맥과 마름모로 이루어진 펜스가 잘 맞아떨어질 것 같다.

205

Clemence

• Babylon workshop

For my intervention on the facade, I wish to work with the Korean sign PATI, and the letters composing the Latin word. I am here as a foreign student so I find interesting to play with both alphabets. I would like to invest the square space of the embankment, and installed colored rectangular strips. These different bands will compose the letters. I think using colored resin if possible. Otherwise painted and then varnished wooden boards could work.

II.a - BALCONI DIMENSION

BABYLON WORKSHOP - PaTi.2017 - *Paulin BARTHE*
research.1.a

III.a - TYPE EXPERIMENTS

BABYLON WORKSHOP - PaTi.2017 - *Paulin BARTHE*
research.1.a

measures taken from zone 304

balcony openning height - 2360 mm
balcony openning width - 2400 mm
pillar width (separation between each balcony module) - 290 mm
railing height - 1205 mm
railing width - 2287 mm
forward offset of railing from pillar - 305 mm
side offset of railing from pillar - 210 mm on each side
bottom offset of railing from floor - 325 mm

the thrid floor would be about 16 meters seen from the crossing of both
street in front of the school.

THE EDGE

THE EDGE ... THERE IS NO HONEST WAY TO EXPLOIN IT BECAUSE THE ONLY PEOPLE WHO REALLY KNOW WHERE IT IS ARE THE ONES WHO HAVE GONE OVER

made with the font "concrete wonders"
(designed by myself last year).

THE EDGE THE EDGE THE EDGE THE EDGE THE EDGE THE ED GE THE EDGE THE E DGE THE EDGE THE EDGE THE EDGE THE EDGE THE EDGE TH E EDGE THE EDGE T

Julien JEAN
BABYLON WORKSHOP

I choose the sentence « Feel at Home » because this is the first words what Ahn said to us when we arrived at PaTi, on the first day. I like this words and , according to me, they represent my feelings when i'm in the school. My first idea is to use 3 grilles and create a modular typeface with colored wires. You can see the first sketches and my grid attached to this folder.

Thank you

Julien

Process sketches from the Babylon Workshop at
Paju Typography Institute.

PaTI에서 열린 바빌론 워크숍의 과정 스케치다.

206

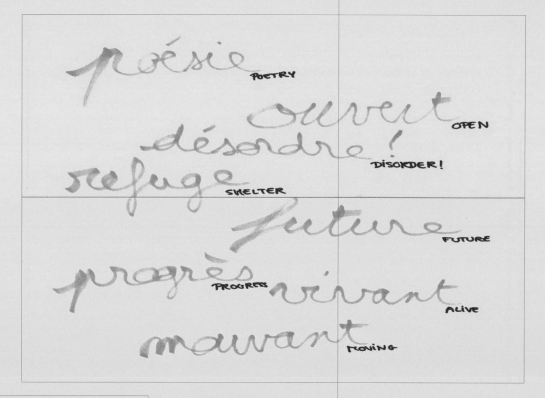

poésie POETRY
ouvert OPEN
désordre ! DISORDER!
refuge SHELTER
future FUTURE
progrès PROGRESS *vivant* ALIVE
mouvant MOVING

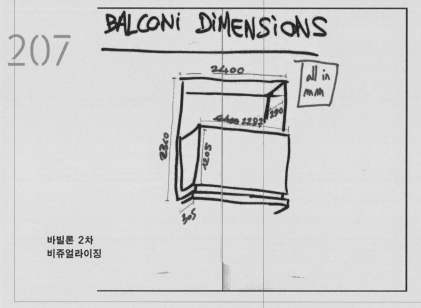

BALCONI DIMENSIONS

207

all in mm

2400

GLASS 2292 290

2360

1205

305

바빌론 2차
비쥬얼라이징

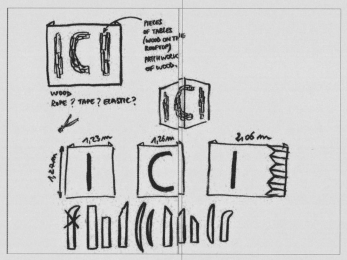

PIECES
OF TABLES
(WOOD ON THE
ROOFTOP)
PATHWORK
OF WOOD.

ICI

WOOD
ROPE ? TAPE ? ELASTIC?

ICI

1,23m 1,26m 2,06m

I C I

LARGE BALCONI

SMALL BALCONI

50 50

40 25

NUMBERS OF DIAMONDS

Professor Robert Probst
School of Design, Communication Design Program
College of Design, Architecture, Art, and Planning
University of Cincinnati

Linear drawing course sequence over a period of two academic years:

Drawn Design *course description/syllabi – (images 1,2,3,4,5)*

1. Beginning with simple exercises: pencil drawings with straight lines, angles, circles, ellipsis, tonal values, textural differentiations, coming to terms with material.
2. Developing a mastery and certainty in estimating proportions, practicing various forms of expression, perceiving how to create a rhythmic composition and to visualize dimension.
3. Commencing with the most perceptible objects such as cubes and cylinders, later endeavoring to analyze and represent in various perspectives more complex objects such as work tools, household objects, and organic shapes. Different drawing techniques and personal visualization characteristics are individually developed and promoted.
4. Transition from rational object representations to expressionist rendering styles. Interpretations are created with regard to light and shadow, special effect, as well as balance and reinforcement of forms.
5. Freely expressing a given theme. Applying a variety of materials and techniques to express complex and specific conceptual information. Either based on observed reality, memory, or imagination.

Visual Translations *course description/syllabi – (images 9,10,11,12,13,14)*

Designing a cohesive series of symbols, consisting of nine individual icons (pictograms)
based on given themes: Energy, Natural Disasters, Global Cultures, Amish Life, Las Vegas, Famous Architecture, Access Symbology.

1. Identification of nine messages.
2. Developing a cohesive and homogeneous quality in levels of complexity and interrelationship.
3. Establishing a systemized graphic approach and unified stylistic direction for a family of symbols.
4. Developing a personal visual language of forms and shapes.

Robert Probst

Professor, University of Cincinnati
Leader, Orville Simpson Center for Urban Futures

A

A: A course syllabus for a two-year course on drawing fundamentals for design students. The course explores basics in rendering to stylistic expression and grows the students' abilities to visualize ideas.

A: 디자인 전공 학생들이 2년 동안 듣게 되는 기초 드로잉 강의 계획서이다. 양식적인 표현을 위한 렌더링의 기초를 탐구하고 아이디어를 시각화하는 능력을 키우는 것이 목표이다.

Professor Robert Probst
School of Design, Communication Design Program
College of Design, Architecture, Art, and Planning
University of Cincinnati

Students in the 4th year of education:

Graphic Design: Concept – *(images 6,7,8,20)*

Based on selected issues: Drugs, Gun Control, Smoking, Music, etc.
creating compelling, visual statements in poster form.

1. Research of subject matter, gathering relevant information, statistics, data.
2. Ideation and conceptual development of selected topic for targeted audience.
3. Design explorations and selection of approach.
4. Final design production and presentation.

Students in the 5th year of education:

Graphic Design Capstone projects *conducted with an entire class of 30 to 40 students working in groups, supervised by two to three faculty members over a period of 6 months.*
All projects commissioned and sponsored by a client.

Students operate in at least two teams:
- Content research
- Writing and editing
- Image and design
- Three-dimensional components
- Technology and electronic production
- Visual material
- Budgeting and financial management

Projects shown:

"Wayfinding system for Cincinnati city districts" – *(image 15)*
"Olympic bid-package" – *(image 16)*
"Taft Museum anniversary show" – *(images 17,18,19)*
"CSO 100" anniversary exhibition of the Cincinnati Symphony Orchestra – *(images 21,22,23,24)*
"Oktoberfest Zinzinnati" exhibition – *(image 25)*
"The Dirt on Midea" archeological exhibition – *(image 26)*
"Garden Center exhibit" – *(image 27)*
"Cincinnati Bicentennial Celebration" design standard – *(images 28,29,30,31,32,33)*
"Tall Stacks" steamboat festival, exhibit, wayfinding, stage design – *(images 34,35,36,37,38,39)*
"Time and Space" exhibition and materials for national SEGD conference – *(image 40)*
"Children of Abraham" sacred spaces, traveling exhibition – *(images 41,42)*

B: A course syllabus for fourth and fifth-year students that guides them through independent research and final capstone projects. Students are encouraged to explore a broad topic of interest and rigorously design a project communicating it.

B: 4-5년차 학생들을 위한 강의 계획서이다. 독자적인 연구와 최종 프로젝트 진행을 지도한다. 학생들이 관심 있는 주제를 폭넓게 탐구하고 그 내용을 전달하는 프로젝트를 철저하게 디자인하도록 독려한다.

Making Drugs Illegal

Makes Drugs Dangerously

Profitable

Support legalization, the drug control solution.

open your eyes

support gun control

This message brought to you by *Parents Against Guns*.

Robert Probst

Student work from several of the courses Robert Probst has taught over the years.

로버트 프롭스트가 수년 동안 가르쳐온 여러 과정에서 나온 학생 작품들

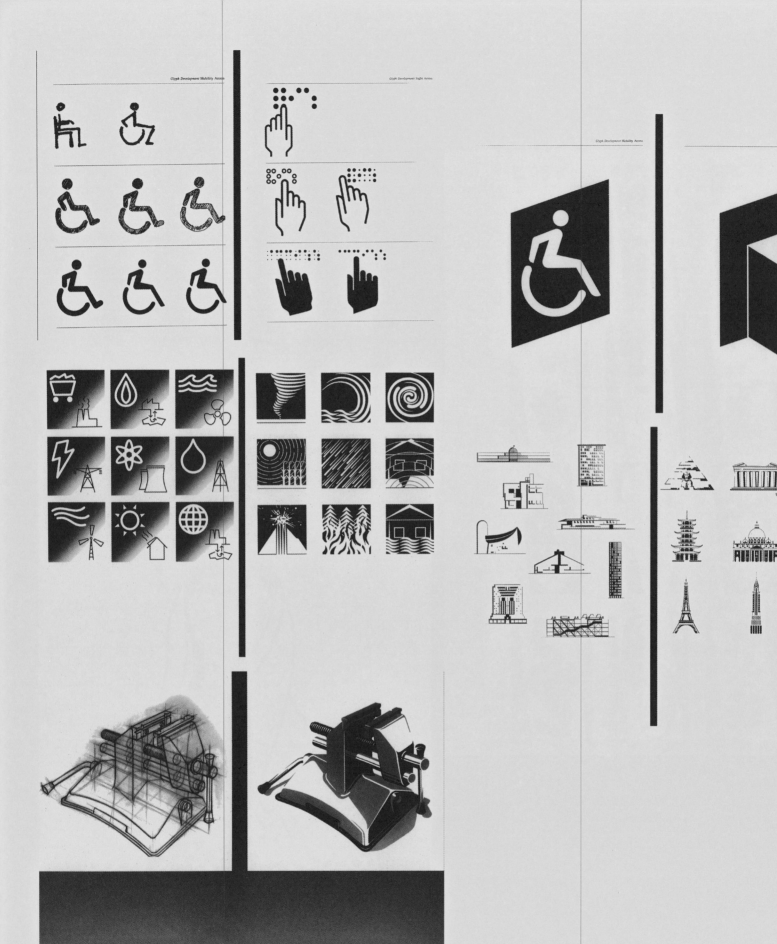

Robert Probst

Student work from several of the courses Robert Probst has taught over the years.

로버트 프롭스트가 수년 동안 가르쳐온 여러 과정에서 나온 학생 작품들

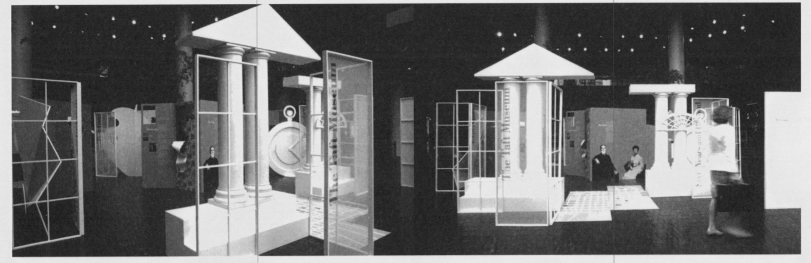

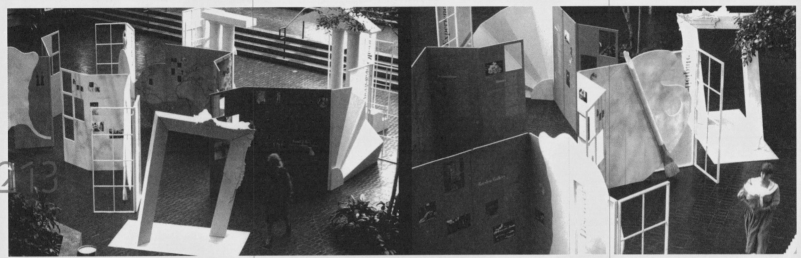

213

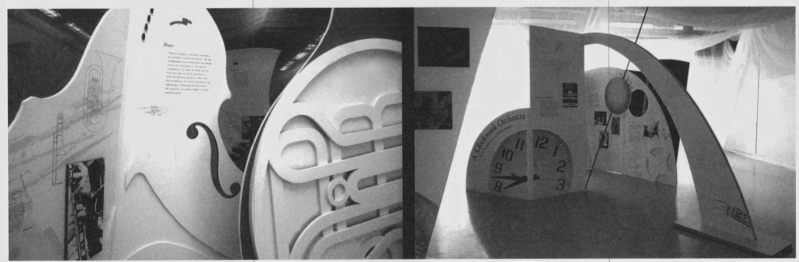

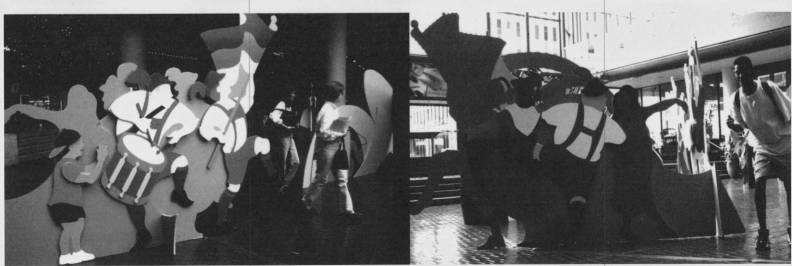

Rolf Müller
Aufgabe im Sommersemester 2013
4. Semester:
Konzeption und Gestaltung
einer visuellen Wegbeschreibung:
von A nach B

Einer der (leider) seltenen Arbeitsbereiche unsers Berufs
als visueller Gestalter ist das Geschichten-Erzählen,
und zwar in und mit Bildern und nur wenigen oder gar keinen Worten.

Ein Weg von A nach B kann alles Mögliche sein:
ein Stück Autobahn, ein Flusslauf von der Quelle bis zur Mündung,
der Versand eines Briefes vom Absender zum Empfänger,
die Verwandlung eines Eis in ein Omelett, die äusserliche
Umwandlung einer Frau in einen Mann oder umgekehrt…
auf jeden Fall etwas, was man visuell erzählen kann.

1
Ideenfindung und knappe schriftliche Beschreibung
und/oder ein „storyboard"
2
Diskussion und Abstimmung mit Rolf Müller
3
Erarbeitung des visuellen Gestaltungsmaterials:
Fotos, Filme, Zeichnungen
4
Konzeption der Wegbeschreibung als Drucksache oder Animation:
Entwicklung der „Dramaturgie"
5
Erster Entwurf, Diskussion und Abstimmung
6
Ausarbeitung des Entwurfs zur Präsentation

Rolf Müller

Founder, Büro Rolf Müller für Visuelle Kommunikation
Designer, Munich Olympic Games, 1972

A 4th semester project where students must
concept visual directions from a point A to a point
B purely using pictures with little to no words.
Embracing concepts of 'Dramaturgy' students
are encouraged to explore directions that expand
visual language.

4학기 프로젝트. 학생들은 어휘를 거의 혹은 전혀 사용하지
않고 오로지 그림만 이용하여 콘셉트 비주얼을 A지점에서
B지점으로 변경해야 한다. 학생들이 '극작법'의 개념을
수용하여 시각 언어를 확장시키는 방향을 탐구하도록 한다.

Rolf Müller
Aufgaben im Sommersemester 2013
6. Semester:
Konzeption und Gestaltung
eines Berufsportraits
sowohl als Broschüre als auch Internetbeitrag

Sie sollen sich einen Beruf aussuchen,
vornehmlich handwerklicher Art,
im persönlichen Umkreis eine Vertreterin
oder Vertreter dieses Berufs ermitteln
und zur Zusammenarbeit bringen,
die Bedingungen, Ausbildungswege und Chancen
des jeweiligen Berufs recherchieren
(bei Innungen und Berufsorganisationen,
nicht aber „herumgooglen" oder Wikipedia
abschreiben)

Konzeption:
1
Sie sollen zunächst beurteilen, welche textlichen
und bildlichen Informationselemente
für das Printmedium und/oder das Internet
geeignet sind und das Ergebnis in einem
Redaktionsplan (mit Terminen) darstellen.
2
Nach diesem Plan wird fotografiert, gefilmt,
werden Interviews geführt, Texte redigiert.
3
Gleichzeitig werden die grafischen
und typografischen
Gestaltungselemente und –regeln
für beide Medien entwickelt.

Gestaltung:
1
Entwicklung der jeweiligen Struktur der Broschüre
und des „storyboards" für den Internet-Auftritt
2
Entwurf von 2 bis 3 prototypischen Doppelseiten
der Broschüre
3
Entwurf von 2 bis 3 prototypischen Webseiten
4
Ausarbeitung der Entwürfe bis zur Präsentation

A 6th semester project where students are tasked
with creating a professional portrait of a particular
profession that functions as a brochure and also
a potential contribution to the internet. This
brochure should show research of this profession
that goes beyond internet searches.

6학기 프로젝트로, 학생들의 과제는 특정 직업을 묘사하는
것이다. 브로슈어 기능을 하는 동시에 인터넷에 쓰일 수도
있는 자료이다. 이 브로슈어는 인터넷 검색을 넘어서는
수준으로 해당 직업에 대한 연구를 담아내야 한다.

Comment nos interventions architecturales, urbaines ou paysagères sur le territoire peuvent-elles contribuer à la résilience de nos milieux naturels et de nos villes?
How can our architectural urban or landscape projects in a given area contribute to the resiliency of the natural settings in our cities?

En tenant compte de la position des designers dans le processus de conception et de fabrication, comment peuvent-ils créer un espace de résistance et présenter des solutions pertinentes en matière d'environnement?
How can designers create spaces of resistance and propose environmental solutions via their position in the conception and production of goods?

Le design peut-il à la fois accomplir sa mission liée à l'économie de marché et à la surconsommation, et développer une conscience environnementale et sociale?
Can design fulfill its mission of sustaining the market economy and overconsumption while designers cultivate an environmental and social conscience?

Le rôle du design dans les projets collaboratifs
The role of design in collaborative projects

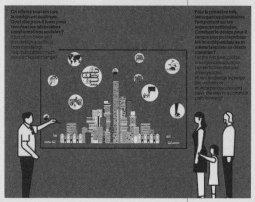

On affirme souvent que le design est politique. Quel rôle peut-il jouer pour favoriser les nécessaires transformations sociales?
It has often been argued that design is political. How can design help bring about much needed social change?

Pour la première fois, les exigences planétaires l'emportent sur les exigences nationales. Comment le design peut-il rendre plus perceptibles les interdépendances et même favoriser un destin commun?
For the first time, global interdependences are more powerful than national emergencies. How can design increase the visibility of shared perspectives and pave the way to a common path forward?

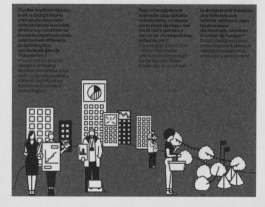

Quelles implications peut avoir le design dans la critique des structures dominantes de la société et dans la proposition de modèles organisationnels radicalement différents, possibles grâce aux technologies de l'information?
How could we involve design in critiquing dominant social structures and in proposing radically different organizational models via information technologies?

Peut-on imaginer une approche de projet plus collaborative, un design qui émane de et mise sur l'expérience qu'ont les citoyens de leur milieu de vie?
Can a designer should: how could collective and collaborative practices be improved to better harness immediate day-to-day lived experience and be an advocate for users?

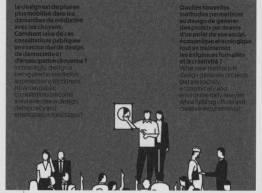

Le designer doit-il assumer des rôles tels que celui de catalyseur dans les processus décisionnels, ou même d'avocat de l'usager?
The designer should assume a catalyzing role in decision-making processes and even advocate for users?

Le design est de plus en plus mobilisé dans les démarches de médiation avec les citoyens. Comment faire de ces consultations publiques un exercice réel de design, de démocratie et d'émancipation citoyenne?
Increasingly, design is being used in mediation approaches with citizens. How can public consultations become a real exercise in design, democracy and emancipation for citizens?

Quelles nouvelles méthodes permettront au design de générer des projets pertinents d'un point de vue social, économique et écologique tout en maintenant les exigences formelles et la créativité?
What new methods in design generate projects that are socially, economically and environmentally relevant while fulfilling official and creative requirements?

Ruedi Baur

Founder, Integral Ruedi Baur
Professorship, HEAD University of Geneva, ENSAD in Paris

Baur's career as a design educator has been truly transdisciplinary. Shared here are slides from the <Le Design Civique et l'esthétique sociale(Project Shared Space: Civic Design and Social Aesthetics)> seminar, which was one of several seminars held at the EHESS (École des Hautes Études en Sciences Sociales).

디자인 교육자로서 바우어가 가진 경력은 진정으로 학제를 뛰어넘는다. 여기서는 EHESS에서 개최된 여러 세미나 중에서 <프로젝트 공유 공간: 도시 설계와 사회 미학> 세미나의 슬라이드 일부를 소개한다. 이 세미나는 디자이너가 도시 환경 안에서 일하며 어떻게 사회 변화에 영향을 미치는지 질문한다.

Quelles stratégies spatiales, écologiques et socio-politiques pouvons-nous envisager pour accélérer la mutation vers les systèmes énergétiques renouvelables, démocratiques et locaux ?
What spatial, environmental and sociopolitical structures can we envision to make the move more quickly towards renewable, local, democratic energy systems?

Comment envisager un « anthropocène responsable », qui comprendra les changements fondamentaux dans nos relations avec la nature et entre humains, ainsi que des innovations importantes en matière de design et de gestion du territoire ?
What would a "responsible Anthropocene" look like if it included fundamental changes in human-to-nature relations and major changes to design and land management?

Quelles stratégies pédagogiques doivent être employées afin de donner aux futurs meneurs la capacité critique de prévoir, créer et produire une gestion du territoire marquée par une plus grande préoccupation écologique et sociale ?
What teaching strategies should be used to give our future leaders the critical faculties they need to foresee, create and practise more environmentally friendly, socially conscious land management?

The seminars ask a question to designers about how they can work within the urban environment to affect social change. The seminar series asks important questions about how design can work and serve the public and all the civic responsibilities that comes along.

이 세미나는 디자이너들에게 어떻게 그들이 도시 환경 안에서 사회적인 변화에 영향을 줄 수 있을지 질문한다. 세미나 시리즈는 디자인이 어떻게 기능하고 대중에게 봉사할 수 있는지 그리고 그에 따르는 시민의 책임 전체에 대하여 중요한 질문들을 던진다.

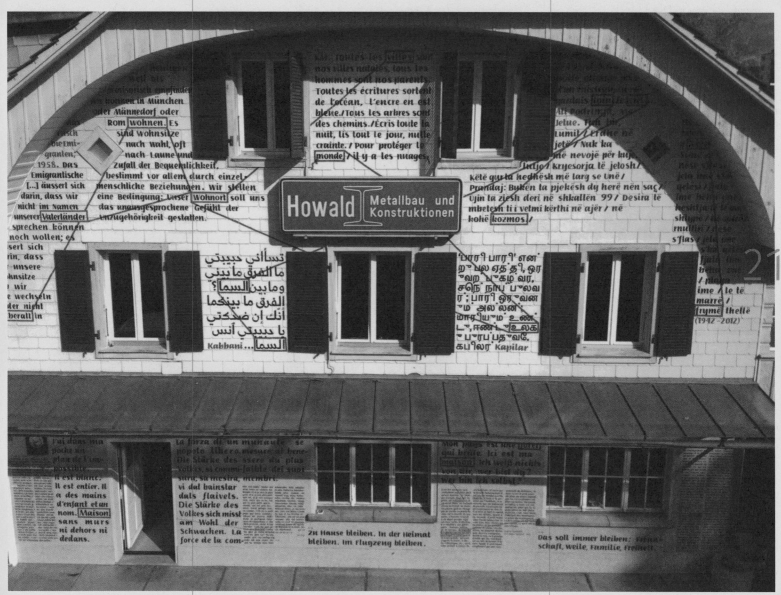

Ruedi Baur

Graphic installation of multilingual literature in the public space in Biel / Biel, a bilingual Swiss city. Project « Voyages entre les langues - Travel between languages", 2017, Switzerland, by Ruedi and Vera Baur, Karelle Ménine.

두 언어가 통용되는 스위스 도시 비엘의 공공 장소에 다국어 그래픽을 설치하는 모습. <언어들 사이의 여행> 프로젝트. 2017, 스위스. 루에디 바우어, 베라 바우어, 카렐레 메닌.

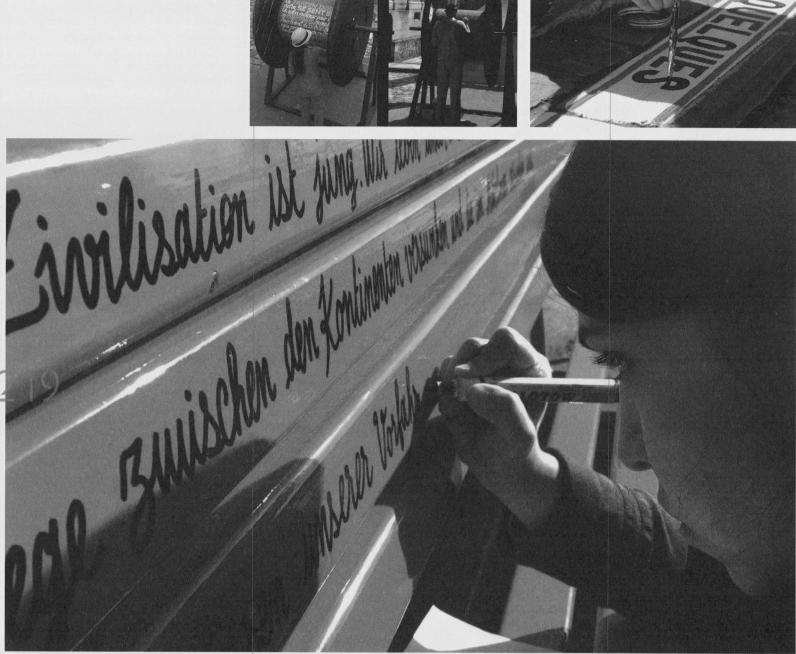

Different projects of interventions in the public space: on the benches of Rapperswil in Switzerland, in the streets of Mons in Belgium, in Bordeaux in France.

공공장소에서 이루어진 서로 다른 프로젝트로 스위스 라퍼스빌의 벤치, 벨기에 몽스와 프랑스 보르도의 거리에서 이루어졌다.

**Studio
di progettazione
grafica**

Sabina Oberholzer
AGI
Renato Tagli

via Cevio Vecchio 19
6675 Cevio
Suisse

telefono
0041 91 754 18 24

Workshop by	:	Sabina Oberholzer AGI, Switzerland Renato Tagli, Switzerland
Title	:	Play with colors …
Topic	:	Selfie

The purpose of the workshop is to be able to communicate emotions
by playing with colors and shape.

Starting from the theory of color, yellow, magenta, cyan "primary colors"
and orange, green, purple, "secondary colors",
the students can play with elements, objects, shapes, colors that
can be found in everyday life and in the nature.

The perfect harmony we find carefully observing the natural elements
around us, and from them we can discover the emotions evoked
by the colors, shapes and light.

During these three-day workshop each student will have the opportunity
to express through a "selfie" their emotions, and communicate
with the elements chosen their own characteristics.

The workshop will be subdivided into phases:

1. phase
Preliminary work and planning
Collection of information necessary for the realization of the selfie

2. phase
Conception and design
Research and development of the concept through the visualization
of illustration elements, colors, objects, photo, typography, etc.

3. phase
Detailed design and execution
Choise and development of the final image.

4. phase
Realization
Each student will prepare the "selfie"
in A3 format vertical, CMYK , 300 dpi and digital print.
The file will be sended to the email address:
soberholzer@swissonline.ch and Pati.

Exhibition of maquettes and presentation …

220

oberholzer-tagli.ch
soberholzer@swissonline.ch

Sabina Oberholzer

Co-Founder, Studio di Progettazione Grafica
Recipient, First Prize, Swiss Post Postage Stamp Design 2010

A workshop using colors and forms to com-
municate emotions. Students researched and
experimented from color theories to visual colors
from nature, forms and everyday objects for 3
days. The students created A3 sized selfies using
the mentioned visual elements to communicate
their emotions.

컬러와 형태를 통해 감정을 전달하는 워크숍이다.
색채 이론부터 자연의 시각적 색상, 형태와 일상적인
물건을 3일 동안 탐구하고 실험했다. 학생들은 위와 같은
시각 요소들을 사용하여 A3 크기의 '셀카'로 자신의
감정을 전달하는 결과물을 만들었다.

Cevio
5 November
2018

Studio
di progettazione
grafica

Sabina Oberholzer
AGI
Renato Tagli

via Cevio Vecchio 19
6675 Cevio
Suisse

telefono
+41
(0) 91 754 18 24
+41
(0) 91 754 24 25
+41
(0) 79 561 15 06

Workshop by
Sabina Oberholzer AGI
& Renato Tagli
Switzerland

221

In 2016 we had the opportunity to give a 3 day workshop at PATI,
a beautiful school with wonderful students, motivated
and full of enthusiasm.

Before starting, we sent a briefing to the students explaining
the concept "Play with colors".

The purpose of the workshop was to communicate emotions
by playing with colors, shapes and materials.

The first day we presented our work, known to the students
who organized themselves in groups to look for various possibilities
to communicate emotions.

On the second day we looked at the various proposals together
and each group presented their work motivating their choices.

It was very interesting to see the range of ideas and the spontaneity
of each student in addressing the issue of color.

After discussing the various proposals together, it was decided
to choose the idea where all the students can interact.

The idea chosen was to collect various colored objects and arrange
them along the road that runs alongside the school
creating a story.

It was fun to see the development and the magic created
when it was made.

oberholzer-tagli.ch
soberholzer@swissonline.ch

222

Sabina Oberholzer

워크숍을 진행하는 모습을 담은 스틸 사진

223

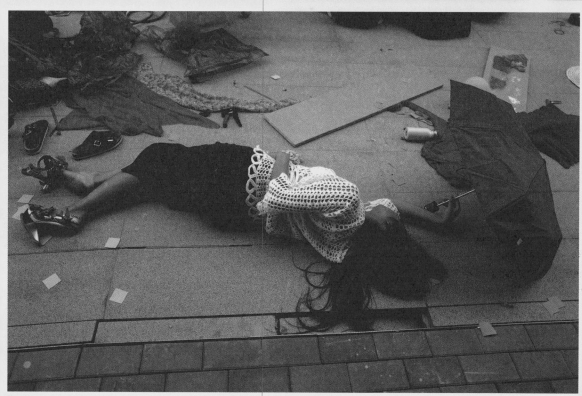

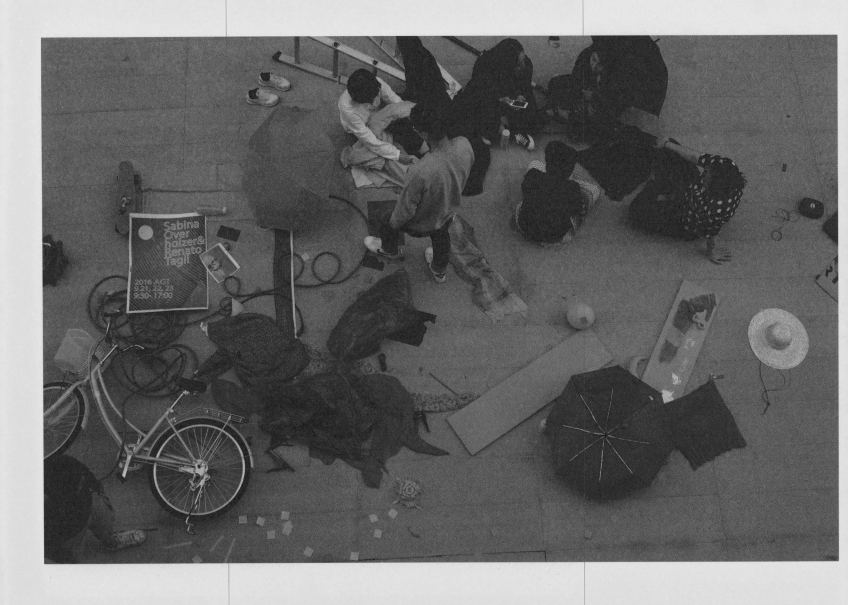

Sabina Oberholzer

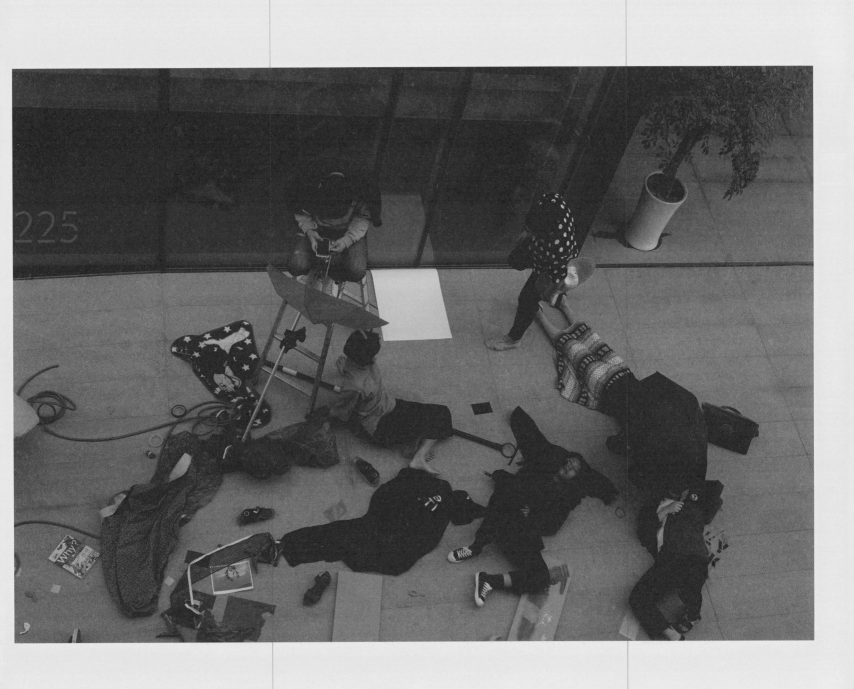

June 6, 2018

Can design touch someones heart?

Course Syllabus, Fall Semester 2018

Project 1, a single person

- 9/11/18 Introduction, go over assignments, sermon on touching heart design

- 9/18/18 Ideas for first project

- 9/25/18 No class

- 10/02/18 Developed ideas and comps for first project

Project 2, a group of people

- 10/09/18 Final presentation of project 1, brief on project 2

- 10/16/18 No Class

- 10/30/18 Ideas for second project, feedback results from the 1st project

- 11/06/18 Developed ideas for second project, feedback results from the 1st project

Project 3, a thing I have learned in my life

- **11/13/18 Very advanced comps**

- 11/20/18 Final presentation of project 2, Brief Project 3

- 11/27/18 **Ideas for project 3, feedback results from the 2nd project, extra class?**

- 12/04/18 Comps

- 12/11/18 final, project 3

206 WEST 23RD STREET 4TH FLOOR NEW YORK NY 10011 · (212) 647 1789 · WWW.SAGMEISTERWALSH.COM · INFO@SAGMEISTERWALSH

Stefan Sagmeister

A course syllabus for a Stefan Sagmeister course at
School of Visual Arts. The theme of this semester is
design that may touch someone's heart.

SVA에 개설된 스테판 사그마이스터의 강의 계획서이다.
이 학기의 주제는 누군가의 마음에 가닿는 디자인이다.

Teaches at School of Visual Arts
Founder, Sagmeister, Inc.

227

附錄：

汕頭大學長江藝術與設計學院

《設計倫理》教案(2007-2008 學年第 2 期)

大綱、課程內容編寫及授課：張志凱

課程名稱：设计伦理　　　　　　　　　　学时：18　　　　　　　学分：1

上课班级：05 平面、05 环艺、05 數字媒体及全校选修　　　　　　教材：综合

教学目的：通过课堂讲授交流（介绍、分析、欣赏）及课堂作业，引导学生了解设计伦理学科的基本常识，
　　　　　认识设计与世界、设计与人本的相互关系。通过课程的开设，培养学生的设计伦理观念，提升
　　　　　个人观点的判断能力，坚持设计"以人为本"，观察、阅读和学习科学的方法，与不同的工作
　　　　　对象进行合作，寻求解决问题的方法。使之成为有爱心和热诚，有责任感，有伦理观念的设计
　　　　　师，让我们的生活体验更加快乐和成功。

教学重点：从伦理学视野来反观设计，理解设计的本质意义，树立信守承诺、关怀人性的设计态度。

教学资料用具准备：數字媒体，影视器材　　　　　学生用具准备要求：纸、笔

第 1 專題
教学课题：设计与世界的关系　　　　　　　教学单元：第 1 周、周 5、第 1、2、3 课时
内容：1、认知世界的过程：包括官感认识、理性认识、思辨分析和直觉思维。作为一名设计师首先有直
　　　　觉思维，必须在对事情有全面、正确的投射的掌握后才有创意的产生。
　　　2、学习的模式
　　　3、学习模式与设计关系
　　　4、我们该怎样去学习设计：我们阅读、观察、学习这些不同的方法，运用不同界别的专业去合作。
　　　　只有当产品交付到用户手中的时候，我们的"设计"才刚刚开始。
形式：讲授 课堂讨论
手段：通过普遍存在的问题，引导同学了解设计的伦理学视野，认识设计与世界的关系
作业或讨论：运用发散性思维对"设计伦理"这个关键词作展开联想的图示练习。

第 2 專題
教学课题：设计的责任　　　　　　　　　　教学单元：第 2 周、周 5、第 4、5、6 课时
内容：1、设计的缘由
　　　2、设计是物化的经验
　　　3、设计的社会责任

　　　案例一：The test of "thinking about people"
　　　案例二：A starving child in Sudan 一位摄影者 kevin Carter 的悲剧
形式：讲授 辅导

Tai-Keung Kan

Honorary Dean, Cheung Kong School of Art and Design,
Shantou University
Recipient, HKDA Lifetime Honorary Award

Above is the syllabus for a course on design ethics
taught at Changjiang College of Art and Design,
Shantou University. The course introduces and
engages students in what 'design ethics' can
mean through six basic projects. The course takes
the form of lectures, readings, case studies and
group dicussions. Students are asked to think
critically not only about design, but also about
how one learns.

위는 산터우대학 창강예술디자인학원의 디자인 윤리
과목 강의 계획서이다. 여섯 가지 기본 프로젝트를 통해
학생들에게 '디자인 윤리'가 무엇을 의미하는지 소개하고
참여하도록 한다. 이 과정은 강의, 강독, 사례 연구와
그룹 토론의 형태로 진행된다. 학생들은 디자인뿐만 아니라
학습 방법에 대해서도 비평적으로 생각해야 한다.

手段：通过案例分析，引导同学体会"设计"的社会意义

作业或讨论：课堂讨论-案例中摄影者 kevin Carter 的出路。

第 3 專題
教学课题：设计师的道德价值 教学单元：第 3 周、周 5、第 7、8、9 课时

内容：1、道德标准是个人与社会的平衡
　　　2、信任品性
正确的道德价值通过信任品性得到实现。信任品性是一种个人和社会的解放，在所有推行民主及市场经济的社会，成功的关键在于如何建立信任，并予以维持，这是一种共同精神的体现。

形式：讲授 小组讨论及交流

手段：辅导 启发 引导

作业或讨论：课堂讨论-中国的人口问题已由数量忧虑已转为品性忧虑的问题，我们该如何建立道德社会？
　　　　　　奥运将至，我们又如何去提升北京市民的文明和形象迎接奥运？

第 4 專題
教学课题：设计的模式 教学单元：第 4 周、周 5、第 10、11、12 课时

内容：1、设计的模式： 设计师通过背景、条框限制的了解，调和内部矛盾、对立、不一致的因素，进而寻求到解决问题的方法。
　　　2、导致劣质设计出现的原因

形式：讲授 小组讨论及交流

手段：辅导 启发 引导

作业或讨论：课堂讨论-同学生活中的好设计及不好的设计。

第 5 專題
教学课题：设计去未来化 教学单元：第 5 周、周 5、第 13、14、15 课时

内容：1、设计去未来化（Defuturing）用学习的态度思考并利用生活中出现的看似不能融合的矛盾，化危机为转机，发展属于未来新创造的生机。
　　　2、绿色设计分享 2007 广州国际设计周的环保设计及英国文化协会在广州巡展的"气候酷派"展览。

形式：讲授 讨论及总结

手段：组织讨论

作业或讨论：课堂讨论-如何看待案例中环保设计的潮流及存在的问题。

第 6 專題
教学课题：虚拟世界的挑战 教学单元：第 6 周、周 5、第 16、17、18 课时

内容：1、现代科技对社会发展的挑战
　　　2、真实世界与虚拟世界的区别
　　　3、正确的生活态度

形式：讲授 讨论

手段：组织讨论

作业或讨论：课堂观看《超时空接触》的部分片断课堂讨论片中女主人公的价值观转变过程

229

香港新界北區米埔有一片珍貴的濕地，是候鳥棲息的地方。眾多鳥類中的黑臉琵鷺是非常珍貴的品種，屬於香港稀有的受保護候鳥。米埔自然保護區也由世界自然（香港）基金會管理，劉氏再度受邀請一起策動了＂小黑路路＂計劃。他首先將黑臉琵鷺塑造成一個可愛的角色，利用一個現成的玩偶改製成＂小黑路路＂。這個立體的角色體形胖胖的，未能配合候鳥飛翔的形態，於是他在設計平面形象時就以兒童繪圖的手法把它描繪得纖瘦輕盈。＂小黑 LOLO＂的標準字體也用相同的描繪手法設計，還把＂黑＂字與兩個＂O＂字母，都繪成圓圓的大眼睛，表現出＂小黑路路＂可愛的神態。

為保護稀有的候鳥，從兒童教育入手去推廣公民環保意識，劉小康找來年輕漫畫師江康泉（江記）創作《小黑路路》的＂大歷奇＂和＂大冒險＂兩系列共八冊圖書（圖23），針對兒童觀賞的品味與好奇心，給小讀者設計一套插圖優美、版面生動易讀、引人入勝的故事書，還配上一個可愛輕便的小布包，方便他們攜帶。它亦成為家長們的親子恩物。這套圖書由朗文（香港）教育於 2002 年出版，發行於各大書店和 WWF 專門店出售。

＂小黑路路＂成為世界自然（香港）基金會的一個品牌，他們出版故事圖書之外，也運用這個品牌形象設計生產一系列的紀念品，配合推廣宣傳之外，也有助籌款等用途。當然，最重要的目的，還是要培養公平受惜自然生態的觀念。

當經濟風暴連續湧至時，實在必須思考不同的市場發展空間。他們認為可利用服務商業企業的豐富經驗，為社會做一些非牟利的服務，就成立前文提及的 CoLAB —— 一個實驗性的創意合作平台。他們結識了一些對社會服務熱心，而專業又在設計以外，如策劃、環保與不同創作範疇的朋友，共同探索新的領域。除了前文詳述的＂不．完美＂計劃，最為人樂道的成功案例就是＂區區肥皂＂。

主婦的手造肥皂

他們結識了葉子儀（Bella），一位單親媽媽。為了方便照顧孩子，找不到時間具彈性又在住所附近上班的工作，她決定自己自僱創業，向銀行借貸了 20 萬港元為啟動資金，學習了製造肥皂的方法，就開設了 6 人生產小組的社企 SLOW，讓低學歷、低技術的人可以自主就業，又可兼顧家中的孩子。

兩年後，葉子儀的肥皂事業獲得成功，她清還了銀行借貸，更想到可將這概念發展至社區，惠及當中的家庭主婦。在經營過程中，她亦感覺自己的局限，在產品包裝和形象方面是弱項。她還是沒有足夠的資金支付設計費，幸得設計師同意，以設計工作當作生意的投資。CoLAB很欣賞和信任葉子儀的經營計劃，願意不收費用提供品牌形象、包裝設計及策略推廣計劃等，設計師變身為投資者，全身參與，最後以營利獲益，生意越成功，收益越豐厚。他們不認為這是單向的義助，而是互利互惠，同時使他們實徹設計、商業與社會平衡發展的經營理念。

首先，他們為肥皂創作一個新的品牌名稱。基於這產品與普羅社區關係密切，就以＂區區肥皂＂命名。區區一件肥皂，似是微不足道地自謙，放下身段的親和感，繁簡兼用的漢字又有不分地域的包容性，英文名稱＂So…Soap!＂也很平易近人。配合單純黑白、簡潔全無裝飾圖案的平面設計風格，盡顯樸實無華的品味（圖27）。

我常常到各地公幹活動，在旅館的浴室中，要辨識細小文字的洗潔液瓶子標籤倍感困難。＂區區肥皂＂的瓶身標籤直接應用＂BODY＂區區洗身、＂HAND＂區區洗手的字體作識別，黑白分明，潔淨脫俗（圖28）。CoLAB 為＂正豆＂豆漿設計容器時，又提出了回收該容器的合作條件，改裝成另一容量的＂區區肥皂＂包裝，進一步實踐環保的概念（圖29）。

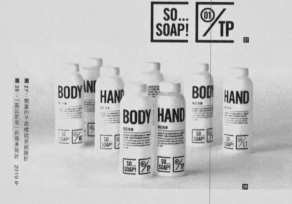

Tai-Keung Kan

Co-founder, Studio thonik
Former Creative Director, Curator, Guest Professor,
Design Academy Eindhoven

Excerpts from the book *Care Design: Design Ethics Thinking and Practice* authored by Kan Tai Keung. The book gathers Keung's thoughts on creativity and presents several case studies of ethical design projects. The select case studies reprinted here show Keung's interest in socially engaged product and branding projects.

칸타이쿵이 저술한 『케어 디자인: 디자인 윤리 사고와 실천』 발췌. 이 책은 창의성에 대한 그의 생각을 모아 윤리적 디자인 프로젝트 사례 연구들을 제시한다. 여기에 선별된 사례 연구로 사회 참여적인 제품과 브랜딩 프로젝트에 대한 칸타이쿵의 관심을 알 수 있다.

230

圖34・330咖啡廳的室內、服務員制服及包裝

圖35・330有機食物專門店門面與貨架

作了一組平易近人的形象圖騰，應用在平面和空間環境中，成為使顧客賞心悅目的品牌視覺形象。室內環境與家具設計主要運用了木材料的原色，不同的木材產生微妙的色彩和肌理的變化，在樸實隨意的風格中，顯露着細緻的高品味（圖33）。平面插圖的線描衍變為鐵線扭曲的線立體構成。加上黑與棕色布料縫製成的工作服，繡上鮮橙色的 Café 330 品牌標準字體，使康復者服務員顯得樸實又帶着一身朝氣（圖34）。這鮮橙色是品牌形象的主調，配黑白和物材原色，組合成清新、親和而高格調的視覺傳達系統。

這個令人耳目一新的 Café 330 形象，使社企新生會的形象大大提升。顧客在這家具獨特個性的小餐廳，不但享用本來就品質良好的餐飲，更在這具文化品味的空間中，體現着閒適的時光；他們再沒有廉價

消費或施予者的心態，服務者亦增添了一份歸屬感，那份可貴的（應有的）尊嚴，衍生着更敬業樂業的心理素質。

由一間小餐廳的成功，吸引了一些高質素的公共空間主動邀請他們駐場，而這個良好的形象亦增強了他們競標的競爭力量。新生會的決策者直接領悟到設計的力量和價值，對 CoLAB 的工作自然更加信賴。當初，CoLAB 與志同道合的年輕設計師及跨界合作者，自願以很微薄的報酬給社企提供專業設計服務，使他們受惠，同時令他們經營社企的觀念改變，漸漸接受付出較高的設計費去做好品牌形象，因為已懂得投資在設計上可得非常豐厚的回報。CoLAB 現時可以收取接近商業的收費，較有尊嚴的報酬。

社會需要正能量

以 Café 330 的成功作為起點，新生會開始確定了 330 作為他們社企的品牌，除了開設更多咖啡店之外，也有售賣有機食物的 farmfresh 330（圖35），與及行銷新生會康復者工場生產出品的 "紅白藍 330" 專門店。

新生會培訓不少精神病康復者一些工作技能，一方面可幫助康復者健康地融入社會，另一方面又以一技之長自食其力。他們常運用低成本的物材，花盡心思構想怎樣能發揮康復者有限度潛能，生產令人樂用的產品。其中一類產品是用紅白藍膠布製作的日用品和文具，但設計得比較平凡，並不特別受關注。當他們體會設計增添了社企的力量後，就自然想到了人稱為 "紅白藍先生" 的設計師黃炳培，他長期鍾情於以紅白藍作思考與創作，贏得好評如潮；而且早已立志以三分之一賺錢時間，用 "又一山人" 的身份做關心社會的工作。

他們一拍即合，2012 年成立了首家主打紅白藍產品的 "紅白藍 330" 概念店（圖36），全由又一山人策劃和設計。他用紅白藍三色反白字加上早已由 CoLAB 設計好的 330 數字，成為店的視覺形象，店的室內環境以素白主調融入了又一山人的紅白藍藝術風格。最重要的是又一山人取得了創作的話語權，自主地更廣泛的將藝術融入日常生活中，使那種非常地道親民的物材提升了品味；同時帶着關心社會的訊息令社羣產生共鳴。當然，他對產品質素有所要求之餘，又充分了解康復生產者的技能如何發揮有效的合作，共享成功的喜悅。

又一山人為 330 設計的紅白藍手工藝品，以 "正面香港" 命名，他

圖36・紅白紅330商標、店舖與工作坊

圖37・紅白藍 X 又一山人產品商標與產品 2012 年

36

37

Dear students and colleagues,

We are on the threshold of yet another summer holiday, the fourth since I joined Design Academy Eindhoven. Time has flown, I must admit, and it feels almost strange to acknowledge that the end of my four-year term as Creative Director and Chair of the Board is drawing near.

Over the past few months I have been considering my future plans and ambitions. In the interest of our school I want to be clear about the result of this thought process. After careful consideration I have decided not to be available for a second term in my present position.

It has been a difficult decision.

In the last years we have embarked on a road of changes and I am happy to have played a role in this. I hope you share my opinion that these are changes for the better.

The academy has a new story and a new position in the world of design. We look at the outside world. We recognise problems that need to be addressed. We see opportunities arise. Rather than suggesting oversimplified solutions we create alternatives. Our creative practice allows us to raise fundamental questions, and we can propose fundamental changes. Now that technology is democratized, small initiatives have the potential to make a big impact on the world. A small institute like ours has become more relevant than ever before.

Today's students are digital natives. This has profoundly changed the nature of education. A school is no longer the place where the old world is passed on to a new generation, contemporary education is about the collaborative invention of a new world— in a dialogue between an older and a new generation of designers. That is the essence of the new educational approach at Design Academy Eindhoven. This new story has been researched and presented in three consecutive exhibitions we staged at the Van Abbe Museum in Eindhoven. *Self Unself* (2013) looked at the unselfish inclination of a new type of designer. *Sense Nonsense* (2014) investigated the validity of a poetic approach as a method for innovation. And

Thomas Widdershoven

친애하는 학생과 동료 들에게

제가 에인트호벤디자인아카데미에 근무하게 된 이래로 네 번째 여름 휴가의 문턱에 있습니다. 시간이 정말 빠르게 흘렀습니다. 크리에이티브 디렉터이자 이사회 의장의 4년 임기가 끝나가고 있다는 것이 어색하게 느껴집니다.

지난 몇 달 동안 제 미래 계획과 야심에 대해 고민했습니다. 우리 학교를 위해 명확한 결론을 내리고 싶습니다. 신중한 고민 끝에 현재의 자리를 내놓으려 합니다.

어려운 결정이었습니다.

지난 몇 년 동안 우리는 많은 변화를 겪었으며, 저 역시 변화에 일조했다는 것을 기쁘게 생각합니다. 여러분도 저와 같이 이런 변화를 긍정적으로 생각했으면 좋겠습니다.

우리 학교는 디자인계에서 새로운 방향성과 위상을 갖습니다. 우리는 외부를 바라보며 문제를 인식합니다. 기회가 생기는 것을 확인하기도 하고, 단순한 해답을 제시하기보다는 대안을 만들어냅니다.

우리의 창조적인 실무를 기반으로 우리는 근본적인 질문을 제기하고, 그래서 우리는 역시 근본적인 변화를 제안할 수도 있습니다. 기술의 민주화로 작은 시작이라도 전 세계에 큰 영향을 미칠 잠재력이 있습니다. 우리 아카데미 같은 소규모 기관이 그 어느 때보다 큰 의미를 가지게 되었습니다.

오늘날 학생들은 디지털 원어민입니다. 때문에 교육의 성격이 근본적으로 바뀌었습니다. 학교는 더는 과거 세계를 새로운 세대로 전달하는 곳이 아닙니다. 현대 교육은 구세대와 신세대 디자이너 사이의 대화를 통해 새로운 세계를 함께 만들어 나갑니다. 이것이 에인트호벤디자인아카데미의 새로운 교육적 접근 방식의 본질입니다.

이 새로운 철학은 에인트호벤의 반아베박물관에서 연이어 진행된 세 차례의 전시회를 통해 연구하고 발표했습니다. <Self Unself> (2013)에서는 새로운 유형의 디자이너가 가진 이기심 없는 성향을 조망했고, <Sense Nonsense> (2014)에서는 혁신을 위한 시적 접근 방법의 타당성을 살펴보았습니다. 마지막으로 <Thing Nothing> (2015)에서는 비물질화되는 세계에서 디자인의 가치를 파헤쳤습니다.

매우 성공적으로 마무리된 졸업 전시는 새로운 방향성을 제시하며 대중의 관심과 함께 호평을 받았습니다.

그러나 그 이상으로 졸업생들의 프로젝트에서 드러난 독창성, 의미 그리고 헌신이 큰 의미가 있었지요.

학교의 국제적 방향성은 크리에이티브 디렉터로서의 제

finally <u>Thing Nothing</u> [2015] delved into the value of design in a dematerialising world.

Our highly successful Graduation Shows attracted large audiences and generated widespread public acclaim for the new story. But more than that: they demonstrated the ingenuity, relevance and dedication expressed in the projects of our graduates. The international focus of the academy was a major issue during my years as Creative Director. We can be proud of some great presentations in Milan. In 2014 the new department Food NonFood staged the truly provocative Eat Shit event. And in 2015 Touch Base was received with great enthusiasm. Other successful international presentations have been held in New York, Suzhou, Macau, Paris and Shenzhen. And in Hong Kong we organised a three-month workshop to strengthen our international agenda.

Crucially important for the continuity of the academy — although less visible to many of you – were the efforts to solidify the school's financial position. Thanks to all involved we are financially healthy. We now rent, instead of own the academy building, which has freed us from a rather costly burden. The Supervisory Board recently approved an investment budget of €2.5 million that allows us to proceed with the educational and professional development in the coming years. There are plans to organise a dialogue programme and to adjust the interior of the building. We added a new space on the first floor, that will develop into a new entrance.

The organisation today has become a lot less hierarchic. Instead of heads for different staff departments (like communications, facilities, operations, human resources and education), we now assign responsibilities to dedicated teams that organise their own processes. Bachelor education has not only been restructured but also revitalised. Two new departments were introduced: Stijn Roodnat now heads Public Private (a merger of two former departments) and Marije Vogelzang started Food NonFood. The former Kompas programme (with four separate heads) has been reframed into Skills and Urgencies, directed by a multi-faceted editorial team.

임기 동안 주요 이슈였습니다. 밀라노에서 있었던 훌륭한 프레젠테이션은 우리에게 자랑스러운 성과입니다. 2014년 새로운 학과인 Food Non-Food가 진정으로 도발적인 <Eat Shit> 행사를 개최했습니다. 그리고 2015년 <Touch Base> 역시 정말 대단한 호응을 받았습니다. 뉴욕, 쑤저우, 마카오, 파리 및 선전에서도 국제적인 프레젠테이션들이 성공적으로 열렸습니다. 그리고 국제적인 의제를 강화하기 위해 홍콩에서 3개월짜리 워크숍을 개최했습니다.

비록 여러분에게는 잘 드러나지 않았겠지만, 아카데미를 유지하기 위해 결정적으로 중요했던 것은 학교의 재정 상태를 견고하게 하는 것이었습니다. 관계자 여러분 덕분에 우리 학교는 재정적으로 건전합니다. 이제 우리는 아카데미 건물을 소유하는 대신에 임대하여 비용 부담을 크게 덜었습니다. 감독 이사회는 앞으로 몇 년 동안 교육과 전문성을 개발하는 데 250만 유로의 투자 예산을 승인했습니다. 대화 프로그램을 조직하고 건물의 인테리어를 수리할 계획이 있습니다. 우리는 1층에 별도의 공간을 만들어서 새로운 입구로 활용할 것입니다.

최근에 조직은 위계 질서를 훨씬 단순화했습니다. 통신, 시설, 운영, 인사 및 교육과 같은 여러 부서에 부서장을 두는 대신 자체적으로 프로세스를 조직하는 전담 팀을 구성했습니다. 학부 교육도 재구성하고 새로운 활력을 불어넣었습니다. 두 개의 새로운 학과를 도입했습니다. 스테인 로드나트는 (이전의 두 학과를 병합하여) Public Private을 이끌고, 마리예 보헬장이 Food Non-Food를 시작했습니다. (네 명의 학과장이 있었던) 이전 콤파스 프로그램은 다면적인 편집팀이 지휘하는 Skills and Urgencies 로 재구성되었습니다.

2014년 '디자인 큐레이팅과 글쓰기'라는 새로운 네 번째 석사 전공 과목이 개설되었습니다. 저스틴 맥거크와 앨리스 트웸로가 이끄는 이 전공은 우리 석사 프로그램에 비평적 성격을 더해주었습니다. 우리는 주요 재정 파트너인 네덜란드 교육문화과학부와 생산적인 협력 관계를 견고하게 유지해왔습니다. 장관은 현대 문화와 교육 및 사회 전반에 비추어 우리 학교의 중요성을 언급하기도 했지요.

교육문화과학부의 지원, 반아베박물관의 열정, 언론과 일반 대중이 보여준 감사한 반응, 우리가 해외에서 경험한 따뜻한 환대, 그리고 무엇보다도 학생들이 만든 작품의 완성도와

For four years(2013–2016) Thomas Widdershoven(AGI 2012) was the Creative Director at Design Academy Eindhoven. Like many design institutions, the faculty at the Design Academy Eindhoven have been questioning the various futures of design practice and education.

토마스 비더쇼벤은 2013년부터 2016년까지 4년 동안 에인트호벤디자인아카데미의 크리에이티브 디렉터로 재직했다. 많은 디자인 기관과 마찬가지로 에인트호벤디자인아카데미의 교수진은 디자인 실무와 교육의 다양한 미래에 대해 의문을 제기해왔다.

Many of those concerns and questions are discussed in this very book. When Widdershoven decided to step down from his position at Design Academy Eindhoven, he penned the following letter to inform everyone of the thoughts behind his decision and the directions he sees design moving.

이 책은 그러한 우려와 질문의 많은 부분을 논의하고 있다. 비더쇼벤이 에인트호벤디자인아카데미에서 물러나기로 했을 때, 위와 같은 편지를 써서 왜 그런 결정을 내렸는지 그리고 그가 생각하는 디자인의 방향성은 무엇인지 모두에게 알렸다.

233

In 2014 Design Curating and Writing started as a new, fourth Master department. Headed by Justin McGuirk and recently Alice Twemlow this department adds critical reflection to the palette of our Master programme.

We have had an intense and productive collaboration with the ministry of Education, Culture and Science (Ministerie van Onderwijs, Cultuur en Wetenschappe, OCW), our main financial partner. Discussions with the minister touched on the importance of our school for contemporary culture, education and society as a whole.

The support of the ministry, the enthusiasm of the Van Abbemuseum, the appreciation shown by press and general public, the warm welcome we experienced abroad and above all the quality and urgency of the work made by our students have made it all worthwhile. I thoroughly enjoyed my presence in this amazing school.

So why did I decide against a second term?

As Creative Director and Chair I had a part-time position at the academy. Meanwhile I kept working at Thonik, the design studio Nikki Gonnissen and I founded in 1993. While the school was in need of a new foundation, Thonik could build on a strong base. This explains why, over these past few years, the focus of my work was on the academy.

But as I was contemplating a second term in Eindhoven it became clear to me how important my actual involvement in design is. Thonik is expanding its activities into new fields and new countries: an exciting prospect for the studio and a development I definitely want to be part of. And, for the first time in my life, I have started work on an architectural project.

I am confident that the academy holds a strong position. In terms of finance, reputation, organisation and education Design Academy Eindhoven faces a bright future. I will miss the students who are shaping this future, and I shall miss the team. Continuity in the board is in good hands with my fellow board member Jurriënne Ossewold. I want to thank you all

Thomas Widdershoven

유효성 덕분에 이 모든 것이 가치를 지니게 되었습니다.

저는 이 훌륭한 학교와 함께하는 시간이 정말 즐거웠습니다.

그런데 제가 왜 두 번째 임기를 고사했을까요?

크리에이티브 디렉터 겸 의장인 저는 학교에서 비전임으로 근무했습니다. 한편으로 니키 고니센과 1993년 함께 설립한 디자인 스튜디오 토닉에서도 계속 일을 했습니다. 학교가 새로운 기반을 필요로 하는 사이, 토닉은 강력한 기반을 다질 수 있었습니다. 그런 이유로 지난 몇 년 동안 저는 일의 초점을 학교에 두었습니다.

그러나 에인트호벤에서의 두 번째 임기를 고려할 때, 제가 실제 디자인에 참여하는 것이 얼마나 중요한지 실감하게 되었습니다. 토닉은 새로운 분야와 국제적인 무대로 범위를 넓혀가고 있었고, 저는 스튜디오의 흥미진진한 활동을 함께하며 발전하고 싶다고 생각했습니다. 그리고 제 생애 처음으로 건축 프로젝트를 시작했습니다.

저는 우리 학교의 위치가 공고하다고 자신합니다. 재정 상태와 명성, 조직 및 교육 면에서 에인트호벤디자인아카데미의 미래는 밝습니다. 저는 이러한 미래를 만들어가는 학생들과 우리 팀을 그리워할 것입니다. 동료 이사인 유리엔느 오스월트가 이사회에서 제 역할을 대신해줄 것입니다. 열정적으로 훌륭하게 협업해주신 여러분 모두에게 감사드립니다.

여름이 지나면 저는 사임할 예정입니다. 9월 6일에 새 학년이 시작되면 여러분에게 직접 작별을 고할 좋은 기회가 있을 것입니다. 학교와 학생 및 우리 모두의 미래를 위해 축배를 드는 자리에 모두가 함께하기를 기원하며 저는 공식적으로 10월 15일에 학교를 떠나고자 합니다.

행운을 빌며

토마스 비더쇼벤
크리에이티브 디렉터
이사회 의장
에인트호벤디자인아카데미

234

for an intense and beautiful collaboration.
After the summer I will step down. The opening of
the new academic year on September 6th provides a
perfect opportunity to say goodbye to you in person.
I hope everyone can join to toast to the future of the
academy, the students and all of us.
I will formally leave the academy on October 15th.

Best wishes

Thomas Widdershoven
Creative Director
Chair of the Board
Design Academy Eindhoven

235

Assignment 4

Creating a personal logo

The design of a symbol or logotype often derives from particular
letterforms. Thorough knowledge of form is essential. Close analysis
may reveal design solutions that are not apparent by cursory
examination of letters. This assignment explores form, counter form
and microaesthetic details of letters to create a personal logo.

Steps

1
Set the initial letters of your first and last name in 96 pt. Helvetica
Medium or Akzidenz Grotesk Bold, and a serif typeface such as Times
Roman or Caslon. You may also consider using italic versions of these
typefaces. Print on white paper.

2
Study the letter's form, counter form, and the counter form between
the letters. Focus on the microaesthetic details of each letterform.
Imagine how the two letters or parts of the letters could be combined
to create a personal logo.

3
Start testing your ideas by tracing the letterforms. You may also
experiment by cutting and pasting laser prints. Work with the actual
letterforms only; do not add flourishes. Aim for abstraction.

4
Explore reversing details of letterforms out of a geometric element,
e.g. circle, oval, square, triangle. Sketch your design exploration; the
design studies must be shown.

5
Finalize two designs in Adobe Illustrator.

6
Print each of the designs in two sizes, 1 in. and 0.375 in. high,
arranged vertically, starting 2 in. from the top of the page, 4 in. apart,
centered left to right, on 8.5 x 11 in. 28 lb. white paper.

Concluding the assignment: hand in two 8.5 x 11 in. pages.
Due: Friday, October 7

One of the logos will be used in assignment 5.

Reference:

T:FT
pp. 23
pp. 26-27
pp. 32-41

T:MM
90-93

Examples

236

Willi Kunz

Author, Phantasmagorias: Daydreaming with Lines
Author, Typography: Formation and Transformation

Two assignments by Willi Kunz teaching students
the fundamentals of designing a logo mark and
form and counterform in typography.

윌리 쿤즈가 학생들에게 내준 두 가지 과제이다.
타이포그래피 안에서 로고 디자인과 형태 및
글자 속공간의 기초를 가르치는 것이 목표이다.

CD271 Designing with Type Willi Kunz
 FIT

 Assignment 3

Exploring the form and counterform of letters

Reference:

T:FT
pp. 20–27
pp. 34–41
pp. 46

T:MM
20–21
90–93

Examples

The microaesthetic details of letterforms and counterforms are
a rich source of inspiration. This assignment explores letterform and
counterform as ready-made elements of graphic design.

Steps

1 – September 16
Set the 26 letters of the alphabet in both upper and lower case,
roman and italic, 96 pt. Univers, Gill, Rockwell, Bodoni, and Caslon,
all regular weight. Print one copy of each on white paper.

2
Study the form and counter form of each letter and select nine or more
letterform details you find interesting.

3
Trace the selected details. You may also define the details by masking
the letterforms. Each detail should roughly fit in a square.

4
Finalize the nine letterform details in Adobe Illustrator. Each detail
should fit in a 9 pica square.

5
Create a 3 x 3 unit grid, each unit measuring 9 picas, with 6 points
between units. On this grid, arrange the letterform details so that they
interact with one another without creating optical clusters.

6
Print the final 28 x 28 pica composition, 2 in. from the top, centered
left to right, on 8.5 x 11 in. 28 lb. white paper.

7 – September 23
Set the 26 letters of the alphabet in both upper and lower case,
96 pt. Univers 75. Print one copy of each on white paper.

8
Using either upper or lower case, create nine letter combinations
characterized by strong counterforms between the letters.

9
Trace the counterforms between the letter combinations.

10
Finalize the nine counterforms in Adobe Illustrator. Each detail should
fit in a 9 pica square.

11
Create a 3 x 3 unit grid, each unit measuring 9 picas, with 6 points
between units. On this grid, arrange the counterforms so that they
interact with one another without creating optical clusters.

12
Print the final 28 x 28 pica composition, 2 in. from the top, centered
left to right, on 8.5 x 11 in. 28 lb. white paper.

Concluding the assignment: hand in two 8.5 x 11 in. pages.
Due: Friday, September 30

237

준비물
텍스트 출력물 여분
커팅매트 A4 크기
칼/가위
풀/스카치테이프
자(20-30cm)
빈 A4용지

바우하우스 총서 9	Bauhaus Bücher 9	Bauhaus Books 9
점선면	Punkt und Linie zu Fläche	Point and line to plane
회화적인 요소의 분석을 위하여	Beitrag zur Analyse der malerischen Elemente	Contribution to the analysis of the pictorial elements
바실리 칸딘스키	Wassily Kandinsky	Wassily Kandinsky
1983	1926	1947

1 typeface, 1 type size	1 or 2 typeface, 2 type size	+ plane	+ images
활자 구성	활자 구성	활자 + 면 혼합 구성	활자 + 사진, 그림 혼합 구성

바우하우스 총서 9 점선면 點線面 회화적인 요소의 분석을 위하여 바실리 칸딘스키 1983
바우하우스 총서 9 점선면 點線面 회화적인 요소의 분석을 위하여 바실리 칸딘스키 1983
바우하우스 총서 9 점선면 點線面 회화적인 요소의 분석을 위하여 바실리 칸딘스키 1983
바우하우스 총서 9 점선면 點線面 회화적인 요소의 분석을 위하여 바실리 칸딘스키 1983
바우하우스 총서 9 점선면 點線面 회화적인 요소의 분석을 위하여 바실리 칸딘스키 1983

바우하우스 총서 9 점선면 點線面 회화적인 요소의 분석을 위하여 바실리 칸딘스키 1983
바우하우스 총서 9 점선면 點線面 회화적인 요소의 분석을 위하여 바실리 칸딘스키 1983
바우하우스 총서 9 점선면 點線面 회화적인 요소의 분석을 위하여 바실리 칸딘스키 1983
바우하우스 총서 9 점선면 點線面 회화적인 요소의 분석을 위하여 바실리 칸딘스키 1983
바우하우스 총서 9 점선면 點線面 회화적인 요소의 분석을 위하여 바실리 칸딘스키 1983

Bauhaus Books 9 Point and line to plane Contribution to the analysis of the pictorial elements Wassily Kandinsky 1947
Bauhaus Books 9 Point and line to plane Contribution to the analysis of the pictorial elements Wassily Kandinsky 1947
Bauhaus Books 9 Point and line to plane Contribution to the analysis of the pictorial elements Wassily Kandinsky 1947
Bauhaus Books 9 Point and line to plane Contribution to the analysis of the pictorial elements Wassily Kandinsky 1947
Bauhaus Books 9 Point and line to plane Contribution to the analysis of the pictorial elements Wassily Kandinsky 1947

Bauhaus Books 9 Point and line to plane Contribution to the analysis of the pictorial elements Wassily Kandinsky 1947
Bauhaus Books 9 Point and line to plane Contribution to the analysis of the pictorial elements Wassily Kandinsky 1947
Bauhaus Books 9 Point and line to plane Contribution to the analysis of the pictorial elements Wassily Kandinsky 1947
Bauhaus Books 9 Point and line to plane Contribution to the analysis of the pictorial elements Wassily Kandinsky 1947
Bauhaus Books 9 Point and line to plane Contribution to the analysis of the pictorial elements Wassily Kandinsky 1947

Bauhaus Bücher 9 Punkt und Linie zu Fläche Beitrag zur Analyse der malerischen Elemente Wassily Kandinsky 1926
Bauhaus Bücher 9 Punkt und Linie zu Fläche Beitrag zur Analyse der malerischen Elemente Wassily Kandinsky 1926
Bauhaus Bücher 9 Punkt und Linie zu Fläche Beitrag zur Analyse der malerischen Elemente Wassily Kandinsky 1926
Bauhaus Bücher 9 Punkt und Linie zu Fläche Beitrag zur Analyse der malerischen Elemente Wassily Kandinsky 1926
Bauhaus Bücher 9 Punkt und Linie zu Fläche Beitrag zur Analyse der malerischen Elemente Wassily Kandinsky 1926

Bauhaus Bücher 9 Punkt und Linie zu Fläche Beitrag zur Analyse der malerischen Elemente Wassily Kandinsky 1926
Bauhaus Bücher 9 Punkt und Linie zu Fläche Beitrag zur Analyse der malerischen Elemente Wassily Kandinsky 1926
Bauhaus Bücher 9 Punkt und Linie zu Fläche Beitrag zur Analyse der malerischen Elemente Wassily Kandinsky 1926
Bauhaus Bücher 9 Punkt und Linie zu Fläche Beitrag zur Analyse der malerischen Elemente Wassily Kandinsky 1926
Bauhaus Bücher 9 Punkt und Linie zu Fläche Beitrag zur Analyse der malerischen Elemente Wassily Kandinsky 1926

238

Woohyuk Park

Co-Founder, artist collective, Jin Dallae and Woohyuk Park
Professor, Seoul National University of Science and Technology

Assignment brief and student work for a typographic poster assignment given students in the Basic Typography course. The brief also becomes the raw material for students to use to manually create designs that will then be refined into dynamic posters.

기초 타이포그래피 수업의 타이포그래피 포스터를 위한 과제 지침과 학생 작업이다. 학생들은 과제 지침을 소재로 삼아 수작업으로 디자인하고 다듬어서 동적인 포스터로 제작한다.

Brown
Rectangle
Discussion

Vertigo Gallery
Mexico City

09
27
2018

Alejandro Magallanes
Anna Lena von Helldorff
Chris Ro
David Smith
Erik Adigard
Erik Brandt
Jean-Benoit Levy
Kiko Farkas
Lucille Tenazas
Marc Català
Markus Dressen
Martin Venezky
Patrick Thomas
Pooroni Rhee
Rico Lins
Selva Hernandez
Thomas Widdershoven
Yeoun Joo Park

240

갈색 직사각형 토론
버티고갤러리
멕시코시티
09
27
2018

In tandem with the AGI Open/Congress of Mexico City in September of 2018, a forum took place where design educators from around the world gathered for an intimate discussion on design education past, present, future. The meeting venue was the Vertigo Gallery, a cultural center, gallery and design studio owned and operated by the prolific Dr. Jorge Alderete—ilustrator, designer and musician extraordinaire. Representing the Alliance Graphique Internationale were designer-educators Alejandro Magallanes, Anna Lena von Helldorff, Chris Ro, David Smith, Erik Adigard, Erik Brandt, Jean-Benoit Levy, Kiko Farkas, Lucille Tenazas, Marc Català, Markus Dressen, Martin Venezky, Patrick Thomas, Poorooni Rhee, Rico Lins, Selva Hernandez, Thomas Widdershoven and Yeoun Joo Park.

The session had several core objectives. There was a great desire to just talk, listen and talk again. Instead of the typical one-channel communication that can take place at conferences and design gatherings where presentations are consumed, one after the other, there was a great desire to both interface and interact during this time. A chance for like-minded, like-souled educators to meet and discuss topics that normally might not be discussed elsewhere. The following can be considered a condensed summary of this dialogue. Due to the open and intimate nature of this discussion, the consensus was that a summary of this dialogue would be more appropriate for publication as opposed to a verbatim transcript. Therefore the following can be thought of as a 'greatest hits' of this conversation. The session was but a few hours but in this short time, immense and rewarding. The following excerpts can be considered representative morsels of the larger conversation.

Investigating 'The Other Side'
The theme for this year's AGI Open/Congress was 'El Otro Lado', or 'The Other Side'. It was a very apropos theme on a number of levels. The theme was selected due to the political climate and tensions existing between the United States of America and Mexico during this time. Discussions of a border wall that would create both a physical and iconic barrier between the two countries. The Other Side spoke to the motivations important to an international organization like the Alliance Graphique Internationale, a group with membership around the world. We are constantly curious what is happening on the other

2018년 9월 멕시코시티에서는 AGI 오픈/회의와 함께 세계 각국의 디자인 교육자가 모여 디자인 교육의 과거, 현재, 미래를 긴밀하게 논의하는 포럼이 열렸다. 회의 장소는 왕성한 활동을 하는 작가 호르헤 알데레테 박사가 소유하며 운영하는 문화센터이자 갤러리 그리고 디자인 스튜디오이기도 한 버티고갤러리였다. 알데레테 박사는 일러스트레이터 겸 디자이너이며 탁월한 음악가이기도 하다. AGI을 대표하여 디자이너 겸 교육자인 알레한드로 마갈라네스와 안나 레나 폰 헬도르프, 크리스 로, 데이비드 스미스, 에릭 아디가드, 에릭 브란트, 장 베누아 레비, 키코 파카스, 루실 테나자스, 마크 카탈라, 마르쿠스 드레센, 마틴 베네츠키, 패트릭 토머스, 이푸로니, 리코 린스, 셀바 에르난데스, 토마스 비더쇼벤 그리고 박연주가 참석했다.

이 세션에는 몇 가지 핵심 목표가 있었다. 무엇보다도 그저 말하고 듣고 또 말하고 싶은 욕구가 대단했다. 프레젠테이션을 차례로 소비하는 컨퍼런스와 디자인 행사의 전형적인 1채널 소통 대신, 이 기간 동안에는 접속과 상호작용을 병행하려는 욕구가 컸다. 생각과 정신이 비슷한 교육자가 서로 만나, 평소 다른 곳에서는 잘 논의하지 않던 주제를 다룰 기회였다. 다음은 이 대화의 요약본으로 볼 수 있다. 개방적이고 친밀한 이 토론의 성격을 고려하면 이 기록은 말을 그대로 옮긴 대화록이 아니라 출판에 더 적합하다는 데 모두의 의견이 일치했다. 따라서 다음 내용은 이 대화에서 '가장 성공적인' 부분으로 볼 수 있다. 그 세션은 불과 몇 시간으로 짧았지만 대단히 보람 있었다. 다음 발췌문은 더 폭넓은 대화에서 추려낸 대표적인 부분이다.

'다른 쪽'을 탐구하다
올해 AGI 오픈/회의의 주제는 '엘 오트로 라도' 즉 '다른 쪽'이었다. 여러 면에서 매우 적절한 주제였다고 할 수 있다. 이 시기에 미국과 멕시코 사이에 존재하는 정치적 기류와 긴장감이 주제 선정의 배경이 되었다. 두 나라 사이에 물리적, 상징적 장벽을 모두 만들어낼 국경 장벽에 대한 논의가 이루어졌다. '다른 쪽'은 AGI처럼 전 세계에 회원을 보유한 국제 기구에 중요한 동기가 된다. 우리는 끊임없이 다른 쪽에서 무슨 일이 일어나고 있는지 궁금해한다. 그리고 오늘 저녁에 있었던 대화도 다르지 않았다. 디자인 교육자들이 전 세계의 디자인 교육을 엿볼 수 있는 귀하고 흔치 않은 기회였다.

이 토론에서는 독일, 미국, 스페인, 멕시코, 한국, 아일랜드,

side. And the dialogue that took place this evening was no different. It was one of those rare and unique opportunities for design educators to get a glimpse of design education from around the world.

Representing the countries of Germany, the United States of America, Spain, Mexico, South Korea, Ireland, the Netherlands, Brazil and Great Britain the discussion engaged in a wide variety of topics on issues and themes through the perspective of each of these respective countries. This group represented a very unique group of educators who also are firmly entrenched in some form of practice and project work that continues to inform their roles and thinking as educators. From poster designers to full-on brand studios, to those who curate, coordinate and instigate; this was a group interested in the multifarious and multifaceted. The assembled, live in projects and also live through teaching. An active conversation grew between those who run similar studios and pedagogical processes. Amongst such like-minded thinkers, there was a certain joy in being able to say the unsaid; fears, concerns, disputes, complaints, worries, concepts that one might not normally be able to discuss back in each respective educators' original academic environments. Here amongst similarly minded folks, all issues, all topics were game. All topics were possible. A chance to momentarily be on 'The Other Side'.

'Ugliest combination in the world'
A certain amount of clarity for what this discussion was needed even though the contents had not yet formerly been declared or determined prior to the dialogue. Upon arrival to the Vertigo gallery, the physical space of the discussion, the actual table for the discussion was a large square and brown table. It was quickly observed that this was the exact shape that designer Stefan Sagmeister shared as being possibly the ugliest combination in the world during his presentation at the AGI Congress on September 25, 2018. Sagmeister, in his recent research on beauty, had determined that one of the ugliest concepts in the world was the brown rectangle. It was a humorous observation that the very table this discussion would take place on was similarly, a brown rectangle. From this moment forward, this event had officially found a name. And from this point on and potentially moving forward, this event has been dubbed the Brown Rectangle Table Discussion in honor of Ste-

네덜란드, 브라질, 영국을 대표하여 각국의 관점으로 이슈와 주제에 관한 다양한 화제를 다루었다.

이 그룹은 모종의 실무와 프로젝트 작업도 확실하게 하면서 교육자로서의 역할과 생각에 필요한 정보를 지속적으로 얻는 매우 독특한 교육자 그룹을 대변했다. 포스터 디자이너부터 브랜드 전문 스튜디오, 기획하고 조정하고 실행하는 사람들에 이르기까지, 다양하고 다면적인 분야에 관심이 있는 그룹이었다. 그들은 모여서, 프로젝트 안에서 그리고 교육을 통해 살아간다. 비슷한 스튜디오와 교육 과정을 운영하는 사람들 사이에 활발한 대화가 이어졌다. 비슷한 생각을 가진 사람들끼리는 나눈 적이 없던 이야기를 하면서 다들 분명히 기뻐했다. 일반적으로 각 교육자가 기존의 학문적 환경에서 토론하지 못했던 불안이나 우려, 논쟁, 불만, 걱정, 개념을 공유할 수 있었다. 비슷한 생각을 가진 사람들과 함께 있으며, 온갖 이슈와 화제들이 나왔다. 모든 화제가 가능했다. 잠시나마 '다른 쪽'에 가볼 수 있는 기회였다.

242

'세상에서 가장 볼품없는 조합'
대화에 앞서 내용을 발표하거나 결정하지 않았음에도 이 논의가 무엇을 위해 필요한지 어느 정도 분명히 할 필요가 있었다. 토론의 물리적 공간인 버티고갤러리에 도착하자, 커다란 갈색 직사각형 테이블이 보였다. 실제 토론용 테이블이었다. 디자이너 스테판 사그마이스터가 2018년 9월 25일 AGI 회의에서 발표할 때 세계에서 가장 볼품없는 조합일 수 있다고 이야기한 바로 그 모양이라는 것을 금세 알 수 있었다. 사그마이스터는 최근 아름다움에 관한 연구에서 세상에서 가장 볼품없는 개념 중 하나가 갈색 직사각형이라고 결론지었다. 이 토론이 이루어질 바로 그 탁자가 이와 유사하게 갈색 직사각형이라는 사실이 유머러스했다. 이후 이 행사에 공식적인 명칭이 생겼다. 그리고 이 시점부터 잠재적으로 앞으로 이 행사는 스테판의 이야기와 몇 시간 동안 우연히 이 그룹의 본거지가 된 환경을 기념하여 '갈색 직사각형 탁자 토론' 이라 칭했다.

우선 그 대화가 일종의 시험 운행이나 실험임을 분명히 했다. 그러한 친밀한 분위기의 대화는 최근의 AGI 오픈/

fan's observation and the coincidental environment that became home for this group for a few hours.

The conversation was at first clarified as a test run or experiment of sorts. In recent memory, such an intimate dialogue had not taken place at recent AGI Open/Congress events. The previous conference in Paris 2017 did have a session singularly dedicated to education that consisted of presentations and at the end, a panel discussion. But that event was open to the public and thus the framework at Paris was similarly a session that spoke more towards a larger audience and was not necessarily a discussion with more rapid back and forth. The goal of this session in Mexico was not to communicate necessarily to an audience, but to have a true, pure and simple conversation. With the diversity in backgrounds, expertise, interests, cultures it was deemed a more appropriate scenario to let the conversation build itself. And that it did. With the larger than large subject of design education as the spine or backbone, the conversation began and spun into an enchanting range of themes and concepts.

What is the main dish of design education today?

The conversation that grew was a glimpse into design education as one meal with many side dishes. The first such theme that took place and was discussed over and over at points in this dialogue was the curious relationship between design and culture.

Martin Venezky began this point of departure by describing a current design landscape that has become largely skewed towards apps, app design, websites, etc. and how in many programs a huge core of any given curriculum is now devoted towards this as it leads to jobs and employment. Martin to this point expressed, 'I feel that design has somehow lost its way as far as serious cultural relevance and its primarily here in the U.S., which is the area that I'm most familiar with. How do we either try to bring that back or accept that fact and redefine that design is going to be mainly about branding and apps in the future? And not about driving culture.'

To this David Smith replied that perhaps this is the way things are going and it cannot be stopped due to the needs of the industry. And that what Martin is perhaps describing is the correct model for graduate level education and not undergraduate level. At the graduate level, explorations and research in culture are encouraged as an addition to commercial prac-

회의 행사에서 이루어진 적이 없다. 앞서 열린 2017년 파리 회의에서는 실제로 오로지 교육만을 주제로 프레젠테이션과 마지막에는 패널 토론까지 마련되었던 세션이 있었다. 그러나 그 행사는 대중에게 공개되는 자리였고 파리 행사의 틀 역시 더 많은 청중을 향해 이야기하는 세션이었다. 좀 더 빠르게 이야기를 주고받는 토론은 아니었던 것이다. 멕시코에서 있었던 이 세션의 목표는 반드시 청중과 소통하는 것이 아니라 진실하고 순수하며 간결한 대화를 나누는 것이었다. 배경과 전문 지식, 관심과 문화의 다양성을 바탕으로 대화가 자체적으로 진행되는 것이 더 적절한 시나리오였다. 그리고 실제로도 그랬다. 디자인 교육이라는 큰 주제를 기본 골격으로 이야기가 시작되어 다양하고 매혹적인 주제와 개념들로 흘러갔다.

오늘날 디자인 교육의 메인 요리는 무엇인가?

대화가 무르익으면서 디자인 교육을 사이드 요리가 다양한 한 끼 식사로 엿보게 되었다. 이 대화에서 반복적으로 논의된 첫 번째 주제는 디자인과 문화 사이의 흥미로운 관계였다.

마틴 베네츠키는 앱과 앱 디자인, 웹사이트 등으로 크게 치우친 현재의 디자인 풍경과 다양한 교육 프로그램 안에서 커리큘럼의 거대한 핵심이 (일자리와 고용으로 이어지기 때문에) 이 부분에 전념하는 양상을 설명하면서 이 이야기를 시작했다. 마틴은 이렇게 표현했다. "나는 디자인이 진지한 문화적 타당성 측면에서 길을 잃었다고 느껴진다. 특히 내게 가장 익숙한 지역인 미국에서 주로 그런 것 같다. 어떻게 하면 과거로 돌아가거나, 혹은 반대로 그 사실을 받아들여 미래에는 문화를 움직이는 추진력이 아닌 주로 브랜드와 앱을 다루는 것으로 디자인을 재정의할 수 있을까?"

이에 대해 데이비드 스미스는 이런 식으로 상황이 진행되는 것으로 보이며 업계의 요구도 있기 때문에 이런 추세를 막을 수는 없다고 답했다. 그리고 마틴이 설명하는 것은 대학원 수준의 교육에서는 올바른 모델이지만 학부 수준은 아닌 것 같다고 했다. 대학원 단계에서는 상업적인 실무와 함께 문화적인 탐구와 연구를 독려한다. 데이비드는 디자인 교육 기간이 더 길어져서 더 이상 2년에서 4년 안에 완료할 수 없게 되었다고 한다. 대학원 수준의 교육은 이제 그러한 문화적 질문을 던지고 탐구하는 곳이다

마틴은 과거에는 문학 또는 음악과 같은 다른 예술 분야와

243

tice. David says the education of a designer has just become longer and no longer something that can be achieved in 2 to 4 years. Graduate level education is now the place where such cultural questions are asked and explored.

Martin continued this point by observing that in the past, there was a large amount of a curriculum devoted to design and say, its relationship with literature or music. But these classes have now become electives and to think in terms of design and say, long form text, does not really exist in the way that it used to. So there is this really peculiar dichotomy of programs that are either at extremes or stuck in the middle. There are programs focused on more traditional graphic design, which may be geared towards more cultural explorations and and those that focus more on design that is more linked to practice and industry.

The theme of culture, culturally aware projects versus practicality and professionalism continued to weave its way in and out of the discussion throughout the evening. It seems there continues to be a divide and perhaps no proper answer as to how design education should continue. Both are necessary to make the institution what it is, a place to learn, a place to challenge yet also a place to prepare for the real world. Is the school a place for such endeavors? Or is the school a preparation for reality?

Asking questions and identifying problems

Kiko Farkas posed the question, "Are we teachers or educators? I think there is a slight difference. Because what I've learned during a small period of time is that it seems like education is no longer needed… But being teachers are different from educators. So I would like to know what our role is? Is it just teachers, teaching how to move something from here to there? Or trying to understand the reasons why we move these things?"

Lucille Tenazas replied, "Well can I just say, when you say education, I think you are looking at a way of thinking so that a person can parlay what they have and apply it or adapt it in the future when there is technology or not. And so education is a meta word I think that looks at instilling the capacity to be adaptable. And I think when I was a young teacher or young educator I thought I would just give projects that replicated what I know. And so I would tell my students design this book, design this cover,

디자인 사이의 관계를 다룬 커리큘럼이 많았다는 것을 언급하면서 이 이야기를 이어나갔다. 그러나 이러한 수업은 이제 선택 과목이다. 그리고 디자인적 측면에서 생각해보면예전처럼 긴 형태의 텍스트는 실제로 존재하지 않는다. 그래서 극단적이거나 중간에 고착된 프로그램 중 하나로 나뉘는 정말 특이한 이분법이 있다. 조금 더 문화적 탐구에 적합한 전통적인 그래픽 디자인 중심 프로그램과 실무나 산업에 더 초점을 둔 프로그램으로 나뉜다.

저녁 내내 토론에서는 문화적인 의식이 높은 프로젝트대 실용성과 전문성이라는 주제가 논의되었다. 계속해서 의견이 갈리고 디자인 교육이 어떻게 지속되어야 하는지에 대해서는 적절한 답이 없는 것 같다. 교육 기관을 지금처럼 배우고 도전하며 현실 세계에 대비하는 장소가 되도록 하려면 두 가지 모두 필요하다. 학교가 그런 노력을 할 수 있는 곳인가? 아니면 학교는 현실에 대한 준비 과정인가?

질문하고 문제점 파악하기

키코 파카스는 질문을 던진다. "우리는 교사인가, 교육자인가? 나는 약간의 차이가 있다고 생각한다. 왜냐하면 내가 짧은 기간 동안 배운 바에 따르면 교육이 더 이상 필요하지 않은 것처럼 보이기 때문이다.…… 그러나 교사가 된다는 것은 교육자가 되는 것과는 다르다. 그래서 나는 우리의 역할이 무엇인지 알고 싶다. 단지 여기서 저기로 무언가를 옮기는 방법을 가르치는 교사일 뿐인가? 아니면 이런 것들을 옮기는 이유를 이해하려 하는가?"

루실 테나자스가 대답했다. "글쎄, 교육이라고 하면 사람이 가지고 있는 것을 활용하고 기술이 있든 없든 미래에 적용하거나 적응할 수 있도록 생각하는 방법을 가리킨다고 생각한다. 그래서 교육은 적응 능력을 주입하는 것을 지칭하는 메타 단어이다. 그리고 내가 젊은 교사나 교육자였을 때는 학생들에게 단순히 내가 알고 있는 것을 복제하는 프로젝트를 부과하려고 했다. 그래서 학생들에게 이 책을 디자인하고, 이 표지를 디자인하고, 이 박물관을 위해 무언가를 디자인하라고 말하곤 했다. 왜냐하면 그건 내가 하고 싶은

design something for this museum because that was something I liked to do. But now I think over time I realize that I am not interested in them developing typologies of what they see out there. So I invented my own way of teaching where it relies on their own response." She then went on to give some examples of projects she gives in her courses on this theme where the students are observing and learning how to respond to certain conditions. Her projects are often completely open ended, which she acknowledges, might drive the students crazy at times and students are tasked with sometimes, "looking for a design problem that you can solve" as opposed to being given the problem explicitly.

Lucille, through her assignments and projects sees such openness as a way for students to connect design to the world around them. She describes a project that she has engaged in for many years where students are to walk from one point to another point in a certain neighborhood or street and they are to observe and define a project from such conditions. It is a challenging project but one also that she firmly believes encourages the designer to be not just an observer but a catalyst and someone who can truly contextualize and grasp situations and environments. But this project in the past sometimes meets resistance because of its open nature. It is no longer just designing something that mimics reality or professional practice but a project that allows students to engage with subject matter at a deeper or unexplored level.

Lucille observed "we cannot be changing our institutions overnight, the reality of it is that what we have in common is that we shape minds and we launch careers and the life lines of people that are young and taught to be prepared in a discipline that we love. So if we want to be relevant and that they can be better, better than our generation, what do we give them now? What are the tools that we can give them and the capacities and their understanding, hopefully they won't become machines. Because careers, design careers, design definitions, the definition of practices will change."

What the students know

The discussion continued with some poignant remarks from Thomas Widdershoven. He both poetically and very appropriately described how he sees places of education, and in particular the perspec-

245

일이었기 때문이다. 그러나 시간이 지나면서 이제는 내가 학생들이 외부에서 보는 유형을 발전시키는 작업에 흥미가 없음을 깨달았다. 그래서 학생들 자신의 반응에 의존하는 교수법을 고안했다." 그리고 나서 그녀는 학생들이 특정 조건에 어떻게 반응해야 하는지를 관찰하고 배우는 관련 수업에서 본인이 학생들에게 부여하는 프로젝트 사례를 들려주었다. 그녀의 프로젝트는 종종 완전히 열린 결말이기도 하다. 그녀 자신이 인정하듯이 때때로 학생들을 미치게 할 수도 있으며, 명확하게 문제점을 알려주기보다 반대로 "해결할 수 있는 디자인 문제 찾기"라는 과업을 맡기기도 한다.

루실은 과제와 프로젝트를 통해 그러한 개방성을 학생들과 디자인을 주변의 세계와 연결시키는 방법으로 본다. 그녀는 학생들이 특정 지역이나 거리의 한 지점에서 다른 지점으로 걸어가면서 관찰을 통해 프로젝트를 정의한 일을 수년 동안 진행한 이야기를 했다. 그것은 분명 힘든 프로젝트이다. 그러나 그녀는 이것이 디자이너가 단순한 관찰자가 아니라 촉매 역할을 하고 상황 및 환경의 맥락을 진정으로 이해하는 능력을 길러준다고 굳게 믿는다. 하지만 과거에는 개방적인 특성 때문에 때로는 저항에 부딪히기도 했다. 이 프로젝트는 현실이나 직업적인 실무를 모방하는 디자인을 하는 것이 아니라, 학생들이 주제를 미지의 수준까지 깊게 탐구할 수 있도록 하는 것이다.

루실은 이렇게 말했다. "우리가 하루 아침에 기관을 바꿀 수는 없다. 현실에서 우리의 공통점이라면 우리가 사랑하는 분야에서 미래를 준비하는 젊은이의 생각을 형성하고 커리어를 시작할 수 있도록 구명 밧줄을 던진다는 사실이다. 만약 우리가 하는 일이 유의미하기를 바라고 학생들이 우리 세대보다 발전하기를 바란다면, 우리는 지금 그들에게 무엇을 주어야 할 것인가? 우리가 줄 수 있는 도구와 능력, 그리고 그들의 이해도를 고려하면, 나는 그들이 기계처럼 되지는 않았으면 좋겠다. 직업적인 커리어와 디자인 경력, 디자인 정의, 실무의 정의가 바뀔 것이기 때문이다."

학생들이 알고 있는 것

토마스 비더쇼벤의 몇 가지 신랄한 발언들과 함께 토론이 이어졌다. 그는 교육 기관을 어떻게 보는지, 특히 자신이 몸 담았던 에인트호벤디자인아카데미의 시각을 시적이고도

tives of his former institution, Design Academy Eindhoven. "In Eindhoven we see a school as a place where generations meet on an equal level - because obviously, the new generation is way more advanced in new technology than the older generation is.

In our system, you get in by being a talent. Our education is based upon that. This was already the way when we were educated. Today we exchange ideas on education, on how to work with young people who are talented and how you get them to a next level. We have all kinds of workshops and assignments. But times have changed. Since the students now know something we, the educators, don't know, we have to wonder how to develop that talent. Ironically our education often results in misunderstanding. That is also an important element. The psychological confusion is a part of an art and design education. I think we should cherish this. We went through this emotional turmoil ourselves. But the main difference with present day education and the one we got is that a school, is no longer a place where an older generation passes something on to a new generation but it is a place where two generations meet and learn from each other. This results in a confusion for both educators and students. This environment makes an art school a free space where – outside of society and free from economic pressure - teachers and students work together to develop new forms, new methods and new values."

What Widdershoven was tangentially hinting at was also the position that one takes as a design educator. As Farkas and Tenazas hinted at earlier, being a design educator isn't simply being a teacher or instructor. Rather, it requires a combination of knowledge, experience, hubris and a clash of confidence to present ways of thinking and practice. This is an ironic stance, because as seasoned practitioners, AGI educators also know there is always a different way of approaching a brief, problem, situation or topic.

'Looking for questions'

Marc Català observed that schools should be places that question even such age old paradigms as form and function and how more often than not there are sets of assumptions about what design is and this is how he learned design. Kiko Farkas and Marc both commented on the ability to think about how to ask. Learning to learn. Teacher and student. Teacher

매우 적절하게 설명했다. "에인트호벤에서는 학교를 각기 다른 세대가 동등한 입장에서 만나는 곳으로 간주한다. 신세대가 기성 세대보다 신기술 면에서 훨씬 앞서는 게 분명하기 때문이다. 재능 있는 학생 만이 우리의 시스템을 통해 입학할 수 있다. 그것은 우리 교육의 기반이다. 이는 우리가 교육받던 당시에도 마찬가지였다. 오늘 우리는 교육에 대한 아이디어를 교환하고, 재능 있는 젊은이들과 어떻게 일하고 그들을 다음 단계로 나아가게 할 수 있는지 이야기하고 있다. 우리는 온갖 종류의 워크숍과 과제를 준비했다. 그러나 시대가 변했다. 이제는 우리 교육자가 모르는 것을 학생이 알고 있으니, 그 재능을 어떻게 키워줄 것인지 생각해야 한다. "우선 우리는 학생에게 재능이 있다고 얘기한다. 들어오면 그렇게 말한다. 우리는 그 점을 고려해야 한다. 우리는 처음에 그렇게 말했다. 우선 우리가 하는 일은 무엇이든 그들이 이미 재능이 있는 학생이라는 사실을 전제로 한다. 우리는 거기에 덧붙일 뿐이다. 그리고 나서, 그들이 우리가 모르는 것을 알고 있기 때문에 우리는 어떻게 그 재능을 개발할 수 있을지 고민해야 한다. 물론, 이 사람들을 움직이게 하는 방법에 대해 꽤 많은 아이디어를 들었기 때문에 그렇게 해왔다."

아이러니하게도 우리의 교육은 종종 오해를 불러온다. 그 또한 중요한 점이다. 심리적 혼란은 예술과 디자인 교육의 한 부분이다. 이건 매우 중요하다. 우리 자신도 이러한 감정적인 혼란을 겪었다. 그러나 현재의 교육과 우리가 받은 교육의 주된 차이는 학교가 더 이상 기성 세대가 새로운 세대에게 무언가를 전달하는 장소가 아니고, 두 세대가 만나 서로에게 배우는 곳이라는 사실이다. 이것은 교육자와 학생 모두에게 혼란스러운 일이다. 이러한 환경 때문에 예술 학교는 (사회로부터 경제적인 압박을 받지 않고) 교사와 학생이 새로운 형태와 새로운 방법과 새로운 가치를 개발하기 위해 함께 노력하는 자유로운 공간이 된다.

비더쇼벤이 한편으로 암시하던 것도 디자인 교육자로서 개인이 취하는 자세였다. 파카스와 테나자스가 앞서 암시했듯이, 디자인 교육자가 되는 일은 단순히 교사나 강사가 되는 것이 아니다. 그보다는 생각하고 실천하는 방법을 제시하기 위해 지식과 경험 그리고 자만심과 약간의 자신감이 필요하다. 이것은 모순인 입장이다. AGI 교육자들은 노련한 실무자로서 작업 개요와 문제점, 상황이나 주제에 접근하는 다른 방법이 항상 존재한다는 사실도 알고 있기 때문이다.

질문을 찾아서

마크 카탈라는 학교는 형태와 기능 같은 오래된 패러다임에도 불구하고 질문을 던지는 장소가 되어야 한다고 말했다. 또한 디자인이 무엇인지에 대한 일련의 가정도 자주 있으며, 자신은 그런 식으로 디자인을 배웠다고 했다. 키코 파카스와 마크는 둘 다 질문하는 방법을 생각하는 능력을 언급했다. 배우는 법을 배우는 것이다. 스승과 제자. 학생으로서의 스승. 답이

as student. Not looking for answers but looking for questions. Looking for ways to question. As Marc often discusses, it is just as much about learning to learn than the learning itself. Questioning. Anna Lena von Helldorff replied that many institutions and their existing frameworks do not allow both teachers and educators to question. The focus is heavy on answers and the students are used to getting answers. David Smith continues to note that a lot of this is industry driven. Industry does not want to engage in the deep or philosophical. They want it quick. They want it now.

This connection of both speed, logic and the desire for now have its connections rooted in the aforementioned role of technology within our profession and within design education. It is a never ending wave that must be acknowledged at all times. Erik Brandt explained the issues he deals with on a daily basis through ongoing curricular revisions that he is tasked with and larger picture education problems that exist perhaps outside the classroom. One particular battle he continues to deal with is this concept of speed and technology. As opposed to fine arts majors where the mediums, tools and methods continue to remain constant in certain ways, design is often at the mercy of technology. He poignantly notes that in a time of Pokémon Go, how can he continue to gauge student interest between the space between a K and a V? Artificial intelligence, virtual reality, these are the new issues in graphic design and graphic design education. And more so, the ability of the designer to truly make anything, literally anything. And this is something that he finds very daunting. The fact that these kind of things or thinking must be conveyed to students. That fact that students must be told, "you are going to have to make everything eventually"!

David Smith noted that the screen is now the focus whether we like it or not. It is a canvas and one that is continuing to shrink as time goes on. David notes that it would be in our best interest to adjust to such conditions but that such a small real estate for design may not be best for critical thinking, expression or interpretation. It is in our best interests to continue to supplement that as it is as opposed to avoiding it.

On a similar tangent, Markus Dressen discussed some of the student work from his courses dealing with first and second year students and some of the same conditions of abstraction and ambiguity. In

아니라 질문을 찾는 것. 질문할 방법을 찾고 있다. 마크가 자주 언급하듯이, 학습 그 자체보다 배우는 법을 배우는 것이 더 중요하다. 질문하기. 안나 레나 폰 헬도르프는 많은 기관과 그곳의 기존 틀은 교사와 교육자 모두에게 질문을 허락하지 않는다고 대답했다. 초점은 답에 집중되어 있고 학생은 답을 얻는 데 익숙하다. 데이비드 스미스는 많은 부분이 산업 중심이라는 것을 거듭 지적한다. 산업은 심오하거나 철학적인 것에 관여하고 싶어 하지 않는다. 그들은 빠른 것을 원한다. 당장 답이 주어지기를 바란다.

이러한 속도, 논리, 욕구의 연결은 현재로서는 우리 직업과 디자인 교육 안에서 앞서 언급한 기술의 역할에 뿌리를 두고 있다. 늘 인정해야 하는 끝없는 물결이다. 에릭 브란트는 그가 매일 다루는 문제를 진행 중인 커리큘럼 개정과 아마도 강의실 바깥에 존재할지도 모르는 더 큰 교육 문제를 통해 설명했다. 그가 지속하고 있는 특별한 싸움은 속도와 기술의 개념이다. 매체, 도구, 방법이 일정한 방식으로 계속 유지되는 미술과는 달리 디자인은 종종 기술에 좌우되곤 한다. 그는 포켓몬고 시대에 어떻게 하면 K와 V 사이의 공간에서 학생들의 흥미를 놓치지 않고 파악할 수 있는가에 대해 날카롭게 지적한다. 인공지능, 가상현실, 이런 것들이 그래픽 디자인과 그래픽 디자인 교육의 새로운 이슈이다. 그리고 더 나아가, 문자 그대로 아무거나 진정으로 만들 수 있는 디자이너의 능력. 그가 정말로 중요하게 여기는 게 바로 이것이다. 이런 종류의 일이나 사고가 학생들에게 전달되어야 한다는 사실이 중요하다. 학생들에게 "결국 여러분이 모든 것을 만들어야 할 것이다"라는 말을 해야 한다는 사실!

데이비드 스미스는 우리가 좋든 싫든, 지금은 스크린이 초점이라고 말했다. 시간이 흐를수록 캔버스의 입지는 줄어든다. 데이비드는 이런 조건에 적응하는 것이 최선이며, 디자인에 남은 작은 영역은 비평적인 사고와 표현 혹은 해석에 최선이 아니라고 지적한다. 이를 회피하지 말고 반대로 계속 보완하는 것이 가장 유익하다.

비슷한 접점에서, 마르쿠스 드레센은 1, 2학년 학생을 대상으로 한 그의 수업에서 나온 학생 작품 일부와 추상화와 모호성의 같은 동일한 조건에 대해 토론했다. 그는 어떤 프로젝트에서 학생들에게 젠트리피케이션이 시작되는 거리를 관찰하고 연구하게 한다. 2년 뒤면 거리가 완전히 달라질 것을 아는 상태에서, 학생은 어떻게 잡지 형식으로 여기에 대한 이해를 표현할까? 잡지는 어떤 내용일까? 많은 학생이 때때로 이런 프로젝트의 진행을 어려워한다. 마르쿠스는 이러한 대규모 열린 결말 프로젝트의 몇 가지 도전 과제와 함께 2, 3학년이 되어서도 그러한 프로젝트의 본질을 파악하는 데 어려움을 겪는 일부 학생들에 대해 언급한다. 심지어 졸업 프로젝트 때까지 망설이기도 한다. 그는 북 아트의 전통이 있는 역사적인 학교 환경에서 그가 마주한 도전과 자신의 현재 사고방식이 그러한 틀 안에서 어떻게 작용하는지

one project, he has students observe and research a street entering gentrification. Knowing that the street will be totally different in two years, how can a student create an understanding of this through the format of a magazine? What would that magazine be about? Many students are sometimes not sure how to go about such a project. Markus discussed some of the challenges of these larger open ended projects and how some students have difficulties grasping the essence of such projects even in their second or third year of study. Even up until their graduation project there is sometimes hesitation. He discusses his challenges in the environment of a historical school with a tradition in book arts and how does his current thinking work within such a framework. But he explained that at the end, it is a way to tackle the subjects and themes he is interested in and how he can place them within the context of graphic design or visual communication design. It is his belief that these projects develop their meaning and implications later. The ability to generate your own questions and asking more questions at the expense of more answers was something generally agreed upon during this discussion. The ability to question.

Abstraction. And the unknown.
This ability of questioning reflected a similar attitude towards a different issue of debate, that is teaching students to approach the intangible. How do students begin to approach topics and projects that aren't concrete? The project that Lucille described about observation and the city is just as much about what is not known as what is known. It is up to the student to deal with these kinds of contexts and formulating on their own. It is this action, whether the students understand it or not, as a way for a different comprehension of a city. It exists less in the formal output or traditional mediums but also very much in how a student would or could interpret the city.

Martin Venezky discussed a course that he developed with Lucille in the year 2000 called Form Studio. It is a course mainly using photography and drawing as a way to think about abstract form, something he feels is vital, "to be able to think within an abstract world as far as its emotional pull, its psychical pull, all of these kinds of things. I find that, to me, that's a vital part of being a designer. I find that

이야기한다. 그러나 그는 그것이 결국 관심 있는 소재와 주제를 다루는 방법이며, 그래픽 디자인이나 시각적 커뮤니케이션 디자인이라는 맥락 안에서 그것들을 배치할 수 있는 방식을 설명한다. 이러한 프로젝트가 나중에 그 의미와 함의를 발전시킨다는 것이 그의 믿음이다. 자신의 질문을 만들고 더 많은 답이 나오는 것을 감수하면서 더 많은 질문을 하는 능력이 이 토론을 하는 동안 참가자들이 일반적으로 동의한 부분이었다. 질문하는 능력.

추상화 그리고 미지의 것
구체적이고 명확하게 정의를 내릴 수 있는 것과 추상적이며 어쩌면 별로 말이 안 될 수도 있는 것 사이에 존재하는 비슷한 차이점에 관한 주제를 논의했다. 적어도 지금까지는. 루실이 관찰과 도시에 대해 설명한 프로젝트에 대해서는 알려진 내용만큼이나 알려지지 않은 내용도 다루었다. 이런 종류의 문맥을 처리하고 스스로 정립하는 것은 학생이 할 일이다. 학생들의 이해 여부를 떠나 이는 도시를 다르게 이해하는 방법이다. 공식적인 결과물이나 전통적인 매체에서는 별로 존재하지 않지만, 학생들이 도시를 해석하려는 방식 혹은 해석할 수 있는 방식 안에는 그렇지 않다.

마틴 베네츠키는 2000년에 루실과 함께 개발한 '형태 스튜디오'라는 강좌를 논의했다. 그것은 주로 사진과 드로잉을 활용하여 추상적인 형태에 대해 생각하는 교육 과정이다. 그는 "감정적 끌림, 심리적인 끌림, 이런 모든 종류의 것들까지 추상적인 세계 안에서 생각할 수 있는 것"을 필수로 여겼다." 나는 그것이 디자이너가 되기 위한 필수적인 부분임을 알고 있다. 내가 접한 거의 모든 커리큘럼에서 발견할 수 없었던 것 같다. 모호성 그리고 그것을 추상적인 형태로 비평하고, 미래 작업의 창작자로 사용할 수 있다는 것, 그것은 어떤 미디어나 어떤 미래에도 완전히 적응할 수 있다는 의미를 갖는다. 하지만

in almost no curricula that I've ever come across. Ambiguity, and being able to critique it as an abstract form, and use it as a generator of future work, which means it's completely adaptable in any media and any future, but almost no program talks about that kind of deep visual…" Form Studio is a very prolific course that both Martin and Lucille have continued to expand upon over the years. The ability for students and designers to approach something through ambiguity is a powerful asset that sometimes does not find acceptance in the design climate of now. The output from these courses though is truly fascinating and stands the test of time both formally and conceptually.

So though abstraction continues to be a debatable component of design education, the abstract future of our mediums and the way we consume design moving forward seem to point towards such concepts as necessities. In a time when we are continuing to move forward to medium agnostic formats and outputs, perhaps furthering the concept of that which makes absolutely no sense, makes sense.

Outcomes and possibilities

[Circling back to ideas about design education's outcomes…] David Smith responded, "I think that is really important and I think one of the things I am very conscious of in practice but also as an educator is that we are all very guilty of defining ourselves by our outputs, be they a book or be they a poster, that that actually defines our design, our artistic practice. That that is a measure of our mastery, our skill and too, it fuels our intellectual capacity. And actually in the future, the designer is going to be very adaptable, depending on the individual. The OECD, the European organization that defines parameters for future funding, they have standards and future education standards. And they say that the essential competencies for education in the 21st century, that for productive work is the use of resources, the use of information is the systems and the use of technology. That the thinking skills, our creative thinking, decision making, problem solving skills, and reasoning. And personal qualities, the responsible, social, self-managing with integrity, and to me, that's a designer." This last point was very apropos and was a shared sentiment among many this evening. The shaping of a designer perhaps exists less so in output or mastery, but the ability of the designer to be

그렇게 깊은 시각적 측면을 이야기하는 프로그램은 거의 없다." 형태 스튜디오는 수년 동안 마틴과 루실 둘 다 계속 확장해온 매우 활발한 교육 과정이다. 학생과 설계자 들이 모호성을 통해 어떤 것에 접근하는 능력은 때때로 현재의 디자인 환경에서 받아들여지지 않기도 하는 강력한 자산이다. 그럼에도 이런 과목의 결과물은 아주 매혹적이며 형식적으로나 개념적으로 시간이 지나도 가치가 있다.

그래서 추상화는 계속해서 디자인 교육의 논쟁적인 요소가 된다. 우리 매체의 추상적인 미래와 우리가 발전적으로 디자인을 소비하는 방식은 필수적인 개념인 듯하다. 우리가 계속해서 매체 불가지론적인 형식과 결과물을 향해 가고 있는 이 시점에, 아마도 더 나아가게 되면 전혀 말이 되지 않는 개념도 이치에 맞게 될 것이다.

결과와 가능성

[디자인 교육의 결과에 대한 아이디어로 돌아가서…] 데이비드 스미스는 대답했다. "나는 그것이 정말 중요한 점이라고 생각한다. 내가 실무에서만이 아니라 교육자로서도 크게 의식하는 것은 우리 모두가 결과물을 통해 우리 자신을 정의하는 것에 대해 매우 죄책감을 느낀다는 것이다. 책이든 포스터이든, 결과물은 우리의 디자인과 예술적인 실무를 실제로 정의하는 것이다. 우리의 숙련도와 기술을 측정하는 척도이기도 하고 지적 능력을 촉진시킨다. 그리고 실제로 경우에 따라서는 미래에 더 잘 적응하는 디자이너도 있을 것이다. 향후 자금 조달을 좌우할 OECD는 미래 교육에 대한 기준을 가지고 있다. 그리고 그들은 21세기 교육에 필수적인 역량이 (생산적인 일을 위해서는) 자원의 사용, 시스템 안에서의 정보 사용과 기술의 사용이라고 말한다. 사고 능력, 우리의 창조적 사고, 의사 결정, 문제 해결 능력 그리고 추론이다. 그리고 개인적 자질, 책임감, 사회성, 성실한 자기 관리의 중요성 역시 빼놓을 수 없다. 내게는 그것이 바로 디자이너이다." 마지막으로 적절하게 지적한 이 부분에 대해 이날 저녁 많은 사람이 공감을 표했다. 디자이너의 육성은 아마도 결과물이나 숙련도보다는 다면성을 갖추는 디자이너의 능력과 학생들에게 모든 것을 탐구하게 허용하는 기관에 달려 있을 것이다. 형식이나 매체에 엄격하게 국한되어 작업할 때는 관여할 수 없는 것들이다.

데이비드는 AGI와 같은 단체는 미래의 커리큘럼을 탐구할

multi-faceted and for institutions to allow students
to explore everything and all. The things that cannot
be engaged with when strictly working in format
or medium.

 David furthers this with a concept he once had that
perhaps an organization like AGI could explore a
future curriculum, perhaps something open source
that would pull together some of the issues of deal-
ing with ambiguity and how one might tackle that in
a project taking place in year one or year two? The
ability for an organization like AGI to pose questions.
To contemplate the value or existence of ambiguity
within design education.

Many institutions, and the design industry for
that matter, are often seeking the quick answer.
There is no bandwidth to engage in deep ques-
tions, philosophical questions or challenges. And
this appears to be the overall trend at the moment.
Speed and efficiency. And students who just want
everything to make sense. But in many programs,
this atmosphere for the abstract and the ability to
challenge the status quo remain in question as well.
Is it possible to question assumptions? Can design
programs question?

 After all the discussions of the evening, to finish
on this thought felt very apropos. A school can be
many things but at the end of the day, it truly is a
place where generations meet. Discuss. Exchange.
And learn.

수 있다고 말했다. 마치 오픈소스처럼 1-2학년 때 하게 되는
프로젝트와 모호성을 한데 모은 프로젝트에서 그것을
어떻게 다룰 것인지 등을 이야기했다.
그 문제에 관해서는 여러 기관들과 디자인 업계에서 종종
빠르고 간편한 답을 찾고 있다. 깊이 있는 질문이나 철학적
질문이나 도전 과제에 관여할 능력은 없다. 속도와 효율성
그리고 모든 것을 이해할 수 있기를 바라는 학생들. 이것이
전반적인 요즘의 경향인 듯하다. 그러나 많은 프로그램에서
추상화를 위한 이러한 분위기와 현상에 도전하는 능력 또한
여전히 불확실하다. 추정에 의문을 제기하는 것이 가능할까?
디자인 프로그램은 의문을 제기할 수 있는가?
 저녁 시간에 이루어진 다양한 논의 끝에, 이러한 사고 과정이
매우 적절히 마무리된 것으로 느껴졌다. 학교는 여러 가지
역할을 할 수 있지만 결국은 서로 다른 세대가 만나는 곳이다.
서로 논의하고 교류하고 배우는 곳인 셈이다.

250

251

Adrian Shaughnessy

Adrian Shaughnessy co-founded the design group 'Intro', an early adopter of digital technology, and a pioneer in digital motion graphics. Shaughnessy left in 2004 to pursue an interest in writing, and to work as an independent design consultant. He writes regularly for many of the leading graphic design journals and has appeared on radio and television talking about design. In 2009, he was awarded a Visiting Professorship at the Royal College of Art. Shaughnessy lectures around the world and is co-founder of the publishing imprint Unit Editions. He is the author of numerous books on design.

에이드리언 쇼네시

에이드리언 쇼네시는 디지털 기술의 얼리어답터이자 디지털 모션 그래픽스의 선구자인 디자인 그룹 '인트로'를 설립했다. 그는 여러 주요 그래픽 디자인 잡지에 정기적으로 글을 기고하고 라디오와 텔레비전에 출연하여 디자인에 관한 이야기를 남겼다. 2009년에는 영국 왕립예술대학의 초빙 교수로 임명되었다. 쇼네시는 전 세계에서 강의하고 있으며 출판 임프린트 유닛 에디션스의 공동 설립자이다. 여러 디자인 관련 책을 쓰기도 했다.

Ahn Sang-soo

Ahn has long been one of the most influential designers in East Asia. His typographical development work in his native Korea has almost made him a household name. He has enjoyed a long career as a designer and educator. He graduated from Seoul's Hongik University, where he has been 20 years a professor. Ahn retired from his alma mater on his age 60, started independant design school PaTI, Paju Typography Institute in Paju Bookcity. He holds a commendation by the Korean Language Academy for his valuable contribution to the advancement of Hangeul (Ahn has four major Korean fonts to his credit). As early as 1983, he was selected as designer of the year by *Design* magazine. He is also editor/art director of the underground art–culture magazine *Report/Report* (1988–2000). From 1997–2001, Ahn was vice-president of Icograda. In October 2000 he chaired Icograda's prestigious millennium congress 'Oullim 2000', held in Seoul. In 2001, he organized 'Typojanchi', an international typography biennale held in Seoul. He received Gutenberg Prize from Leipzig 2007.

안상수

안상수는 오랫동안 동아시아에서 가장 큰 영향력을 가진 디자이너 중 한 명으로 꼽혀왔으며, 타이포그래피를 발전시킨 공로로 한국에서도 지명도가 높다. 디자이너와 교육자로서 오랜 경력을 가진 그는 홍익대학교를 졸업하고 모교에서 20년 동안 교수로 재직했다. 60세에 퇴직한 뒤 파주출판도시에 독립 디자인 학교인 PaTI를 설립했다. 주요 한글 폰트 네 개의 저작권 보유자로서 한글 발전에 기여한 공로로 한글학회 표창을 받았다. 1983년에 월간《디자인》에서 올해의 디자이너로 선정했다. 1988년부터 2000년까지 언더그라운드 문화 예술 무크지《보고서보고서》의 편집과 디렉팅을 담당했다. 1997년부터 2001년까지는 이코그라다의 부회장을 맡았으며, 2000년 10월에 서울에서 개최된 이코그라다 밀레니엄 회의 '어울림 2000' 회장을 역임했다. 2001년에 서울국제타이포그래피비엔날레 '타이포잔치' 조직위원회 위원장을 맡았고, 2007년에는 라이프치히에서 구텐베르크상을 받았다.

Alice Twemlow

Alice Twemlow is a research professor at the Royal Academy of Art, The Hague (KABK) where she leads the Lectorate Design with the theme "Design and the Deep Future" and an associate professor at Leiden University in the Academy for Creative and Performing Arts, where she supervises design-focused PhD candidates. Previously, Twemlow was head of the Design Curating & Writing Master at Design Academy Eindhoven, and before that, she was founding chair of the Design Research, Writing & Criticism MA at the School of Visual Arts in New York. Twemlow writes about design for a range of publications, including *Eye*, *Dirty Furniture*, *frieze*, and *Disegno*. Her most recent book, *Sifting the Trash: A History of Design Criticism*, was published by MIT Press in 2017.

앨리스 트웸로

앨리스 트웸로는 헤이그왕립예술학교의 연구 교수로서 "디자인과 심오한 미래"라는 주제로 디자인 강좌를 진행하고 있다. 또한 레이던대학교의 창작과 공연예술 아카데미 부교수로도 재직하며 디자인 중심의 박사과정 학생들을 감독한다. 그에 앞서 트웸로는 에인트호벤디자인아카데미의 디자인 큐레이팅과 글쓰기 석사 과정 책임자였으며, 그 이전에는 뉴욕의 SVA에서 디자인 리서치, 글쓰기와 비평 석사과정을 도입하고 학과장을 역임했다. 트웸로는《Eye》《Dirty Furniture, frieze》《Disegno》등 다양한 출판물에 디자인 관련 글을 쓰고 있다. 그녀의 가장 최근 저서는 2017년에 MIT대학 출판부에서 출간한『Sifting the Trash: A History of Design Criticism』이다.

Anna Lena von Helldorff

Anna Lena von Helldorff's praxis is based on the principle of collaboration in varying constellations and formats—reflecting on forms of exhibiting, presenting, publishing, making public—she understands graphic design or rather gestaltung as an editing process to communicate and visualize existing and new structures and their content as an act of interpretation, a process of translation—as vital part of society and therefor everyday life—with a focus on the potential relation between language, type, image and meaning—considering the economic conditions in visual production. Her studying of visual communication started in Munich as daughter of Rolf Müller, passed through the Academy of Visual Arts Leipzig with cyan, Ruedi Baur, Markus Dreßen—and continues as teaching herself when there is the chance. She founded the collective studio buero total (2006–2019) and co-founded the KV—Art Association of Contemporary Art Leipzig, reflecting on contemporary production of visual culture and its resources. She moved to Munich in 2019, to take on the heritage of Rolf Müller, considering the archive as platform and source for questions and discourse in visual communication—looking at the past in the present to project a future.

안나 레나 폰 헬도르프

안나 레나 폰 헬도르프의 활동은 다양한 집단과 포맷의 협업 원리를 바탕으로 하며 전시, 발표, 출판, 공표의 형태를 사회, 곧 일상 생활의 필수적인 부분으로 간주하고 있다. 그녀는 그래픽 디자인 혹은 조형을 기존의 구조와 새로운 구조를 전달하고 시각화하는 편집 과정으로 이해하며, 그 내용을 해석 행위이자 번역 과정으로 본다. 이때 언어, 활자, 이미지, 의미 사이의 잠재적인 관계에 초점을 두고 시각적인 생산의 경제적 조건을 고려한다. 롤프 뮐러의 딸인 그녀는 뮌헨에서 시각 커뮤니케이션을 공부했고, 사이언, 루에디 바우어, 마르쿠스 드레센이 다닌 라이프치히시각예술아카데미를 거쳤다. 그 뒤에도 그녀는 기회가 있을 때마다 배움을 이어갔다. 콜렉티브 스튜디오 부에로 토탈을 설립하고 KV-라이프치히 현대미술협회를 공동 창립하여, 동시대 시각 문화의 생산과 그 자원에 대해 고민한다. 2019년에 뮌헨으로 이주하여 롤프 뮐러의 유산을 관리하고 있다. 그녀는 아버지가 남긴 이 아카이브를 시각 커뮤니케이션의 질문과 담론을 위한 플랫폼이자 원천으로 여기고 있으며 "미래" 를 계획하기 위해 현재 시점에서 과거를 바라본다.

Ariane Spanier

Ariane Spanier was born in Weimar, Germany. She studied visual communication at the Art Academy Berlin-Weißensee. After a stay in New York she opened her design studio in Berlin in 2005. Many of Ariane Spanier's clients have a cultural background such as galleries, artists, filmmakers, musicians, publishers and architects. The studio's focus lies on the design of books, catalogues, posters, but identities, animations, illustration and digital design are equally part of the studios practice. Since 2006 Ariane has been the creative director of Fukt, an annual magazine for contemporary drawing. Spanier has won many awards, including from the Type Directors Club of New York, D & AD, the 100 Best Austrian, German and Swiss Posters Competition, the Graphis Poster Annual and, in 2011, the design competition for the design of Kieler Woche, the largest sailing festival in the world with its unique design history. Her work has been published in numerous magazines and design books. She has been a member of Alliance Graphique Internationale since 2013. Since 2018 she is a permanent juror overseeing the annual competition for the "Kieler Woche". Ariane Spanier lives and works in Berlin. www.arianespanier.com

아리안 스파니에

아리안 스파니에는 독일 바이마르에서 태어났다. 그녀는 베를린에 있는 바이센제미술학교에서 시각커뮤니케이션을 공부했다. 뉴욕에서 얼마 동안 지낸 뒤 그녀는 2005년에 베를린에 디자인 스튜디오를 열었다. 아리안 스파니에의 클라이언트 중 다수는 갤러리, 예술가, 영화제작자, 음악가, 출판인, 건축가와 같은 문화적 배경을 가지고 있다. 스튜디오는 책, 카탈로그, 포스터의 디자인에 중점을 두고 있지만 아이덴티티, 애니메이션, 일러스트레이션, 디지털 디자인도 스튜디오 실무의 한 부분이다. 2006 년부터 그녀는 현대 미술의 연간지인《Fukt》의 크리에이티브 디렉터 역할도 맡고 있다. 스파니에는 뉴욕의 타입디렉터스클럽, D & AD, 100 Best Australian, German and Swiss Posters Companition, Graphis Poster Yearning, 2011년에는 독특한 디자인 역사를 지닌 세계 최대의 항해 축제인 Kieler Woche의 디자인 공모전 등에서 많은 상을 받았다. 수많은 잡지와 디자인 책에 그녀의 작업물이 게재되었다. 그녀는 2013년부터 AGI의 회원이었으며, 2018년 이후로는 영구 회원이 되었다. 매년 열리는 "키엘러 워슈" 대회의 심사위원인 아리안 스파니에는 베를린에서 일하며 지내고 있다. www.arianespanier.com

Educators

Elisabeth Kopf

Born in Vorarlberg, she has been living and working in Vienna since 1981. Autodidactic studies and projects succeeded in the opening of the studio Design Buero Baustelle in 1999. The design label "Baustelle" stands for conceptual and progressive design, high quality and cross-border-thinking. Project-related cooperation with scientists, researchers, artists, designers, writers, psychologists, cultural managers and media experts support the characteristic qualities of the studio. National and international clients as well as self-initiated projects keep the design network "Baustelle" busy. Since 2004, she has been teaching at the University of Applied Arts Vienna, where she founded Babylon Design School, a playground of passion, fantasy and creativity. Together with Regina Rowland, she co-founded the research and education project Alphabet of Life — Nature's Learning Lab. She has been a member of AGI – Alliance Graphique Internationale since 2006.

Cho Hyun

Hyun Cho, born in 1969 Seoul Korea, received his MFA degree at Yale University in 2002 and founded his design studio S/O Project in 2003. Since 2015 he has been lecturing students as an Assistant Professor at Korea National University of Arts and is currently an enrolled designer at FontFont Germany. Moreover, as a member of AGI he is continuing in branding and design based on graphic design and typography.

Chris Ro

Chris Ro(b.1976) is a designer and graphic artist. His work can be characterized for their kinetic, spatial, poetic and atmospheric properties. Born in Seattle, Chris went on to study architecture at the University of California at Berkeley. After working as both architect and designer he went on to study graphic design at the Rhode Island School of Design. This mixed background continues to influence his explorations that fluctuate between both two and three dimensions. He is often at home when exploring concepts in motion and space and their relationship to the more static surfaces of graphic design. He recently finished research exploring concepts in Korean space at Seoul National University. His work has been exhibited all over the world and is part of the permanent collections of the Victoria and Albert Museum, Musée des Arts Décoratifs, Die Neue Sammlung and the National Hangeul Museum.

Christof Gassner

Christof Gassner was educated at the Kunstgewerbeschule Zürich under the guidance of Walter Käch and Josef Müller-Brockmann. Followed by various industry and publishing assignments. Then starting in 1966, set up own graphic design studio in Frankfurt am Main; relocated to Darmstadt in 1992. The design studio specializes in editorial design, corporate design, typography, poster, book and stamp design. In the 1980s: ecological projects, co-founder and art director of Öko-Test Magazin, 1986–2006: professor of graphic design and typography at the Fachhochschule Darmstadt and at the Kunsthochschule Kassel, then visiting lecturer in China.

David Smith

David is founder and principal of Atelier Projects—one of the most awarded and critically acclaimed design studios in Ireland. David graduated from Dunlaoghaire College of Art and Design in 1993. In 1998 he completed his graduate studies at L'Atelier National de Recherche Typographique in Paris where he studied under Jean Widmer. Upon graduating he worked freelance in Paris before moving to the Netherlands to work with UNA Designers in Amsterdam. He returned to Dublin and established his Atelier in 2000. Today he continues to combine project work—specialising in editorial and typographic design—with his academic commitments. A Senior Lecturer and former Programme Chair of Visual Communication Design, he is currently Head of Faculty at IADT, Dunlaoghaire—the largest Art, Design and Film school in Ireland. In 2012 he founded the 100Archive – a national archive and digital repository for for Irish graphic and communication design. www.100archive.com

Erik Adigard

Erik Adigard is, with Patricia McShane, a partner in M-A-D, an interdisciplinary studio combining brand positioning, interaction design, visual communication, video, media installations and environmental design. M-A-D's routinely works on the relationships between technology and socio-cultural concerns. Notable works are visual essays and websites for Wired, the short documentary Webdreamer exploring the decay of digital culture, the book Architecture Must Burn and the branding of IBM software. Recent projects include the Spontaneous Interventions exhibits, a 400m-tall animation for the ICC tower in Hong Kong, and the design of Expanded Field, an exploration of the convergence between architecture and art practices. Other commissions include installations for biennales in Paris, Lisbon, St Etienne and Venice. As part of the Bauhaus Centennial, Adigard is currently working on SENSEFACTORY, a large multidisciplinary installation. Adigard teaches communication design at the CCA. He works between M-A-D's main office in the SF Bay Area and his studio in Montpellier, France.

253

엘리자베스 코프

포어아를베르크에서 태어나 1981년 이후 빈에서 거주하며 일하고 있다. 독학과 자체 프로젝트로 1999년에 디자인 부에로 바우스텔레스튜디오를 설립했다. 디자인 라벨인 "바우스텔레"는 개념적이고 진보적인 디자인, 고품질과 경계를 넘는 사고를 의미한다. 과학자, 연구원, 예술가, 디자이너, 작가, 심리학자, 문화 관리자, 미디어 전문가 들과 협력하는 여러 프로젝트는 스튜디오의 특징을 보여준다. 독일의 국내외 클라이언트와 자체 주도 프로젝트를 진행하며 디자인 네트워크 "바우스텔레"가 분주하게 일하고 있다. 2004년 이후, 빈응용미술대학교에서 가르치며, 그곳에서 열정과 판타지와 창의성의 놀이터인 바빌론 디자인 스쿨을 설립했다. 레지나 롤런드와 함께, 연구 교육 프로젝트 <생명의 알파벳 — 자연 학습 연구실>을 시작했다. 2006에 AGI 회원이 되었다.

조현

1969년 서울에서 태어난 조현은 2002년 예일대학교에서 MFA 학위를 받았다. 이듬해에는 자신의 디자인 스튜디오 S/O Project를 열었으며 2015년부터는 한국예술종합학교 조교수로 재직하며 학생들을 가르치고 있다. 또한 현재 독일 FontFont의 디자이너로 등록되어있기도 하다. 조현은 AGI 회원으로서 그래픽 디자인과 타이포그래피에 기반을 둔 브랜딩과 디자인 작업을 지속하고 있다.

크리스 로

크리스 로는 디자이너이자 그래픽 아티스트다. 그의 작업이 가진 특징은 동적이며, 공간적이고 시적인 분위기를 자아낸다는 것이다. 1976년에 시애틀에서 태어난 크리스 로는 UC버클리에서 건축을, RISD에서 그래픽 디자인을 공부했다. 이후 샌프란시스코, 함부르크, 베를린과 뉴욕에서 활동했다. 현재 서울에서 작업하며, 홍익대학교 시각디자인학과 교수로 재직하고 있다. 건축가이자 그래픽 디자이너로서의 경험은 2차원과 3차원을 오가며 탐색하는 그의 작업에 지속적으로 영향을 미쳤다. 그는 종종 집에서 움직임과 공간의 개념 그리고 그래픽 디자인의 정적 표면과의 관계를 탐구한다. 최근에는 서울대학교에서 한국의 공간 개념을 탐구하는 그래픽 연구로 박사 과정을 마쳤다. 그의 작품은 런던의 빅토리아앤알버트박물관, 파리 장식미술관, 뮌헨 국제디자인박물관 그리고 서울 국립한글박물관에 영구 소장 되어 전시되고 있다. 현재 AGI 회원이다.

크리스토프 가스너

크리스토프 가스너는 취리히예술대학교에서 발터 캐흐와 요제프 뮐러 브로크만의 지도를 받았다. 이어서 다양한 산업과 출판 프로젝트에 참여했다. 그 후 1966년에 프랑크푸르트암마인에 독자적인 그래픽 디자인 스튜디오를 설립하였고, 1992년에는 다름슈타트로 이전했다. 그의 디자인 스튜디오는 편집 디자인, 기업 디자인, 타이포그래피, 포스터, 책, 우표 디자인을 전문으로 한다. 1980년대에는 생태 프로젝트를 수행하고 《Öko-Test》 잡지를 공동으로 창간하여 아트 디렉터를 맡았다. 1986년부터 2006년까지 다름슈타트응용과학대학교와 카셀예술대학교에서 그래픽 디자인과 타이포그래피 교수로 재직했고, 이후 중국에서 초빙 강사로 일하기도 했다.

데이비드 스미스

데이비드는 아일랜드에서 가장 많은 상과 호평을 받는 디자인 스튜디오인 아틀리에 프로젝츠의 설립자 겸 대표이다. 1993년 던런어예술디자인대학교를 졸업했다. 1998년에는 파리의 국립타이포그래피연구아틀리에에서 장 위드메르 밑에서 대학원 과정을 마쳤다. 졸업 직후 파리에서 프리랜서로 일하다가 네덜란드로 가서 암스테르담의 UNA 디자이너들과 일했다. 2000년에 더블린으로 돌아와 자신의 아틀리에를 세웠다. 오늘날 그는 편집 디자인과 타이포그래피 디자인을 전문으로 프로젝트 작업과 자신의 학문적인 시도를 지속적으로 결합하고 있다. 던런어에 위치한 아일랜드 최대의 미술, 디자인, 영화 학교인 IADT에서 부교수와 시각 커뮤니케이션 디자인 학과장을 역임했으며 현재는 대표 교수이다. 2012년에는 아일랜드 디자인을 위한 100 아카이브를 설립했다. www.100archive.com

에릭 아디가드

에릭 아디가드는 퍼트리샤 맥셰인과 공동으로 브랜드 포지셔닝, 인터랙션 디자인, 시각 커뮤니케이션, 비디오, 미디어 설치 및 환경 디자인을 결합한 학제적인 스튜디오 M-A-D의 파트너를 맡고 있다. M-A-D는 일상적으로 기술과 사회문화적 관심 사이의 관계를 연구한다. 주목할 만한 작업은 《Wired》를 위한 시각 에세이와 웹사이트, 디지털 문화의 붕괴를 탐구하는 단편 다큐멘터리 <Webdreamer>, 단행본『Architecture Must Burn』과 IBM 소프트웨어 브랜딩 작업이다. 최근 프로젝트로는 <Spontaneous Interventions> 전시, 홍콩 ICC타워에 설치된 400m 높이의 애니메이션, 그리고 건축과 예술 관행이 융합된 탐구 <Expanded Field> 디자인 등이 있다. 또 다른 작업으로 파리, 리스본, 생테티엔과 베니스의 비엔날레를 위한 설치물들도 있다. 아디가드는 CCA에서 커뮤니케이션 디자인을 가르치고 있으며, 샌프란시스코 베이 지역의 M-A-D 본사와 프랑스 몽펠리에의 스튜디오를 오가며 일한다.

Erik Brandt

Erik Brandt is a graphic designer and educator who has been active since 1994. He is currently Chair of the Design Department and Professor of Graphic Design at MCAD (Minneapolis College of Art and Design) in Minneapolis, Minnesota. He is a member of the Alliance Graphique Internationale (AGI) and curated Ficciones Typografika, a project dedicated to typographic exploration in a public space. Educated internationally, his career began as a cartoonist in Japan in 1994, and has since found focus largely in print media. He maintains a small graphic design studio, Typografika (Visual Communication und Konditorei). His work has been published and exhibited internationally and he has also received recognition for his very, very silly short films.

Finn Nygaard

Finn Nygaard · Graphic Designer, Poster Artist, Painter. Born in Denmark 1955 · Established Finn Nygaard Inc. in 1979. From 1990 – 1995 he was partner of the Danish design group Eleven Danes and the European Designers Network EDEN. Finn Nygaard is a frequent guest lecturer to student and professional groups. He has given many poster workshops and lectures all over the world; a.o. Japan, China, Taiwan, India, Korea, the US, Mexico, Bolivia, the Czech Republic and Slovakia. He lives and has his studio and atelier at the Island of Mors in the Limfjord – northern part of Denmark. Finn Nygaard has created posters, illustrations, graphic design and corporate identities, brands, and colour consultings for Danish and international companies. He has created more than 700 posters, many of which he has received awards for. He has had several one-man shows and exhibitions all over the world. Throughout his career, Finn Nygaard has been a prolific creator of posters and prints. The results have been featured in exhibitions worldwide, his posters and design projects have been shown in major galleries and museums, and he has taken part in the most important international poster exhibitions since the 80's and has been member of many international juryes. Most important one-man shows: IdcN, Nagoya, Japan – "Visual Voice" · Modern Art Gallery, St. Petersburg, Russia · Galleri Fine-Art, Nagoya, Japan · National Museum in Poznan, Poland · Pallfy Palais in Bratislava, Slovakia · The Danish Museum of Art & Design, Denmark – "Finn Nygaard with Friends" · The Museum of Printing History, Houston, Texas, USA · "We are all equal" · Querétaro, Mexico · MUSÉF, La Paz, Bolivia · Dansk Plakatmuseum/ Danish Poster Museum, Denmark · Imam Ali Museum, Tehran, Iran · MK61 Morsø Kunstforening, Denmark · Morsø Gymnasium, Mors, Denmark – We are all equal. Finn Nygaard's works are included in numerous international collections. Finn Nygaard is member of AGI, Alliance Graphique Internationale, fn@FinnNygaard.com, www.FinnNygaard.com

Hua Jiang

Jiang Hua, PhD, was born in Zhoushan, Zhejiang in 1973. He started to study traditional culture and Chinese art since childhood. From 1996 till now, he has been focusing on curating, criticism and practice on the base of graphic design. Jiang Hua is a professor of Design School, CAFA (Central Academy of Fine Arts), the founder and curator of IGDB (Ningbo International Graphic Design Biennial), and an AGI member (2006-).

Jaemin Lee

Jaemin Lee founded studio fnt in 2006 and took part in various projects with his partners over ten years. He has actively worked with Junglim Foundation since 2011 on projects about architecture, culture, arts and education, forum, exhibitions and research in order to explore meaningful exchanges with the public about subjects like the social role of architecture and urban living. He also taught graphic design at Seoul National University, and currently teaches at the University of Seoul.

Jan Wilker

Jan Wilker grew up in Ulm, Germany. He attended Stuttgart University's architecture school, and graduated from the State Academy of Art & Design Stuttgart in Communication Design. He moved to New York in late 2000 to start karlssonwilker, a design studio, together with Icelander Hjalti Karlsson. They work with an eclectic list of clients on a wide variety of projects. Jan has taught at Cooper Union, SVA, and Parsons. He frequently lectures and holds sought-after workshops around the world.

Javier Mariscal

Valencian designer, adopted by Barcelona. Mariscal's life is a love affair with drawing. From an early age, he looks at the world imagining new shapes, stories and characters while escaping all stereotypes and any kind of labelling. Designing the mascot Cobi for the 1992 Olympic Games, his trips to California, Japan, Paris, or Portugal decisively influenced his drawings. He worked with many designers, engineers and architects such as Memphis, Alessi, Magis, Cosmic and Phaidon. He won the "Premio Nacional de Diseño" in 1999 and exhibited in the Georges Pompidou Center in Paris, and participates in the Kassel Documentary, to which several retrospectives and up like: Mariscal Drawing Life in the London Design Museum. In 2010, Javier Mariscal once again changes the game to venture into the animated film with "Chico & Rita" alongside Fernando Trueba. The movie wins a Goya Award and is nominated to the Oscars for Best Animated Picture. Mariscal is currently working on the preliminary drawings of an animated documentary, a comic book that explains the formation of our planet and the creatures that live on it, and the sketches for a travel journal of Los Angeles for the French brand Louis Vuitton.

에릭 브란트

에릭 브란트는 그래픽 디자이너 겸 교육자로서 1994년부터 활동했다. 현재 미네소타주 미니애폴리스에 있는 미니애폴리스예술디자인대학교의 디자인 학과장과 그래픽 디자인 교수로 재직 중이다. AGI 회원이며 공공장소에서 이루어지는 타이포그래피를 탐구하는 프로젝트 <Ficciones Typografika>를 큐레이팅했다. 여러 나라에서 공부했으며, 1994년 일본에서 만화가로서 경력을 시작했다. 이후 주로 인쇄 매체에 집중하고 있다. 소규모 그래픽 디자인 스튜디오 타이포그라피카를 운영하고 있다. 그의 작품은 국제적으로 출판되고 전시되어 왔으며, 매우 장난스러운 단편영화들로 인정받기도 했다.

핀 나이가드

1955년 덴마크에서 태어난 그래픽 디자이너이자 포스터 아티스트, 화가이다. 1979년에 핀 나이가드 사 설립하고 1990년부터 1995년까지 덴마크 디자인 그룹 일레븐 데인스와 유럽 디자이너 네트워크 EDEN의 파트너로 활동했다. 전 세계 학생과 전문가 그룹을 위한 강연에 자주 참석한다. 일본, 중국, 대만, 인도, 한국, 미국, 멕시코, 볼리비아, 체코와 슬로바키아 등 세계 각국에서 다수의 포스터 워크숍과 강의를 해왔다. 덴마크 북부 림피오르드의 모르스섬에 거주하며 스튜디오와 아틀리에를 운영한다. 덴마크 국내외 기업을 위한 포스터, 일러스트레이션, 그래픽 디자인 및 기업 아이덴티티, 브랜드 및 색상 컨설팅 작업을 했다. 700점 이상의 포스터를 제작했고 그 중 다수가 상을 받았다. 전 세계에 걸쳐 수차례 개인전과 기타 전시회에 참여했다. 활동 기간 내내 포스터와 인쇄물 작업을 왕성하게 해왔다. 결과물은 세계적인 전시회에서 소개 되었고, 그의 포스터와 디자인 프로젝트가 주요 갤러리와 미술관에 전시되었다. 그는 1980년대 이후 가장 중요한 국제 포스터 전시회에 여러 번 참가했으며 여러 차례 심사위원으로 활동하기도 했다. 주요 개인전: IdcN, 일본 나고야– <비주얼 보이스> · 모던 아트 갤러리, 러시아 상트페테르부르크 · 갈레리 파인 아트, 일본 나고야·국립미술관, 폴란드 포즈난·팰피 궁전, 슬로바키아 브라티슬라바· 덴마크 미술 디자인 뮤지엄, 덴마크 [김2]– <핀 나이가드와 친구들> ·인쇄역사박물관, 미국 텍사스 휴스턴· <우리는 모두 평등하다> · 멕시코 퀘레타로· MUSÉF, 볼리비아 라파즈· 덴마크 포스터 미술관, 덴마크 · 이맘 알리 뮤지엄, 이란 테헤란· MK61 모르소 미술관, 덴마크 · 모르소 김나지움, 덴마크 모르스– <우리는 모두 평등하다> 많은 국제 컬렉션에 핀 나이가드의 작품이 포함되어있다. AGI 회원이다.

254

화장

화장 박사는 1973년 저장성 주산시에서 태어났다. 어린시절부터 전통 문화와 중국 미술을 배우기 시작했다. 1996년부터 지금까지 그래픽 디자인을 기반으로 큐레이팅과 비평과 실무에 중점을 두고 활동하고 있다. 화장은 중국 중앙미술원의 디자인 스쿨 교수이며, 닝보 국제디자인비엔날레의 창립 큐레이터였다. 2006년부터 AGI 회원이다.

이재민

이재민은 2006년에 스튜디오 fnt를 설립했으며 10여 년 동안 여러 파트너와 함께 다양한 프로젝트에 참여했다. 건축의 사회적 역할과 도시 생활 같은 주제로 대중과 의미 있는 교류를 하기 위해 2011년부터 정림건축문화재단과 함께 건축, 문화, 예술, 교육, 포럼, 전시, 연구에 관한 프로젝트에 적극적으로 참여했다. 서울대학교에서 그래픽 디자인을 강의했으며, 현재는 서울시립대학교에서 가르치고 있다.

얀 빌커

얀 빌커는 독일 울름에서 성장했다. 슈투트가르트 대학교에서 건축을 공부했으며 슈투트가르트 국립조형예술대학교에서 커뮤니케이션 디자인을 전공했다. 2000년대 후반에 뉴욕으로 건너가 아이슬란드 디자이너 히야티 칼슨과 함께 karlssonwilker를 설립했다. 그들은 다방면에 걸친 클라이언트와 작업한다. 얀은 쿠퍼유니언, SVA, 파슨스디자인스쿨에서 학생들을 가르쳤다. 그가 전 세계를 돌아다니며 자주 주최하는 강의와 워크숍은 상당히 호응을 얻고 있다.

하비에르 마리스칼

바르셀로나에 입양되었다고 말하는 발렌시아 디자이너. 마리스칼의 삶은 그림에 대한 애정으로 점철된다. 그는 어릴 때부터 어떤 종류의 고정관념이나 꼬리표도 배제하면서 새로운 모양, 이야기, 캐릭터를 상상하며 세상을 바라보다. 1992년 바르셀로나올림픽의 마스코트 '코비'를 디자인한 그는 미국 캘리포니아와 일본, 파리, 포르투갈을 여행하면서 화가로서 지대한 영향을 받았다. 마리스칼은 Memphis, Alessi, Magis, Cosmic 그리고 Phaidon과 같이 많은 디자이너, 엔지니어, 건축가 들과 일했다. 그는 1999년 "Premio Nacional de Diseño"에서 우승하여 파리의 조르주퐁피두센터에 작품을 전시했고, 카셀 다큐멘터리와 같은 몇몇 회고전에도 참여했다. 2010년 런던디자인뮤지엄에서 열린 <Mariscal Drawing Life>도 마찬가지이다. 같은 해에 하비에르 마리스칼은 페르난도 트루바와 함께 <치코와 리타>라는 영화에서 호흡을 맞췄다. 이 영화는 고야상을 수상하고 오스카 애니메이션작품상 후보에도 올랐다. 마리스칼은 현재 애니메이션 다큐멘터리, 지구에 살고 있는 생물의 형성을 다룬 만화책, 그리고 프랑스 명품 브랜드 Louis Vuitton의 로스앤젤레스의 여행 스케치 도면 등을 작업하고 있다.

Jean-Benoît Lévy

Educated in Graphic Design at the Basel School of Design, Jean-Benoît Lévy is a visual designer. Founder of the "Studio AND" in Basel, J-B L has relocated in San Francisco, California in 2001. Known mainly for his street posters and postage stamps, J-B L has received numerous international design awards. J-B L works on projects emphasizing visual design, and visual communication. He published a book about hand- signs at Lars Müller Publishers. Member of the Alliance Graphique Internationale since 1998, Jean-Benoit has also regularly brought his expertise and enthusiasm to the classroom, teaching workshops and classes at educational institutions including the Basel School of Design, the Rhode Island School of Design, Art Center Europe, and the California College of the Arts. He currently teaches fundamentals of graphic design, both, at San Jose State University and San Francisco State University.

장 베누아 레비

바젤디자인대학교에서 교육받은 시각 디자이너이다. 바젤의 Studio AND 설립자로서 2001년에 캘리포니아주 샌프란시스코로 이주했다. 주로 거리 포스터와 우표 디자인으로 알려졌고 국제적인 디자인상을 많이 받았다. 시각 디자인과 시각 커뮤니케이션 프로젝트를 진행한다. 라스뮬러 출판사에서 수신호에 대한 책을 출판했다. 1998년부터 국제그래픽연맹의 회원이며 바젤디자인대학교, RISD, 아트센터유럽, CCA 등에서 워크숍과 수업을 하면서 정기적으로 자신의 전문성과 열정을 강의에 쏟아왔다. 현재 새너제이주립대학교와 샌프란시스코주립대학교에서 그래픽 디자인의 기초를 가르치고 있다.

Jessica Helfand

Jessica Helfand is an artist, designer, and writer. She grew up in Paris and New York City, and received her BA and MFA from Yale where she taught for more than two decades. A founding editor of Design Observer, she is the author of numerous books on visual and cultural criticism, and has taught in Paris, Porto, London, Malta, the Netherlands, and at schools and universities across the United States. The first-ever recipient, in 2010, of the Henry Wolf Residency at the American Academy in Rome, Jessica Helfand has been a Director's Guest at Civitella Ranieri, and will be a fellow at the Bogliasco Foundation in the autumn of 2019.

제시카 헬펀드

제시카 헬펀드는 디자이너이자 작가, 아티스트이다. 파리와 뉴욕에서 자랐으며 예일대학교에서 학사와 석사 학위를 받았다. 모교에서 20년 넘게 강의하기도 한 그녀는 《Design Observer》의 창간 당시 편집자였다. 제시카 헬펀드는 시각적, 문화적 비평과 관련된 많은 책을 쓴 저자이다. 파리와 포르투, 런던, 몰타, 네덜란드, 그리고 미국의 여러 학교에서 강의했다. 2010년에 로마의 American Academy에서 수여하는 Henry Wolf Residency를 처음으로 받았다. 제시카 헬펀드는 Civitella Ranieri의 디렉터스 게스트이며, 2019년 가을부터는 Bogliasco Foundation의 펠로우로 활동할 예정이다.

Jin Jung

Jin Jung is a graphic designer and professor at Kookmin University, Seoul, where as a student he pursued studies in philosophy and visual communication design. He then completed an MFA at Yale in graphic design. He opened the TEXT design studio upon his return to Korea in 2009, and has worked on a wide range of projects for Platform 2009, Gwangju Biennale 2010, the Nam June Baik Art Center, the National Theater Company of Korea, National Museum of Modern and Contemporary Art, Korea and others. He participate international exhibition as graphic designer, such as Typojanchi, Seoul (2012, 2015), 'Vitality' Triennale Design Museum, Milan (2012), 'Korea Now' Les Arts Décoratifs, Paris (2015), 'Korea Posters' The Design Museum, Munich (2017).

정진열

정진열은 그래픽 디자이너이자 국민대학교 교수이다. 국민대학교에서 철학과 시각 커뮤니케이션을 공부한 다음 예일대학교에서 그래픽 디자인 전공으로 MFA 과정을 마쳤다. 그는 2009년 한국으로 돌아와 TEXT 디자인 스튜디오를 열었고 플랫폼 2009, 광주 비엔날레 2010, 백남준아트센터, 국립극단, 국립현대미술관 등의 프로젝트에 폭넓게 참여했다. 그는 그래픽 디자이너로서 2012년과 2015년 서울 타이포잔치, 밀라노 트리엔날레 디자인 박물관에서 열린 <Vitality>, 파리 장식미술관의 <Korea Now> (2015), 뮌헨 디자인 박물관에서 열린 <Korea Posters> (2017) 등의 국제적인 전시에 참여했다.

Johnny Kelly

Johnny is an Irish animator, director and human being who lives in Dublin. His work spans stop frame animation, CGI, illustration and lots between. Johnny's a graduate of the Royal College of Art. His short films have been shown on the BBC, ARTE, PBS and been screened and awarded at film festivals around the world including Palm Springs, TED, Anima Mundi and the Edinburgh Film Festival. The stop motion film he directed for Chipotle, Back to the Start, won the Film Grand Prix at the Cannes Advertising Festival. He's been on award juries for ID&AD, AICP and British Arrows, and he's a proud member of the Alliance Graphique Internationale.

조니 켈리

조니는 더블린에 거주하는 아일랜드인 애니메이터 겸 감독이다. 영국 왕립예술대학을 졸업했으며 그의 작품은 스톱 프레임 애니메이션, CGI, 일러스트레이션을 아우르며 장르 사이에 걸친 작품도 많다. 그의 단편 영화들은 BBC, ARTE, PBS에서 상영되었고 팜스프링스, TED, 아니마 문디, 에든버러 영화제를 포함한 전 세계 영화제에서 상영되고 상도 받았다. 그가 치폴레 브랜드를 위해 감독한 스톱 모션 영화 <Back to the Start>는 칸 광고제 대상을 받았다. D&AD, AICP, 브리티시애로우어워드의 심사위원을 역임해왔으며 AGI의 회원이기도 하다.

Jon Sueda

Originally from Hawaii, Sueda has practiced design everywhere from Honolulu to Holland. After earning his MFA in Graphic Design from CalArts in 2002, he was invited to North Carolina State University to serve as a designer in residence, followed by an internship in the Netherlands with Studio Dumbar. In 2004, Sueda founded the design studio Stripe, which specializes in print and exhibition design for art and culture. In 2007, he relocated to the San Francisco area where he served as Director of Design at the CCA Wattis Institute for Contemporary Arts for seven years, and is currently the Chair of the MFA Design program at California College of the Arts. Sueda curated the exhibitions The Way Beyond Art: Wide White Space for the CCA Wattis Institute for Contemporary Arts; Work from California for the 25th International Graphic Design Biennial in Brno, Czech Republic, and All Possible Futures for SOMArts Cultural Center in San Francisco.

존 수에다

하와이 출신인 수에다는 호놀룰루부터 네덜란드에 이르기까지 다양한 지역에서 디자인 작업을 해왔다. 2002년 칼아츠에서 그래픽 디자인 MFA를 받은 후 노스캐롤라이나 주립대학교에서 입주 디자이너로 초빙되었다. 이어서 네덜란드의 스튜디오 둠바르에 인턴으로 근무했다. 2004년에 문화 예술 분야의 인쇄 및 전시 디자인을 전문으로 하는 디자인 스튜디오 스트라이프를 설립했다. 2007년에는 샌프란시스코 지역으로 이주하여 7년 동안 CCA 와티스 현대미술연구소에서 디자인 디렉터로 재직했으며 현재 CCA에서 MFA 디자인 프로그램 학과장을 맡고 있다. 수에다는 CCA 와티스 현대미술연구소의 <The Way Beyond Art: Wide White Space>, 체코의 브르노에서 열린 제25회 국제그래픽디자인비엔날레의 <Work from California>, 샌프란시스코 소마츠문화센터 <All Possible Futures> 전시를 큐레이팅했다.

Kiko Farkas

Education and career: 1979: life drawing at Arts Students League, New York. 1982: graduated as an architect. 1987: Founded Máquina Estúdio to work as a graphic designer and illustrator. Publications: Novum (June 1991, October 2000), Print (November 1987), Communication Arts (2005). International exhibitions: International Poster Biennial, Colorado, 1991, 1993, 1995, 1997; Brno Biennial, 1990; 'New Graphic Design in Brazil', Lisbon; Triennial of the Stage Poster, Sofia, 1997, 2003; Special room at 'Brésil à l'affiche', Chaumont, 2004–2005. In 2004 Kiko won a national contest to create the identity for international tourism in Brazil. His children's books have won several prizes, including the Jabuti grand prize for fi ction for his book Um passarinho me contou. At the 8th ADG biennial (2004, 2006), Máquina Estúdio was the most awarded studio in Brazil. Kiko Farkas is a lecturer, a founder of ADG, the Brazilian association of graphic designers, and an invited teacher at Miami Ad School.

키코 파카스

1979년에 뉴욕 아츠 스튜던츠 리그에서 라이프 드로잉 수강했다. 1982년에 건축가로 졸업한 후 1987년에 그래픽 디자이너 겸 일러스트레이터로 일하기 위해 마퀴나 에스투디오를 설립했다. 《노범》(1991년 6월, 2000년 10월), 《프린트》(1987년 11월), 《커뮤니케이션 아츠》(2005년) 등 여러 출판물 지면에 소개되었다. 국제 포스터 비엔날레(콜로라도, 1991, 1993, 1995, 1997), 브르노 비엔날레(1990), 리스본에서 열린 <브라질의 새로운 그래픽 디자인>, 무대 포스터 트리엔날레(소피아, 1997, 2003), <브레실 라피셰> 전 특별 전시 (쇼몽, 2004–2005) 등의 국제적인 전시에 참가했다. 2004년에 키코는 국제적으로 브라질 관광의 정체성을 창조하기 위한 전국 대회에서 우승했다. 『작은 새가 나에게 말해주었네』로 자부티 상 최우수상을 받은 것을 비롯하여 어린이책으로 몇 가지 상을 수상했다. 제8회 ADG 비엔날레(2004, 2006)에서 마퀴나 에스투디오는 브라질에서 가장 많은 상을 받은 스튜디오였다. 키코 파카스는 강사이자, 브라질 그래픽 디자이너 협회(ADG) 설립자이며, 마이애미 애드 스쿨의 초빙교사이다.

Kyungsun Kymn

Kyungsun Kymn is a graphic designer and a professor at Seoul National University. He was the organizing member of Graphic Design Asia 2018, the director of Typojanchi, International Typography Biennale in 2015 and design exhibition curator for Jindalrae 2006. He worked at Cheil Communications and Hong Design as designer. He teaches graphic design and typography.

김경선

김경선은 그래픽 디자이너이자 서울대학교 교수이다. 그는 그래픽 디자인 아시아 2018의 조직 멤버였으며 타이포잔치, 2015 국제타이포비엔날레 디렉터와 2006 진달래의 큐레이터를 맡기도 했다. 제일기획과 홍디자인에서 디자이너로 재직하기도 했다. 그는 그래픽 디자인과 타이포그래피를 가르치고 있다.

Lucille Tenazas

Lucille Tenazas is the Henry Wolf Professor of Communication Design at Parsons School of Design in New York, and currently the Associate Dean in the School of Art, Media and Technology (AMT). Previously, she taught at California College of the Arts in San Francisco for 20 years where she developed a graduate curriculum with an interdisciplinary approach and focus on form-giving, teaching and leadership. Her work is at the intersection of typography and linguistics, with design that reflects complex and poetic means of visual expression. Originally from Manila, the Philippines, she has taught and practiced in the United States since 1979, a trajectory that included living in San Francisco, Rome, Italy and New York. Her first experience of living in a design environment was as a graduate student at Cranbrook Academy of Art in Michigan in the early '80s, exposed to the work of Eliel and Eero Saarinen, and Charles and Ray Eames. An authority in the evolving state of design education, she has conducted workshops in institutions throughout the United States, Asia and Europe. She was the national president of the American Institute of Graphic Arts (AIGA) from 1996-98 and was awarded the AIGA Medal for lifetime achievement in design in 2013.

Marc Català

Marc Català worked at Grafica and Pentagram before founding Mucho with fellow AGI member Pablo Juncadella. During the first three years of Mucho, he combined running the studio with being the joint creative director of The Observer (UK). Today Mucho incorporates the original independent studio mentality with a global approach to design, having become one of the most influential figures in the Barcelona design scene. On top of the regular design practice, Mucho is developing Why Design, a blog and a series of talks, and also a masters degree at IDEP design school called PostGrafica, all of which are structured around the idea that design and visual language can generate meaning and modulate thought. Català is developing a research project on the matter called Visual Thinking.

Markus Weisbeck

Markus Weisbeck is a graphic designer and Professor based in Frankfurt am Main and Weimar. He founded the Design-Studio Surface in 2000. Weisbeck has lectured and participated in numerous international conferences on design related subjects and has taught at various universities including the UDK Berlin, University Darmstadt the HGB Leipzig, Paju typography Institute PaTI in Korea,Taiwan Tech in Taipeh, Hubei Institute of Technology, summer Academy Hangzhou, China, Y-Festival Macau, and has been teaching as Professor for Grafik Design at Bauhaus in Weimar since 2011. He is frequent jury member in design competitions worldwide and part-time writer for the Frankfurter Allgemeine Zeitung, Frieze and Form in the discipline of Grafik Design. Since 2013 he is an official member of the Alliance Graphique Internationale. His design projects include the art direction of the Museum für Moderne Kunst Frankfurt am Main, the Forsythe Company, Documenta 11, the corporate identity for Zumtobel, the Jewish Museum Frankfurt, the Städel Architecture Class, the German pavillion, Venice Biennale 2007 and 2009, the 7th International Architecture Biennial (BIA) São Paulo, Manifesta 7, publication series for Sternberg Press and many other books for (individual) artists."

Martin Venezky

Martin Venezky is a designer and artist based in San Francisco, California. Throughout his career as a graphic designer, while specializing in book design and typography, Venezky has maintained a deep and continued interest in photographic process and abstraction. For the past several years, he has created new bodies of work in photography and photographic installation. Venezky has an undergraduate degree from Dartmouth College and an MFA in Design from Cranbrook Academy of Art. He has taught at RISD and CalArts and, for over 25 years, at California College of the Arts in San Francisco, where he is currently Professor in the Graduate Design Program. The San Francisco Museum of Modern Art honored Venezky with a 2001 solo exhibition, and, in 2005, his monograph, *It Is Beautiful...Then Gone*, was published by Princeton Architectural Press. In 2015 Venezky was inducted into the esteemed Alliance Graphique Internationale (AGI). In 2018, San Francisco's Letterform Archive acquired an extensive collection of his work, studies and process for their permanent collection.

Mucho

Founded in 2002, Mucho an independent studio with international presence and global work. Today it is 6 partners strong, and manages offices in Barcelona, San Francisco, Paris and New York. Mucho is dedicated to generating design with meaning. This is based on strategic thinking and visual narrative through the articulate use of the image. Mucho's work produces purposeful design by using collective intelligence, integrating clients to an atmosphere of a multicultural studio. As part of a regular design practice, Mucho is developing Why Design, a blog and a series of talks, and also PostGrafica, a masters degree at IDEP design school in Barcelona, all of which are structured around the idea that design and visual language can generate meaning and modulate thought.

루실 테나자스

루실 테나자스는 뉴욕 파슨스스쿨오브디자인의 커뮤니케이션 디자인학과의 헨리 울프 교수이며 현재 아트미디어테크놀로지스쿨의 부학장이다. 이에 앞서 샌프란시스코의 CCA에서 20년 동안 가르쳤으며 그곳에서 학제적인 접근법을 취하며 조형과 강의와 리더십에 초점을 둔 대학원 과정을 발전시켰다. 그녀의 작업은 타이포그래피와 언어학의 교차점에 있어, 복잡하고 시적인 시각적 표현 수단을 반영하는 디자인을 선보인다. 필리핀 마닐라 출신으로, 1979년부터 미국에서 가르치고 일해왔으며, 샌프란시스코와 이탈리아 로마와 뉴욕을 오가는 생활을 했다. 처음으로 디자인 환경에서 생활한 경험은 1980년대 미시건주의 크랜브룩 예술 아카데미 대학원생 때였고, 이때 엘리엘 사리넨과 이로 사리넨, 찰스와 레이 임스 부부의 작업을 접했다. 그녀는 디자인 교육의 발전 방향에 대한 권위자로서 미국과 아시아, 유럽의 교육 기관에서 워크숍을 진행했다. 1996년부터 1998년까지 미국그래픽아트협회의 전국 대표였으며 2013년에 디자인 분야의 AIGA 평생공로상을 받았다.

마크 카탈라

마크 카탈라는 AGI 멤버 파블로 준카델라와 함께 무초를 설립하기 전에 그라피카와 펜타그램에서 일했다. 무초 설립 후 초기 3년 동안 그는 스튜디오 운영과《Observer》의 공동 크리에이티브 디렉터를 겸했다. 오늘날 무초는 원래 독립적인 스튜디오의 사고방식과 디자인에 대한 글로벌 접근방식을 통합하여 바르셀로나 디자인 분야에서 가장 영향력 있는 스튜디오 중 하나가 되었다. 무초는 일반적인 디자인 실무 외에도 블로그와 일련의 대담 '와이 디자인'과 '포스트그라피카'라는 IDEP 디자인 학교의 석사 학위를 개발하고 있는데, 이 모든 학위는 디자인과 시각 언어가 의미를 창출하고 생각을 조절할 수 있다는 개념을 중심으로 구성되어 있다. 카탈라는 시각적 사고에 대한 연구 프로젝트를 진행하고 있다.

마르쿠스 바이스벡

마르쿠스 바이스벡은 프랑크푸르트와 바이마르를 중심으로 활동하는 그래픽 디자이너이자 교수이다. 2000년에 Surface라는 디자인 스튜디오를 설립했다. 바이스벡은 수많은 국제 디자인 컨퍼런스에 참여하고 그곳에서 강연도 진행했다. 또한 UDK 베를린, 다름슈타트대학교, HGB 라이프치히, PaTI, 후베이공과대학교 등 세계 각국의 디자인 학교에서 강의했으며 2011년부터 바이마르의 바우하우스그래픽디자인 교수로 학생들을 가르치고 있다. 그는 국제 디자인대회의 심사위원으로 자주 활동하며《Frankfurter Allgemeine Zeitung》《Frieze》《Form》등에 그래픽 디자인과 관련하여 종종 글을 기고한다. 2013년부터 AGI 공식 회원으로 활동하고 있다. 그는 다음과 관련한 디자인 프로젝트를 진행했다. 프랑크푸르트현대미술관, 포사이스컴퍼니, 도큐멘타11, 춤토벨사의 CI, 프랑크푸르트 유대인박물관, 슈테델건축클래스, 2007년과 2009년 베니스비엔날레, 제7회 상파울로 BIA, 매니페스타7, Sternberg 출판사의 간행물을 비롯한 다른 개인 아티스트들의 책 작업 등.

마틴 베네츠키

샌프란시스코에 기반을 둔 디자이너 겸 예술가로서 북 디자인과 타이포그래피를 전문으로 한다. 베네츠키는 사진의 과정과 추상화에 지속적인 관심을 갖고 있다. 지난 몇 년 동안 사진과 사진 설치 분야에서 새로운 작업을 창조했다. 다트머스대학교에서 학사 학위를 받고 크랜브룩예술아카데미에서 디자인 석사학위를 받았다. RISD와 칼아츠에서 강의했고, 지난 25년 동안 샌프란시스코의 CCA에서도 가르쳤으며 현재 대학원 디자인 프로그램의 교수직을 맡고 있다. 샌프란시스코현대미술관에서 2001년에 베네츠키의 업적을 기리며 개인전을 개최하였고 2005년에는 모노그래프『It Is Beautiful...Then Gone』이 프린스턴 아키텍처럴 프레스에서 출간되었다. 2015년 AGI에 가입했고, 2018년에는 샌프란시스코의 글자꼴 아카이브에서 영구 소장을 위해 그의 작업과 연구와 그 과정을 대거 수집하기도 했다.

무초

2002년에 설립된 무초는 국제적으로 활동하는 독립 스튜디오이다. 오늘날 바르셀로나와 샌프란시스코, 파리, 뉴욕 등지에 여섯 개의 사무실을 운영하고 있는 무초는 의미 있는 디자인을 만들어내기 위해 노력하고 있다. 이는 전략적 사고와 비주얼 내러티브를 통한 이미지의 명료한 사용에 기초한 것이다. 무초의 작업은 클라이언트와 함께 다문화적 분위기에서 집단 지성을 통해 목적이 확실한 디자인을 만들어낸다. 정규적인 디자인 실무의 일환으로, 무초는 블로그와 일련의 강의인 Why Design, 바르셀로나의 IDEP디자인스쿨의 석사 과정인 PostGrafica와 관련한 일을 하고 있다. 이는 모두 디자인과 시각 언어가 의미를 만들어내고 우리의 생각을 조절할 수 있다는 아이디어를 중심으로 구성된다.

Nancy Skolos

Born in Ohio, Nancy began her education in design at the University of Cincinnati in industrial design. After two years of study, she was accepted as an undergraduate student at Cranbrook Academy of Art where she completed her BFA in interdisciplinary design, and then went to graduate school in graphic desing at Yale. After graduation, she and her husband, photographer/designer Tom Wedell, whom she met at Cranbrook opened a studio in Boston. The studio's work came into its own in the 80s where the developing high technology industry opened up opportunities for making the invisible visible. The team's surreal photographic concepts combined with rational typographic structures gave voice to abstract concepts such 'software.' A 1993 *Eye Magazine* feature on the studio labeled their attitude "techno-cubist." Over the span of their career, their approach has evolved and their client base has expanded, but their passion for blurring the boundaries between photography and design has remained the foundation of their vision. Nancy is currently a Professor at the Rhode Island School of Design where she has also served as Head of Graphic Design and Dean of Architecture and Design.

Oded Ezer

Oded Ezer is a graphic artist and typographer, best known for his experimental typographic design fiction projects and for his ongoing contribution to Hebrew type design. Ezer studied graphic design at the Bezalel Academy of Art & Design, Jerusalem. In 2000 he went on to establish his own independent studio, Oded Ezer Typography, where he specializes in typographic and fonts design. In 2004 Oded founded HebrewTypography type foundry, selling his own typefaces to leading media companies and design studios. Ezer's projects, posters and graphic works are showcased and published worldwide, and are part of permanent collections of eminent museums. Oded Ezer is a senior lecturer at the Holon Institute of Technology (HIT); Teaches at the Nuova Accademia di Belle Arti Milano (NABA); Was an artist-in-residence at the Rhode Island School of Design (RISD); And frequently leads typography workshops in the US, Europe and Asia. His first monograph *Oded Ezer: The Typographer's Guide to the Galaxy* was published by Die Gestalten Verlag in May 2009.

Patrick Thomas

Thomas is a graphic artist, author and educator. He studied at Central Saint Martins and the Royal College of Art before relocating to Barcelona in 1991. In 2005 he published Black & White, a compilation of his work for the International Press. In 2011 Laurence King Publishing, published his second book Protest Stencil Toolkit. A revised edition was released in April 2019. In 2007 he set up his first press. Since then he has exhibited his limited-editions across five continents, where many are now held in private and public collections. In April 2018 he was interviewed on BBC Radio 4 Front Row about his public installation Breaking News. The project has since been realised in various European cities. He has given talks about his practice and held workshops worldwide. Between 2004–05 he was Graphic Research Fellow at Liverpool John Moores University and since October 2013 he is a professor of visual communication at the Stuttgart State Academy of Art. In May 2019 he released Open_collab, a free self-run project to encourage collaboration and experimentation. Since 2011 he is based in Berlin. In 2019 he was invited for a residency at Villa Massimo, the German Academy in Rome."

Pooroni Rhee

Pooroni is an illustrator and a graphic designer based in Seoul, Korea. She grew up in Korea and Jordan, and studied Painting at Rhode Island School of Design as an undergraduate, and earned MFA and Doctor of Design in Visual Communication Design from Seoul National University. She was chosen as the Next Generation Design Leader by the Ministry of Industry and Energy. She is currently an assistnant professor in the Department of Industrial and Visual Design, University of Seoul.

René Knip

René Knip studied at the Academy of visual Arts St.Joost, Breda. He initially planned to become a painter, but an important teacher, type designer and calligrapher Chris Brand, stimulated his fascination for lettering, calligraphy and typography. For this reason Knip switched to the applied arts. he graduated with distinction in 1990. After an intensive training of three years as the assistant designer to Anthon Beeke, he started his own atelier in 1992. Atelier René Knip concentrates on graphic design at the dividing line between flat and three-dimensional works. Knip calls it the '2-1/2 dimension'. In his opinion this is a fallow land, a largely unexplored field. Other typical ARK interests are the miraculous effects between the male and the female: the autonomic possibilities of the applied graphic art; the independency of material and colour; and type design and calligraphy as visual tools. ARKTYPE.NL was launched in 2012, 25 architectural type related projects which he designed together with graphic designer Janno Hahn. These spatial letter tools will be for sale on the internet. www.arktype.nl Atelier Rene Knip is a one man studio, but for years he functions with a solid team of mostly self trained freelancers around him. Rene Knip won several graphic awards and teaches / lectures all around the world. He is a member of the Alliance Graphique Internationale since 2005. After 20 years in the center of Amsterdam, Knip moved in 2006 to a Frysian farmhouse in the north of the Netherlands. In 2016 He moved back to the west with his family. Right now, he lives and works in bloemendaal where he designed his new Atelier. He is married to filmmaker Jorien van Nes and father of Yuna (2008) and Finn (2011)

257

낸시 스콜로스

오하이오에서 태어난 낸시는 신시내티대학교에서 디자인을 공부하기 시작했다. 2년에 걸쳐 공부를 마치고, 크랜브룩예술아카데미 학부생으로 들어가, 그곳에서 학제 간 디자인 BFA를 받았다. 이후 그래픽 디자인 전공으로 예일대학교 대학원에 진학했다. 졸업 후에는 크랜브룩에서 만나 결혼한 남편 톰 웨델(사진작가 겸 디자이너)과 함께 보스턴에 스튜디오를 열었다. 1980년대는 첨단 기술 산업으로 보이지 않는 것을 볼 수 있던 시대여서 일거리가 순조롭게 들어왔다. 합리적인 타이포그래피 구조를 결합한 이들의 초현실적인 사진 콘셉트는 '소프트웨어' 같은 추상적인 개념에 목소리를 불어넣었다. 이 스튜디오를 다룬 1993년 《Eye》 매거진 특집에서는 그들의 태도를 "테크노 큐비스트"라고 표현했다. 경력이 쌓이는 동안 그들의 접근법은 진화했고 고객 기반이 확장되었지만, 사진과 디자인의 경계를 모호하게 하는 열정은 그들이 가진 비전의 근간으로 남아 있다. 낸시는 현재 RISD에서 교수로 재직 중이며 그래픽 디자인과 학과장과 건축 디자인 학부 학장을 역임했다.

오데드 에제르

오데드 에제르는 실험적인 타이포그래픽 디자인 픽션 프로젝트와 히브리 활자 디자인에 대한 지속적인 공헌으로 가장 잘 알려진 그래픽 아티스트 겸 타이포그래퍼다. 에제르는 예루살렘의 베잘렐 미술 디자인 아카데미에서 그래픽 디자인을 공부했다. 이어 2000년에 타이포그래피와 폰트 디자인을 전문으로 하는 독립 스튜디오 오데드 에제르 타이포그래피를 설립했다. 2004년 오데드는 히브루타이포그래피 활자 주조소를 설립하여 자신의 서체를 선도적인 미디어 회사와 디자인 스튜디오에 판매했다. 에제르의 프로젝트, 포스터, 그래픽 작품들은 전 세계적으로 전시되고 출판되며, 저명한 박물관에 영구 소장되었다. 오데드 에제르는 홀론공과대학의 수석 강사이며, 밀라노의 누오바미술아카데미에서 강의한다. RISD 입주 작가 경력이 있으며 미국, 유럽, 아시아에서 종종 타이포그래피 워크숍을 진행한다. 그의 첫 번째 모노그래프 『오데드 에제르: 은하계를 여행하는 타이포그래퍼를 위한 안내서』는 2009년 5월 게슈탈텐 출판사에서 출간되었다.

패트릭 토머스

그래픽 아티스트, 작가, 교육자이다. 영국의 센트럴세인트마틴스와 왕립예술대학에서 수학한 후 1991년 바르셀로나로 이주했다. 2005년에 작품집 『Black & White』를 인터내셔널 프레스에서 출판했다. 2011년, 로렌스킹 출판사가 그의 두 번째 책 『Protest Stencil Toolkit』을 출판했다. 2019년 4월에 개정판이 나왔다. 2007년에 자신의 첫 번째 출판사를 설립했다. 그 이후 한정판 도서들을 다섯 개 대륙에 걸쳐 전시했으며, 현재 다수가 민간이나 공공 컬렉션의 일부로 소장되어 있다. 2018년 4월, 그는 BBC 라디오 4 〈프론트 로우〉에서 자신의 공공 설치물 〈브레이킹 뉴스〉 관련 인터뷰를 했다. 이후 그 프로젝트는 유럽의 여러 도시에서 구현되었다. 전 세계적으로 자신의 작업에 대해 강연하고 워크숍을 열었다. 2004년부터 2005년 사이에 리버풀 존무어스대학교의 그래픽 리서치 펠로우였고, 2013년 10월부터 슈투트가르트주립미술아카데미의 시각 커뮤니케이션 교수로 재직하고 있다. 2019년 5월에는 협업과 실험을 장려하는 자기 주도 프로젝트 〈오픈_콜랩〉을 공개했다. 2011년부터 베를린에 거주하고 있으며, 2019년에는 로마의 독일 아카데미 빌라 마시모에서 레지던시 초청을 받았다.

이푸로니

서울을 중심으로 활동하는 일러스트레이터이자 그래픽 디자이너다. 한국과 요르단에서 성장했으며 RISD에서 회화를 전공한 뒤, 서울대학교에서 시각 커뮤니케이션 디자인 전공으로 MFA와 박사학위를 받았다. 지식경제부 주관 차세대디자인리더로 선정된 바 있으며, 현재는 서울시립대학교 산업디자인학과 조교수로 재직 중이다.

르네 크닙

크닙은 브레다의 신트요스트시각예술아카데미에서 공부했다. 처음에는 화가가 되려 했지만, 중요한 스승이자 활자 디자이너 겸 타이포그래퍼 크리스 브랜드의 영향으로 레터링과 캘리그래피, 타이포그래피에 매료되었다. 결국 크닙은 응용예술로 방향을 전환했다. 그는 1990년에 우등으로 학교를 졸업하고 안톤 비케의 조수로 3년 동안 강도 높은 훈련을 받은 다음 자신의 스튜디오 아틀리에를 시작했다. 아틀리에 르네 크닙은 평면과 입체 작품의 갈림길에선 그래픽 디자인에 집중한다. 크닙은 그것을 '2와 1/2 차원'이라고 한다. 그는 이것이 휴한지, 즉 대체로 미개척지라고 생각한다. 아틀리에 르네 크닙의 다른 관심사는 여성성과 남성성의 기적적인 효과, 응용 그래픽 아트의 자율적 가능성, 재료와 색의 독립성, 그리고 시각적 도구로서의 활자 디자인과 캘리그래피이다. 2012년에는 ARKTYPE.NL을 출범시켜 그래픽 디자이너 야노 한과 함께 스물다섯 건의 건축적인 활자 관련 프로젝트를 디자인했다. 이 공간적인 글자 도구들은 인터넷 www.arktype.nl에서 판매된다. 아틀리에 르네 크닙은 1인 스튜디오지만 수년 동안 대부분 독학으로 공부한 프리랜서로 구성된 든든한 팀과 함께 일하고 있다. 르네 크닙은 다수의 그래픽 디자인상을 받았고 전 세계에서 강의한다. 2005년부터 AGI 회원이다. 암스테르담 중심지에서 20년을 보낸 후 2006년에 네덜란드 북부의 프리지아식 전통 농가로 이사했다. 2016년에는 가족과 함께 다시 서부로 이사했다. 지금은 새로운 아틀리에가 있는 블루먼달에 거주하며 일하고 있다. 영화제작자 요리엔 판 네스와 결혼하여 두 자녀 유나와 핀을 두었다.

Robert Probst

Robert Probst received his design education from the University of Essen, Germany, and the College of Design Basel, Switzerland. In 1975 his professional career began in Otl Aicher's Bureau for Visual Communication, Rotis. His four decades of practice are based on work for cultural, historical, zoological, medical, educational, municipal institutions, and for the private sector. Since 1978 he has been Professor of Graphic Design at the University of Cincinnati; Director of the School of Design, 2001–2007, and Dean of the College of Design, Architecture, Art, and Planning, 2007–2018. He is currently leading the Simpson Center for Urban Futures at the University's Innovation Hub. Professor Probst's academic and professional work is featured in numerous publications. He has received many awards from professional organizations and has lectured at institutions and international conferences in the United States, Mexico, England, Spain, Germany, Switzerland, South Korea, Australia, and Saudi Arabia. His work is included in the permanent collections of the Ohio Arts Council, the Cooper-Hewitt Smithsonian Design Museum in New York, The National Museum of Modern Art in Tokyo, the Museum of Design Zurich, and the ICOGRADA Hall of Fame, London. In 1997 he was elected member of AGI. He served on the Board of Directors of the international Society for Environmental Graphic Design and as President of its Education Foundation. In 1996 he was named Fellow of SEGD. In 2010 he was selected as one of the nation's top twenty-five design educators and administrators by the Design Futures Council and in 2019 he was the recipient of SEGD's National Educator Award. Mr. Probst has three children with his wife Alison, — Jasmine, Alistair, and Lyndon.

Rolf Müller

Rolf Müller is known above all for his design of the visual identity of the Munich Olympic Games in 1972. Shortly after graduating from the famous Ulm School of Design, his former professor Otl Aicher entrusted him with this work, which set new standards in international design. In parallel, he established his design buero Büro Rolf Müller für Visuelle Kommunikation in Munich. For nearly four decades, the buero developed corporate identities, books, magazines and signage systems on the highest level. The buero's projects include the visual identity of the City of Leverkusen, forged over several decades, and the magazine „HQ High Quality" for the company Heidelberger Druckmaschinen, of which 39 issues were published. As a storyteller and system designer, Rolf Müller has left his mark on international design history with his work. His stance has had a decisive impact in shaping the way in which today's communications designers view their profession.

Ruedi Baur

Ruedi Baur is a franco-swiss multidisciplinary graphic designer born in Paris in 1965. He trained in graphic design at Michael Baviera and at the School of Applied Arts in Zürich (Schule für Gestaltung). After having created BBV (Lyon–Milan–Zürich) in 1983, he set up Integral Concept in 1989, presently comprising the studios of five independent partners, who are able to intervene jointly on any cross-disciplinary project. Between 1989 and 1994, he coordinated the department of design 'information space' at the École des Beaux-Arts in Lyon; between 1994–1996, he ran a course based on the theme 'civic and design spaces'. In 1995, he became professor of corporate design at the Hochschule für Grafik und Buchkunst, Leipzig, where he was rector from 1997 until 2000. There he created the Interdisciplinary Design Institute (2id) in 1999. In April 2004 he set up the Design Institute at the Hochschule für Gestaltung und Kunst der Stadt Zürich (HGKZ). He regularly teaches at Laval University, Québec (École de Percée), the CAFA of Beijing, China, the Lu Xun Academy of Shenyang, at the EnsAD - Paris and HEAD - Geneva.

Ruedi Baur defended his doctoral thesis in 2016 at the University of Strasbourg on "the civic values of public representation systems."
Several structures accompany Ruedi Baur's work and research:
- Integral Designers, Paris (founded in 1989) : design studio working on issues of information, orientation, identification and staging of cities and neighbourhoods in the digital context.
- IRB Laboratory, Paris (founded in 2007) : a laboratory of visual experimentation that Ruedi Baur shares with Denis Coueignoux
- Civic city (founded in 2011 with Vera Baur-Kockot) : an associative network working on design issues
- dix—milliards—humains (founded in 2018 with Vera Baur-Kockot) : a research-création institute in design

Sabina Oberholzer

Sabina Oberholzer studied with Livio Bernasconi, Sergio Libiszewsky and Bruno Monguzzi at the CSIA in Lugano. In 1983 Sabina founded the Studio di Progettazione Grafica with her partner Renato Tagli in Cevio, in the Italian-speaking region of Switzerland. Oberholzer and Tagli are alive to the relationship between nature and creativity, and sensitive to their responsibilities within the small community in which they live and work. Driven not by economics but rather by a belief in quality and clarity of the message, Oberholzer's design philosophy is based on appropriateness and generally results in the elimination of the superfluous, ornate or artificial.

로버트 프롭스트

로버트 프롭스트는 독일 에센대학교와 스위스 바젤디자인대학교에서 디자인 교육을 받았다. 1975년에 오틀 아이허의 시각 커뮤니케이션 스튜디오인 로티스에서 커리어를 시작했다. 지난 40년 동안 문화, 역사, 동물, 의료, 교육, 시립 기관들 및 민간 부문을 위한 작업에 기반을 두고 일했다. 1978년부터 신시내티대학교의 그래픽 디자인 교수로 재직했으며, 디자인 대학원의 디렉터(2001~2007)와 디자인, 건축, 미술, 기획 학부의 학장(2007~2018)을 역임했다. 현재 이 대학의 혁신 허브에서 심프슨도시미래센터를 이끌고 있다. 프롭스트 교수의 학술적, 전문적 저작은 수많은 출판물에 소개되었다. 전문 기관으로부터 다수의 상을 받았으며 미국, 멕시코, 영국, 스페인, 독일, 스위스, 한국, 호주, 사우디아라비아의 기관과 국제 회의에서 강의했다. 그의 작품은 오하이오 예술 위원회, 뉴욕의 쿠퍼휴잇스미스소니언디자인 박물관, 도쿄 국립현대미술관, 취리히 디자인박물관, 런던의 ICOGRADA 명예의 전당에 영구히 소장되었다. 1997년에 AGI 회원으로 가입되었다. 국제 환경그래픽디자인협회 이사회에서 활동했으며 협회 교육재단 이사장을 역임했다. 1996년에는 SEGD 펠로우로 선정되었고, 2010년에는 디자인 미래 위원회가 주관하는 미국 최고의 디자인 교육자/행정가 25인 중 한 명으로 꼽혔다. 2019년에는 SEGD의 전미 교육자상을 받았다. 아내 앨리슨과 함께 재스민, 알리스테어, 린든 세 자녀를 두고 있다.

롤프 뮐러

롤프 뮐러는 1972년 뮌헨올림픽의 비주얼 아이덴티티로 가장 잘 알려진 디자이너이다. 울름조형대학을 졸업하고 얼마 지나지 않아 그는 은사인 오틀 아이허의 신임에 힘입어 국제적으로 세계 디자인계에 새로운 기준을 제시한 이 작업에 참여하게 된다. 그는 동시에 뮌헨에 Buro Rolf Muller fur Visuelle Kommunikation라는 디자인 스튜디오도 설립했다. 거의 40년 가까이 그의 스튜디오는 높은 수준의 CI, 책, 잡지, 사인 체계 디자인 작업을 수행했다. 레버쿠젠시와는 수십 년 동안 관계를 유지했으며, 39호까지 발간된 하이델베르거드룩마쉬넨사의 잡지 《HQ High Quality》 작업도 함께 했다. 스토리텔러 그리고 시스템 디자이너로서 롤프 뮐러는 세계 디자인사에 그의 흔적을 뚜렷이 남겼다. 그의 입지는 오늘날 커뮤니케이션 디자이너들이 자신의 미래를 설계하는 데 지대한 영향을 주었다.

루에디 바우어

루에디 바우어는 프랑스와 스위스 국적을 가진 그래픽 디자이너로서 1965년 파리에서 태어났다. 마이클 바비에라에게 그래픽 디자인을 배우고 취리히응용예술학교에서 공부했다. 1983년에 BBV(리옹-밀라노-취리히)를 만든 다음, 1989년에는 엥테그랄 콘셉을 설립했다. 엥테그랄 콘셉은 현재 독립 파트너 5인의 스튜디오로 구성되어 있으며 이들은 학제적인 모든 프로젝트에 공동으로 관여할 수 있다. 1989년과 1994년 사이에, 리옹의 에콜데보자르에 디자인학과 '정보 공간'을 조성했다. 1994년부터 1996년까지는 '시민과 디자인 공간'이라는 주제로 강좌를 운영했다. 1995년에는 라이프치히미술대학교에서 기업 디자인 교수가 되었고 1997년부터 2000년까지 총장을 역임했다. 1999년에 그곳에 학제적 디자인 연구소(2id)를 만들었다. 2004년 4월, 취리히디자인예술대학교에 디자인 연구소를 세웠다. 퀘벡의 라발대학교, 베이징의 CAFA, 셴양의 루쉰아카데미, 파리의 국립장식미술학교, 제네바의 HEAD에서 정기적으로 강의하고 있다. 2016년에 스트라스부르대학교에서 "공공 표현 시스템의 시민적 가치"를 주제로 한 박사학위 논문이 통과되었다.

루에디 바우어의 작업과 연구 관련 단체:
- 인티그럴 디자이너스, 파리(1989년 설립): 디지털 컨텍스트에서 도시와 지역의 정보, 방향성, 식별 및 구현 문제를 다루는 디자인 스튜디오
- IRB 연구소, 파리(2007년 설립): 데니스 쿠에뉴와 함께 세운 시각 실험 연구소
- 시빅 시티(베라 바우어 콕코트와 함께 2011년 설립): 디자인 문제를 다루는 관련 네트워크
- 디스—밀리아르—위망 (베라 바우어 콕코트와 함께 2018년 설립): 디자인 연구 기관

사비나 오버홀처

사비나 오버홀처는 루가노의 CSIA에서 리비오 베르나스코니, 세르지오 리비제프스키, 브루노 몬구치와 함께 공부했다. 1983년 사비나는 파트너인 레나토 타글리와 함께 스위스의 이탈리아어 사용 지역 체비오에 스튜디오 디 프로제타지오네 그라피카를 설립했다. 오버홀처와 타글리는 자연과 창조성의 관계를 의식하며 그들이 거주하고 일하는 작은 공동체 안에서 자신들의 책임에 민감하다. 경제학이 아니라 메시지의 품질과 명확성을 중시하는 오버홀처의 디자인 철학에 따라 적절성에 기반을 두고 일반적으로 군더더기와 화려한 장식 또는 인위적인 부분을 제거한다.

Stefan Sagmeister

Sagmeister received his MFA in graphic design from the University of Applied Arts in Vienna and, as a Fulbright Scholar, a master's degree from Pratt Institute in New York. He formed the New York based Sagmeister Inc. in 1993 and has since then, designed graphics and packaging for the Rolling Stones, Talking Heads and Lou Reed. He was nominated five times for the Grammy awards and finally won one for the Talking Heads boxed set. He has also won most international design awards. The monographs about his work titled _Sagmeister Made You Look_ and _Things I've Learned in my Life_ so far both became bestsellers. His work has been seen in solo shows in Zürich, Vienna, New York, Berlin, Tokyo, Osaka, Prague, Cologne and Seoul. Stefan has tried to keep his studio small. He lectures extensively on all continents.

Tai-Keung Kan

As a world-renowned designer and artist, Dr. Kan has earned numerous awards including the "Hong Kong Ten Outstanding Young Persons" award in 1979 and the Urban Council Design Grand Award in 1984; he was also the first Chinese citizen to be included in the 1995 "Who's Who in Graphic Design" of Switzerland. He was conferred the Honour of Bronze Bauhinia Star and the Honor of Silver Bauhinia Star in 1999 and 2010 respectively. In 2016, Kan was awarded HKDA Lifetime Honorary Award by Hong Kong Designers Association. At present, Kan is actively involved in educating and promoting art and design profession. He is now the Honorary Dean of the Cheung Kong School of Art and Design, Shantou University, a fellow member of Hong Kong Designers Association; a member and the member of Chinese Committee of the Alliance Graphique Internationale, an advisor of the Leisure & Cultural Services Department, the Honorary Advisor of Hong Kong Museum of Art and board member of the West Kowloon Cultural District Authority.

Thomas Widdershoven

Thomas Widdershoven is co-founder and director of thonik (established in 1993). thonik is the Amsterdam based collective of designers with a speciality in visual communication, graphic identity, interaction- and motion design. thonik offers their clients a visual voice that sets apart and differentiates: providing pole position. thonik has its roots firmly planted in society, willing to actively engage in the dialogue of what is right and what is fair. We seek to change the world. One design at a time. thonik is thoroughly familiar with the power of design and its capacity to transform, to unify, to communicate, to celebrate, to bring joy and provoke thought. Our work embraces those traits. Thomas is former creative director of Design Academy Eindhoven, curator and guest professor.

Willi Kunz

Willi Kunz is a typographer, graphic designer, artist and author practicing in New York. He was a teacher of typographic design at the Ohio State University, and the School of Design, Basel, Switzerland. He is the author of Typography: Macro- and Microaesthetics, (English editions 1998, 2000, 2002), editions also in German, Spanish and Chinese. Typography: Formation and Transformation (2003). Phantasmagorias: Daydreaming with Lines (2017). Many of his works are in the collection of the Museum of Modern Art, NY; the Cooper Hewitt, Smithsonian Design Museum, NY; the Herb Lubalin Study Center of Design and Typography, Cooper Union, NY; the RIT Graphic Design Archive, Rochester, NY; the Getty Museum, Los Angeles; the San Francisco Museum of Modern Art; the Denver Art Museum; the Museum of Design, Zürich; and the Bibliothèque Nationale de France, Paris; and many important private collections. Willi Kunz is a member of AGI (Alliance Graphique Internationale).

Woohyuk Park
Jin Dallae & Park Woohyuk

The artist collective 'Jin Dallae and Park Woohyuk' run the project 'Archive An-nyeong' ('An-nyeong' is a Korean word and it is used to say hello and it also means goodbye), a real/virtual platform that records questions about the order, rules, norms, practices, and patterns behind objects and phenomena through a variety of attitudes. Past exhibitions include solo events 'Crescendo: DOT, DOT, DOT, DOT' (space willing n dealing, 2018), 'A Concrete Case' (Space Sarubia, 2016), 'The Lion, the Witch and the Wardrobe' (D project space, 2015), 'Signal' (Geumcheon art factory, 2014), and group events 'Artist On The Move - International Residency Exchange Episode' (Media Art Wall of National Museum of Modern and Contemporary Art, 2018), 'Pattern Exercise' (Keumho Museum, 2017), 'Unforeseen' (National Museum of Modern and Contemporary Art, 2016), and 'APMAP' (Amore Pacific Museum, 2015)."

259

스테판 사그마이스터

사그마이스터는 빈 응용미술대학교에서 그래픽디자인 MFA를 받았고, 풀브라이트 장학생으로 뉴욕 프랫인스티튜트에서 석사학위를 받았다. 1993년, 뉴욕에 사그마이스터 사를 설립했으며, 그 이후로 롤링스톤스, 토킹헤즈, 루리드를 위한 그래픽과 패키지 디자인을 해왔다. 다섯 차례 그래미상 후보로 올랐고, 토킹헤즈의 박스 세트로 결국 그래미상을 받았으며 다수의 국제적인 디자인상을 받았다. 2001년, 그의 작업에 대한 모노그래프『Sagmeister Made You Look』이 부스클리본 에디션스에서 출간되어 베스트셀러가 되었다. 사그마이스터 사에서 했던 작업을 가지고 취리히와 빈, 뉴욕, 베를린, 도쿄, 오사카, 프라하, 쾰른 그리고 서울에서 개인전을 열었다. 스테판은 스튜디오를 소규모로 유지하며 세계적으로 폭넓은 강연 활동을 하고 있다.

칸타이콩

세계적인 디자이너이자 아티스트인 칸타이콩 박사는 1979년에 '홍콩의 뛰어난 젊은이 10인' 상과 1984년 도시위원회 디자인 대상을 비롯하여 수많은 상을 받았다. 또한 중국인으로서는 처음으로 1995년 스위스『후스후 그래픽 디자인 인명사전』에 실리기도 했다. 1999년, 2010년에 브론즈 바우히니아 스타와 실버 바우히니아 스타 훈장을 각각 받았으며, 2016년에는 홍콩 디자이너협회로부터 평생공로상을 받았다. 현재 칸타이콩은 미술과 디자인 분야의 교육과 진흥을 위한 활동에 적극 참여하고 있다. 산터우대학교 창강예술디자인학원 명예 원장, 홍콩디자이너협회 회원이며 국제그래픽연맹 중국위원회의 회원, 홍콩 여가문화서비스부 고문, 홍콩미술관 명예고문이며 웨스트 카오룽 문화지구 당국의 이사회 회원이다.

토마스 비더쇼벤

토마스 비더쇼벤은 1993년에 설립된 토닉의 공동 창업자 겸 디렉터이다. 토닉은 시각 커뮤니케이션, 그래픽 아이덴티티, 인터랙션 디자인과 모션 디자인을 전문으로 하는 암스테르담의 디자이너 공동체다. 토닉은 차별화된 시각적 목소리를 제시하여 고객들이 선도적인 위치를 점유할 수 있도록 한다. 토닉은 사회에 단단히 발을 내리고, 무엇이 옳고 무엇이 정당한지에 대한 대화에 적극적이다. 한 번에 하나의 디자인을 통해 세상을 바꾸고자 한다. 토닉은 디자인의 힘과 변화시키고, 통일시키고, 전달하고, 축하하며, 기쁨을 가져오고 생각을 자극하는 디자인의 역량을 철저하게 알고 있다. 이곳의 일은 그러한 특징을 아우른다. 토마스는 에인트호벤디자인아카데미의 크리에이티브 디렉터였으며, 큐레이터 겸 객원 교수이다.

윌리 쿤즈

윌리 쿤즈는 뉴욕에서 활동하는 타이포그래퍼, 그래픽 디자이너, 예술가, 작가이다. 오하이오주립대학과 스위스 바젤디자인대학교에서 타이포그래피 디자인을 가르쳤다. 저서로는 1998년, 2000년과 2002년에 영어로, 그리고 독일어, 스페인어, 중국어로도 출간된『Typography: Macro- and Microaesthetics』(1998),『Typography: Formation and Transformation』(2003), 『Phantasmagorias: Daydreaming with Lines』(2017)가 있다. 그의 작품 다수가 뉴욕 현대미술관과 쿠퍼휴잇국립디자인박물관, 허브루발린디자인타이포그래피 연구센터, 쿠퍼유니언, 뉴욕주 로체스터의 RIT 디자인아카이브, 로스앤젤레스의 게티센터, 샌프란시스코 현대미술관, 덴버미술관, 취리히 디자인박물관, 파리의 프랑스국립도서관, 그리고 미국의 주요 개인 컬렉션에 소장되어 있다. 윌리 쿤즈는 AGI 회원이다.

박우혁
진달래&박우혁

예술 공동체 진달래&박우혁은 사물과 현상의 질서, 규칙, 규범, 관습, 패턴에 대한 의문을 다양한 태도로 기록하는 가상 혹은 실제의 플랫폼, 프로젝트 <아카이브안녕>을 전개하고 있다. 개인전 <크레센도: 닷, 닷, 닷, 닷>(스페이스 윌링엔딜링 2018), <구체적인 예>(사루비아다방 2016), <사자, 마녀 그리고 옷장>(구슬모아당구장 2015), <시그널>(금천예술공장 2014), 단체전 <이동하는 예술가들-국제교환편 (국립현대미술관 미디어아트월 2018), <패턴연습> (금호미술관 2017), <예기치않은>(국립현대미술관 2016), <APMAP>(아모레퍼시픽미술관 2015) 등의 전시에 참여했다.

261